COMPING IS USAGE. ASK FIRST.

WORK BOOK CONTENTS

YOU

YOU AND YOUR FELLOW MAN

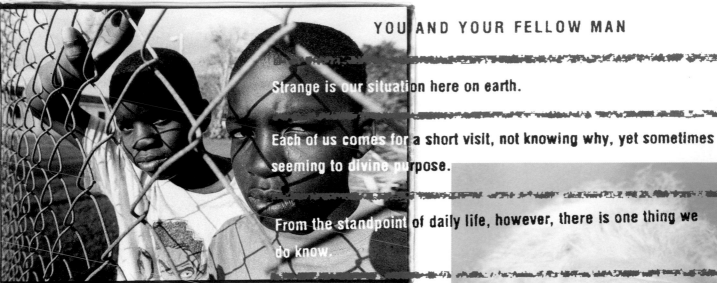

Chris Coxwell

Strange is our situation here on earth.

Each of us comes for a short visit, not knowing why, yet sometimes seeming to divine purpose.

From the standpoint of daily life, however, there is one thing we do know.

That we are here for the sake of humanity. . . for the countless unknown souls with whose fate we are connected by a bond

Many times a day I realize how my own outer and inner life is built upon the labors of my fellow human beings, both living and dead, and how earnestly I must exert myself in order to give in return as much as I have received and am still receiving.

Albert Einstein

FPG International

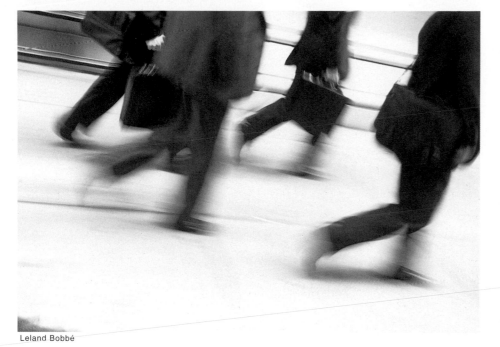

Leland Bobbé

IT'S 7:30 P.M.
AND YOU JUST
SAT DOWN FOR
DINNER AFTER
A REALLY LONG
D A Y .

From the standpoint of daily life, however, there is one thing we do know.

Chris Coxwell

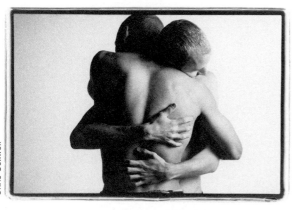

WE ARE CONNECTED BY A
BOND OF SYMPATHY

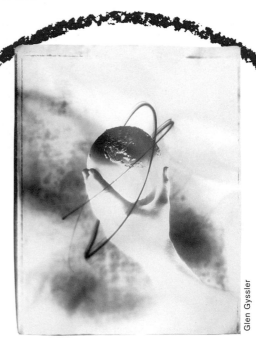

Glen Gyssler

WE ARE HERE FOR THE
SAKE OF HUMANITY

and your fellow man

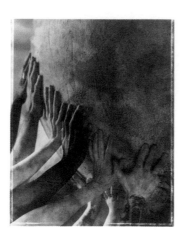

Publisher/Editor
ALEXIS SCOTT
Creative Director/Designer
CRAIG BUTLER
Managing Editor
SUSAN HALLER
Advertising Sales Director
SUZANNE SEMNACHER
Director of Production
PAUL SEMNACHER
Marketing Director
BOB SCHMOLZE
Wholesale Circulation
JOCELYN KAY
Art Directors
ZOË HENNEGAN
VLADIMIR PAPERNY
Production Artist
GAVAN DONNOT
Advertising Sales Reps
MARCIA FARRELL
ALLEGRA LEACH
LINDA LEVY
ROBERT PASTORE
ROBERT SAXON
LORI WATSON
Editorial Associates
MARILYN WALSH
DANA SLESINGER
Editorial Associate/New York
FRANCESCA MECCARIELLO
Editorial/Research
JENNIFER BELLA
COURTNEY CUMMINGS
ABIGAIL FLEISHMAN
CLARE GIBBS
CHRISTINA GREGORY
MARK JACKSON
KATIE JAVELERA
TAIFA KIMBROUGH
LISH ROLDAN
CYNTHIA CLAIRE
STOCKHAMMER
MICHELLE VILLEGAS
Advertising Assistant/Chicago
NANCY MOREY
Production Manager
LYNN D. PILE
Traffic Manager
EDMOND OSBORN
Production
RON LARSON
JERRY PIERETTI
CARMEN L. PILE
Production Assistants
JAMIE EDWARDS
EDUARDO JETER
SARA KRAMER
Computer Systems Manager
MARCUS CATLETT
JAMES LA VIOLA
Word Processor
NJERI CATLETT
Proofreader & Editorial Consultant
GARY M. JOHNSON
Cover Photograph
MICHELE CLEMENT
Bookend Concept
JERRY KRAMER
Printer
TOPPAN PRINTING COMPANY
LTD., TOKYO, JAPAN
Accounting/Financial Services
RICHARD SCOTT
Controller
ELAINE FAHN
Chairman of the Board
HEATHER SCOTT
Vice-President
ASHLEY BUTLER

But, every once in a while, stop and think.

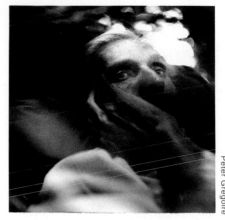

Peter Gregoire

It's 7:30 p.m. and you just sat down for dinner after a really long day. The phone rings. It's another call from another organization requesting another donation. And after you've said - not so graciously - that you were eating dinner and to call later or not at all, you wonder how they knew you were just sitting down.

But, every once in a while, stop and think about all those organizations that call. Most of them represent people who really care about our world. Whether it's the veterans of many wars, or Greenpeace, or Mothers Against Drunk Drivers, or Doctors Without Borders, they're doing their job if they can make us think and maybe even take action.

Make a donation. Canvas the 'hood. Join. It can only make you and the world feel good. And JUST SAY YES.

We would like to thank the following people for creating dividers and covers representing their favorite organizations for the 1997 WORKBOOK.

CHARLES BURNS
MICHELE CLEMENT
WILL CROCKER
JULIE DENNIS
KAREN KUEHN
MARK LAFAVOR
MADWORKS
ADAM NIKLEWICZ
DAVID SLONIM

JUST SAY YES

Philip-Jon

It can only make you and the world feel good.

KAREN KUEHN

CAUSE

*DAAP, Domestic Abuse
Awareness Project, New York
212-353-1755*

*Bless all the abused and give them
strength to pull out and
go beyond.*

*Bless DAAP's spiritual
messenger, Donna Ferrato:
Bless her continued vision and
courage to witness violence in
America's homes and for her
work to aid battered women's
organizations to better
help themselves.*

*Guardian Angel: Grandpa Label
Wardrobe: Church Street Surplus
Wings: Courtesy of David Ross
Retouching: Christopher Bishop*

Guardian Angel

Angel of God, my
guardian dear to
whom his love commits
me here - Ever this
day - be by my side
to light and guard
to rule and guide.

EASTERN STATES

Connecticut

Delaware

Maine

Maryland

Massachusetts

New Hampshire

New Jersey

New York

Pennsylvania

Rhode Island

Vermont

Washington, DC

West Virginia

*Artist's Rep

*Artist's Rep

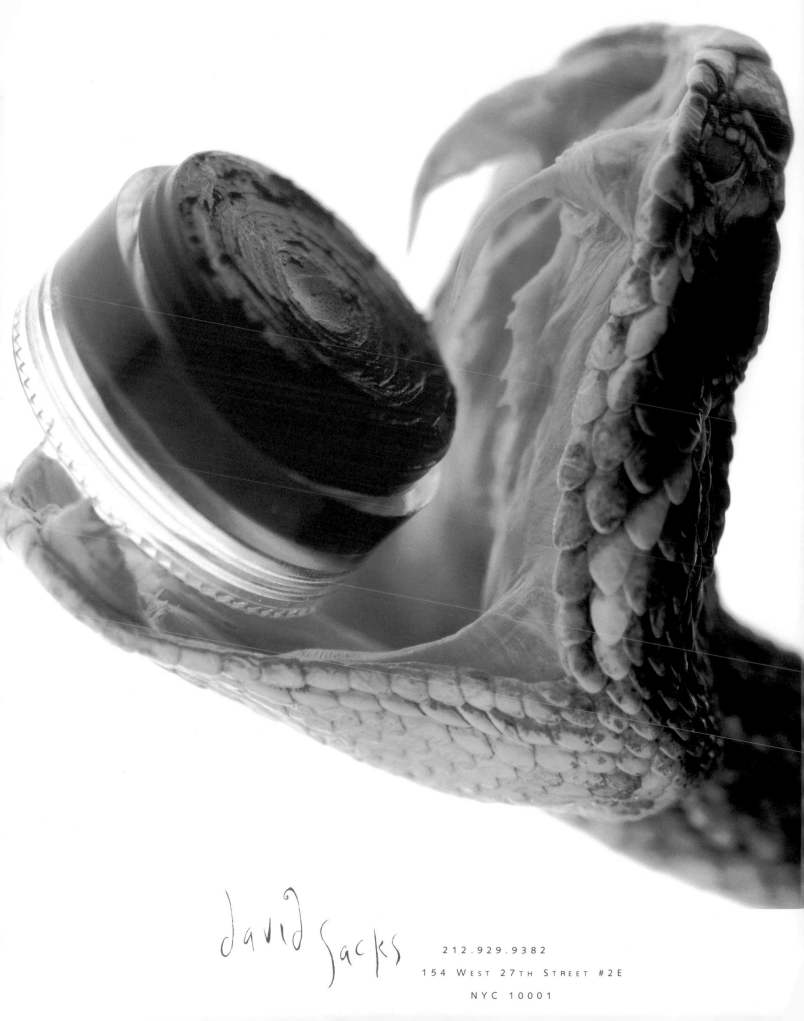

david Jacks

212.929.9382

154 WEST 27TH STREET #2E

NYC 10001

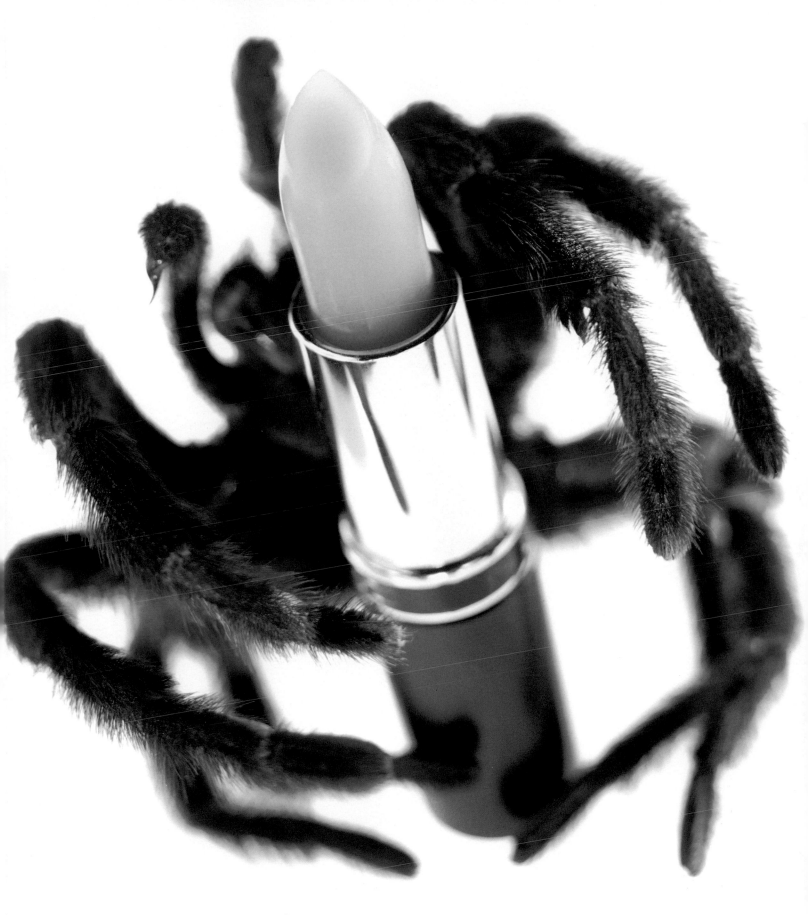

david sacks

212.929.9382

154 West 27th Street #2E

NYC 10001

13

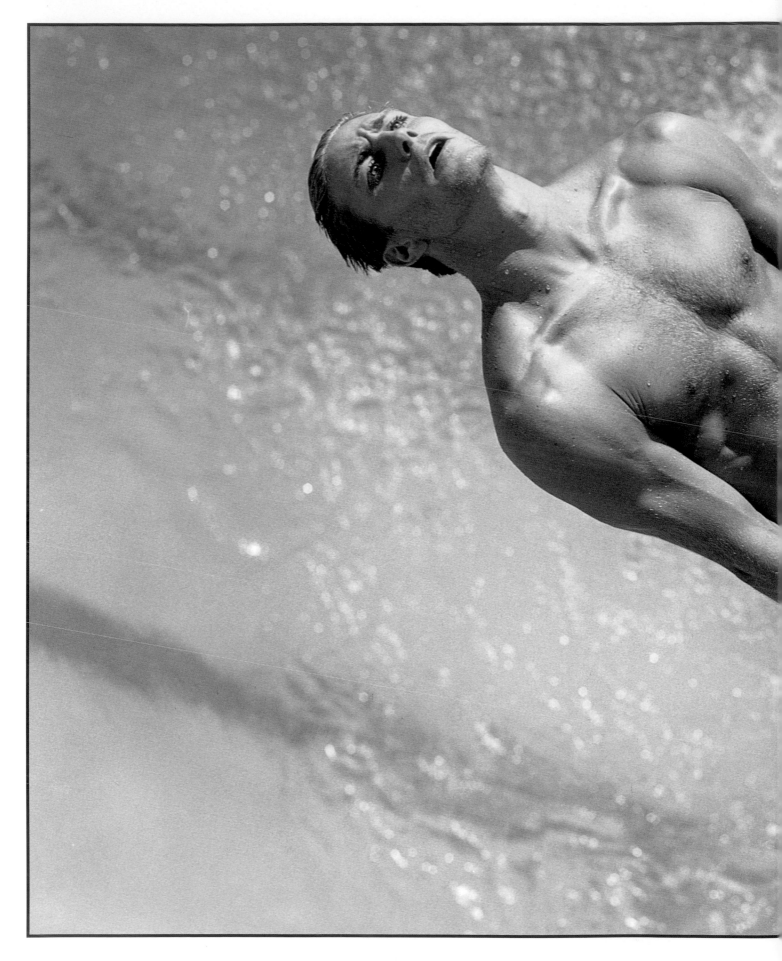

David Burnett

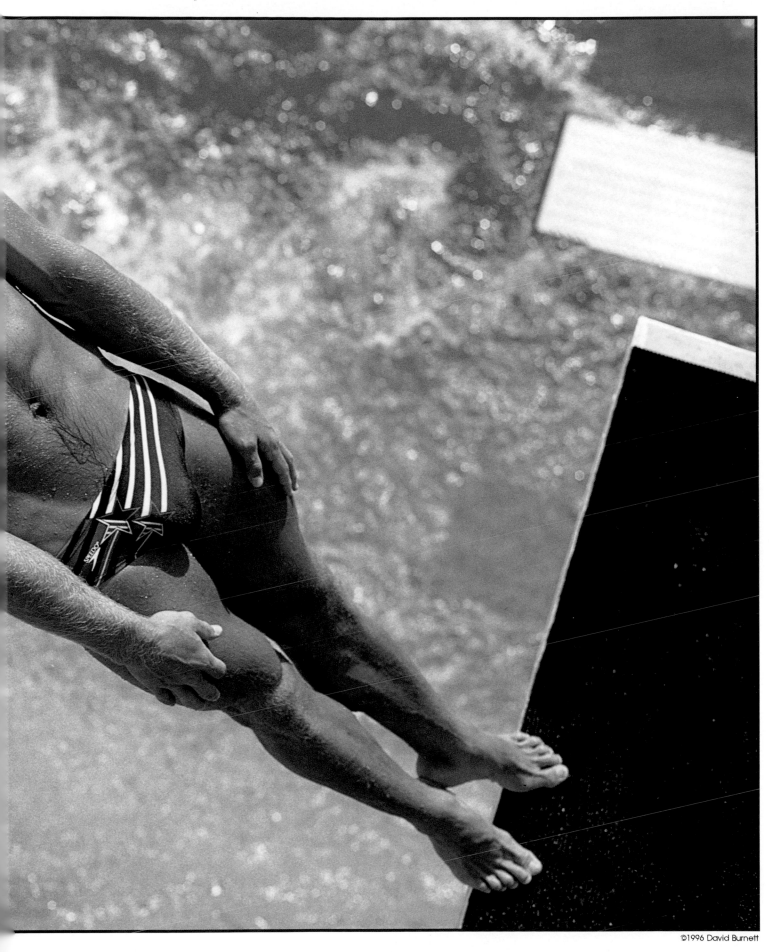

REPRESENTED BY KEN MANN (212)944-2853 FAX:(212)921-8673

BradGuice

212.941.6096 Represented by Janice Moses 212.779.7929

LUCIANA PAMPALONE

Represented by Janice Moses 212.779.7929

L U C I A N A P A M P A L O N E

R e p r e s e n t e d b y J a n i c e M o s e s 2 1 2 . 7 7 9 . 7 9 2 9

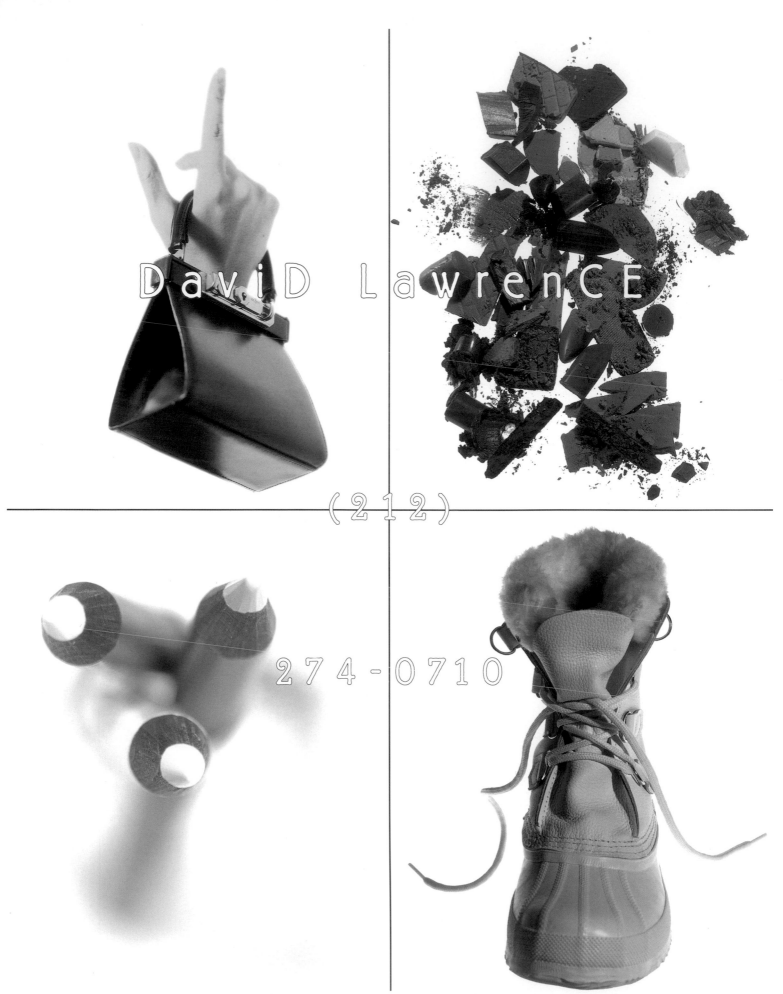

DaviD LawrenCE

(212)

274-0710

Represented by Janice Moses (212) 779-7929

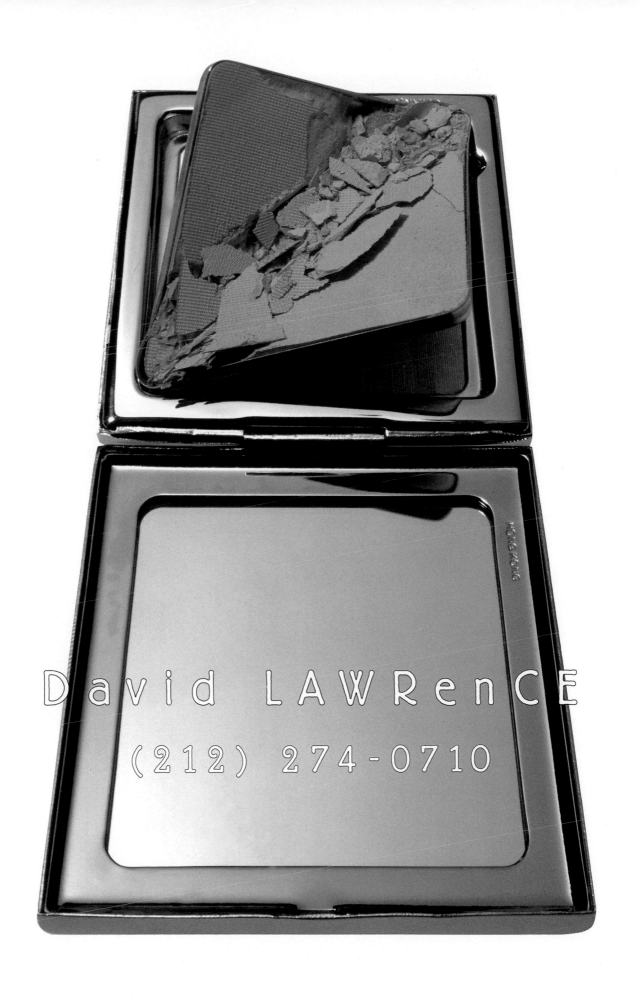

David LAWRenCE

(212) 274-0710

k a r e n k u e h n

P R I N T & F I L M

Telephone 212 477 1251 Facsimile 212 477 1482

k a r e n k u e h n

P R I N T & F I L M

Telephone 212 477 1251 Facsimile 212 477 1482

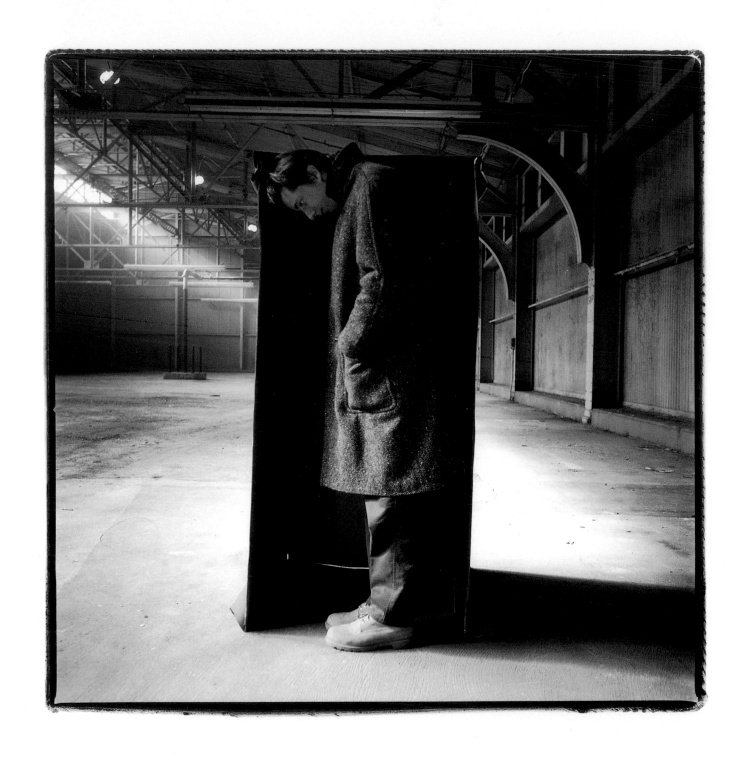

karen kuehn

PRINT & FILM

Telephone 212 477 1251 Facsimile 212 477 1482

k a r e n k u e h n

P R I N T & F I L M

Telephone 212 477 1251 Facsimile 212 477 1482

HELEN TROTMAN

212 645 1752

Represented by Janice Moses 212 779 7929

H E L E N T R O T M A N

2 1 2 6 4 5 1 7 5 2

Represented by Janice Moses 212 779 7929

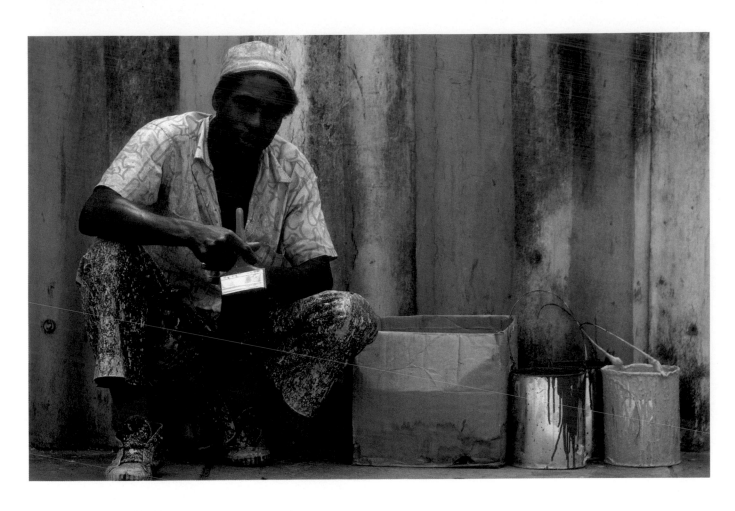

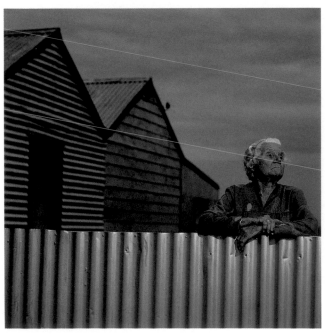

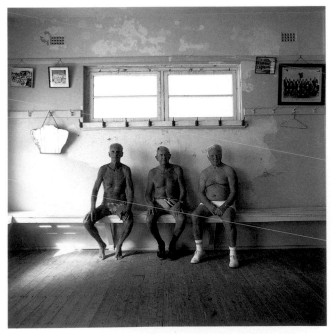

MICHAEL O'BRIEN

512-472-9205 OR 800-579-7511

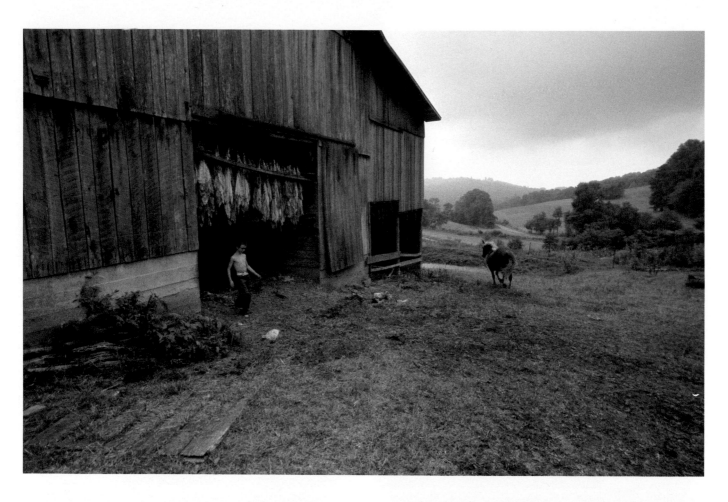

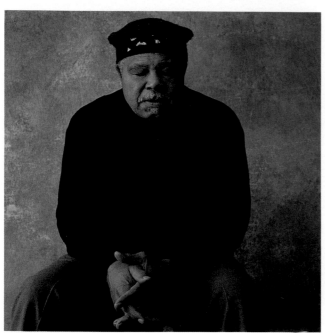

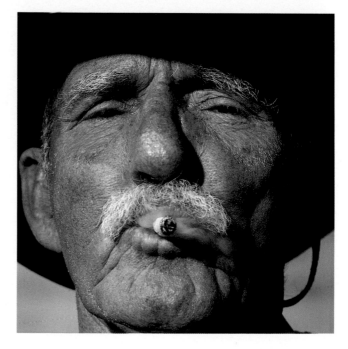

MICHAEL O'BRIEN
512-472-9205 OR 800-579-7511

Steve Bronstein

ABSOLUT SQUEEZE.

ABSOLUT CITRON.

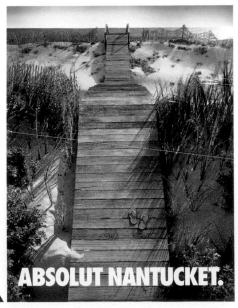

ABSOLUT NANTUCKET.

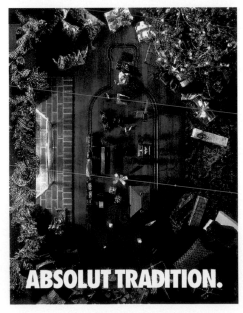

ABSOLUT TRADITION.

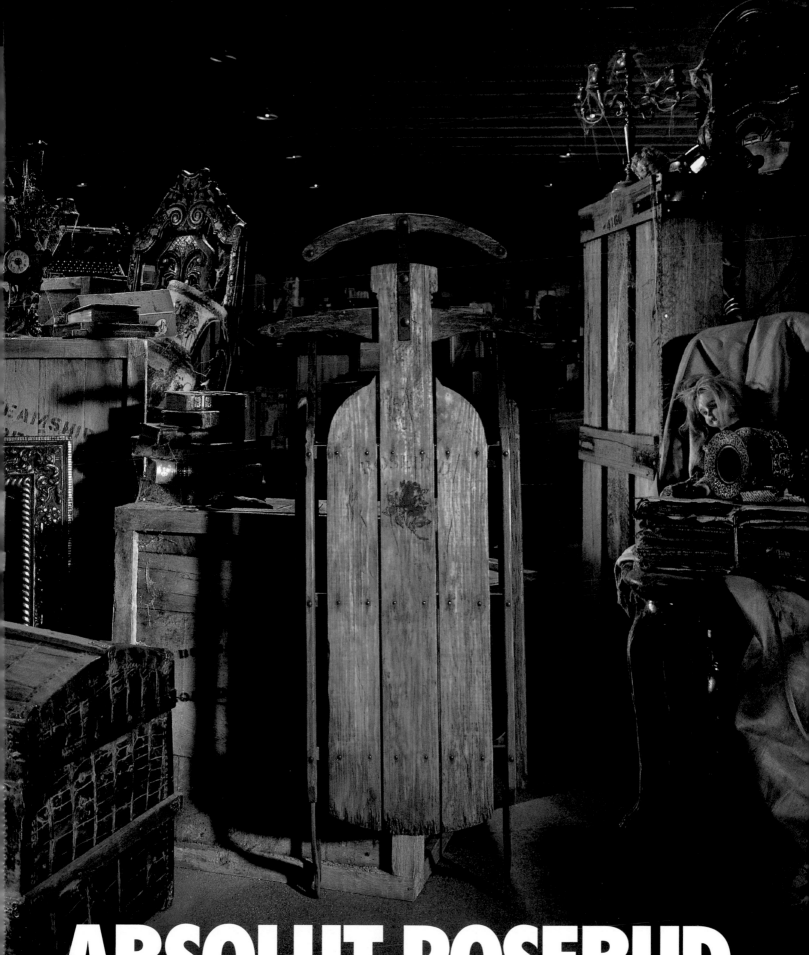

ABSOLUT ROSEBUD.

Steve Bronstein

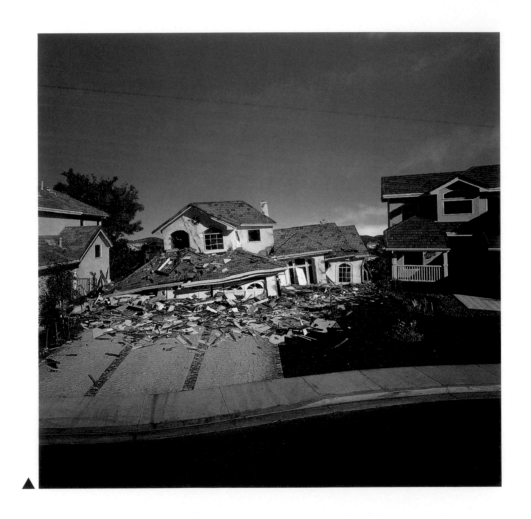

▲ Miniature Set

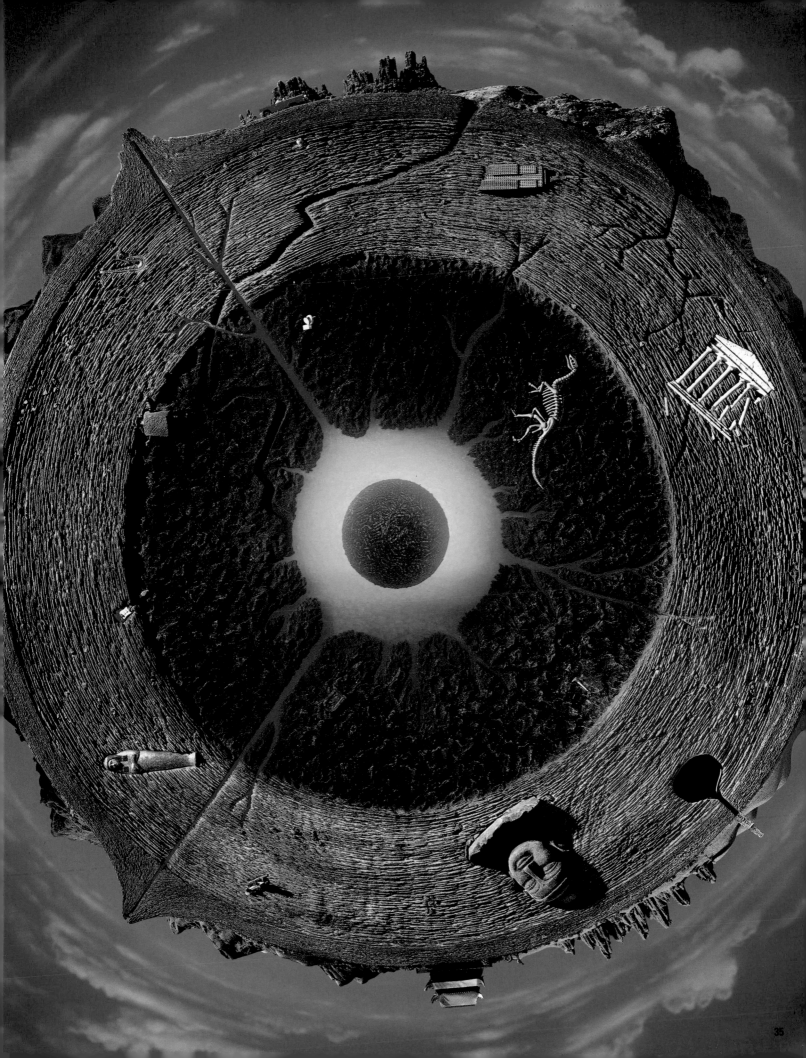

Howard Berman

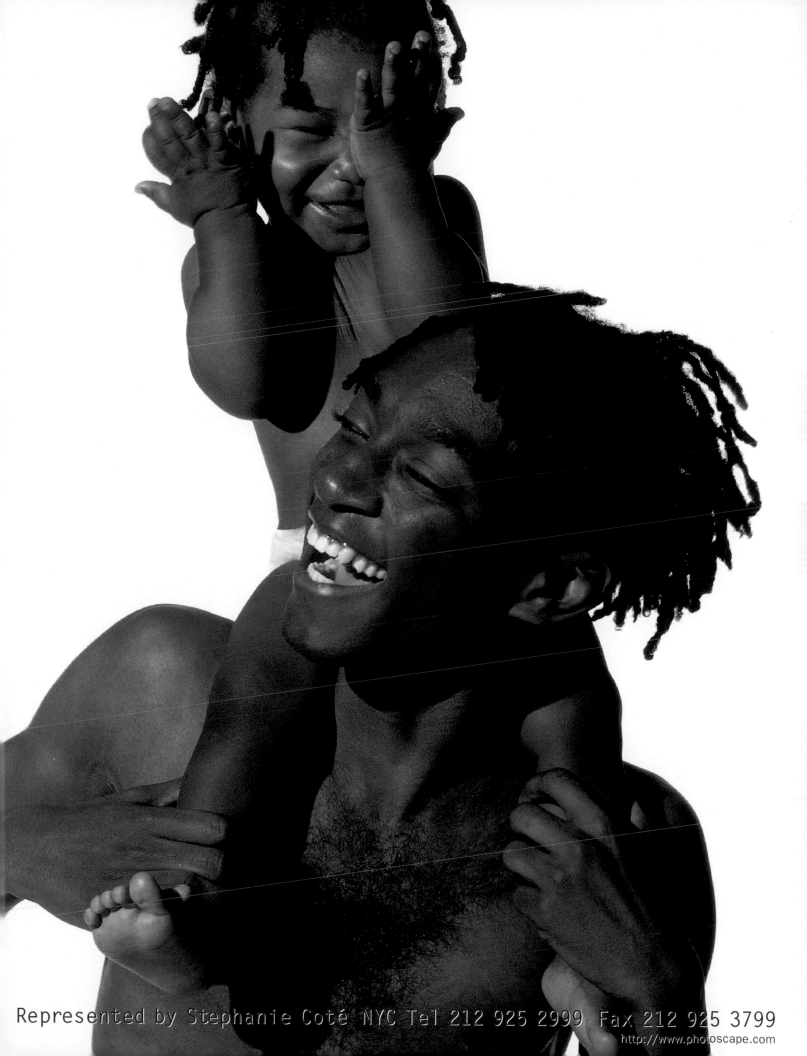

Howard Berman

Represented by Stephanie Coté NYC Tel 212 925 2999 Fax 212 925 3799
http://www.photoscape.com

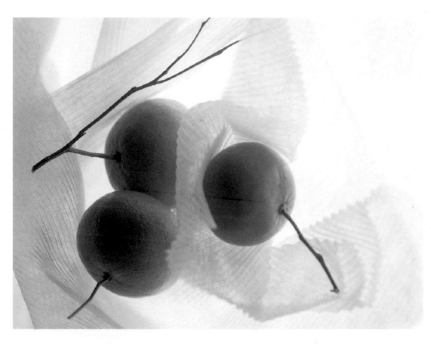

Bret Wills

Represented by Stephanie Coté NYC Tel 212 925 2999 Fax 212 925 3799

http://www.photoscape.com

Bret Wills

Represented by Stephanie Coté NYC Tel 212 925 2999 Fax 212 925 3799
http://www.photoscape.com

H O W A R D S C H A T Z

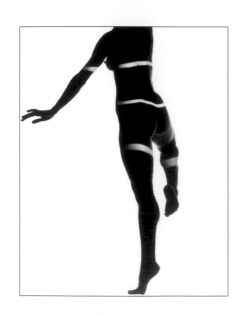

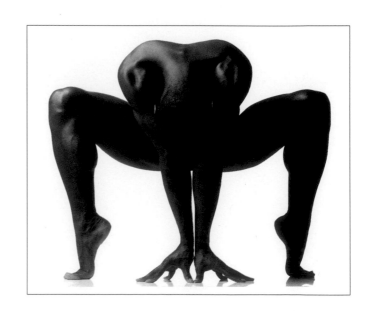

TEL 212/334-6667 CONTACT BEVERLY ORNSTEIN FAX 212/334-6669

HOWARD SCHATZ

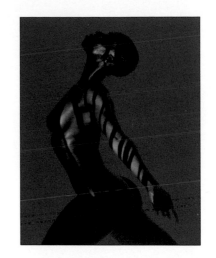

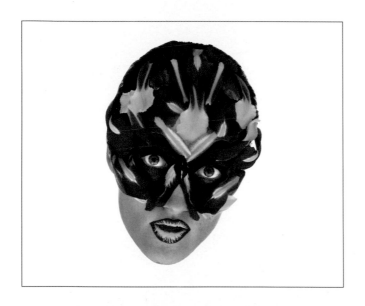

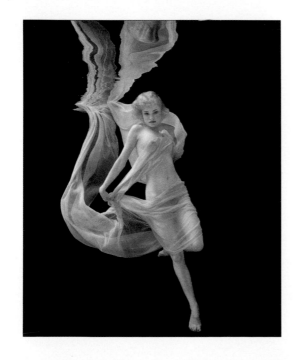

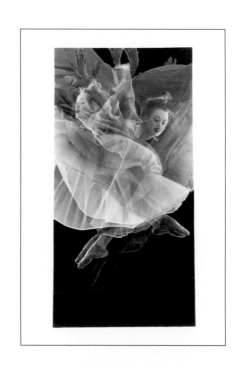

BETH GALTON

212.242.2266
Film Reel Available

Represented by Marsha Pinkstaff 212.799.1500
Midwest Representation Atols & Hoffman 312.222.0504

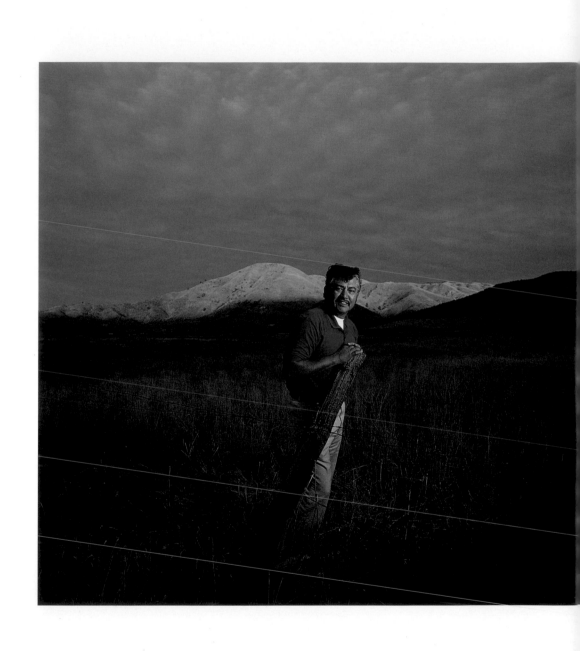

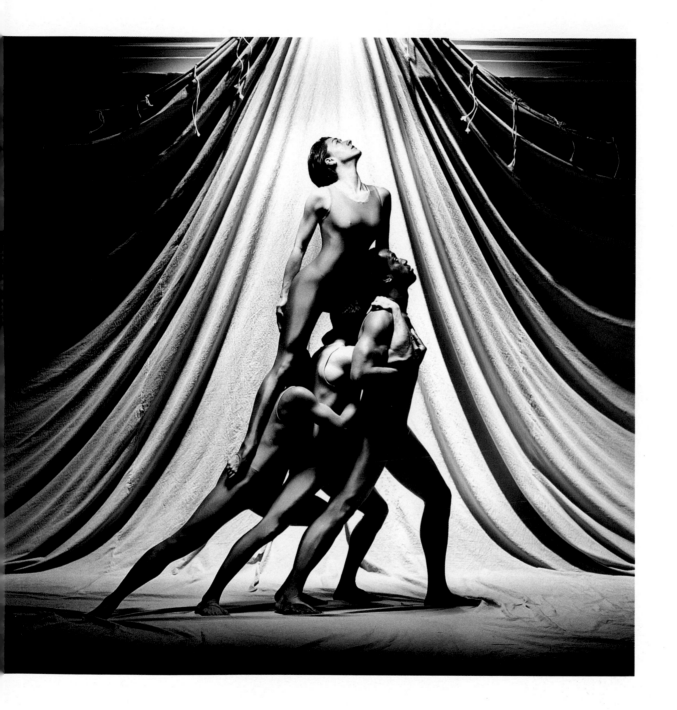

JEFF CORWIN PHOTOGRAPHY 206 522.0505

REPRESENTED by DEBORAH BROWN 212 674.2002

55

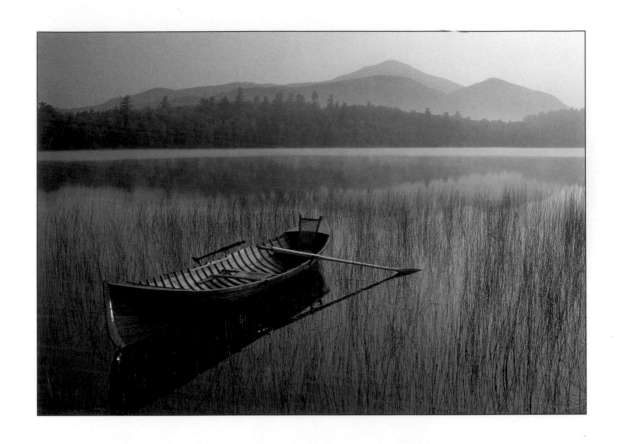

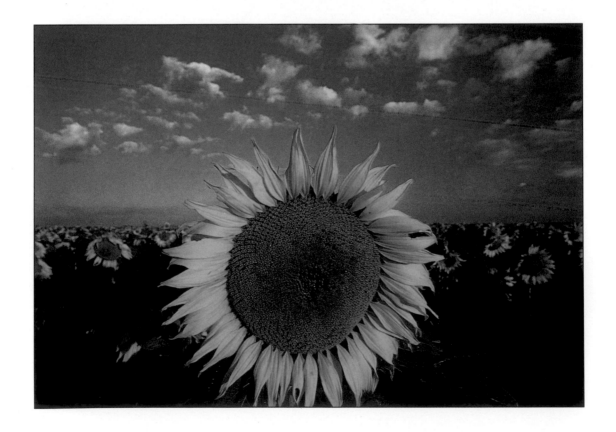

Michael Melford 860.536.7247

Represented by Deborah Brown + Assocs. 212.674.2002

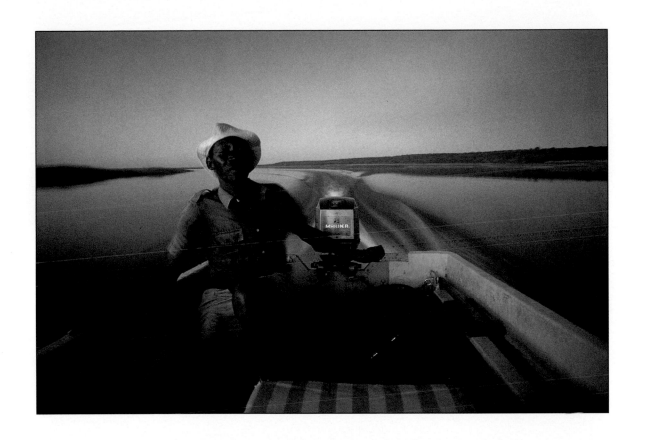

Michael Melford 860.536.7247

Represented by Deborah Brown + Assocs. 212.674.2002

FRANK MARCHESE

(860) 232-4417

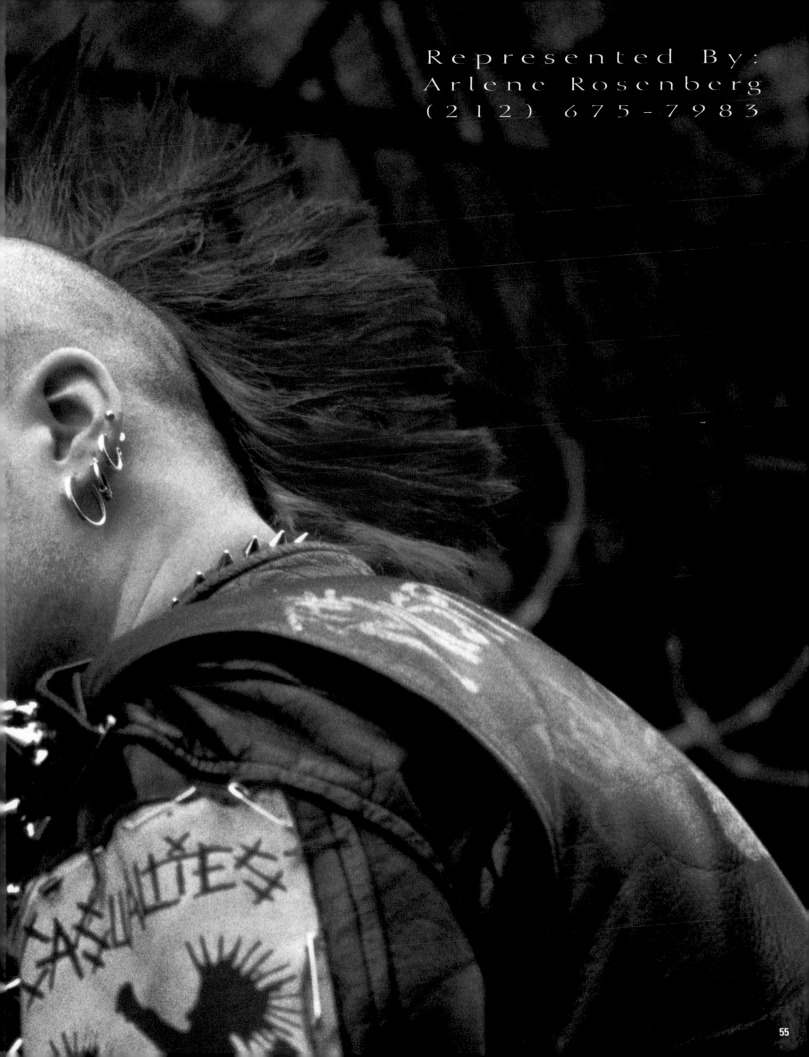

Represented By:
Arlene Rosenberg
(212) 675-7983

55

Scott
Van Sicklin

PHOTOGRAPHY
860·232·4417

plotkin

bruce plotkin
12 west 27th street, nyc 10001
212.889.5200 fax 212.889.5223

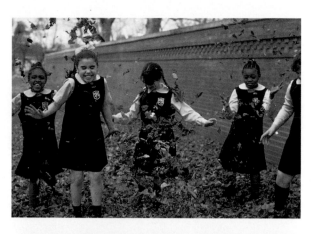
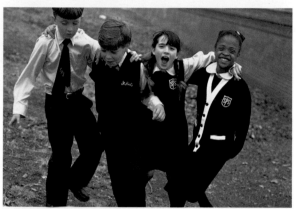

bruce plotkin

12 west 27th street, nyc 10001

212.889.5200 fax 212.889.5223

plotkin

CHARLES MARAIA

New York City 212.206.8156

Patricia Kaneb, CEO, Priscilla of Boston

JAMES SALZANO

Rosie Shank, Showgirl, Folies Bergere, Las Vegas

JAMES SALZANO

Rob Howard

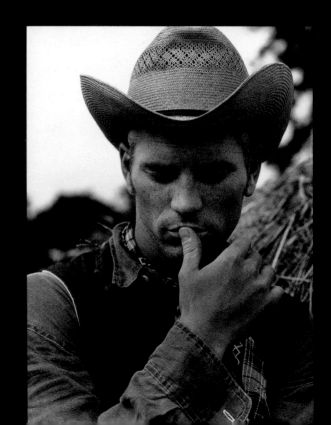

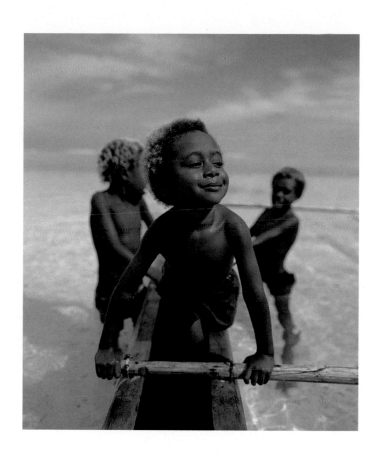

Represented by Bernstein & Andruilli 212-682-1490 Fax:212-286-1890

IL Y A UNE VIE APRES LA MORT.

L'aluminium est recyclable à 100% et à l'infini. Tout en conservant ses qualités propres de légéreté, malléabilité, conductibilité, protection et esthétique, un objet en aluminium est recyclable à 100%. Ce qui signifie que cette boîte pourra demain redevenir une autre boîte ou pourquoi pas un carter d'automobile, une aile d'avion ou une façade et cela autant de fois que l'on voudra. Cette recyclabilité parfaite ne requiert à chaque transformation que 5% de l'énergie nécessaire à la fabrication de l'aluminium primaire. Elle garantit, outre une formidable économie, la préservation **L'ALUMINIUM** des ressources naturelles et le respect de notre environ- **LE PRECIEUX METAL** nement. Voici pourquoi l'aluminium est aujourd'hui, et à juste titre, considéré comme un métal très écologique.

EDF s'engage à intervenir en moins de 4 "Cou-Cou".

EDF Electricité de France

Nous vous devons plus que la lumière.

Philip Habib

Le carton ondulé s'adapte à vos mesures.

LE CARTON ONDULÉ. IL N'A PAS FINI DE VOUS SURPRENDRE.

Represented by Bernstein & Andruilli
212-682-1490 Fax: 212-286-1890

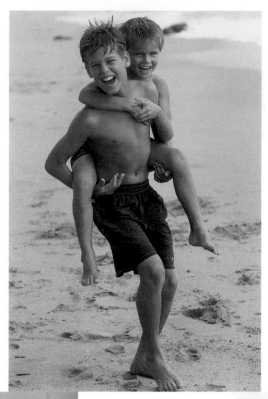

ROBERT MANELLA PHOTOGRAPHY

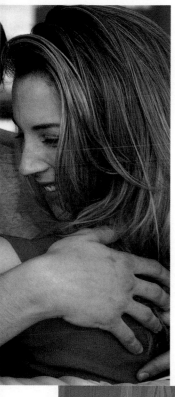

2 1 2 - 6 4 5 - 6 4 1 9

PETER BOSCH

477 BROOME STREET
NEW YORK N.Y. 10013
(212) 925 0707

REPRESENTED BY MICHELE FILOMENO 212 965 1000

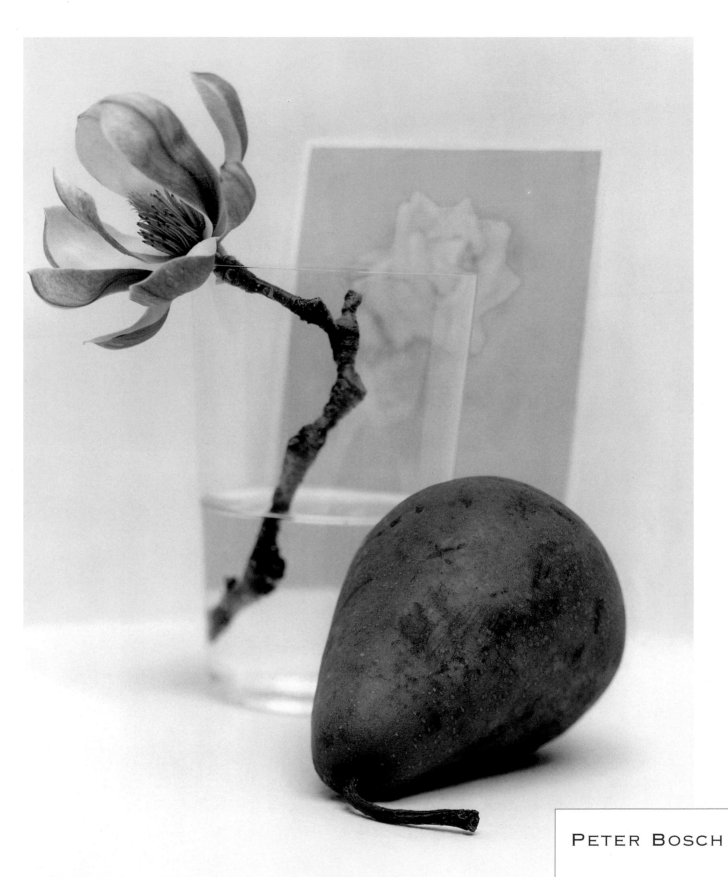

H E A T H robbins

310 EAST 23RD STREET NO.7G NEW YORK, NEW YORK 10010

212 254 5780

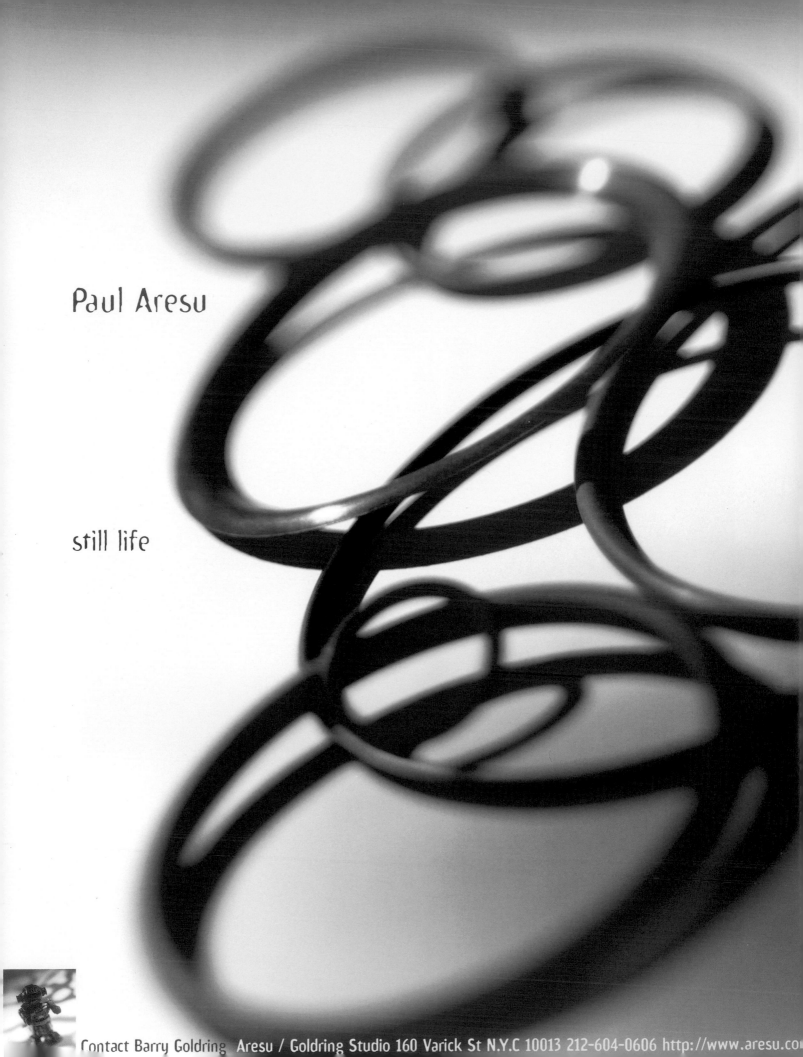

Paul Aresu

still life

Contact Barry Goldring Aresu / Goldring Studio 160 Varick St N.Y.C 10013 212-604-0606 http://www.aresu.co

Paul Aresu

People

Judd Pilossof 135 West 26th St New York City (212) 989-8971

Contact Marge Casey (212) 486-9575 Fax: (212) 838-5751

Judd Pilossof · 135 West 26th St. New York City (212) 989-8971 · Contact Marge Casey (212) 486-3575 Fax: (212) 838-5751

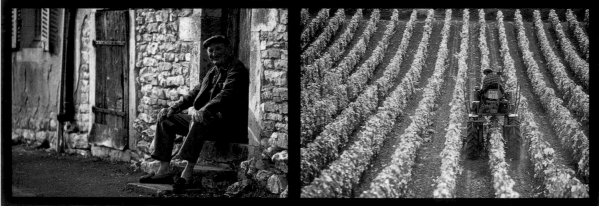

KINDRA CLINEFF PHOTOGRAPHY
TEL 617 . 756 . 0020

KINDRA CLINEF PHOTOGRAPHY
TEL 617 . 756 . 0020

ROBERT MILAZZO PHOTOGRAPHY (212) 947·4073

DLM

212 297 0041

Joe **D**iBartolo | Laura **L**emkowitz | Ralph **M**ennemeyer

dana buckley • **212-206-1807**

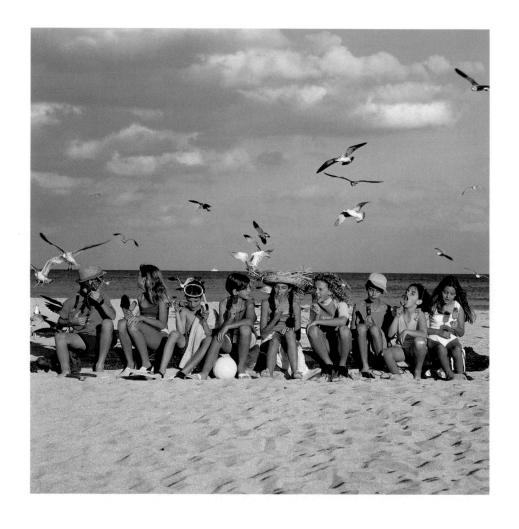

DLM

212 297 0041

michael luppino • **212-633-9486**

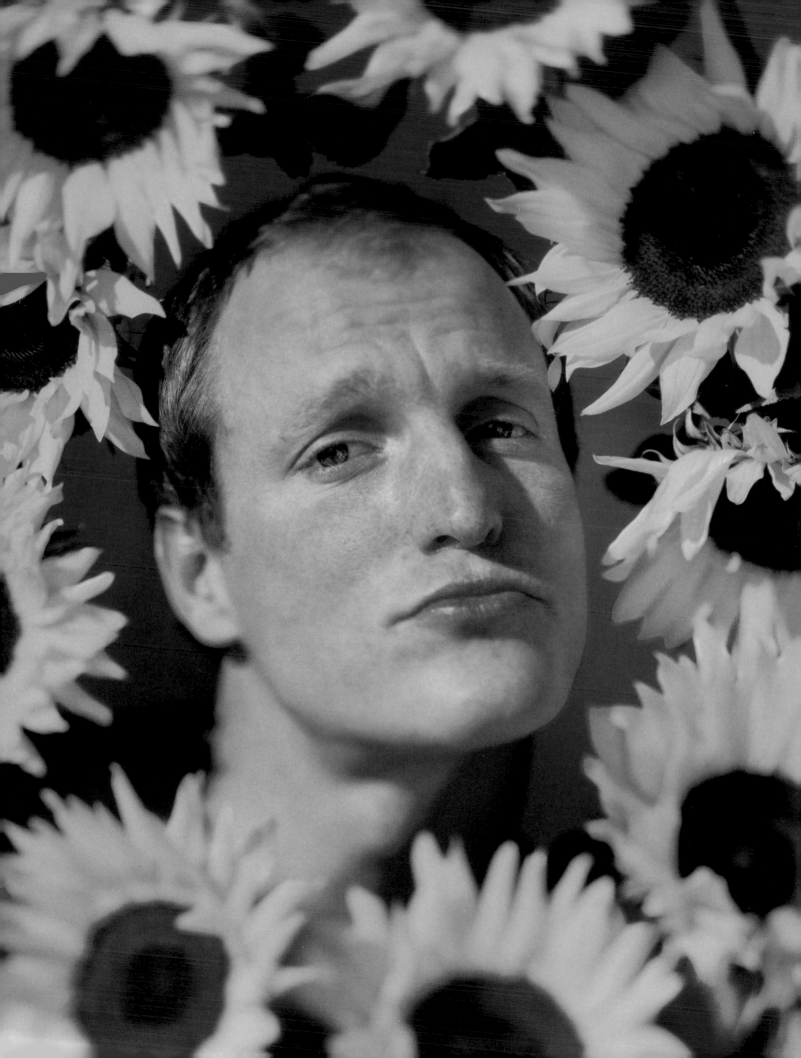

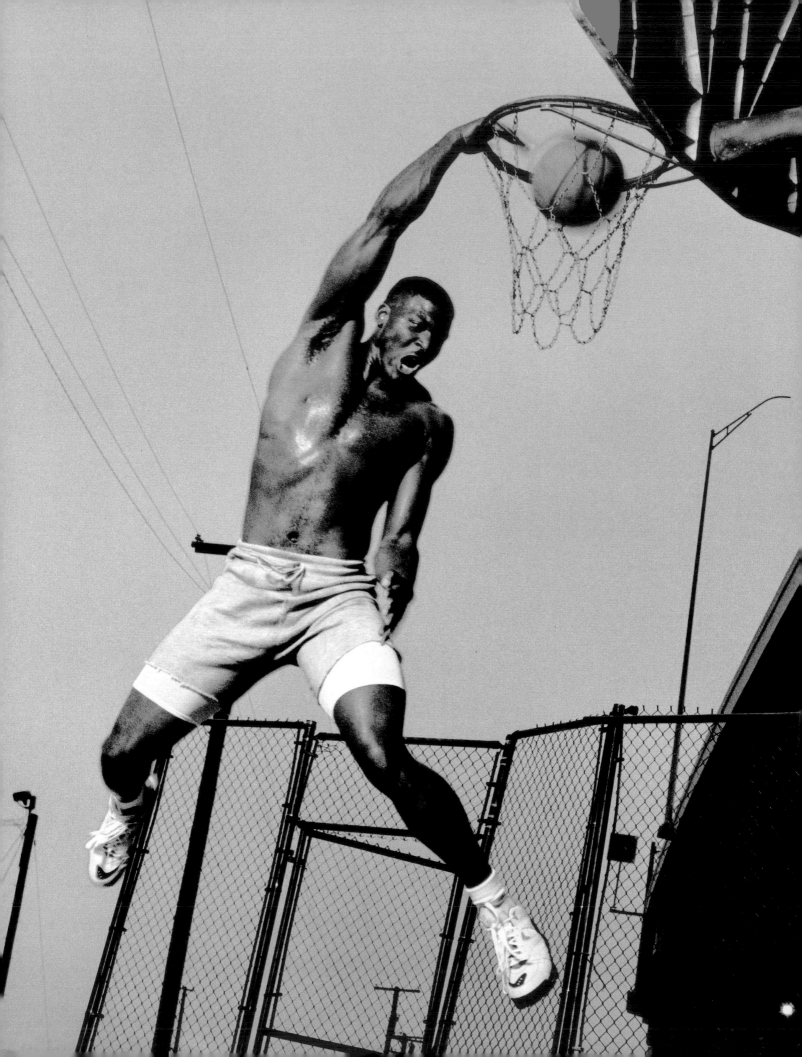

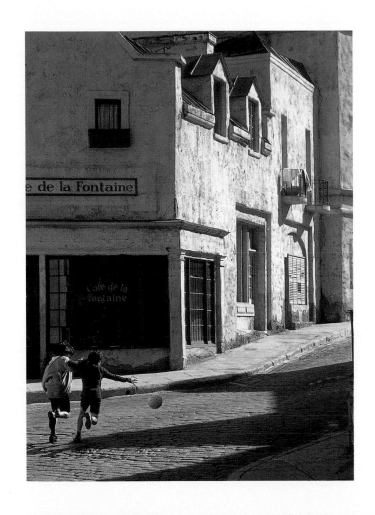

pete stone • **503-224-7125**

212 297 0041

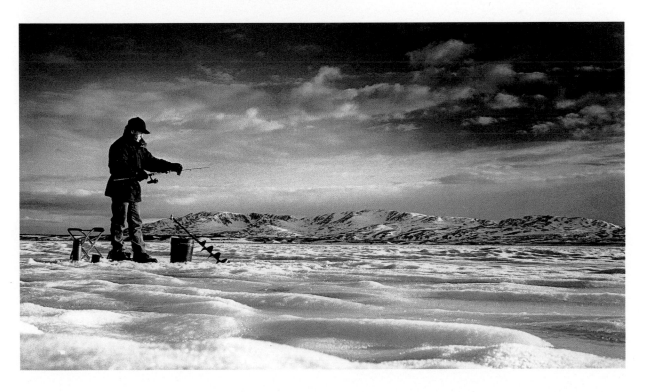

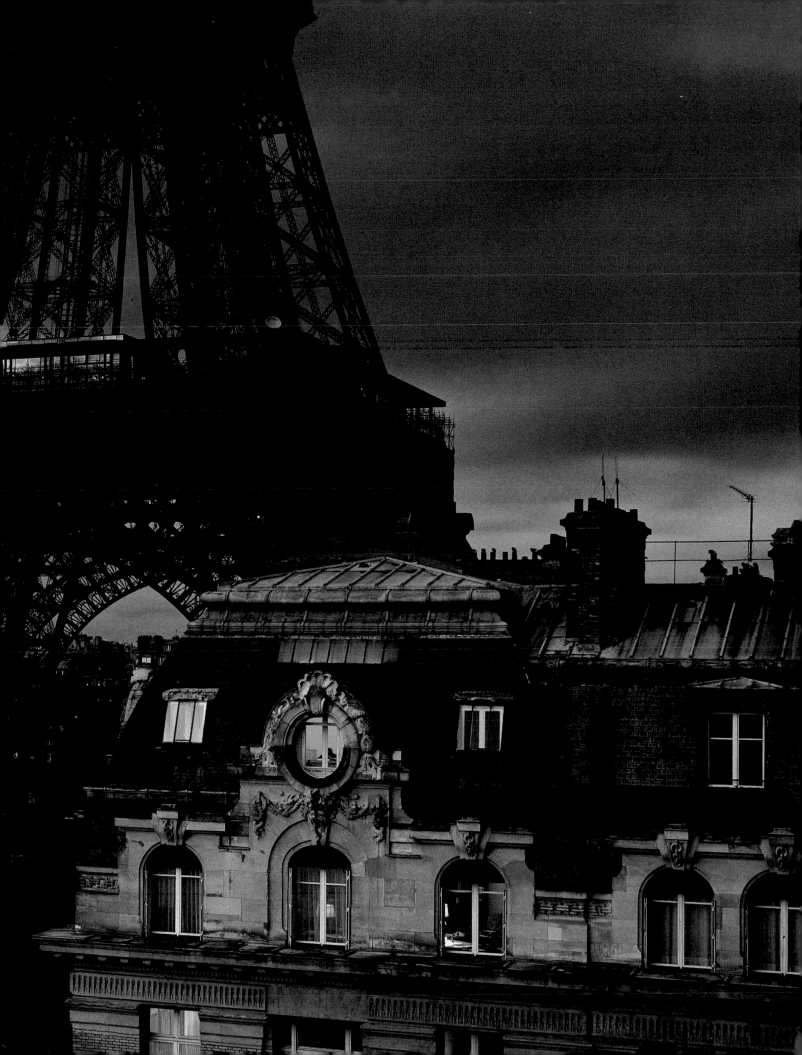

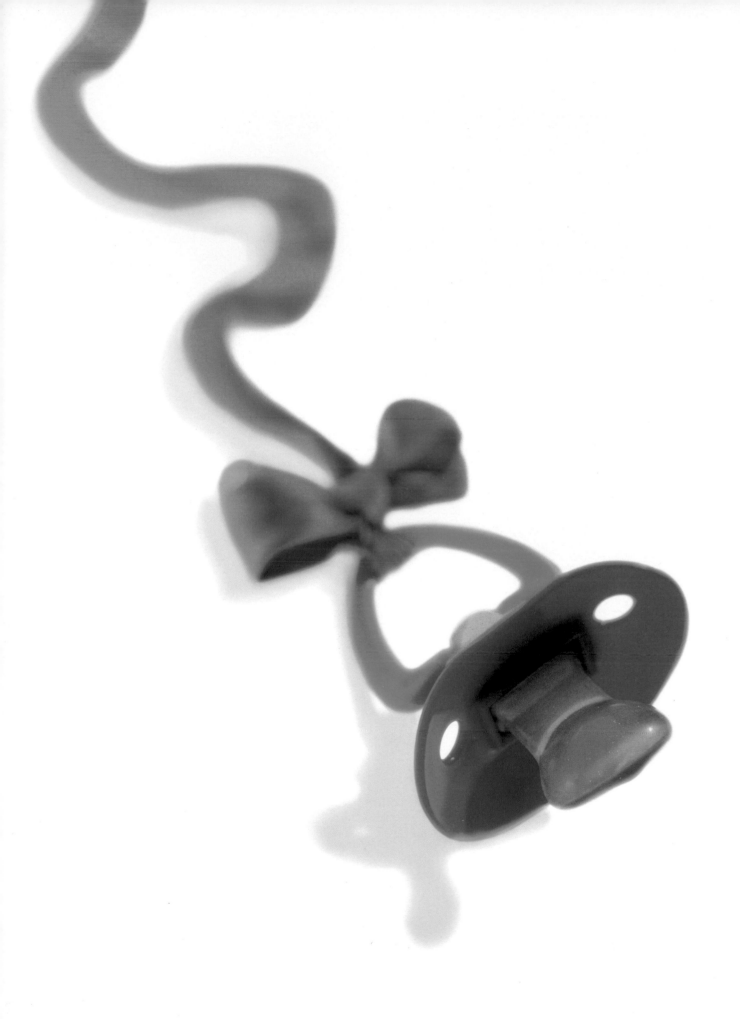

david weiss • **212-924-1030**

DLM

212 297 0041

98

chas bush • 213-466-6630

les jörgensen • 212-358-1092

DLM

212 297 0041

satoshi • **212-727-0001**

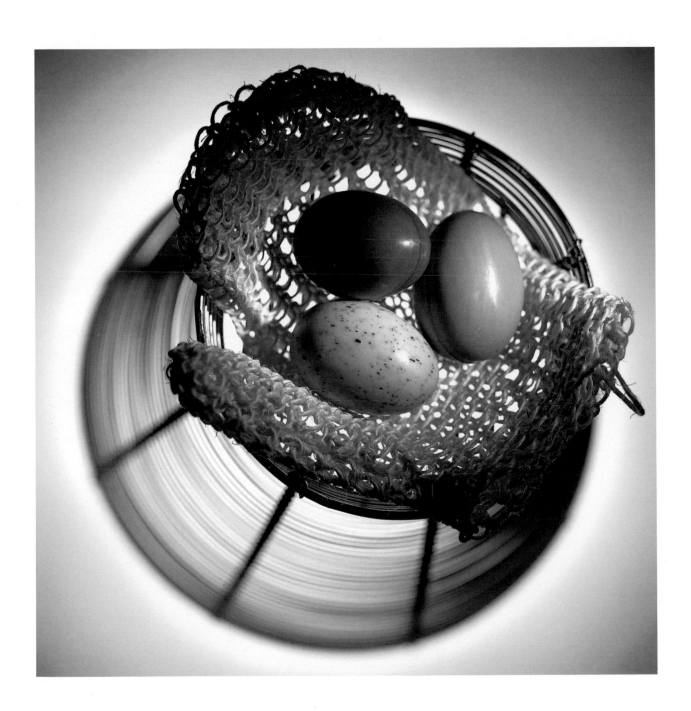

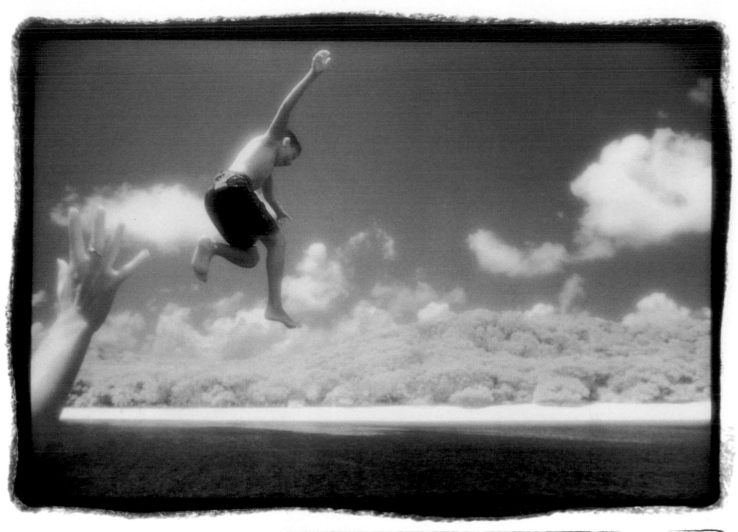

theo

theo westenberger photography
366 broadway suite 8a
new york, new york 10013
(212)732-5900 (212)267-8509fax

represented in L.A. by Hamilton Gray
(213)380-3933

theo

theo westenberger photography
(212)732-5900 (212)267-8509fax

represented in L.A. by Hamilton Gray
(213)380-3933

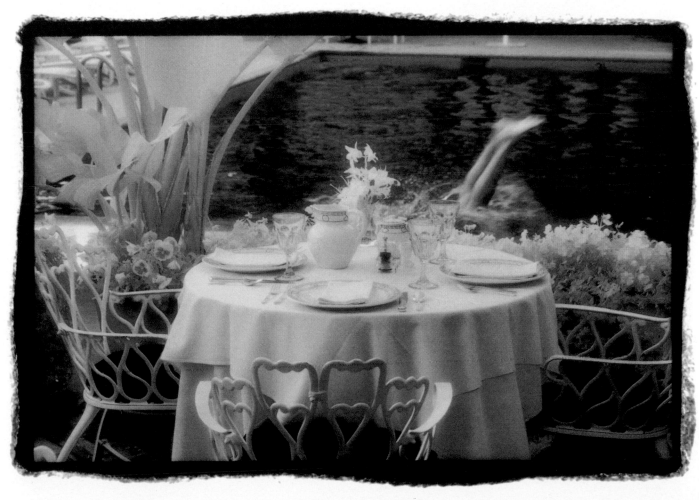

17

THEY SAY ESKIMOS HAVE 17 WAYS TO SAY SNOW. SO?

ART DIRECTORS KNOW 1,000,000 WAYS TO SAY FIGHT.

MARKTHAYER
photography

studio: 617/542.9532
represented by laura yengo: 212/420.1121

Geoff Stein Studio

348 Newbury Street

Boston, MA 02115

Phone: 617 536 8227

Fax: 617 536 7113

Geoff Stein Studio

348 Newbury Street

Boston, MA 02115

Phone: 617 536 8227

Fax: 617 536 7113

Baltimore, Maryland / Washington, DC [**410.362.5659**] Fax [**410.945.1026**]

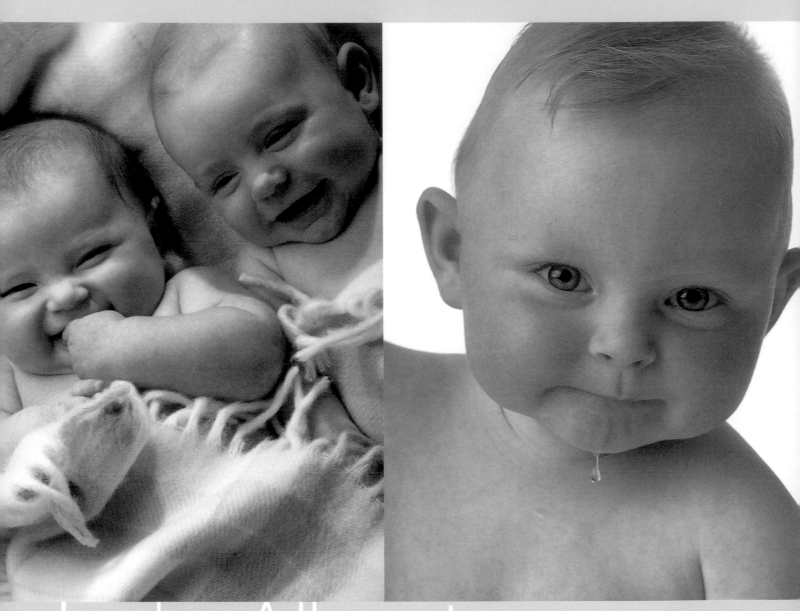

Jade Albert

212.242.0840

Represented by Linda Ruderman 212.369.7531

jim graham

jim graham is represented by john hopkins 212.427.1451

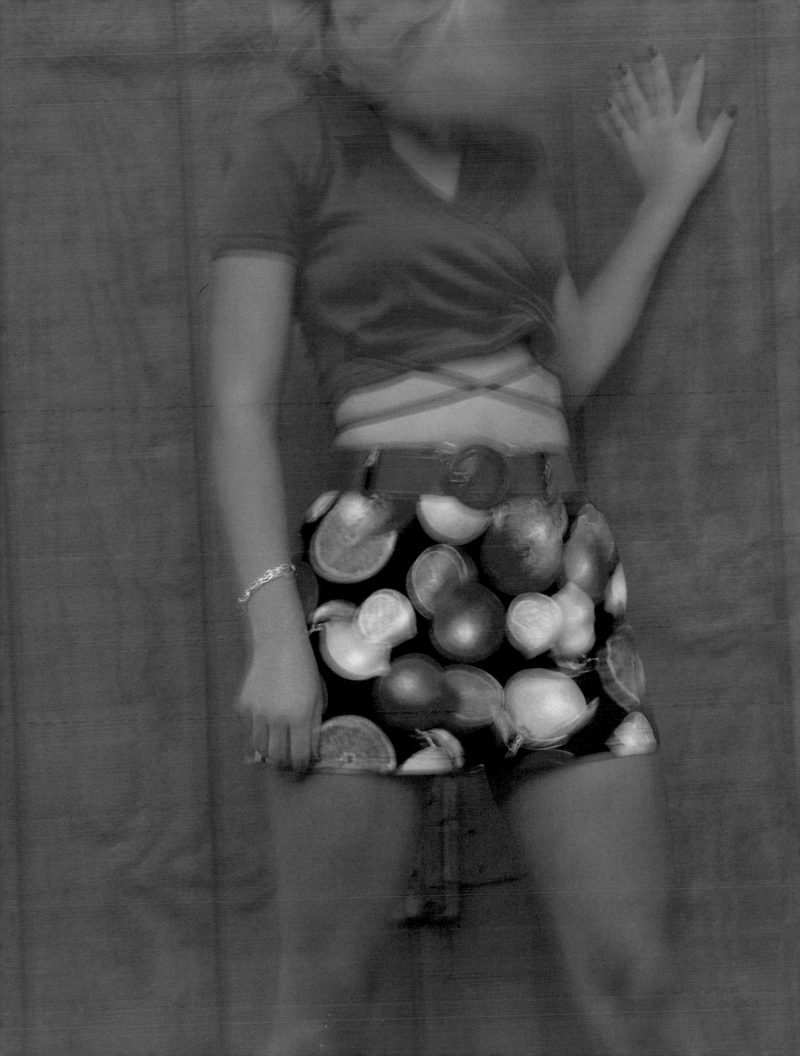

 A S T R I A N N I

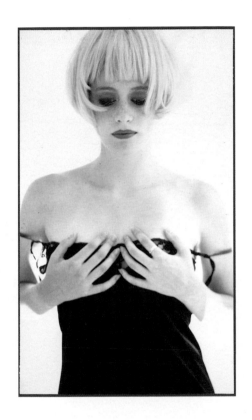

FASHION AND STILL LIFE

2 1 2 . 9 2 9 . 5 9 4 4 / F A X 2 1 2 . 9 2 9 . 5 8 5 9

MITCHEL GRAY

tel. 212.665.1481
fax: 212.665.1781

TONS of USEFUL STUFF JUNE 1996

Men's Health

Slim & Strong
▸ The Perfect Workout
▸ The Ideal Diet

New Male Sex Drug

Great Abs, No Situps

Decode Your Body Signals

The Best Exercise Machine

Maximum Nutrition, Minimum Fuss

Outwit Your Boss (It's Not That Hard)

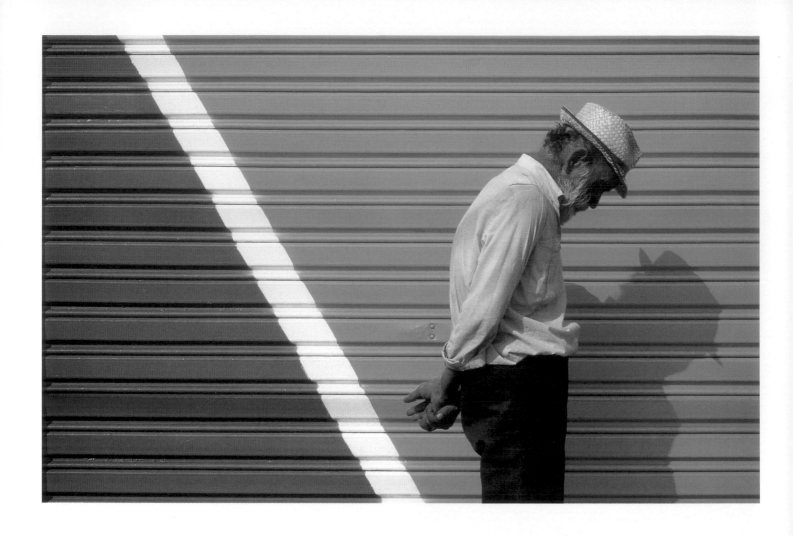

David Mendelsohn Photography
EMail: eyesite@davidm.com
Website: http://www.davidm.com
Represented by Chip Caton: 860-523-4562

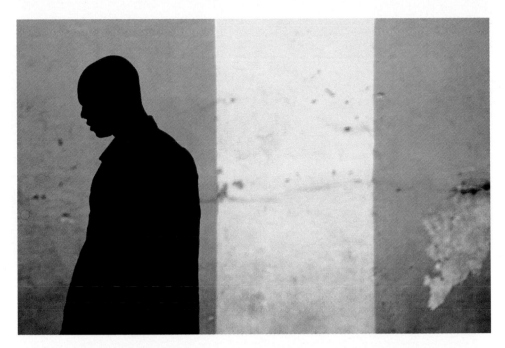

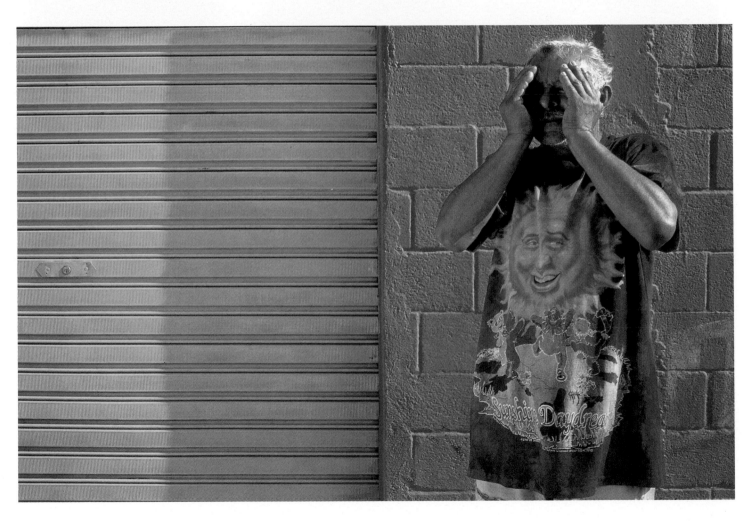

MENDELSOHN

◆ David 603-659-2530

WEIDLEIN

PETER WEIDLEIN PHOTOGRAPHY • 860-231-9009 • 212-989-5498 • FAX 860-231-9128

REPRESENTED BY CHIP CATON • 860-523-4562 • FAX 860-231-9313

WEIDLEIN

VIÑALES, CUBA

TRINIDAD, CUBA

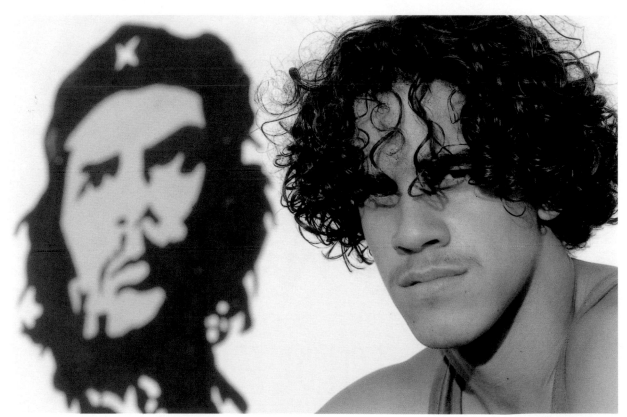

PINAR DEL RIO, CUBA

MELANIE EVE BAROCAS

78 HART ROAD GUILFORD, CT 06437 FAX 203/457-0022 TEL 203/457-1717
REPRESENTED BY CHIP CATON 860/523-4562

HARTFORD, CONNECTICUT

PORT-AU-PRINCE, HATI

MELANIE EVE BAROCAS

78 HART ROAD GUILFORD, CT 06437 FAX 203/457-0022 TEL 203/457-1717
REPRESENTED BY CHIP CATON 860/523-4562

SHAFFER/SMITH PHOTOGRAPHY
Phone/212.982.9620 Fax/212.979.1174

∫COTT ■■■
DORRANCE
800.971.7447

Reebok Int'l.

Carolyn Ross Photography . Boston

617 . 482 . 6115

Represented by Fusion 800 . 570 . 0522

Jim Raycroft
Photography Worldwide

326 A Street
Boston, Massachusetts 02210 U.S.A.
617.542.7229
800.542.5505

Represented by:
Fusion
800.570.0522

Jim Raycroft

Photography Worldwide

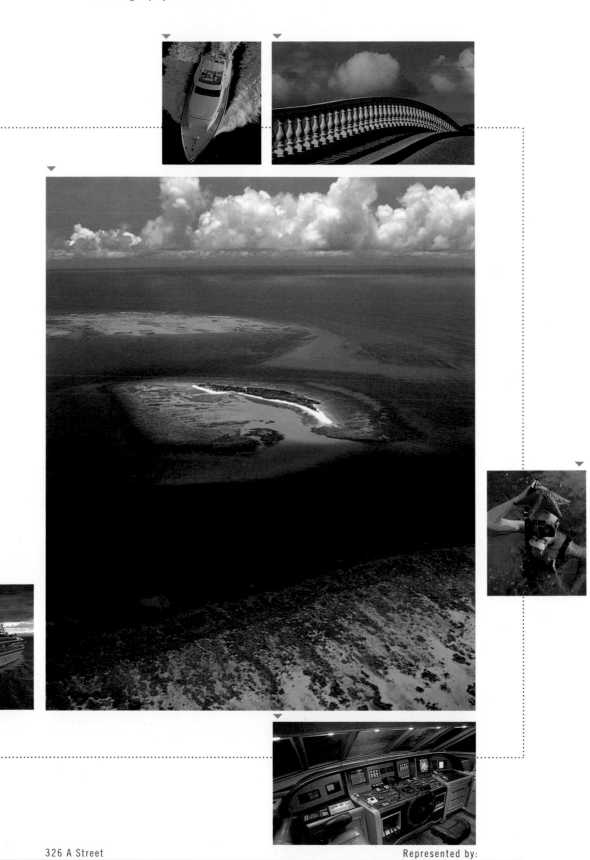

326 A Street
Boston, Massachusetts 02210 U.S.A.
617.542.7229
800.542.5505

Represented by:
Fusion
800.570.0522

ADVERTISING

CORPORATE

STOCK

INTERNET: HTTP://WWW.DLPI.COM

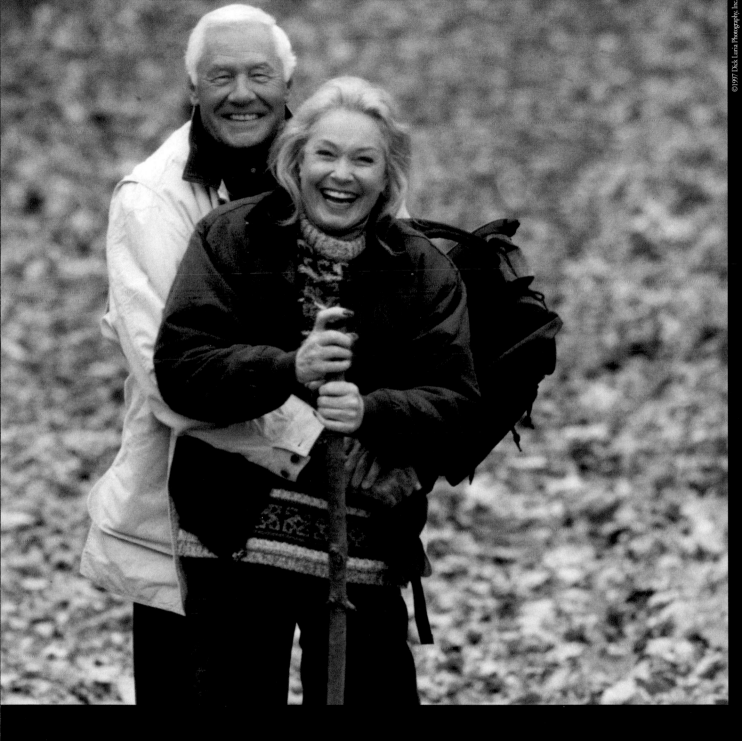

DICK LURIA
P H O T O G R A P H Y I N C

914-948-2904
fax. 914-948-3107

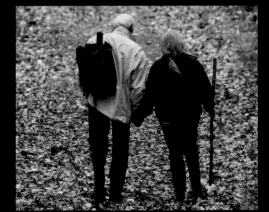

DEBORAH
Feingold

rep
Patti Silverstein
212.228.7924

studio
133 W19th St
New York City 10011
tel 212.924.9710
fax 212.924.9715

Julia Louis Dreyfus

Carmichael Lynch
National Car Rental

SHR
Volkswagen

J O N
GIPE
photo

Ogilvy & Mather
IBM

Bozell Worldwide
New York Times

141

DAVID BISHOP

P H O T O G R A P H Y

180 VARICK STREET · NEW YORK, NEW YORK 10014 · TELEPHONE-212.929.4355 · FACSIMILE-212.337.0768
REPRESENTED BY KORMAN + COMPANY · TELEPHONE-212.727.1442 · FACSIMILE-212.727.1443

PLEASE SEE ADDITIONAL WORK IN THE Blackbook

Your Link to
Blue Cross and Blue Shield
of Massachusetts

AccountLink™

AMERICAN EXPRESS
AT & T
BANK OF TOKYO
BLUE CROSS / BLUE SHIELD
DISNEY
FIDELITY INVESTMENTS
LOTUS
MCI TELECOMMUNICATIONS
MERRILL LYNCH
POLAROID

tel 617.423.6638 fax 617.345.9296 #25 DRY DOCK AVENUE. BOSTON, MA 02210

tel 617.423.6638 fax 617.345.9296 #25 DRY DOCK AVENUE. BOSTON, MA 02210

AMERICAN EXPRESS
AT & T
BANK OF TOKYO
BLUE CROSS / BLUE SHIELD
DISNEY
FIDELITY INVESTMENTS
LOTUS
MCI TELECOMMUNICATIONS
MERRILL LYNCH
POLAROID

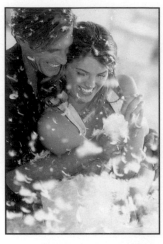

H E U B E R

WILLIAM HEUBERGER IS REPRESENTED BY **PAMELA BLACK** 212.979.2636 / 212.242.1532
140 WEST 22ND STREET, NEW YORK, NY 10011 FILM REEL AVAILABLE

G E R

MASULLO

MASULLO

Ralph Masullo

Masullo Inc.

111 West 19 Street
Studio 2B
New York, NY
10011
1.212.727.1809 Phone
1.212.924.4936 Fax

John Montana

Masullo Inc.

111 West 19 Street
Studio 2B
New York, NY
10011
1.212.727.1809 Phone
1.212.924.4936 Fax

MONTANA

SCOTT 31 HARRISON STREET NEW YORK NY 10013
FRANCES TEL. 212 227-2722 FAX. 212 227-1127

COLIN COOKE

BILL BALLENBERG

ROSS WHITAKER

DIRECTORS: PETER PIOPPO-TABLETOP, GREG DUDLEY-FASHION/BEAUTY

BRUCE JAMES
(WEST COAST)

PETER MORELLO

CHRIS M
ROGERS

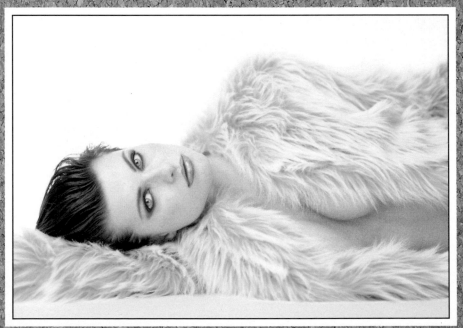

ROBERT BACALL
REPRESENTATIVES
(212)254-5725 FAX:(212)979-9524
e-mail:rbacall@msn.com

153

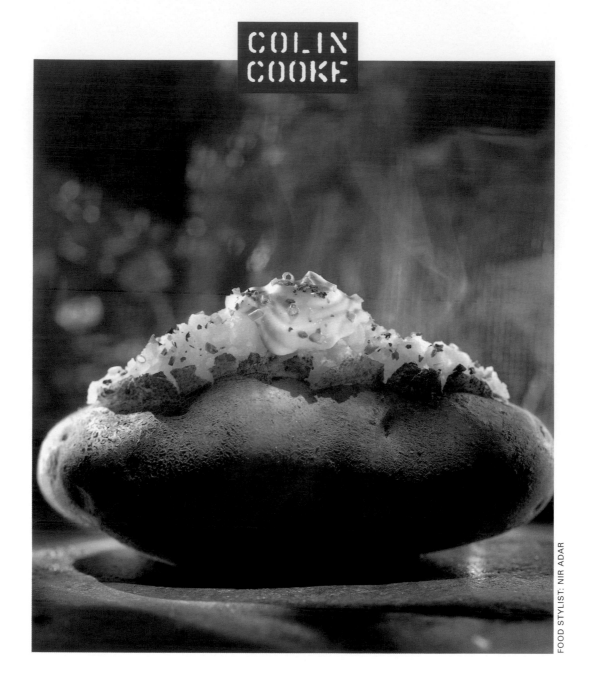

COLIN
COOKE

FOOD STYLIST: NIR ADAR

REPRESENTED BY ROBERT BACALL / 212.254.5725 / FAX 212.979.9524

COLIN
COOKE

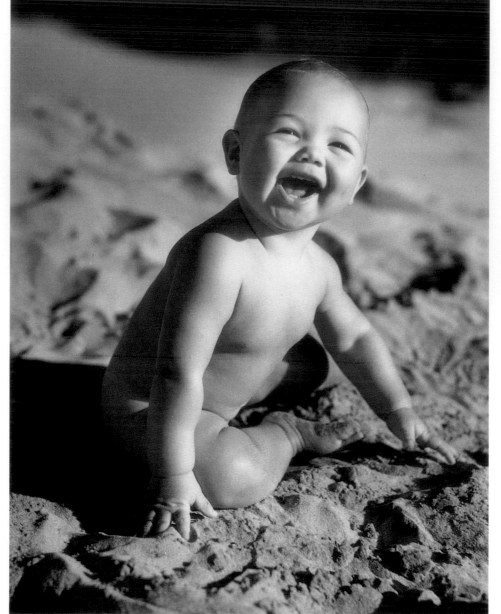

rep.

Robert

Bacall

212

254-5725

Ross Whitaker

212 741-7322 fax: 212 366-0418

All photographs: Ross Whitaker ©1997

Design: Joy Makon Art Direction & Design

BILL BALLENBERG | 212 989 8089

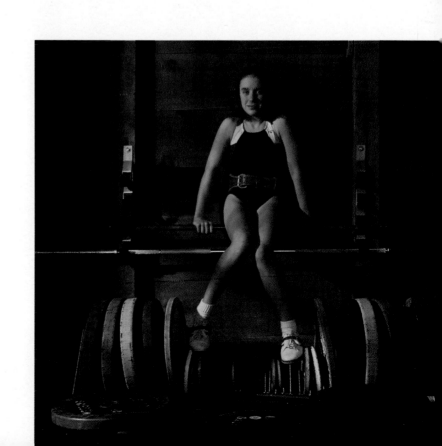

212.242.7420

REPRESENTED IN THE SOUTH BY ARTLINE
704.376.7609

CHRIS m. ROGERS

CHRIS m. ROGERS

212.242.7420

REPRESENTED IN THE SOUTH BY ARTLINE
704.376.7609

Peter Zander

212 627 7627

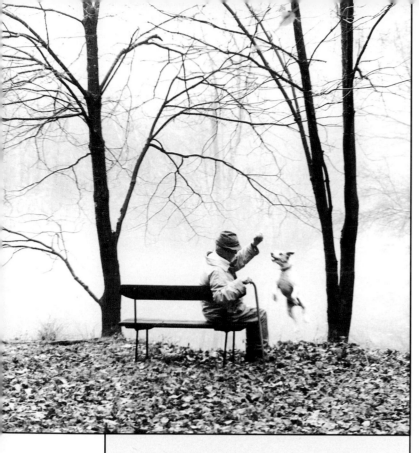

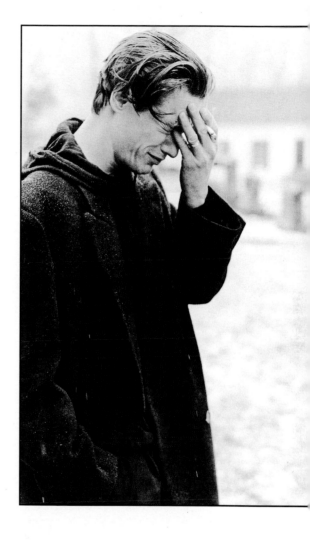

P e t e r
Z a n d e r

212 627 7627

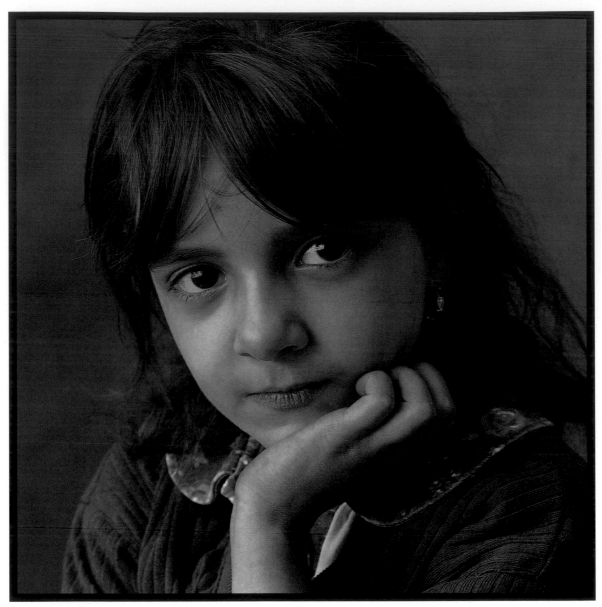

OPERATION SMILE

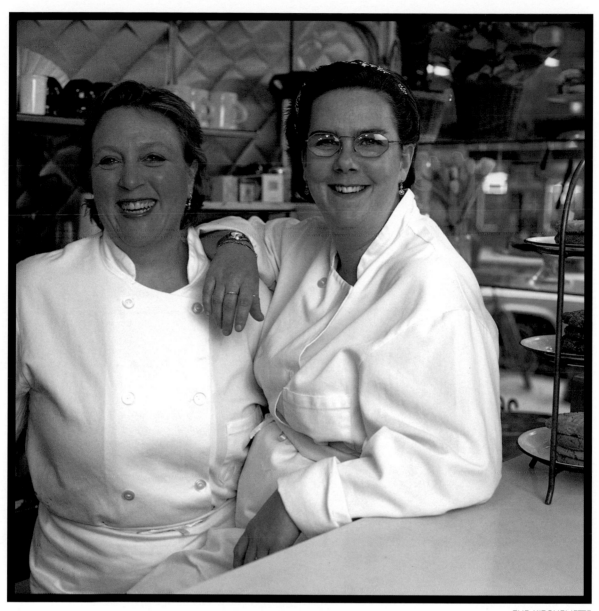

THE KITCHENETTE

John Wilkes

Studio

Represented by Dario Sacramone

212.929.0487 Fax 212.242.4429

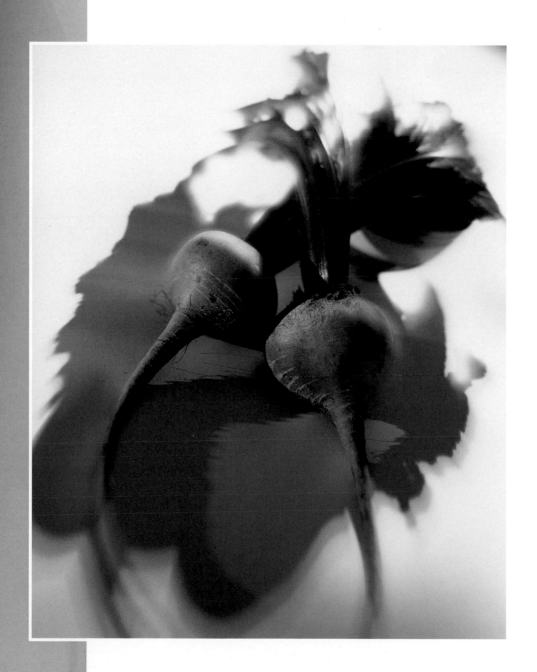

Studio 212.645.1110 Fax 645.1665
135 West 26th St. New York NY 10001

Stock upon request

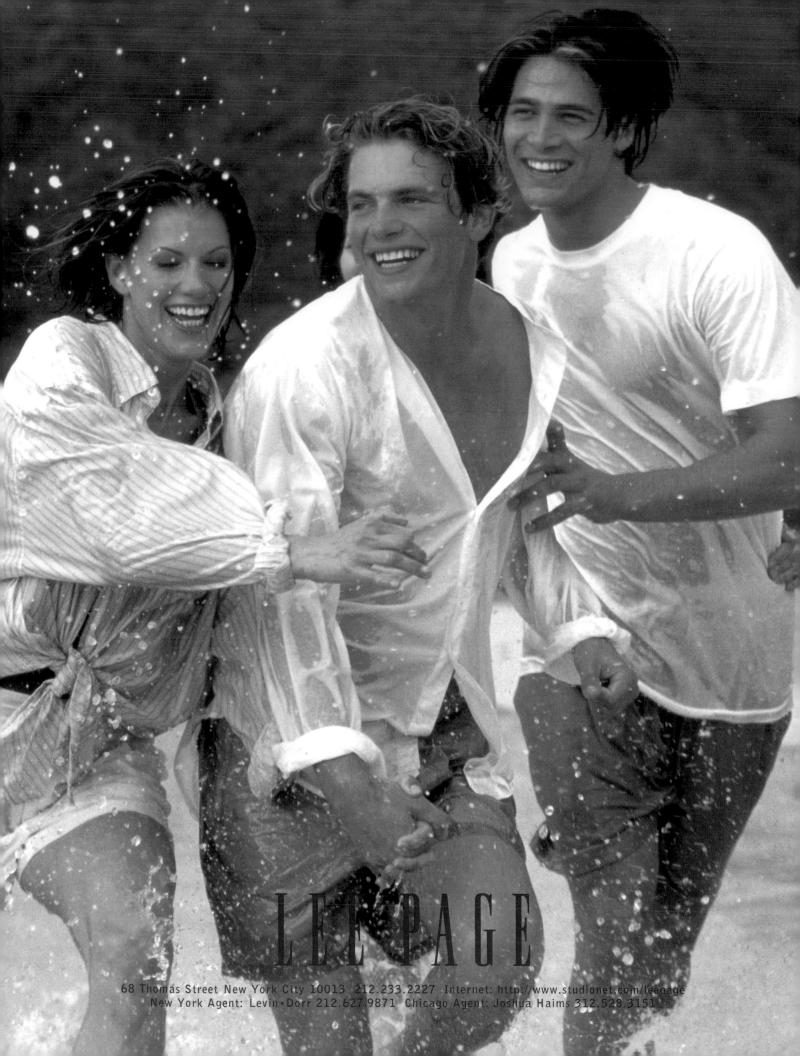

LEE PAGE

68 Thomas Street New York City 10013 212.233.2227 Internet: http://www.leepage.com
New York Agent: Levin•Dorr 212.627.9871

MATTHEW KLEIN

104 W17, NYC 10011

T: 212 255-6400

F: 212 242-6149

E: mk@matthewklein.com

REPRESENTED BY

LEVIN•DORR

T: 212 627-9871

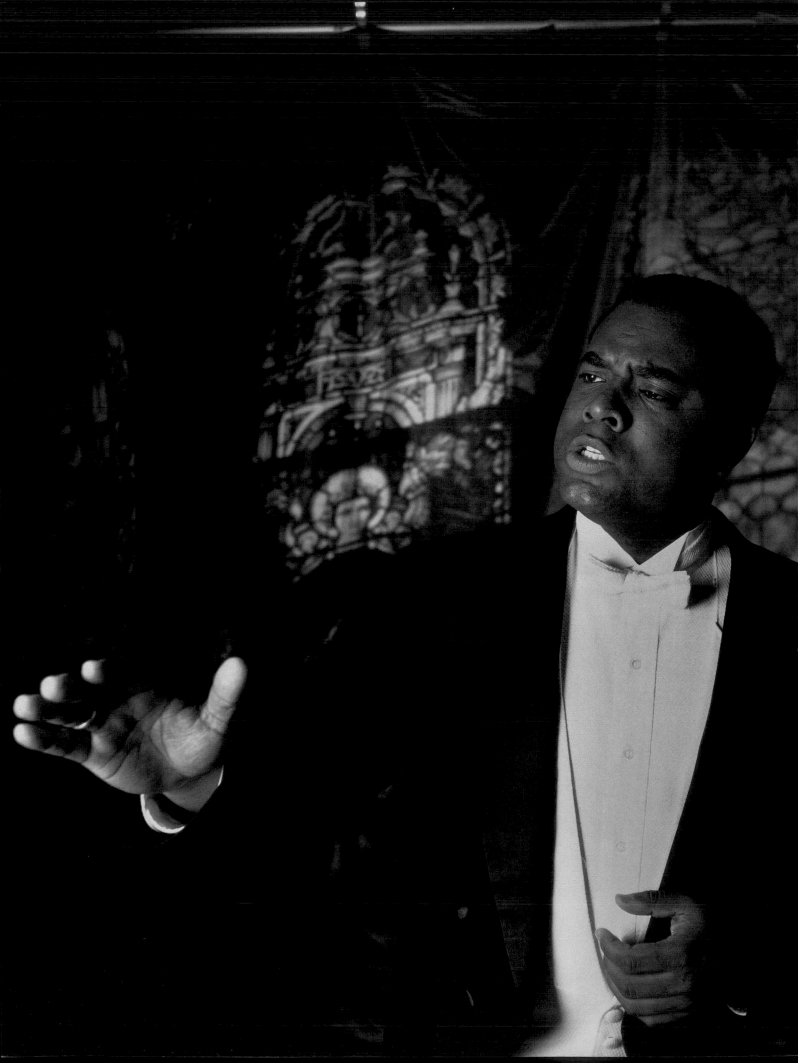

Bill **O** *' Connell*

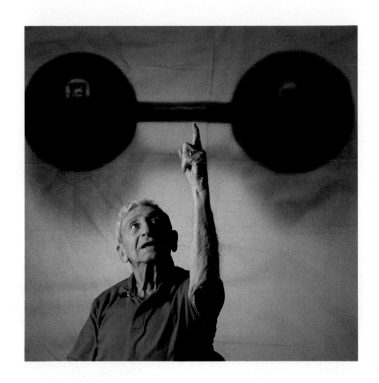

Photography

Boston, Massachusetts

800.710.2779

REGIS FIALAIRE

Represented By

ZARI
INTERNATIONAL

REGIS FIALAIRE

Represented By

ZARI
INTERNATIONAL

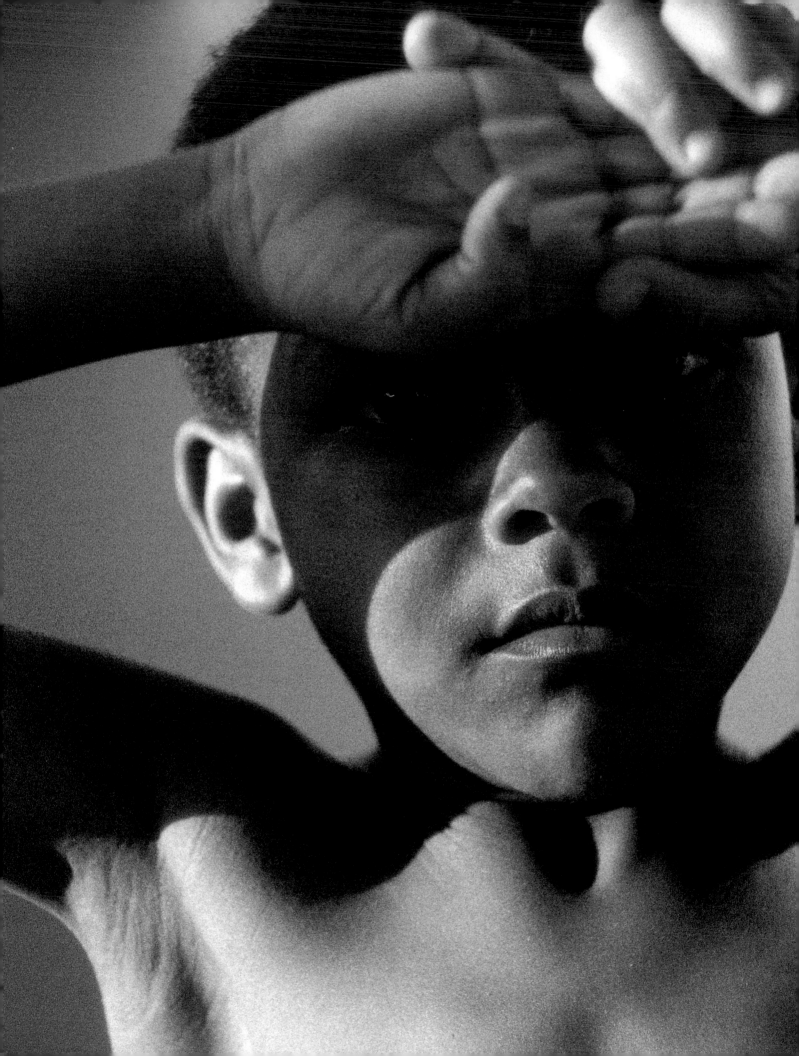

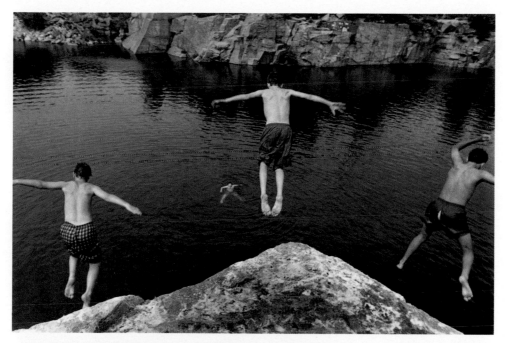

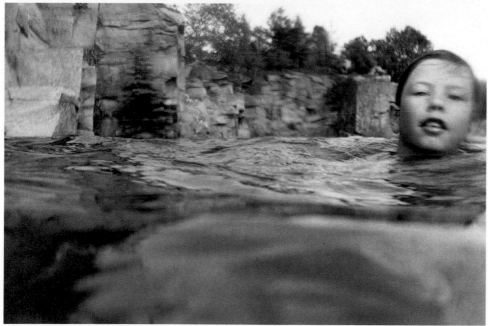

617·426·9111 www.malyszko.com

Call 412-481-4142 to

receive my complete portfolio of

dog and cat photography.

———◦○◦◦———

It'll be the package in

the plain brown wrapper.

HARRY GIGLIO PHOTOGRAPHY, INC.

Nathan Lane

PETER FREED 212.645.0818

REPRESENTED BY CHRISTINE GOODMAN 212.691.2667

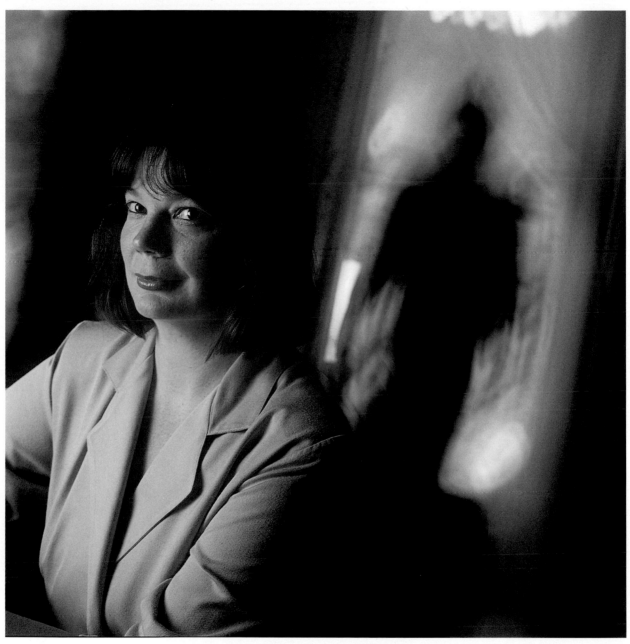

Susan Ress, Psychic

PETER FREED 212.645.0818

REPRESENTED BY CHRISTINE GOODMAN 212.691.2667

john.HOLT//studio

25 Drydock Avenue . Boston . Massachusetts 02210-2307 // 617-426-4658 . fax 617-426-1425 . e-mail visiondude@aol.com

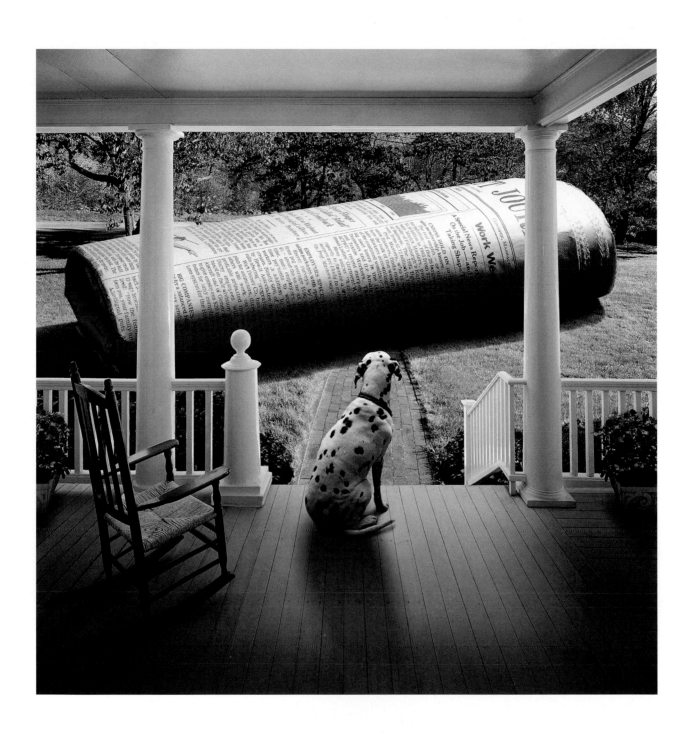

john.HOLT//studio

25 Drydock Avenue . Boston . Massachusetts 02210-2307 // 617-426-4658 . fax 617-426-1425 . e-mail visiondude@aol.com

SIMON METZ PHOTOGRAPHY

56 WEST 22 STREET NEW YORK NY 10010 - PHONE 212-807-6106 - FAX 212-929-8716

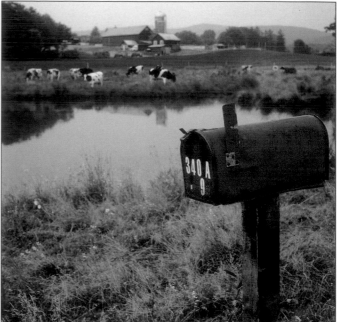

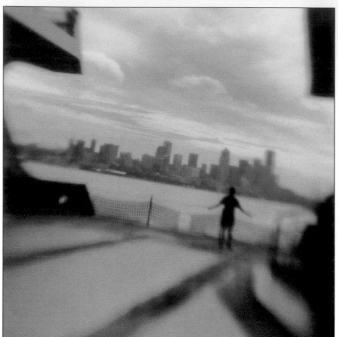

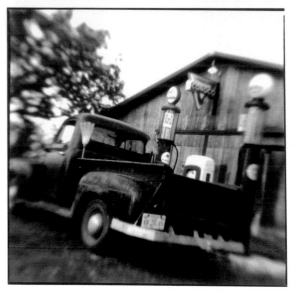

ROBINSON
JAMES

James Robinson Photography 212 580 1793 Fax 721 9139 · Represented by Gary Hurewitz + Associates 212 764 0004 Fax 764 0002

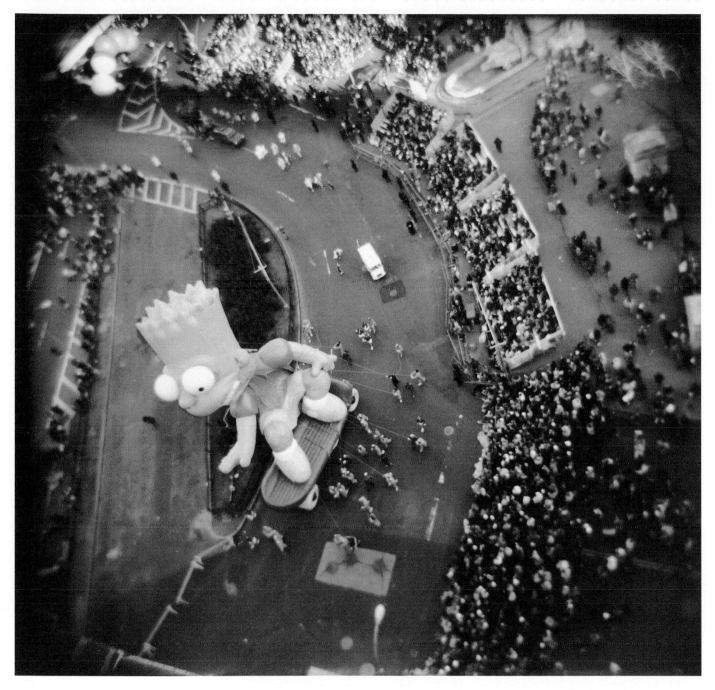

ROBINSON
JAMES

James Robinson Photography 212 580 1793 Fax 721 9139 · Represented by Gary Hurewitz + Associates 212 764 0004 Fax 764 0002

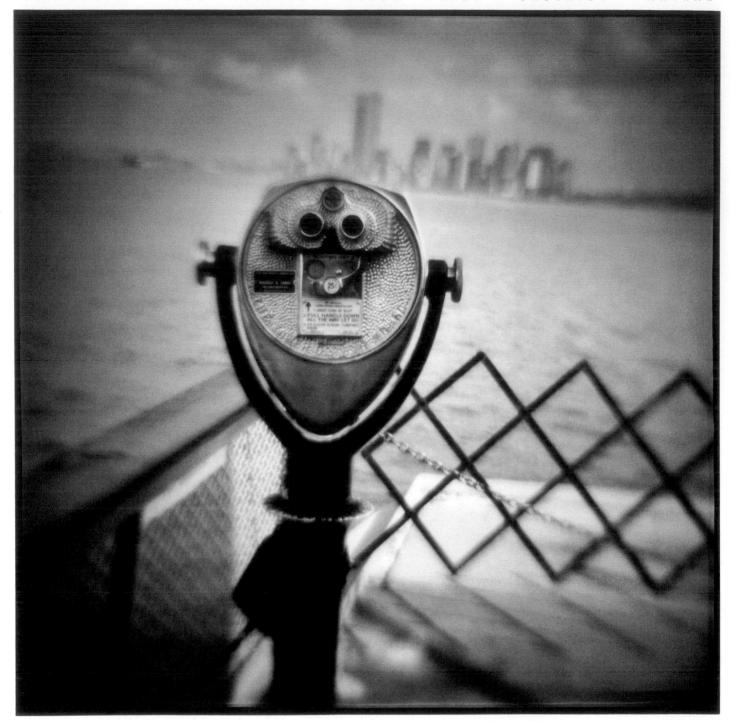

ROBINSON
JAMES

James Robinson Photography 212 580 1793 Fax 721 9139 · Represented by Gary Hurewitz + Associates 212 764 0004 Fax 764 0002

RAYTHEON · NISSAN · IBM · SEAGRAM · GEORGIA PACIFIC · PSION

ROBINSON
JAMES

James Robinson Photography 212 580 1793 Fax 721 9139 · Represented by Gary Hurewitz + Associates 212 764 0004 Fax 764 0002

A L L A N P E N N

Studio 617 423 1776 FAX 617 423 9257

Represented by Gary Hurewitz 212 764 0004 FAX 212 764 0002

A L L A N P E N N

Studio 617 423 1776 FAX 617 423 9257

Represented by Gary Hurewitz 212 764 0004 FAX 212 764 0002

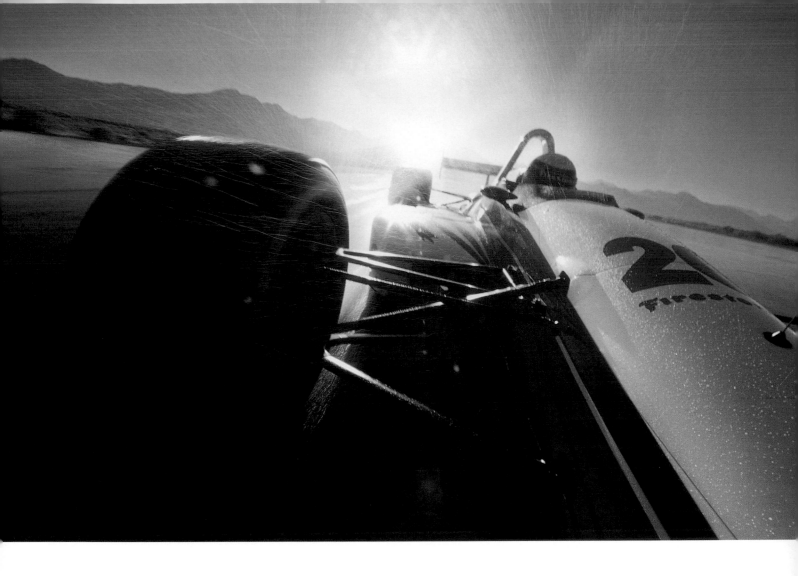

VINCENT DENTE

REPRESENTED BY **GARY HUREWITZ** 516 FIFTH AVENUE NEW YORK CITY 10036

phone **212 7640004** *fax* **212 7640002**

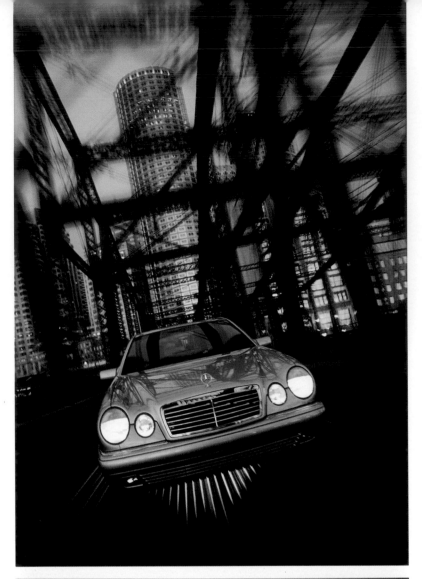

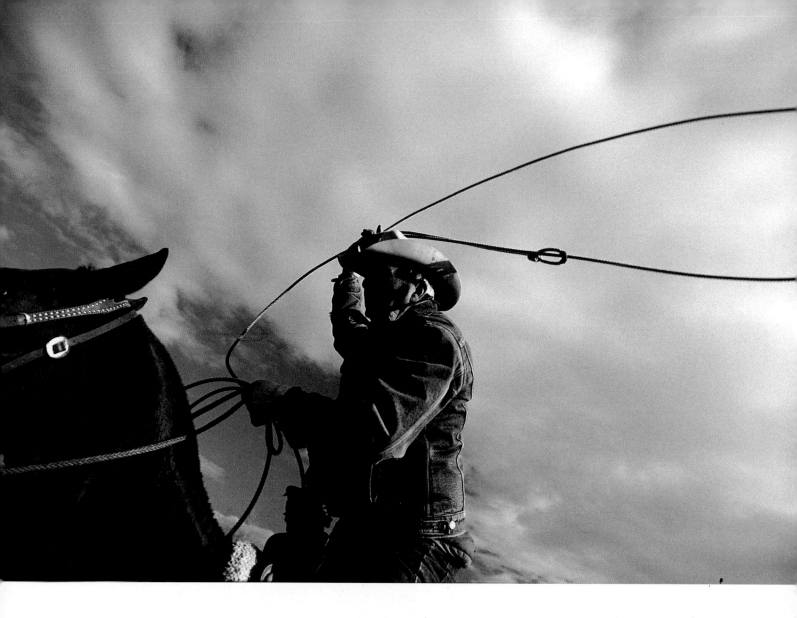

VINCENT DENTE

REPRESENTED BY **GARY HUREWITZ** 516 FIFTH AVENUE NEW YORK CITY 10036

phone 212 7640004 *fax* 212 7640002

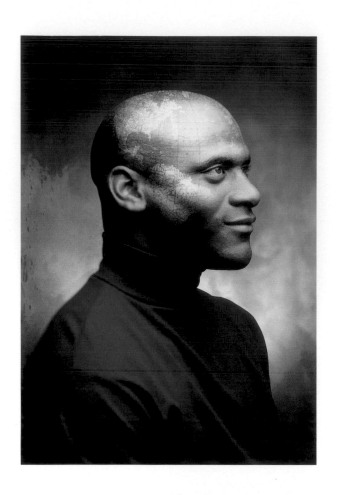

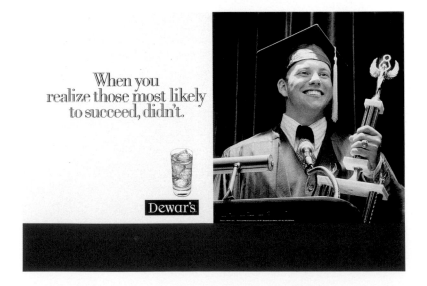

When you realize those most likely to succeed, didn't.

Dewar's

TONY D'ORIO

Studio (312) 421-5532 Fax (312) 421-8063

In the East: Gary Hurewitz & Associates (212) 764-0004 Fax (212) 764-0002

In the Midwest: Atols & Hoffman (312) 222-0504 Fax (312) 222-0503

TONY D'ORIO

Studio (312) 421-5532 Fax (312) 421-8063

In the East: Gary Hurewitz & Associates (212) 764-0004 Fax (212) 764-0002
In the Midwest: Atols & Hoffman (312) 222-0504 Fax (312) 222-0503

PETER JOHANSKY

New York City

212.242.7013

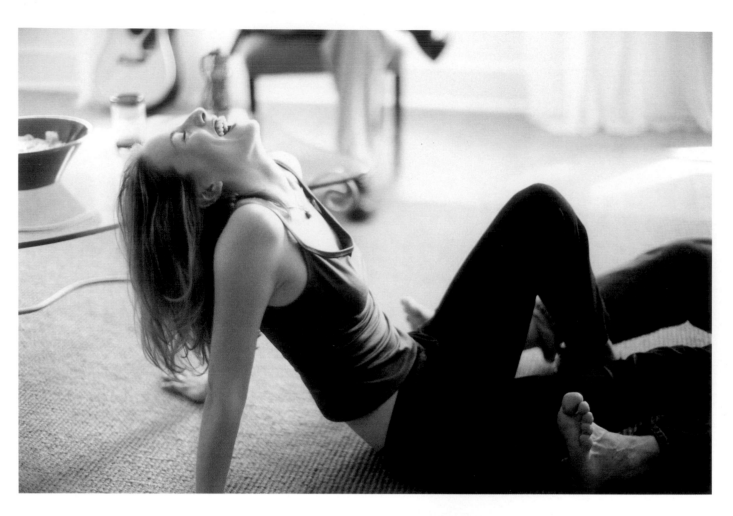

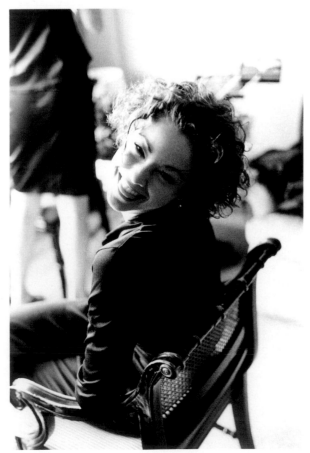

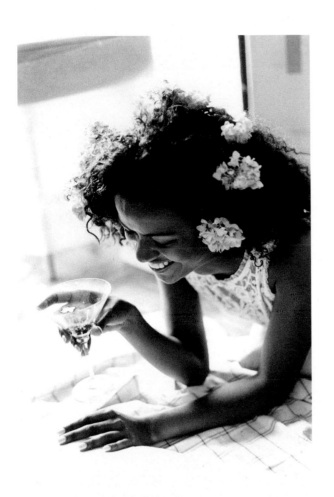

ALAN KAPLAN STUDIO *ak* NEW YORK CITY, NY

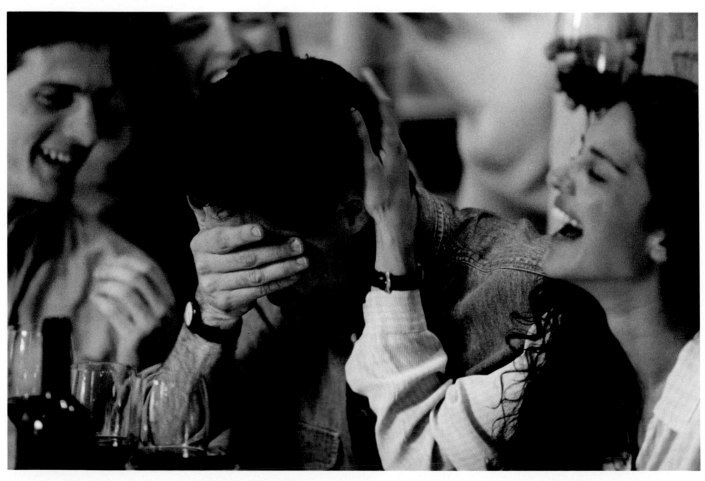

ALAN KAPLAN STUDIO NEW YORK CITY, NY

ALAN KAPLAN STUDIO NEW YORK CITY, NY

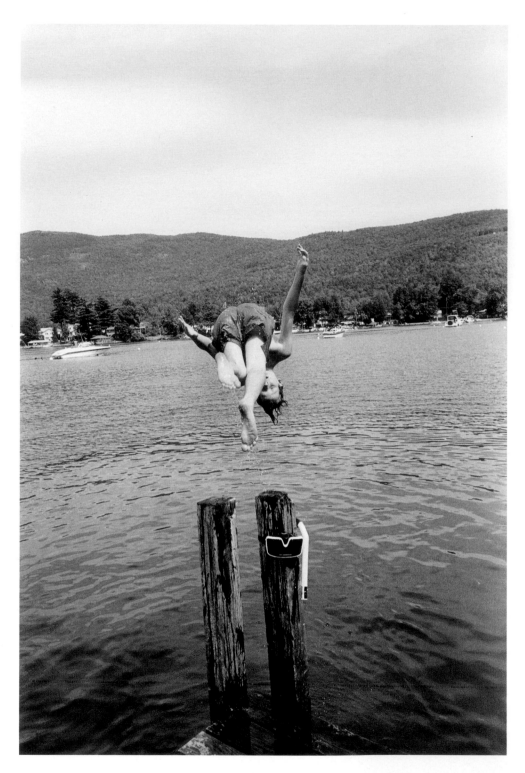

ALAN KAPLAN STUDIO NEW YORK CITY, NY

7 EAST 20TH STREET, NEW YORK, NY 10003

REPRESENTED BY: GARY HUREWITZ & ASSOCIATES, INC. 212.764.0004, FAX 212.764.0002
& CAROLYN POTTS & ASSOCIATES, INC. 773.935.8840, FAX 773.935.6191
STUDIO 212.982.9500 FAX 212.614.0732

ART DIRECTION: JOE PETRUCCIO • COLOR PRINTS: COLOR EDGE

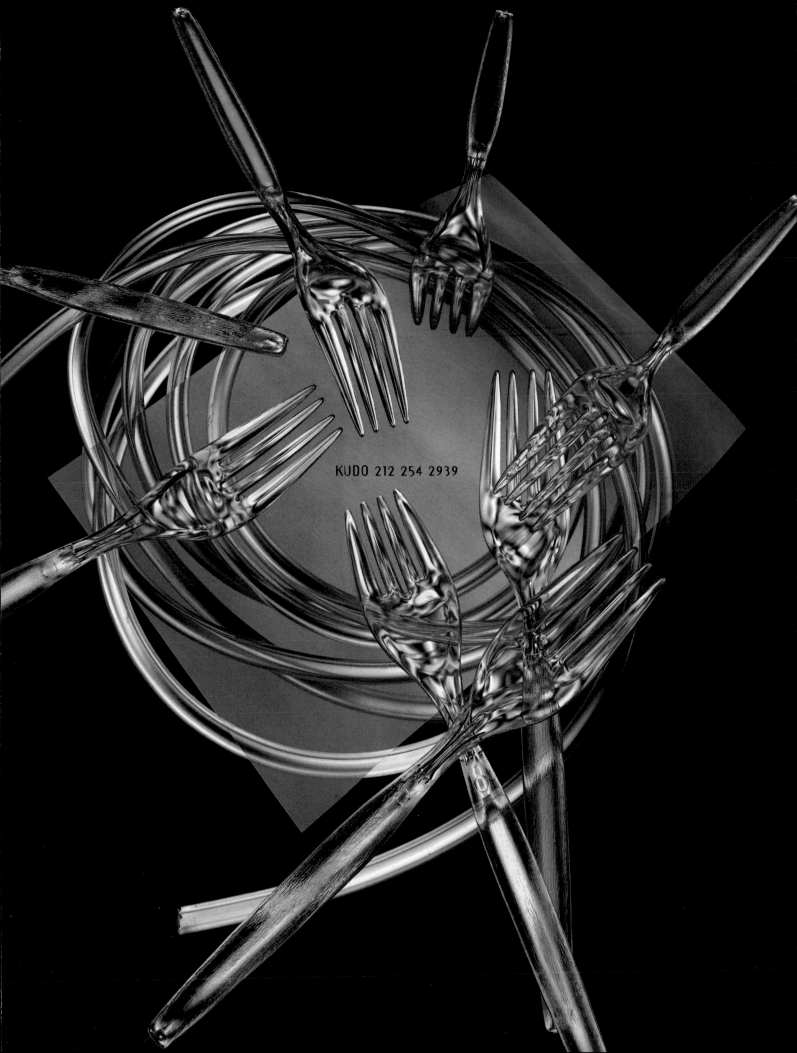

KUDO 212 254 2939

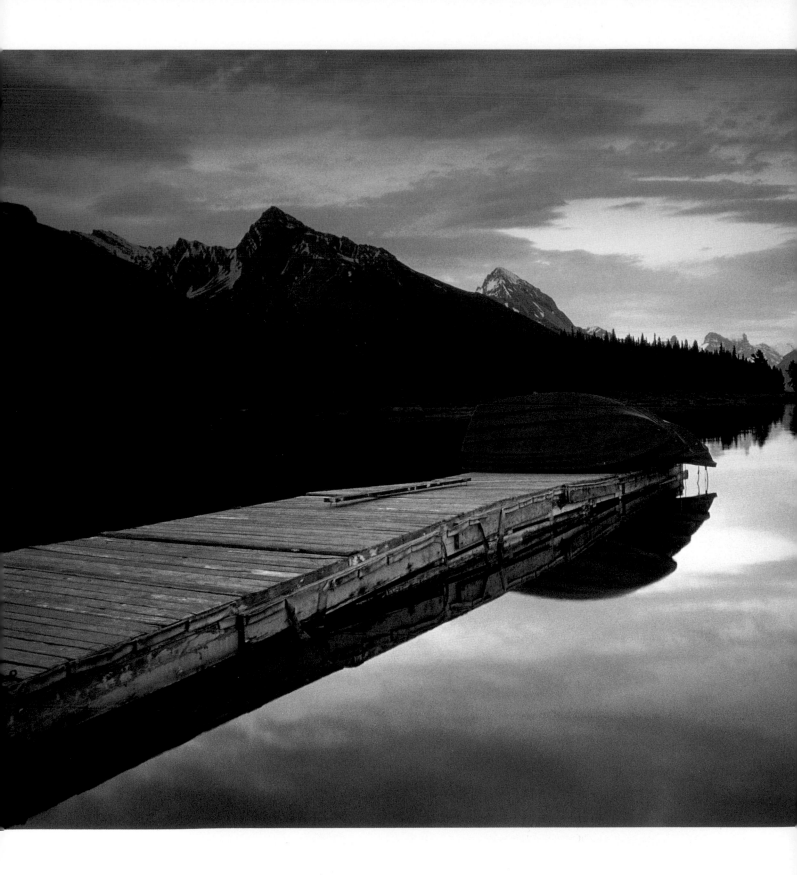

• *represented by Carolyn Potts & Associates Inc.* 773 935-8840 • *fax* 773 935-6191

• *represented in Toronto by Nicki Peters* 416 922-8446 • *fax* 416 975-9583

• *studio* 306 352-3707 • *fax* 306 352-9255 • *e-mail* *walker.photo.ltd@sk.sympatico.ca*

WALKER

DOUGLAS E. WALKER PHOTOGRAPHER LTD.

TODD HAIMAN

REPRESENTED BY CAROLYN POTTS & ASSOCIATES 773-935-8840

STUDIO 212-391-0810

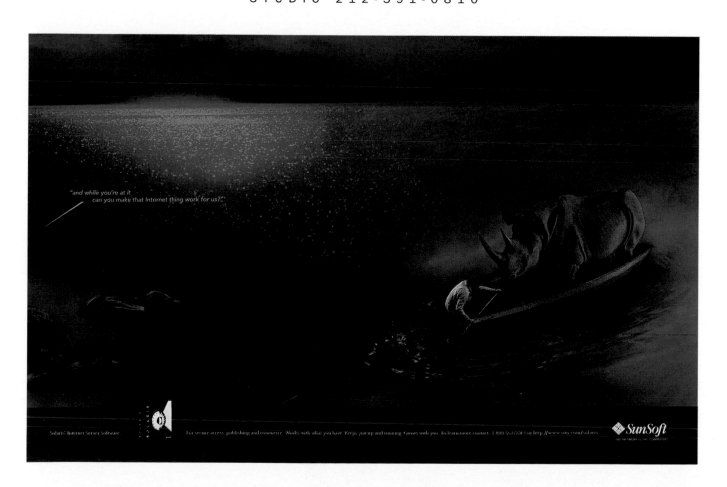

"and while you're at it
can you make that Internet thing work for us?"

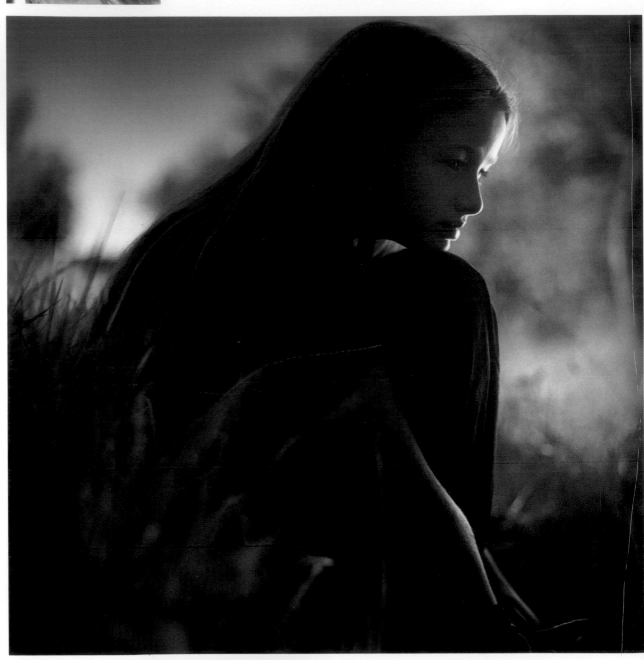

B A R D

212 929 6712

M A R T I N

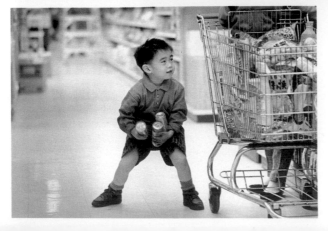

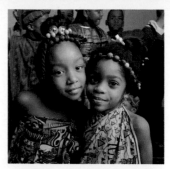

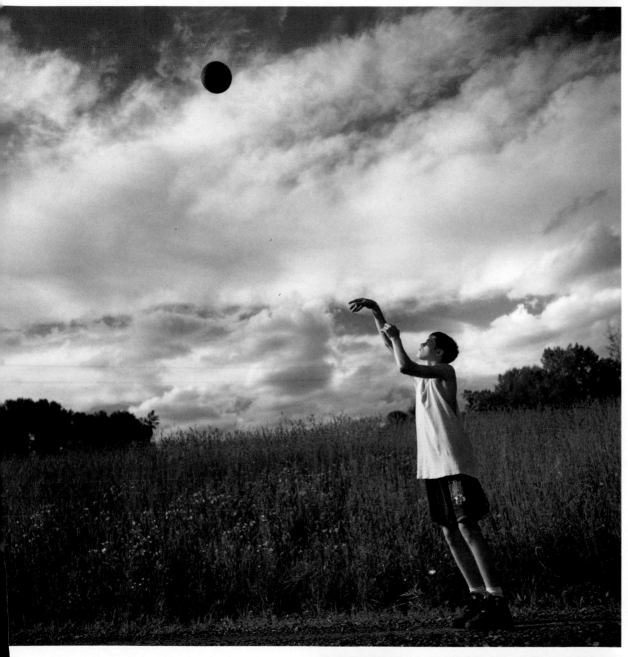

B A R D

212 929 6712

M A R T I N

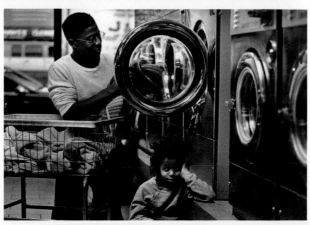

T

TED MORRISON

Photography

286 FIFTH AVE

Ny Ny 10001

TEL 212 279 2839

Fax 212 967 1848

http://www.

tedmorrison.com

RALPH LAUREN
POLO SPORT

WOMAN

M

T

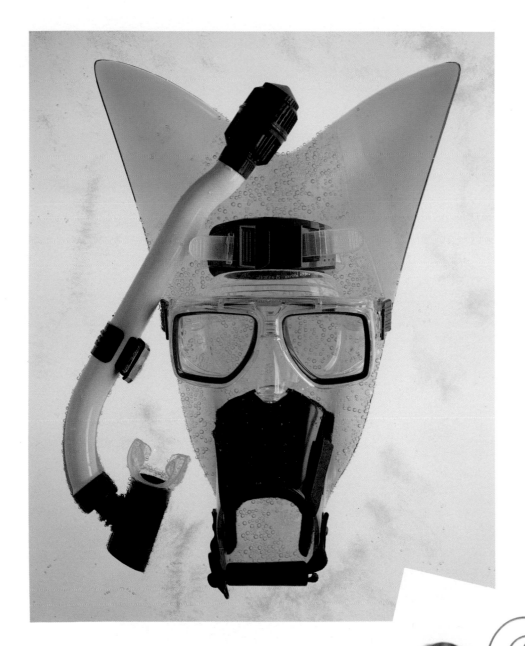

TED MORRISON
Photography
286 FIFTH AVE
Ny Ny 10001
TEL 212 279 2839
Fax 212 967 1848
h t t p : / / w w w .
t e d m o r r i s o n . c o m

M

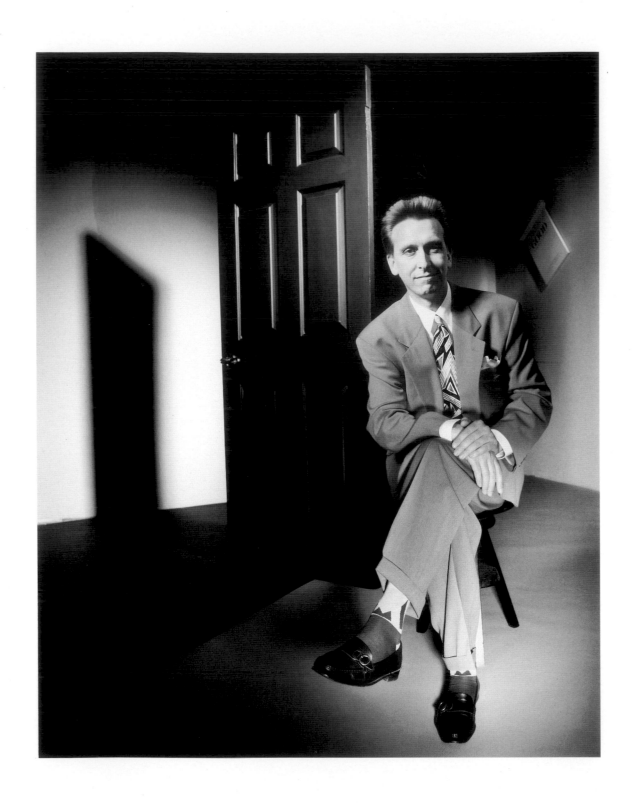

 DEBI | FOX IN D.C. (202) DEBI FOX
IN N.Y. (212) 603 9099

photography

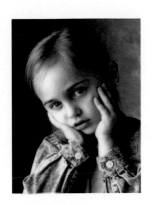

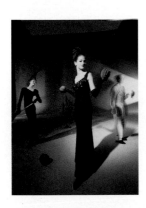

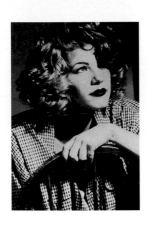

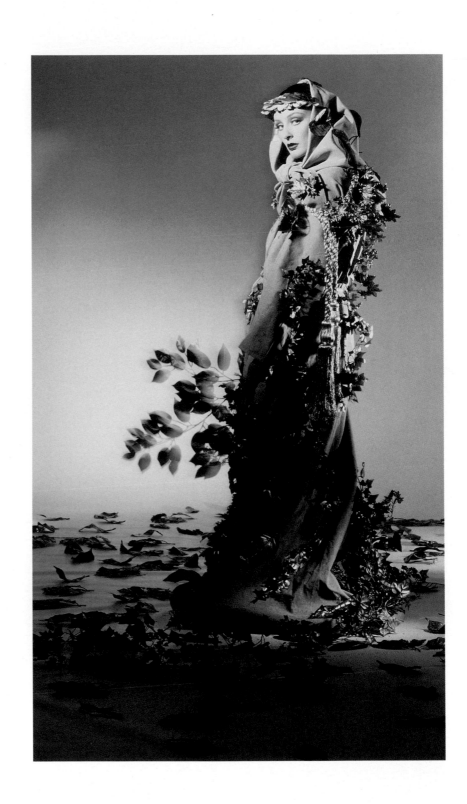

EORGE KAMPER

(800) 950-7006

(212) 627-7171

http://www.KSCstudio.com

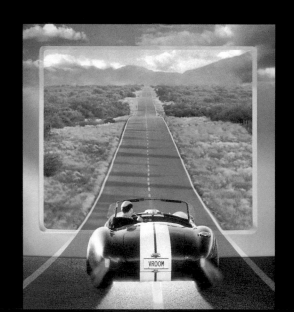

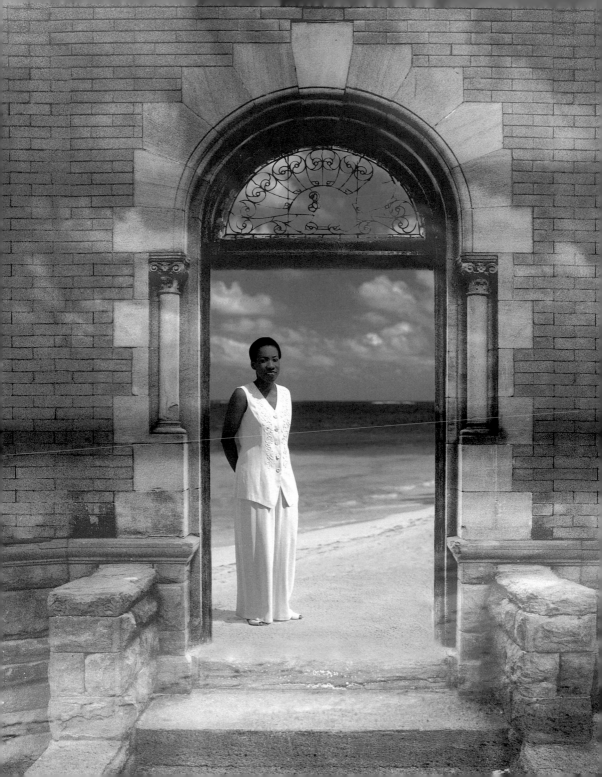

BRIAN SPROUSE

(800) 950-7006

(212) 627-7171

http://www.KSCstudio.com

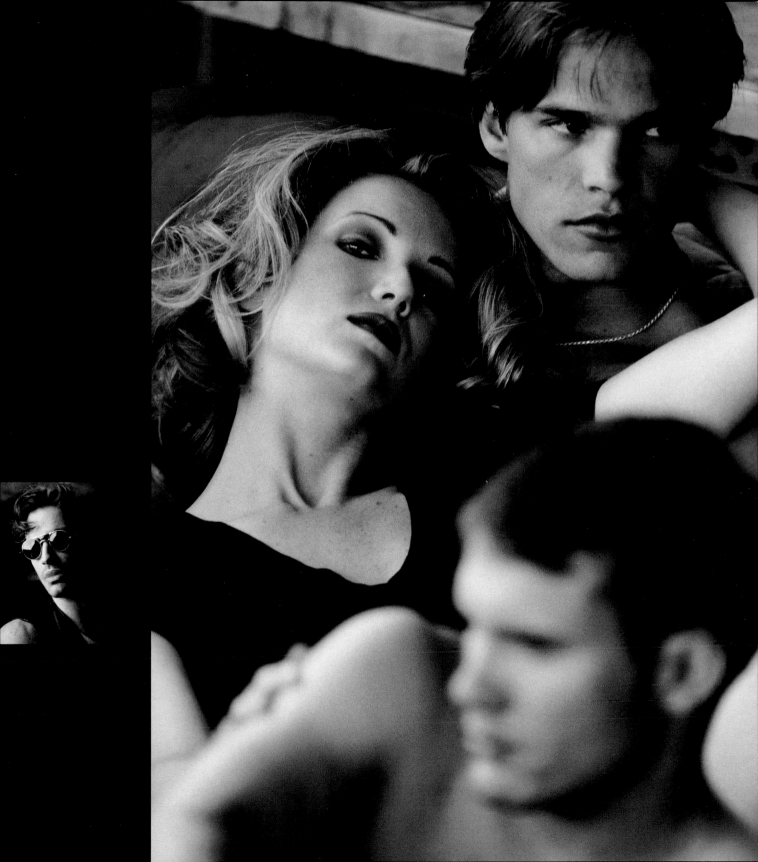

(800) 950-7006

(212) 627-7171

http://www.KSCstudio.com

WALTER COLLEY

Jeanne Strongin 212 473 3718

UHER

529 W42ST NYC, NY 10036
■ TEL: 212 594 7377
■ FAX: 212 971 9546

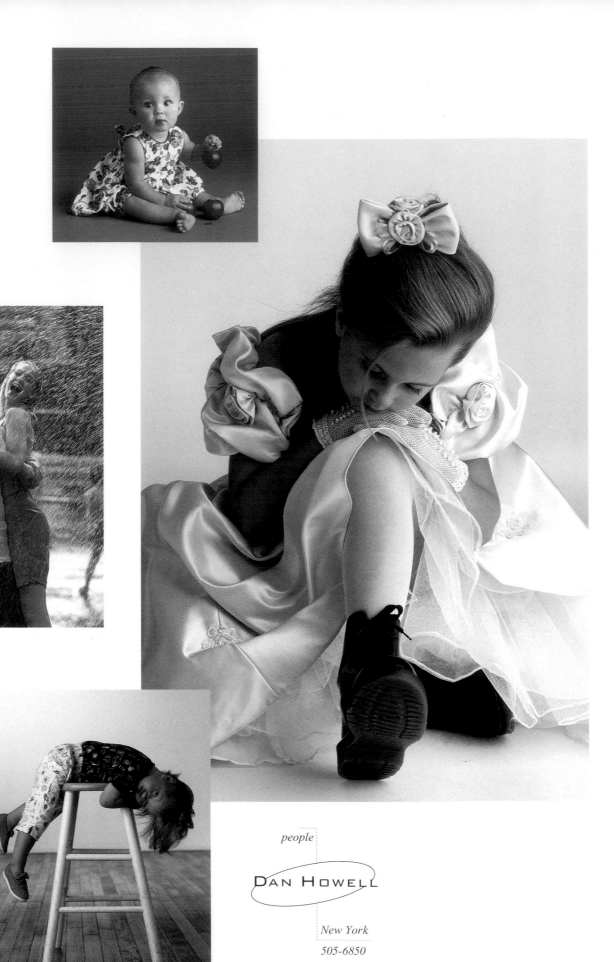

people

DAN HOWELL

New York
505-6850

people

DAN HOWELL

New York
505-6850

231

Still-life photography available through Contrino/Hankin Associates, 212 741-0155.

Jamie Hankin 212 687-1120

FUJI RDPI

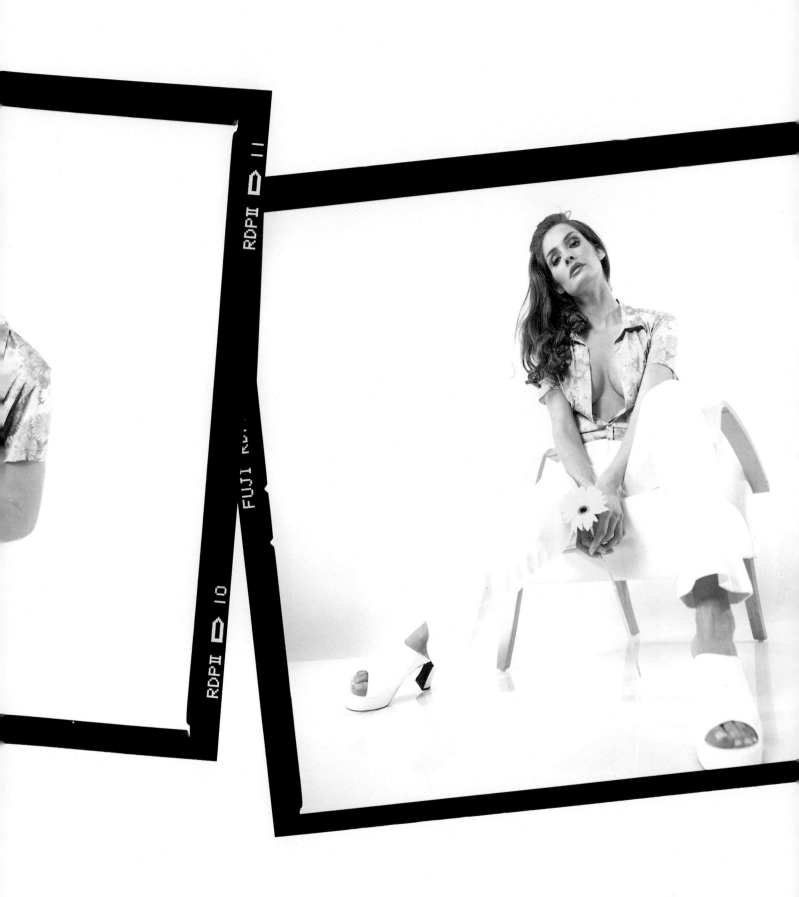

Jamie Hankin 212 687-1120

ERIC JACOBSON

45 East 20 Street New York City 10003 Studio 212.777.0070

ERIC JACOBSON

—

45 East 20 Street New York City 10003 Studio 212.777.0070

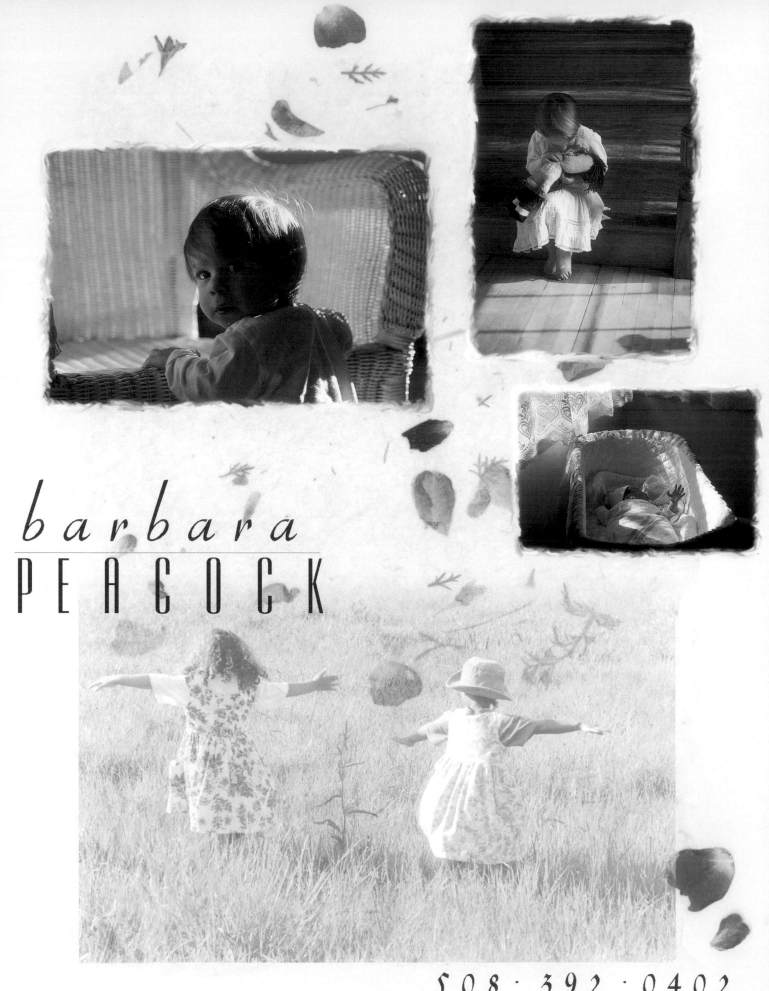

barbara
PEACOCK

508 · 392 · 0402

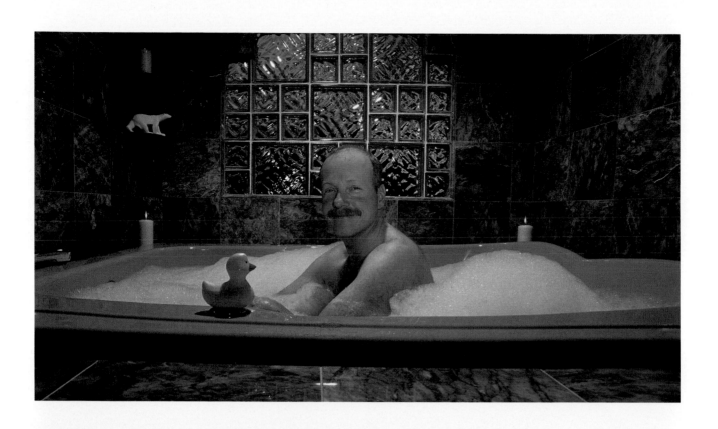

BIEGUN

239

CHRISTIAN BELPAIRE

Photographe(r) 212 7427874 Represented by Jackie Page

CHRISTIAN BELPAIRE

Photographe(r) 212 7427874 Represented by Jackie Page

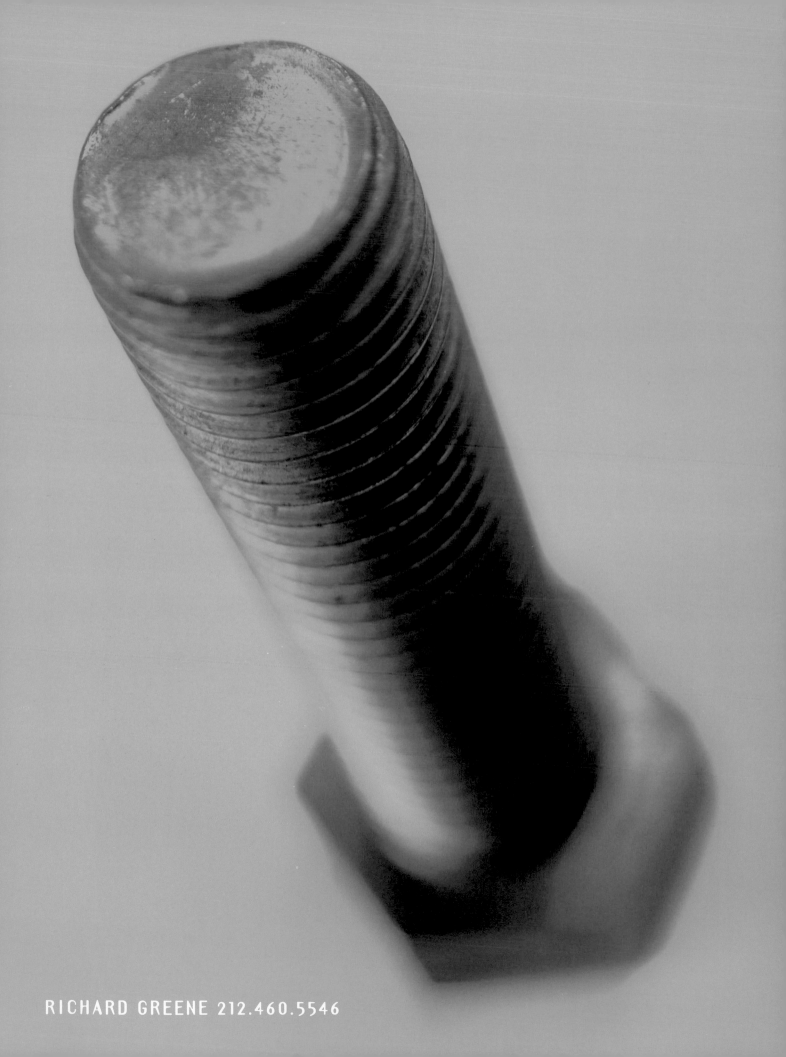

RICHARD GREENE 212.460.5546

lori adamski-peek

p.o. box 4033
park city, utah 84060
801 • 649 • 0259

REPRESENTED BY: RANDY COLE TEL: (212) 679-5933 / FAX:(212) 779-3697

lori adamski-peek

p.o. box 4033
park city, utah 84060
801 • 649 • 0259

REPRESENTED BY: RANDY COLE TEL: (212) 679-5933 / FAX:(212) 779-3697

PATRICK
HARBRON

212-633-9052

represented by

new york

RANDY COLE

NY 212-679-5933

PATRICK HARBRON

212-633-9052

new york

represented by

RANDY COLE

NY 212-679-5933

DAVID hautzig (212) 779-1595 • http://www.users.interport.net/~dhautzig
PHOTOGRAPHY

CHRIS VINCENT

REZNY, INC. ■

NYC 212 691 1894

FAX 212 691 1685 ■

Cvphoto@concentric.net ■

VINCENT

REPRESENTED BY
JERRY ANTON
212 633 9880
FAX 212 633 9883
AntonJ646@aol.com

AARON REZNY

REZNY, INC

NYC 212 691 1894

FAX 212 691 1685

Rezny@concentric.net

REZNY

REPRESENTED BY
JERRY ANTON
212 633 9880
FAX 212 633 9883
AntonJ646@aol.com

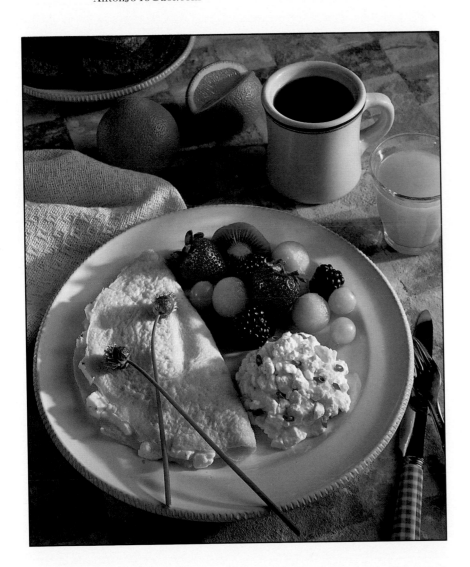

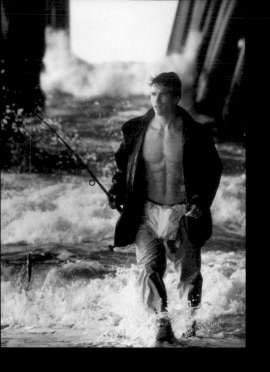

ROB LANG

New York 212-595-2217
Represented by Lise Hintze 516-689-7054
Los Angeles 310-319-1929

ROB LANG

New York 212-595-2217
Represented by Lise Hintze 516-689-7054
Los Angeles 310-319-1929

O'CLAIR PHOTOGRAPHY
516.598.3546

Represented in New York by Lise Hintze
516.689.7054

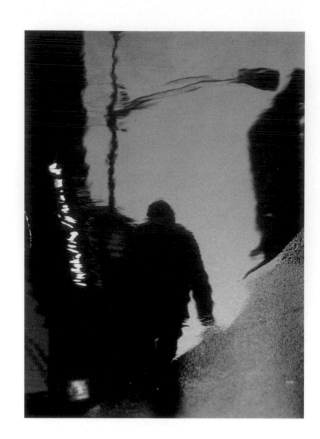

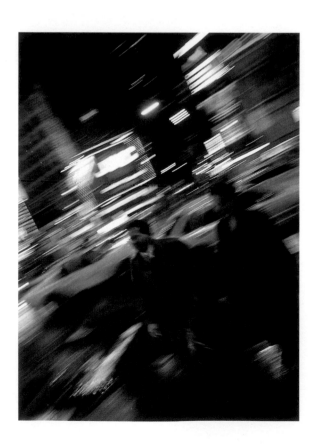

LELAND BOBBÉ 212.685.5238

LELAND BOBBÉ 212.685.5238

ZIMMERMAN

DAVID ZIMMERMAN STUDIO, INC.
TWENTIETH STREET, NEW YORK, NEW YORK 10011 PHONE: 212 206 1000 FAX: 212 620

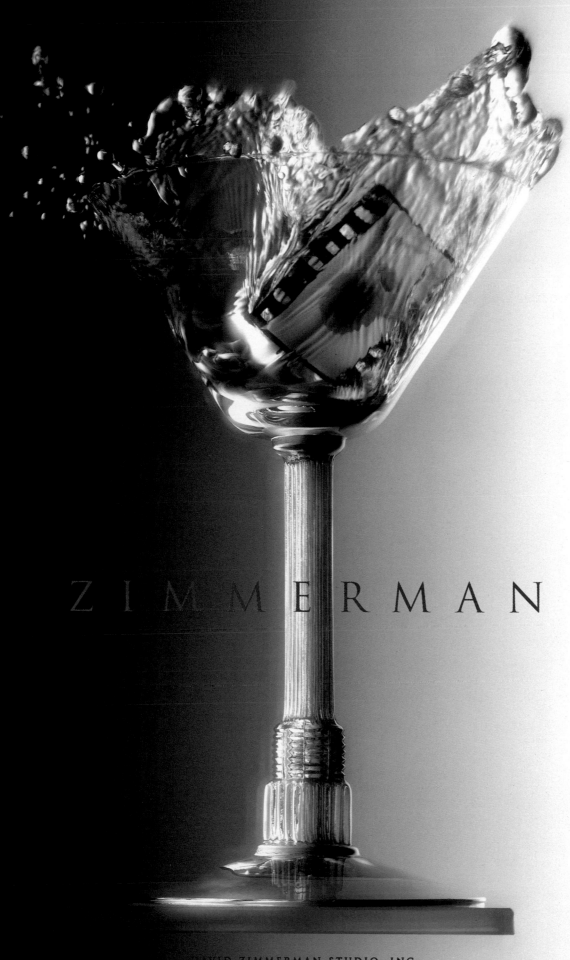

ZIMMERMAN

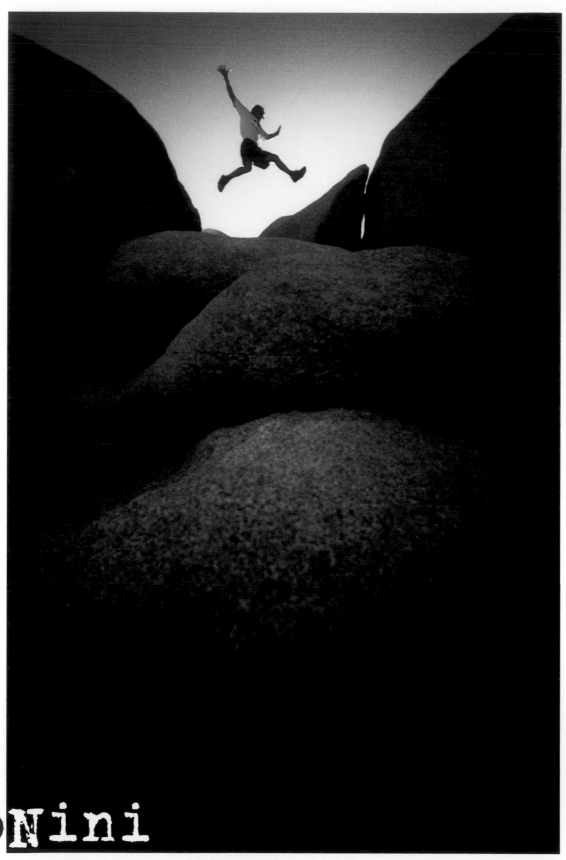

BoNini

Steve BoNini Photography 503.239.5421.

Represented by:

(East) Robert Mead 800.717.1994

(West) NAdine Kalmes 310.829.5233

BoNini

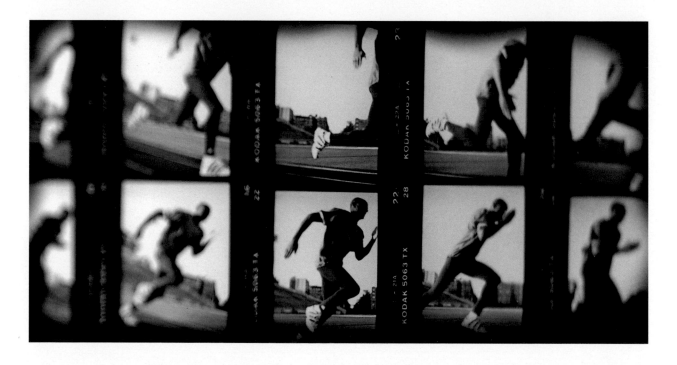

Steve BoNini Photography 503.239.5421. Represented by:
(East) Robert Mead 800.717.1994 (West) NAdine Kalmes 310.829.5233

BURGESS BLEVINS

BURGESS BLEVINS 410 685 0740 REPRESENTED BY ROBERT MEAD ASSOCIATES 800 717 1994

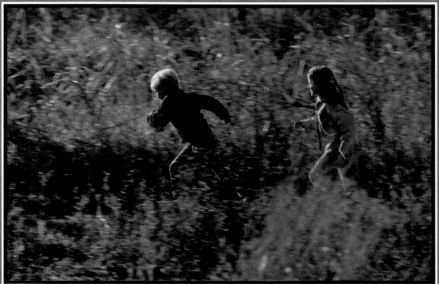

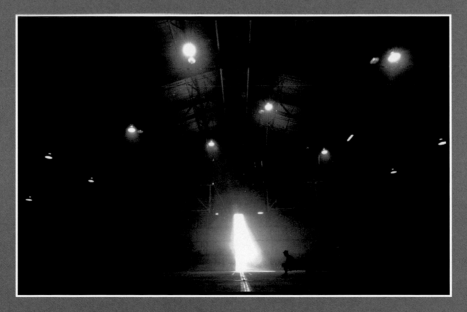

BURGESS BLEVINS

BURGESS BLEVINS 410 685 0740 REPRESENTED BY ROBERT MEAD ASSOCIATES 800 717 1994

N I C K
VEDROS

© NICK VEDROS, VEDROS & ASSOCIATES 1996

CLIENT: QSP

CLIENT: ATLANTIC BELL

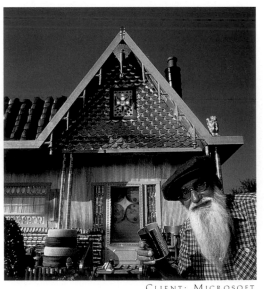

CLIENT: MICROSOFT

N I C K
VEDROS

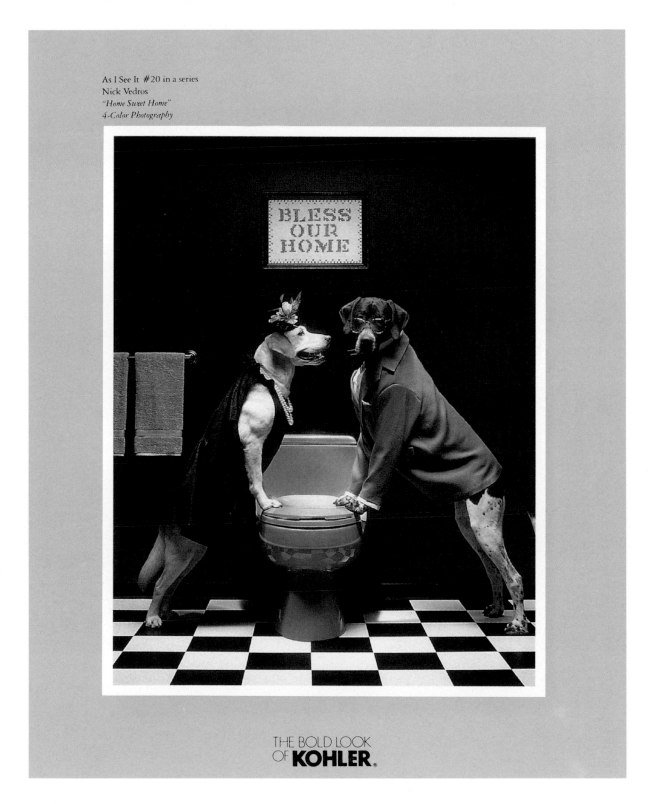

As I See It #20 in a series
Nick Vedros
"Home Sweet Home"
4-Color Photography

THE BOLD LOOK
OF **KOHLER**.

MICHAEL YAMASHITA

MICHAEL YAMASHITA

REPRESENTED BY ROBERT MEAD ASSOCIATES

1-800-717-1994 FAX 914-835-0791

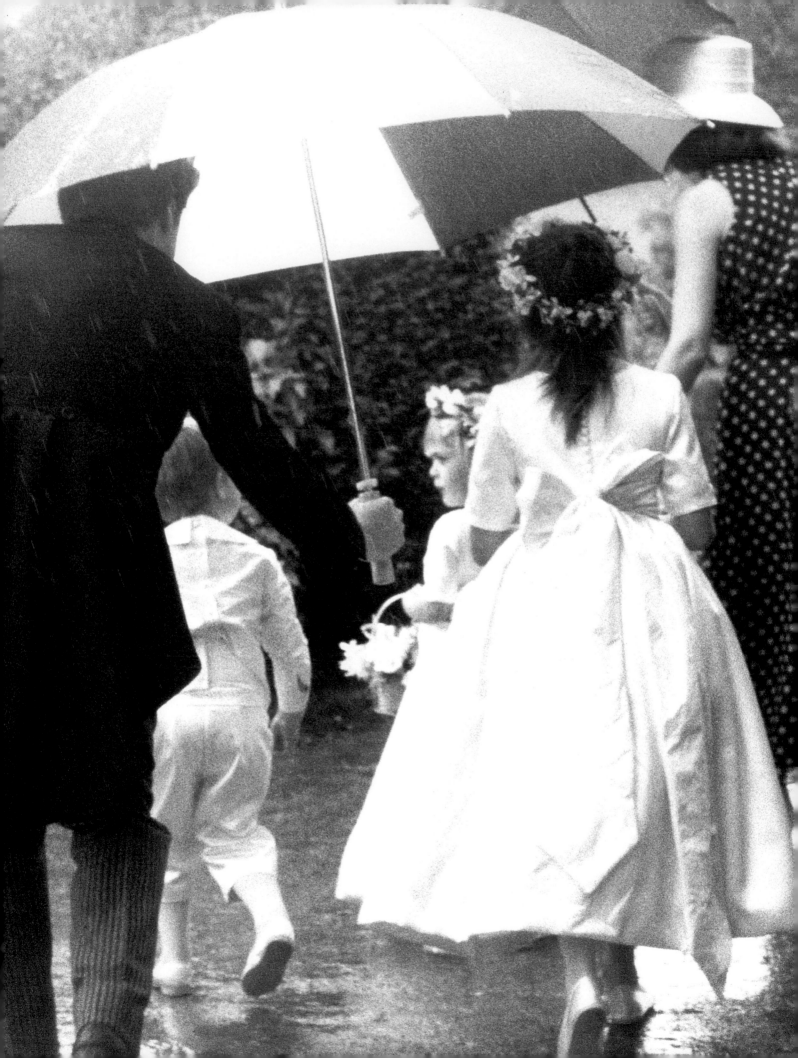

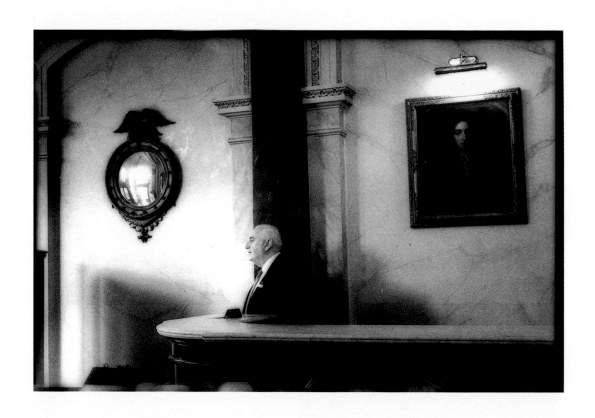

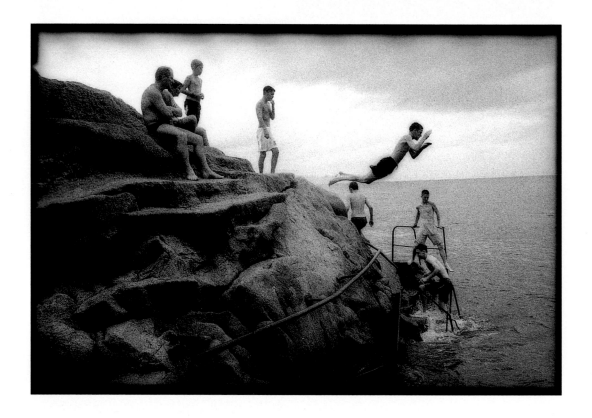

ELIZABETH ZESCHIN

Represented by Robert Mead Associates
800. 717. 1994

BILL WHITE ~ studio

• phone : 2l2.5 3 3.4l95

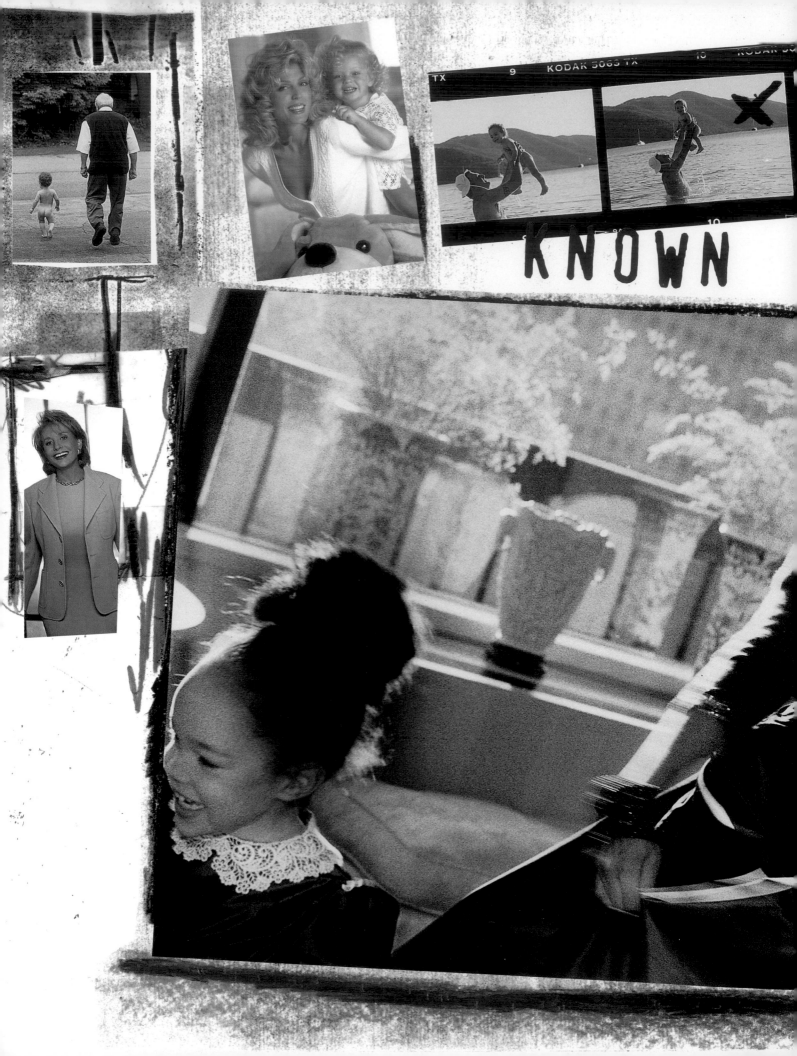

KNOWN

UNKNOWN

SHONNA VALESKA

140 EAST 28 STREET
NEW YORK NY 10016
212 683 4448
FAX 212 696 5171

mark berg
fronk

(703)425-0084
in nyc (212)221-3376

LIGHTSCAPES

audrey
berg
mark
fronk

(703)425-0084
in nyc (212)221-3376

Rita Maas

2 1 2 . 9 2 9 . 0 4 4 1

Rita Maas

212.929.0441

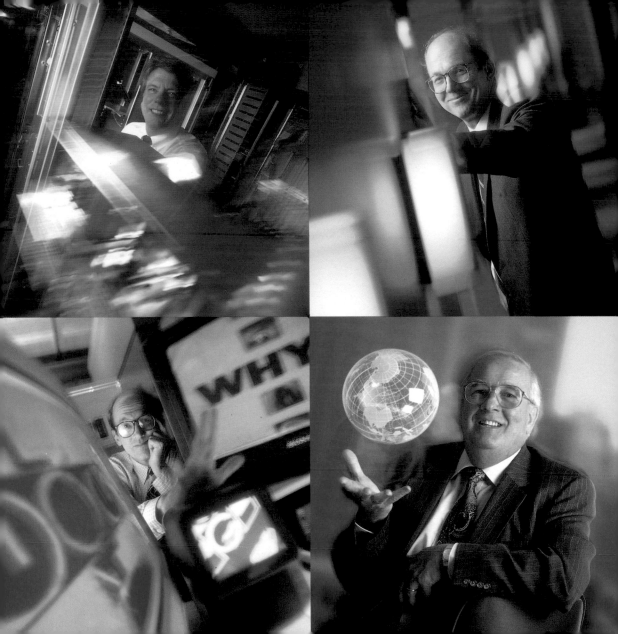

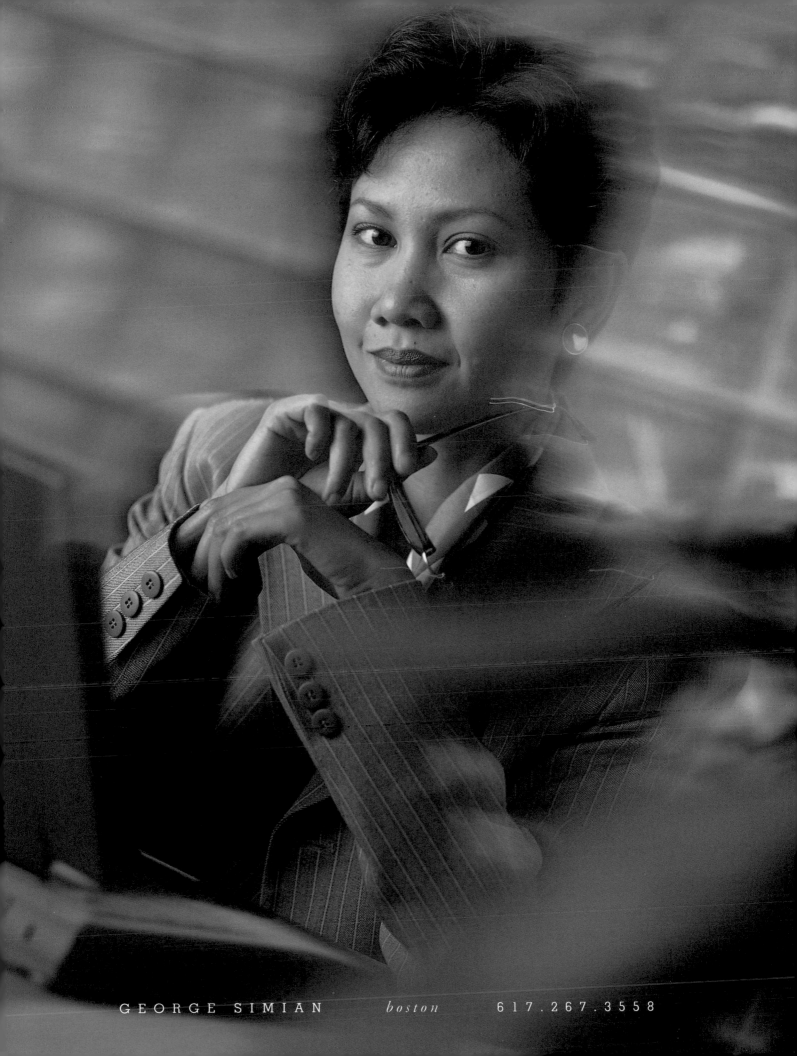

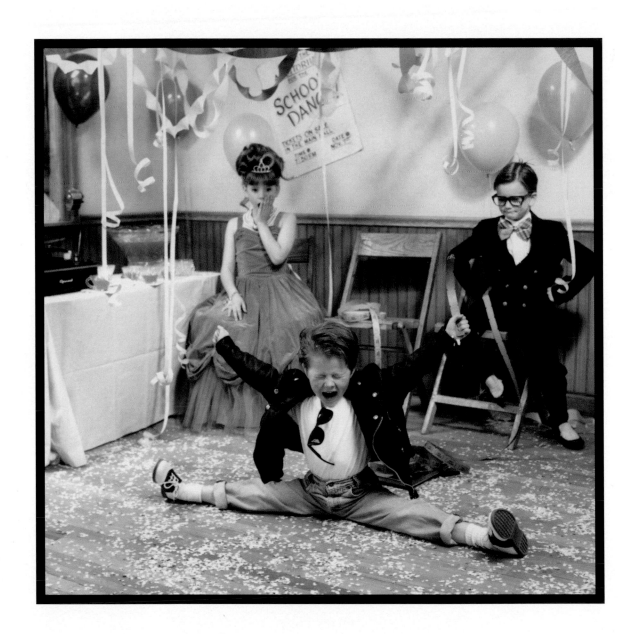

Phoebe

Cleo Sullivan

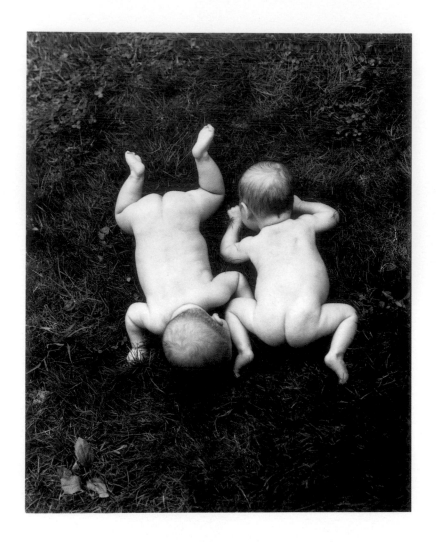

ALLURE

NEW YORK TIMES MAGAZINE

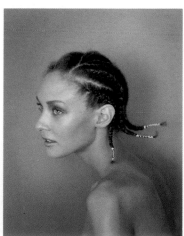

ALLURE

BETTY WILSON REPRESENTS

PHOTOGRAPHERS

212-595-2124 / 9 WEST 84TH STREET, NY, NY 10024 / PARIS: CARLA GHIGLIERI, 43-14-09-03

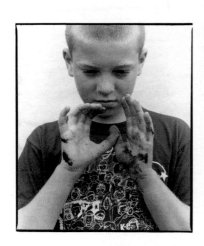
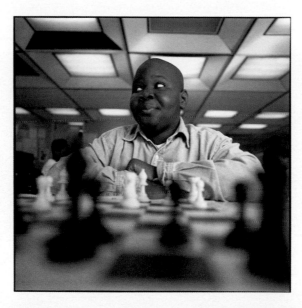
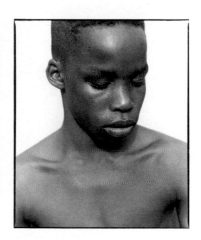
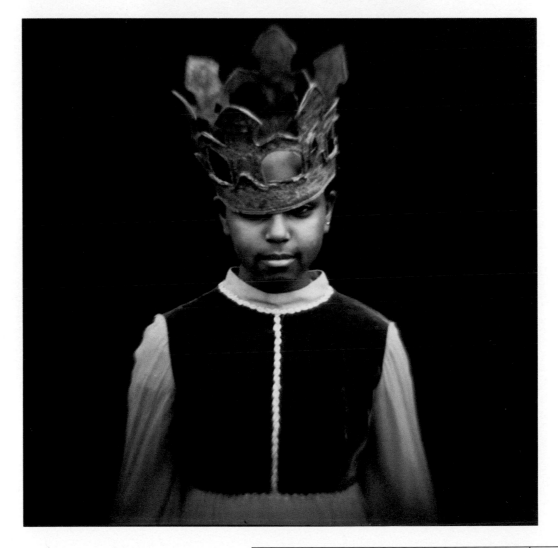
283

GEORGE DIEBOLD

201.744.5789

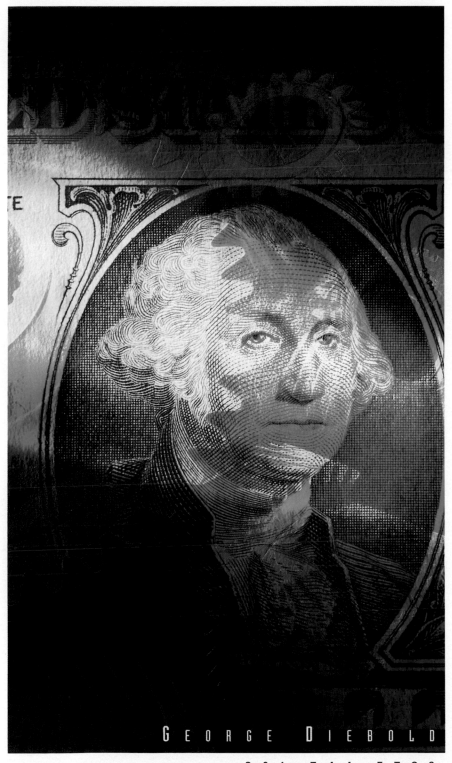

GEORGE DIEBOLD

201.744.5789

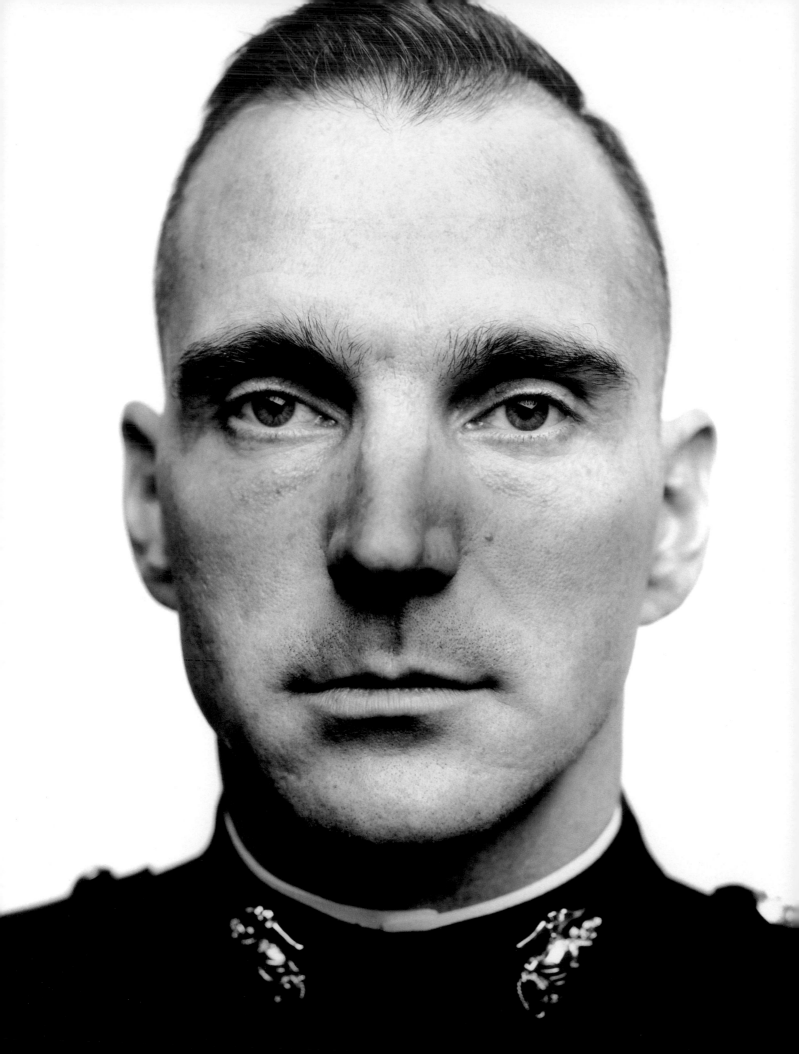

Mark Havriliak Photographer · Studio: 107 West 25th Street 3a New York, New York 10001 · 212.969.8763

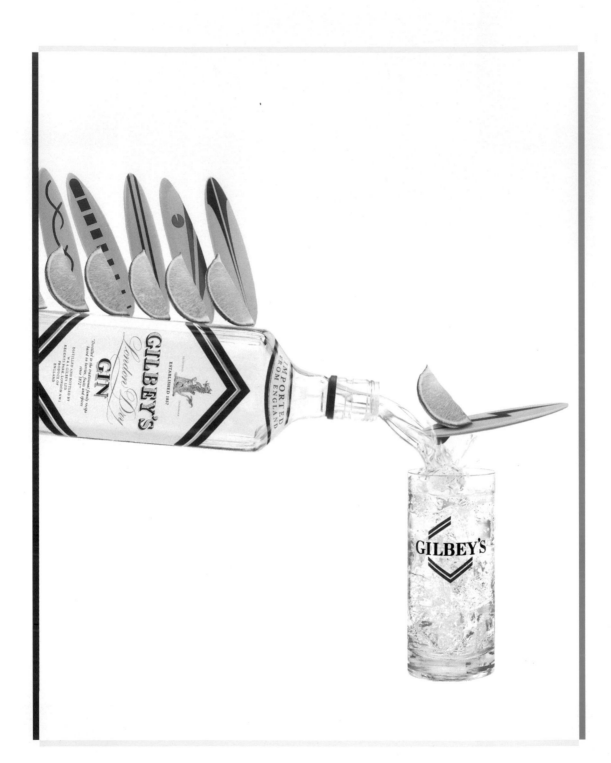

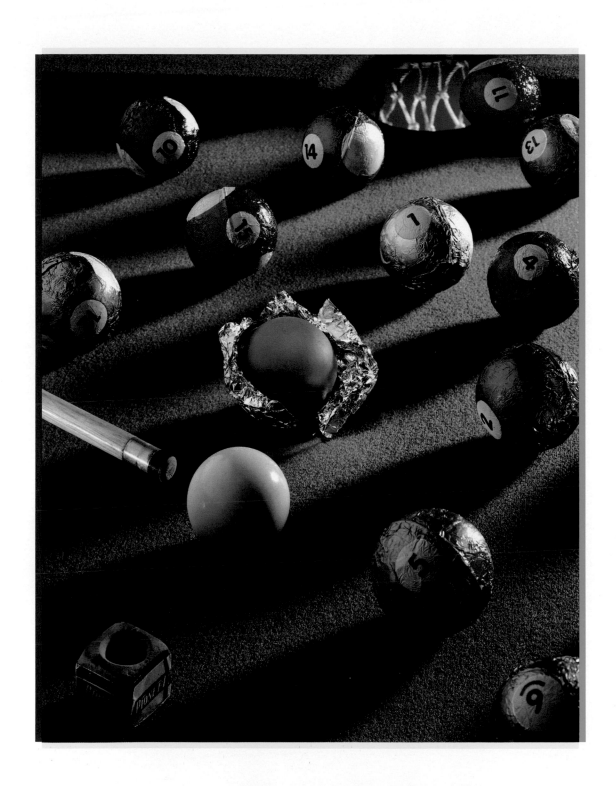

DANBARBA

212.420.8611 · barphoto@village.ios.com

AUGUSTUS
BUTERA

AUGUSTUS BUTERA (212) 864 7772

*Partial client list includes: M.C.I., Fuji,
Kids FootLocker and Johnson & Johnson*

291

CHANEL

Joaillerie

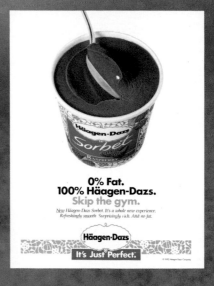

**0% Fat.
100% Häagen-Dazs.
Skip the gym.**

*New Häagen-Dazs Sorbet. It's a whole new experience.
Refreshingly smooth. Surprisingly rich. And no fat.*

Häagen-Dazs
It's Just Perfect.

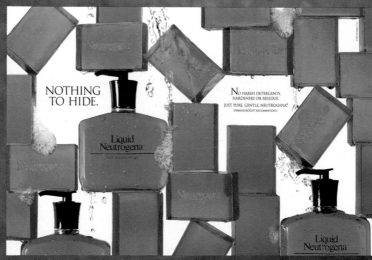

NOTHING
TO HIDE.

NO HARSH DETERGENTS,
HARDENERS OR RESIDUE.
JUST PURE, GENTLE, NEUTROGENA.
DERMATOLOGIST RECOMMENDED.

Liquid
Neutrogena

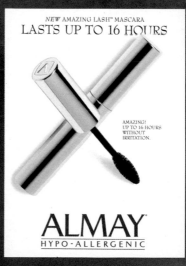

NEW AMAZING LASH™ MASCARA
LASTS UP TO 16 HOURS

AMAZING!
UP TO 16 HOURS
WITHOUT
IRRITATION.

ALMAY®
HYPO-ALLERGENIC

Vecchione

Print & Film, Inc.

WASHINGTON, DC
301.495.1055 F: 301.495.1058

Represented By:
Julia Schieken 301-309-3896
In Texas: Ally Godfrey 214-827-2559

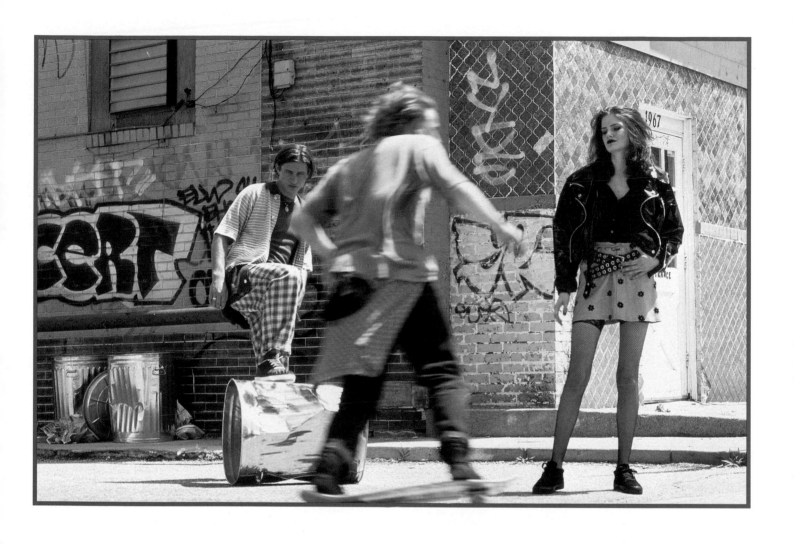

Vecchione

Print & Film, Inc.

WASHINGTON, DC
301.495.1055 F: 301.495.1058
Represented By:
Julia Schieken 301-309-3896
In Texas: Ally Godfrey 214-827-2559

Corinne Colen
PHOTOGRAPHY

515 Broadway, New York City
212.431.7425 fax 212.431.7816

Corinne Colen
PHOTOGRAPHY

515 Broadway, New York City
212.431.7425 fax 212.431.7816

LITTLEHALES

© U.S. Army / Young & Rubicam

BRETON LITTLEHALES PHOTOGRAPHER WASHINGTON.DC 202.291.2422 REPRESENTED BY JUDI GIANNINI 301.439.0103

LITTLEHALES

Laurie Lewis

BRETON LITTLEHALES PHOTOGRAPHER WASHINGTON, DC 202.291.2422 REPRESENTED BY JUDI GIANNINI 301.439.0103

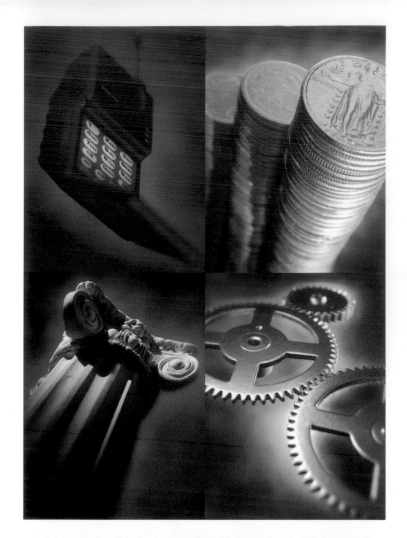

PHOTOGRAPHER
WM.
DEMPSEY
III
703 241 7580

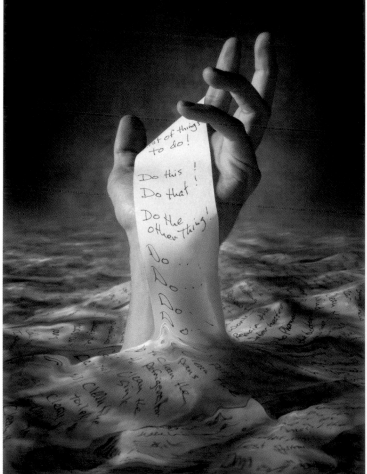

conceptual imaging

digital photo illustration

still life photography

represented by

judi giannini

301.439.0103

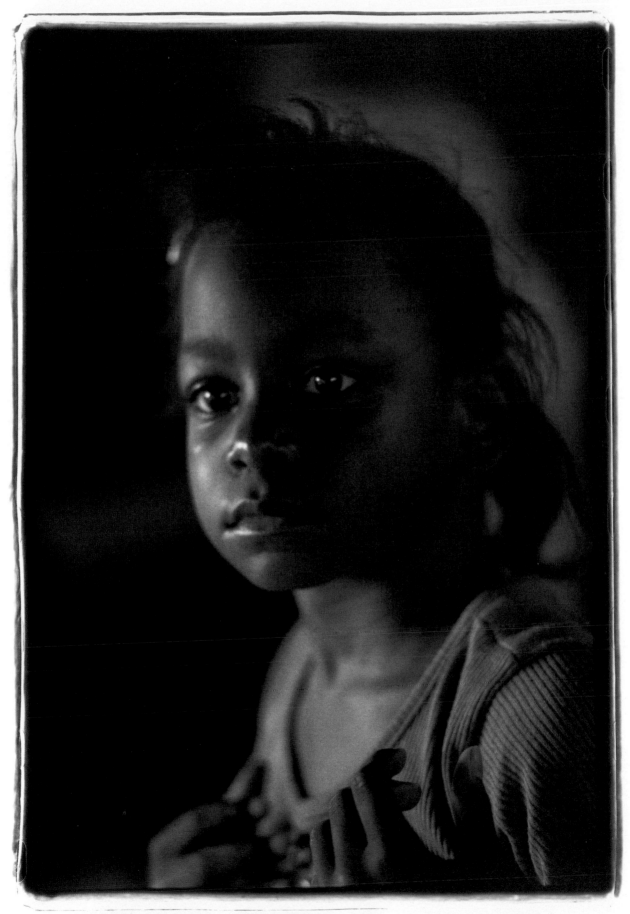

CHRIS COXWELL, PHOTOGRAPHY, INC. 1.800.604.5815

Louis
Wallach

212 352-0730
Represented By
Stephen Madris 212 475-7068

Louis Wallach

In Los Angeles: Lee+Lou 310•287•1542

CHUCK KUHN

Print and Film Images *of* America

212·355·0390 206·842·1996

JAMEY STILLINGS

Represented by Sharpe + Associates

West 310.641.8556 East 212.595.1125 Studio 800.724.0209

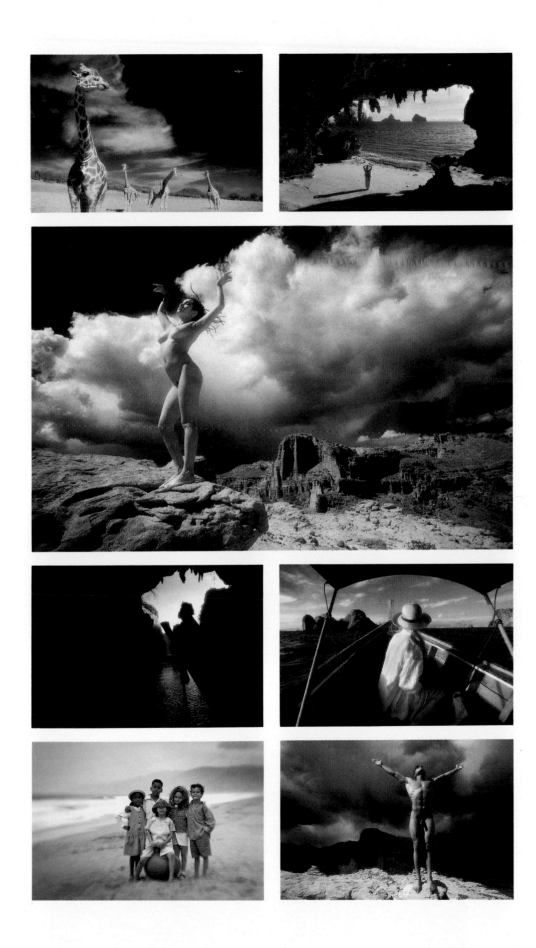

LITTLE FISH

Jacques Cousteau at Machu Picchu

BIG FISH

JONATHAN LEVINE PHOTOGRAPHY

6 West 20TH Street, NYC 10011 212-229-1841

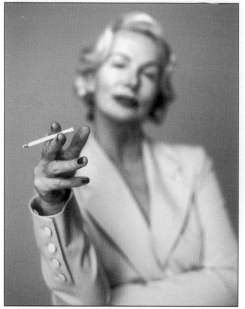

Nadav Kander

Hashi

Richard Corman

Eric Meola

Walter Iooss

Michael Zeppetello

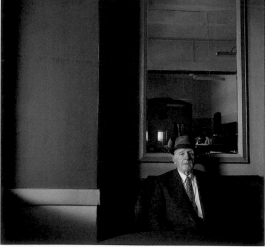

Rolph Gobits

Toni Meneguzzo

REPRESENTING > PHOTOGRAPHERS: Joel Baldwin, Richard Corman, Rolph Gobits, Anthony Gordon, Bruce Wolf, Michael Zeppetello. **DIRECTORS:** Ron Ames, Gene Cernilli, Henry Corra, Tom DiCillo,

STOCKLAND MARTEL

Timothy Greenfield-Sanders

Timothy White

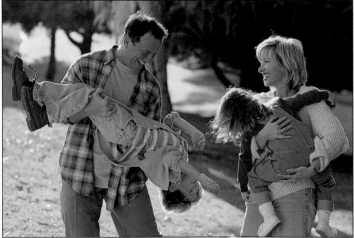

Joel Baldwin

Leen Thijsse

Ruedi Hofmann

Bruce Wolf

Uli Rose

Timothy Greenfield-Sanders, Hashi, Ruedi Hofmann, Walter Iooss, Nadav Kander, Toni Meneguzzo, Eric Meola, Uli Rose, Leen Thijsse, Timothy White, Anita Madeira, Tom Schiller, Bruce Wolf. > 5 UNION SQUARE WEST, NEW YORK, NY 10003, telephone: **212·727·1400**, internet: **www.stocklandmartel.com**

BRUCE WOLF

New York City 212 633 6660
Represented by Stockland Martel: NYC 212 727 1400
Bill Rabin & Associates: Chicago 312 944 6655
Film reel available

WALTER IOOSS

REPRESENTED BY STOCKLAND MARTEL

5 UNION SQUARE WEST, NEW YORK NY 10003

TELEPHONE: 212 727 1400 FAX: 212 727 9459

Represented by

New York:

Stockland Martel

Tel: 212.727.1400

HASHI

HASHI STUDIO INC.

Tel: 212.675.6902

Fax: 212.633.0163

Tokyo:

HASHI Studio Tokyo

Tel: 03.3479.8410

Paris:

Veronique P. Domergue

Tel: 1.45 06 41 00

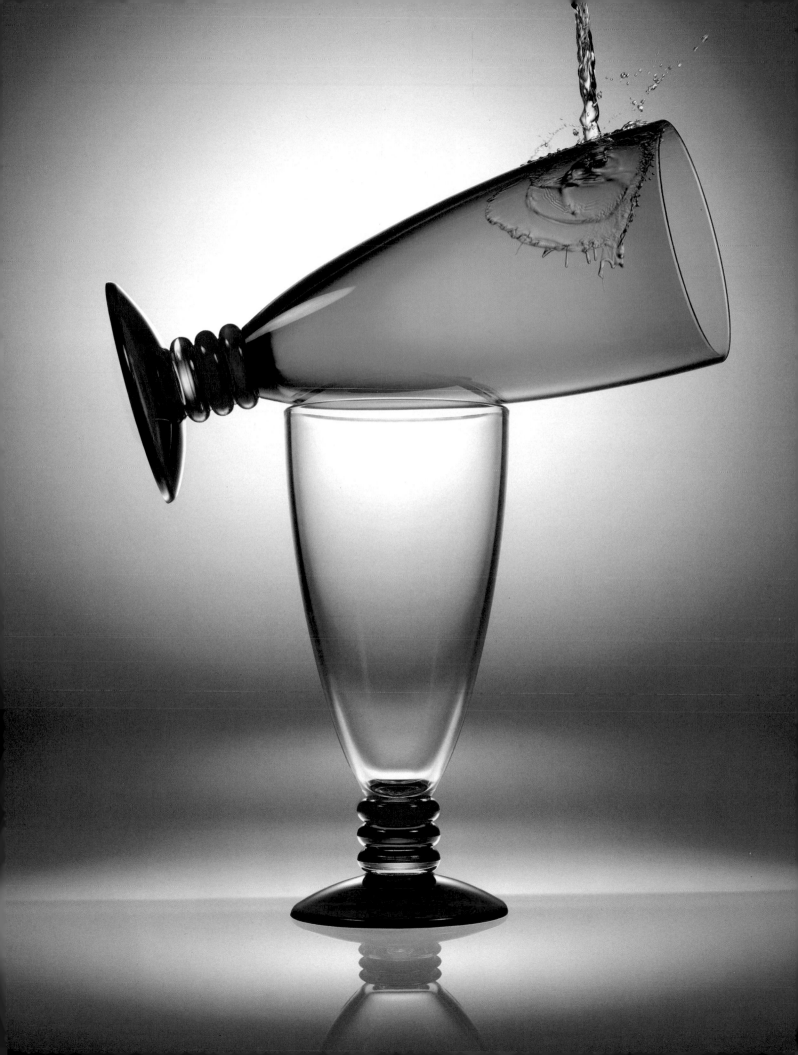

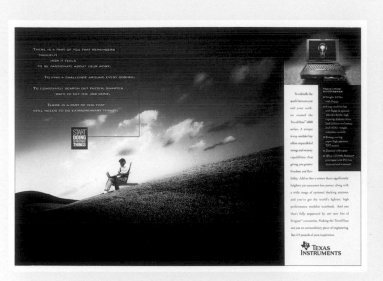

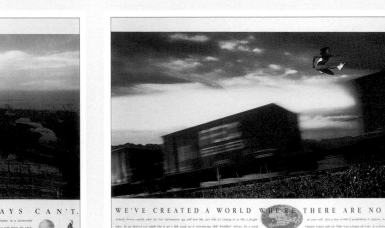

L E E N T H I J S S E

REPRESENTED BY STOCKLAND MARTEL 212.727.1400

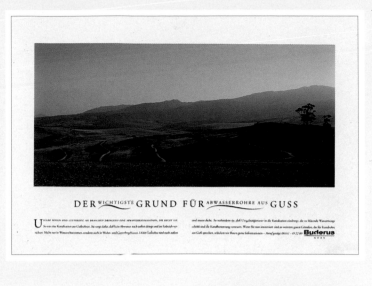

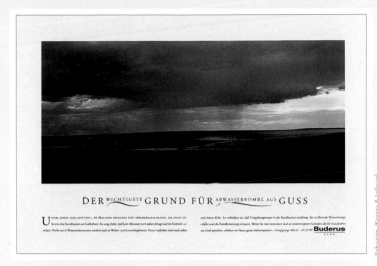

DER WICHTIGSTE GRUND FÜR ABWASSERROHRE AUS GUSS

Buderus GUSS

DER WICHTIGSTE GRUND FÜR ABWASSERROHRE AUS GUSS

Buderus GUSS

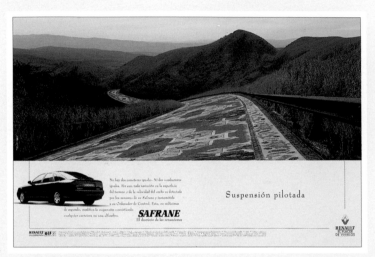

Suspensión pilotada

SAFRANE
El dominio de las sensaciones

RENAULT

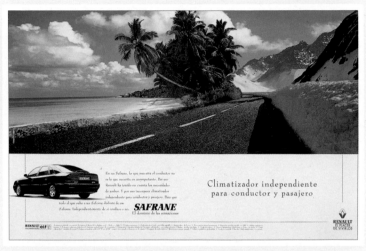

Climatizador independiente
para conductor y pasajero

SAFRANE
El dominio de las sensaciones

RENAULT

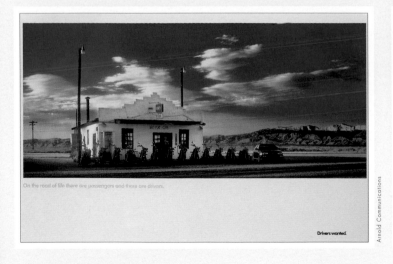

On the road of life there are passengers and there are drivers.

Drivers wanted.

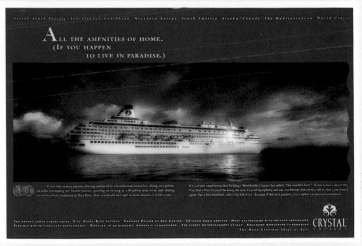

ALL THE AMENITIES OF HOME.
(IF YOU HAPPEN
TO LIVE IN PARADISE.)

CRYSTAL
CRUISES

L E E N T H I J S S E

W W W . L E E N T H I J S S E . C O M

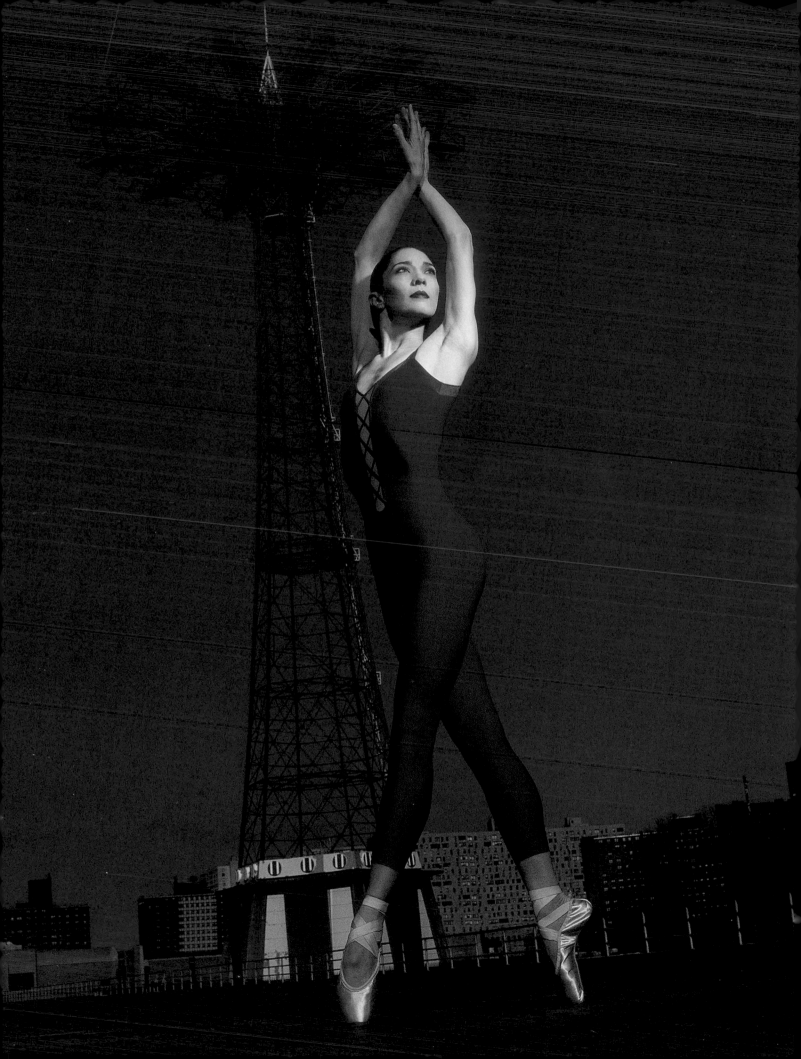

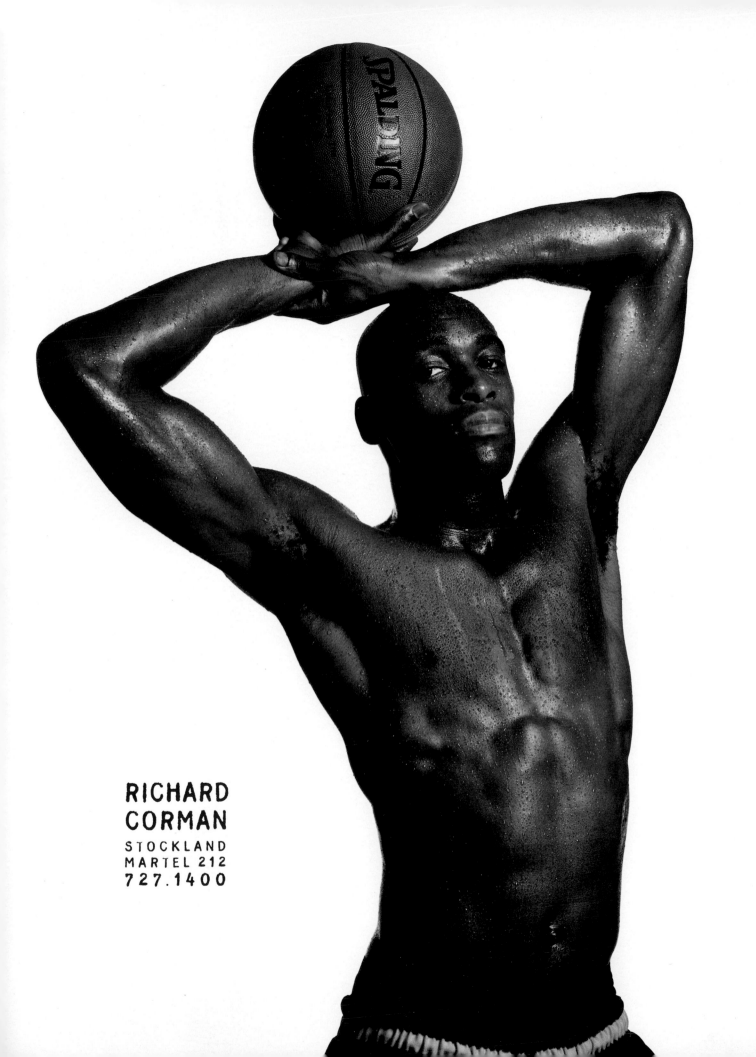

RICHARD
CORMAN
STOCKLAND
MARTEL 212
727.1400

321

JOEL BALDWIN

REPRESENTED BY STOCKLAND MARTEL (212) 727-1400

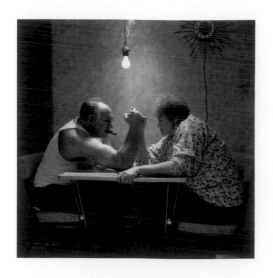

DENNIS KITCHEN

115¹/₂ Crosby Street, New York, NY 10012 (212) 431-7678

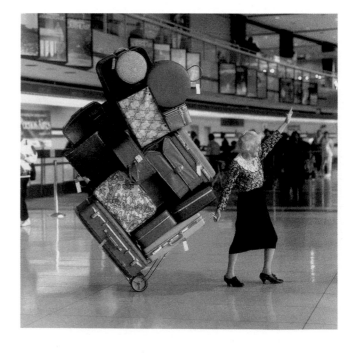

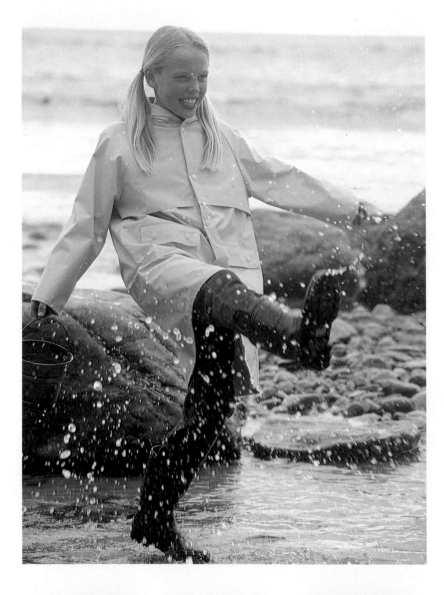

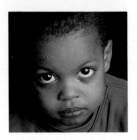

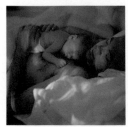
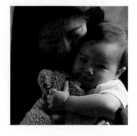
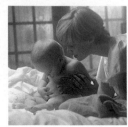

CAMILLE TOKERUD PHOTOGRAPHY
115 1/2 Crosby Street, New York, NY 10012 (212) 431-7607

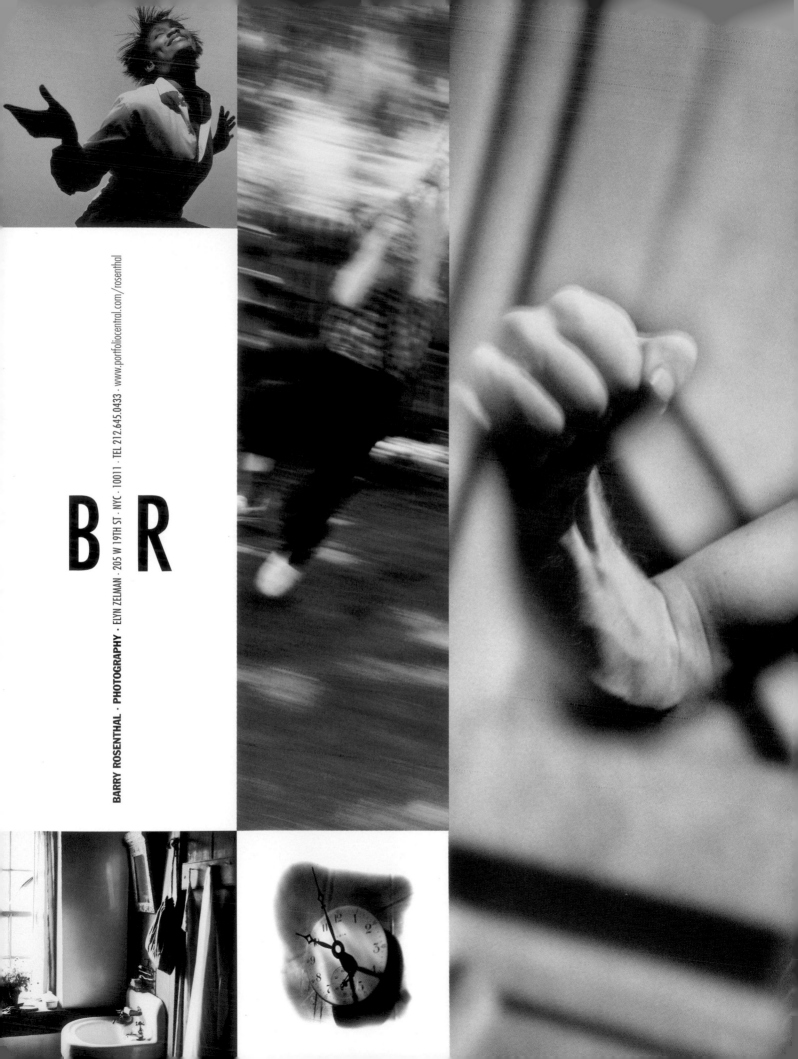

B R

BARRY ROSENTHAL · PHOTOGRAPHY · ELYN ZELMAN · 205 W 19TH ST · NYC · 10011 · TEL 212.645.0433 · www.portfoliocentral.com/rosenthal

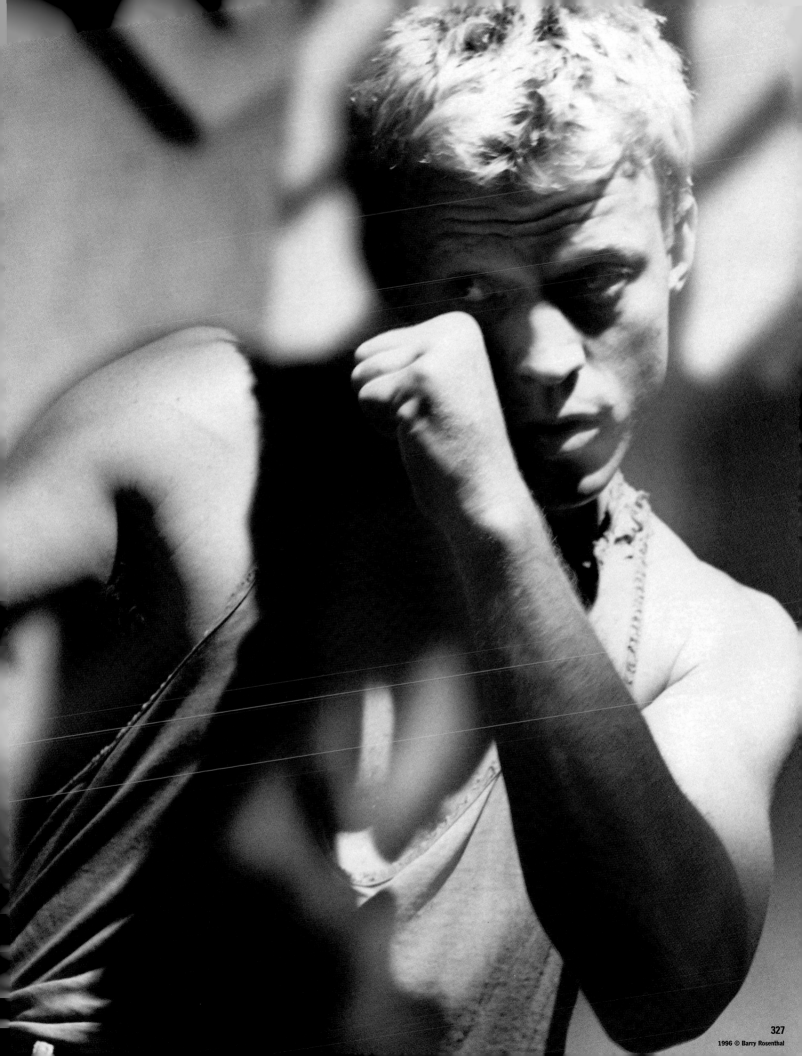

327

The pays Basque. No American breakfast. Croissants in tissue from the bakery next door. Coffee and a table in the bar. One of the locals arrives. Wordlessly, a shot is placed before him. And i thought my coffee was strong!

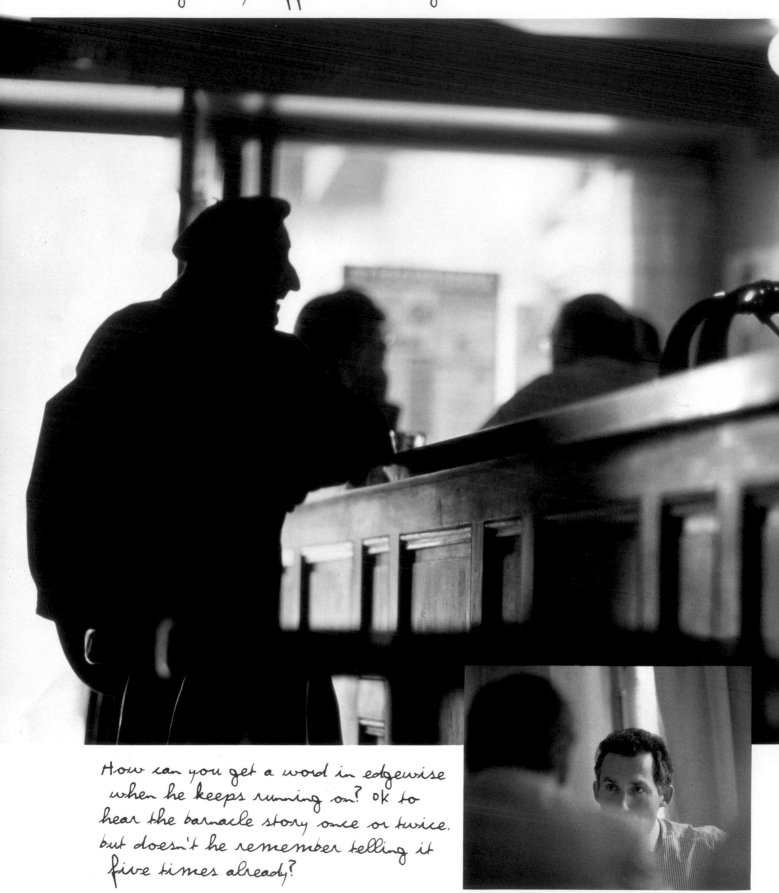

How can you get a word in edgewise when he keeps running on? OK to hear the barnacle story once or twice, but doesn't he remember telling it five times already?

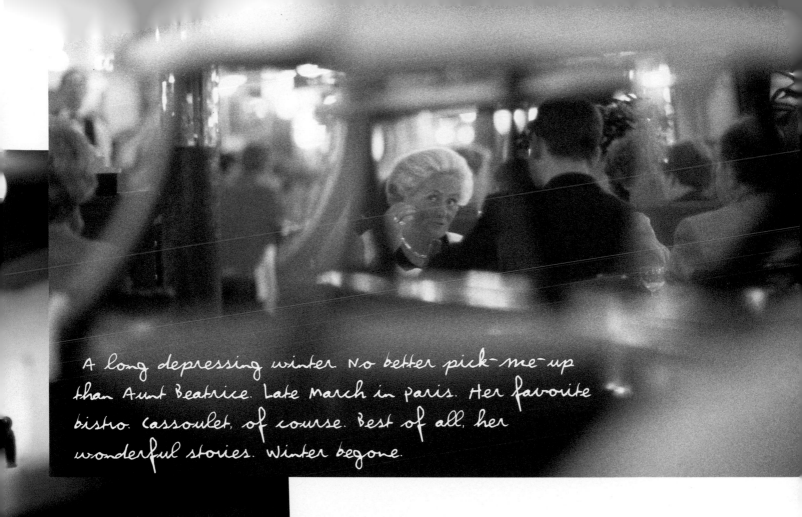

A long depressing winter. No better pick-me-up than Aunt Beatrice. Late March in Paris. Her favorite bistro. Cassoulet, of course. Best of all, her wonderful stories. Winter begone.

Let's see. pronounced widow's peak. Weak chin. Goatee. Something strong that includes his face. The eyes. The eyes have it.

PHOTOGRAPHY

Adam Auel
photography

301.608.9472

Michael Pohuski

410 962 5404

Print and Film

Represented by:

The Roland Group

301 718 7955

PŌ'HÜ'ŜKI

PŌ'HÜ'SKI

MICHAEL POHUSKI

410 962 5404

PRINT AND FILM

REPRESENTED BY:

THE ROLAND GROUP

301 718 7955

Neil Selkirk
212 243 6778

Represented by
Karen Russo

Neil Selkirk
212 243 6778

Represented by
Karen Russo

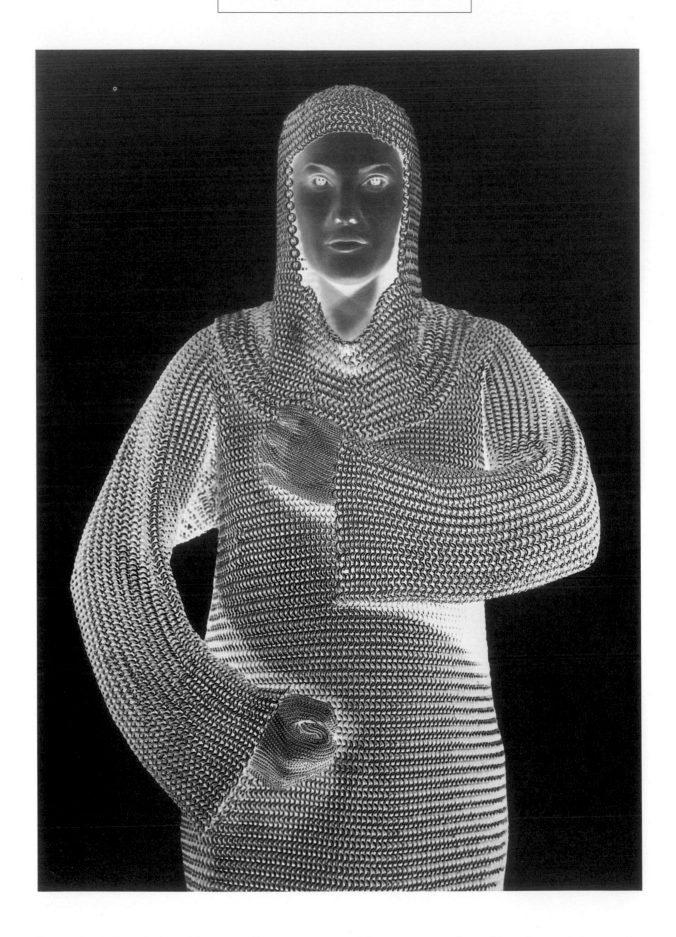

Wayne Calabrese

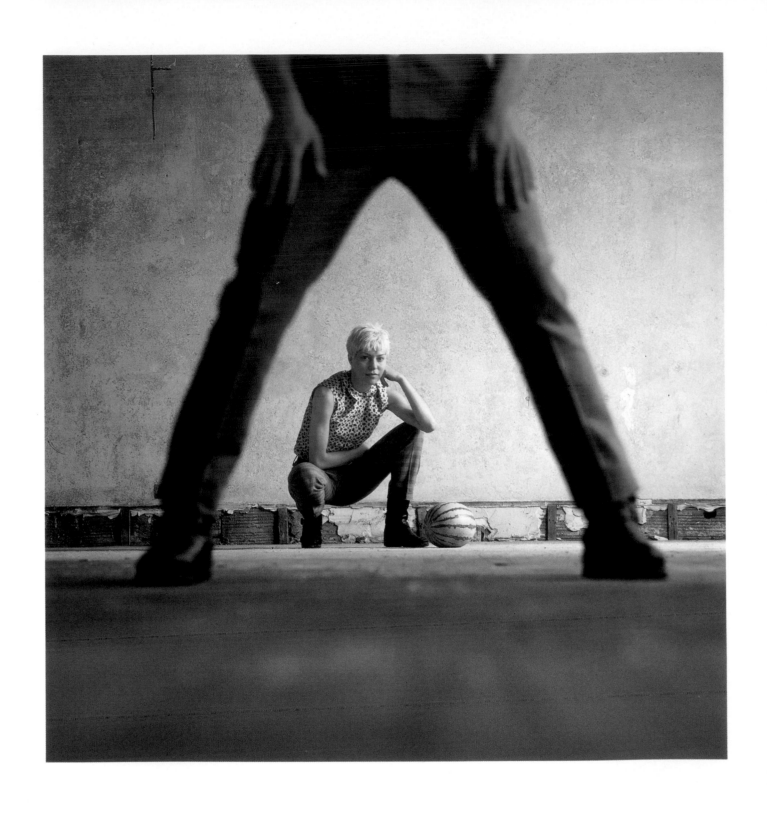

ANDREW M. LEVINE

212 - 861 - 8374

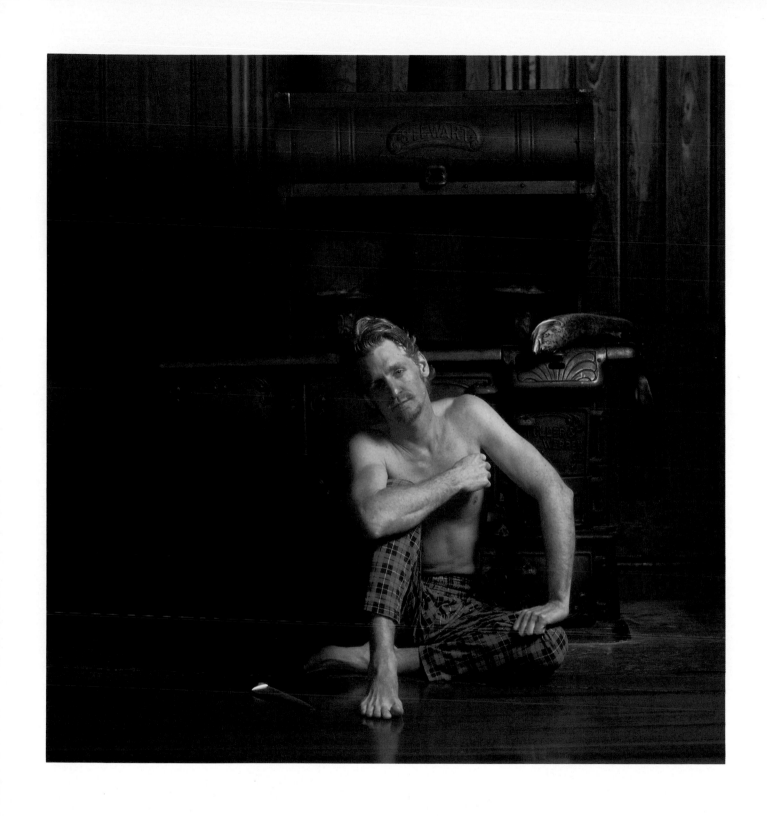

ANDREW M. LEVINE

212-861-8374

Bruce Peterson 617-292-9922 www.brucepeterson.com

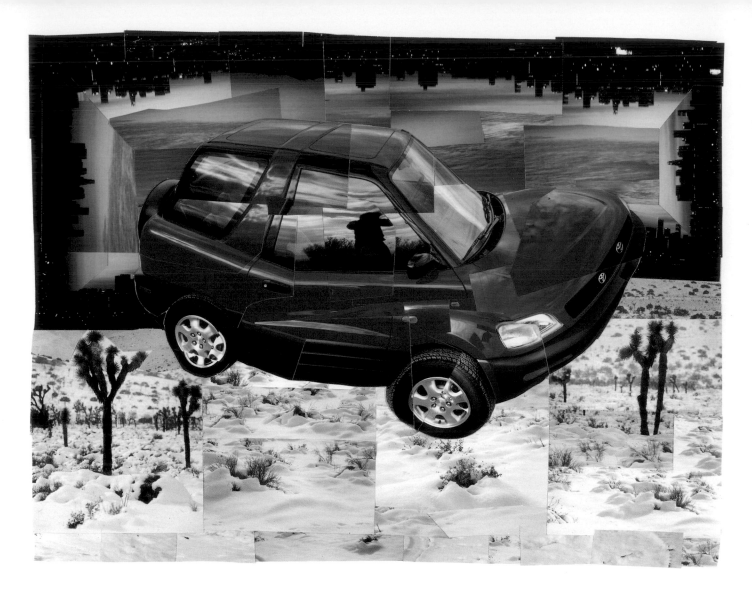

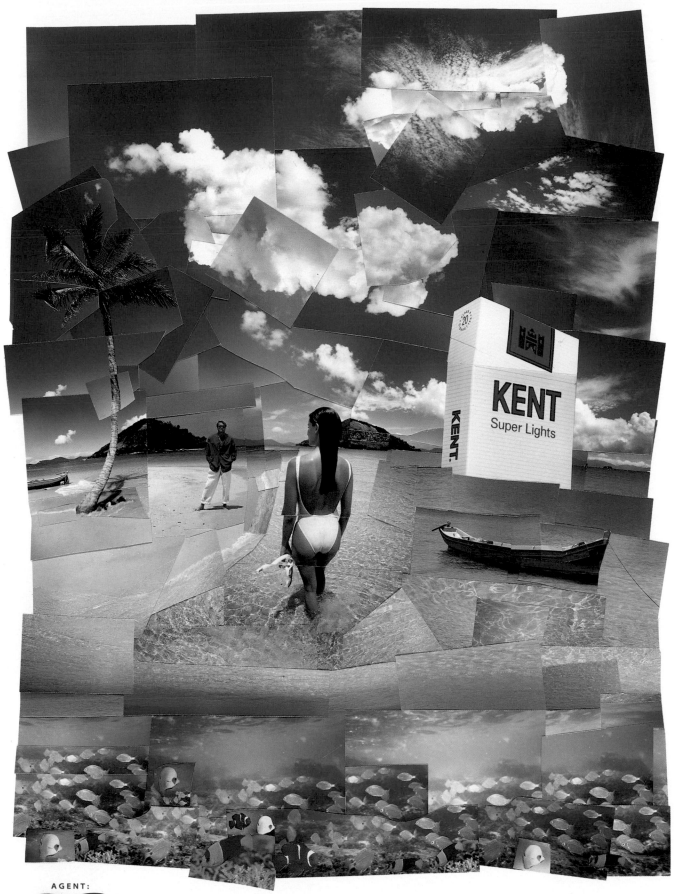

jeremy wolff 212·334·1049

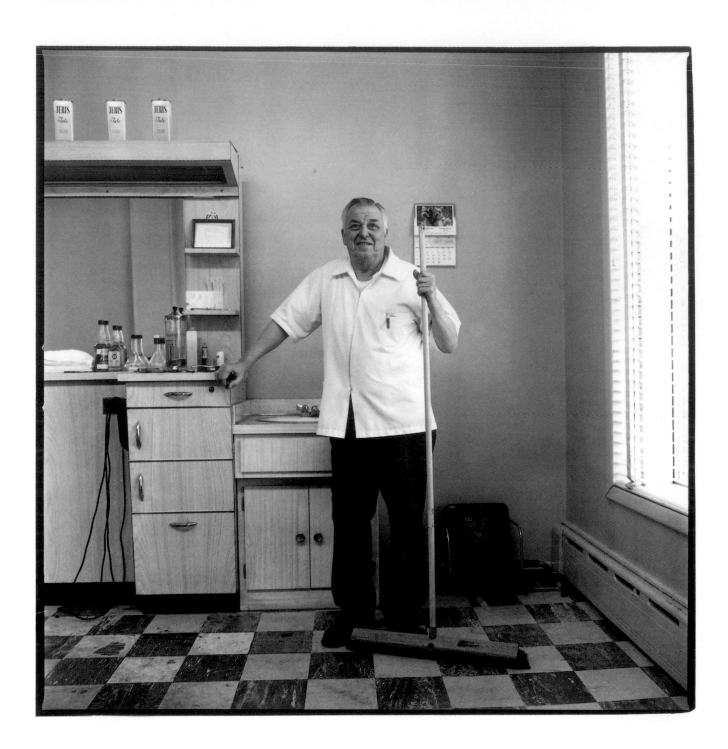

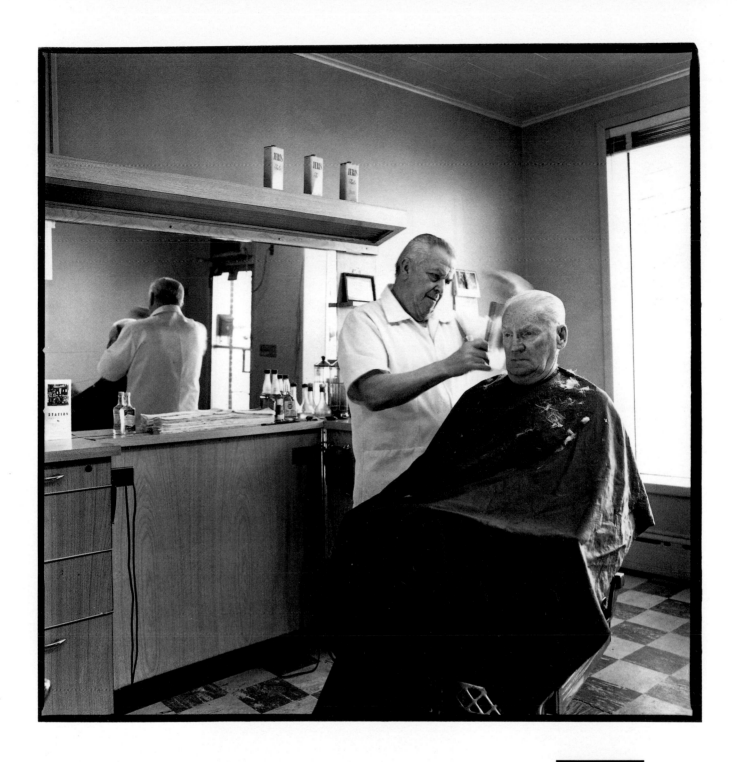

IDEAS AND OBJECTS

b
WESTHEIMER

BILL WESTHEIMER
167-169 SPRING STREET
NEW YORK, NEW YORK 10012

☎ [212] 431•6360
FAX: [212] 431•5496

ASSIGNMENT AND STOCK

WESTHEIMER

BILL WESTHEIMER
167-169 SPRING STREET
NEW YORK, NEW YORK 10012

☎ [212] 431•6360
FAX: [212] 431•5496

LindaBohm

L.D.BOHM STUDIOS, INC.
(201) 746-3434 • (212) 349-5650 • FAX (201) 746-4905

ROMEO PHOTOGRAPHY LTD
1415 SOUTH 9TH STREET
PHILADELPHIA, PA 19147

215 271 5799
FAX 271 5337

888 271 9899

ROMEO

ROMEO PHOTOGRAPHY LTD
1415 SOUTH 9TH STREET
PHILADELPHIA, PA 19147

215 271 5799
FAX 271 5337

888 271 9899

BERENHOLTZ

RICHARD BERENHOLTZ ASSIGNMENT AND STOCK PHOTOGRAPHY NEW YORK CITY 212 222 1302 FAX 212 316 4241

BERENHOLTZ

RICHARD BERENHOLTZ ASSIGNMENT AND STOCK PHOTOGRAPHY NEW YORK CITY 212 222 1302 FAX 212 316 4241

Mercer

RALPH MERCER PHOTOGRAPHY

300 SUMMER STREET BOSTON MASSACHUSETTS 02210

617 542 2211 FAX 617 542 1844

REPRESENTED IN CHICAGO BY BOB WOLTER AND ASSOCIATES 312 670 8770

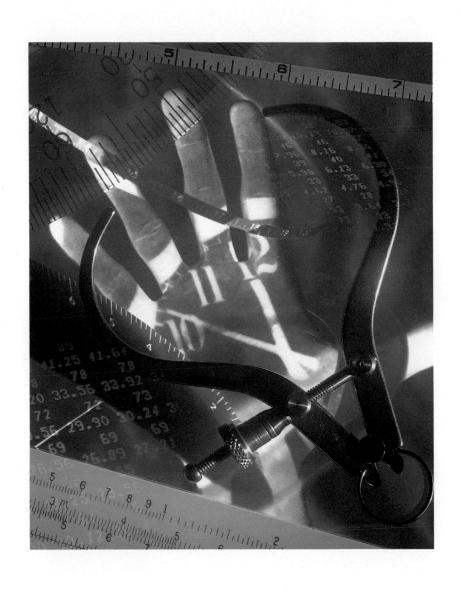

RALPH MERCER PHOTOGRAPHY

3 0 0 S U M M E R S T R E E T B O S T O N M A S S A C H U S E T T S 0 2 2 1 0

6 1 7 5 4 2 2 2 1 1 F A X 6 1 7 5 4 2 1 8 4 4

REPRESENTED IN CHICAGO BY BOB WOLTER AND ASSOCIATES 3 1 2 6 7 0 8 7 7 0

David Leach

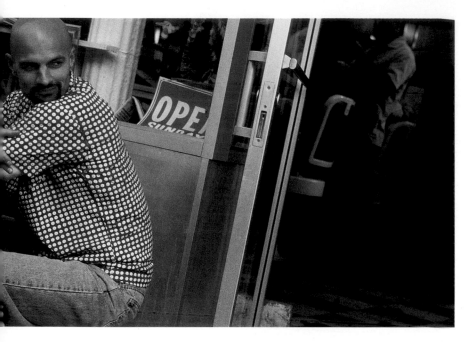

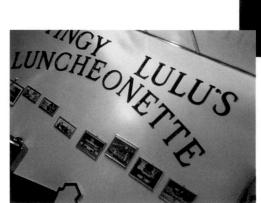

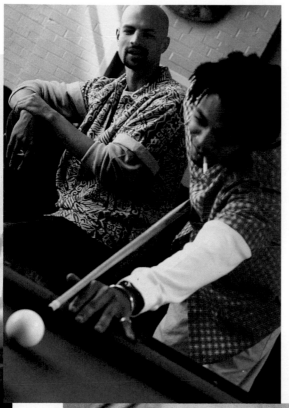

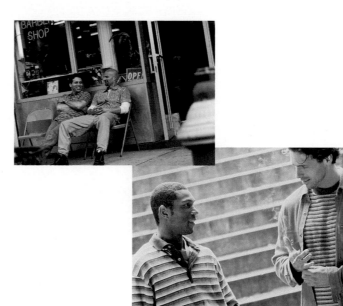

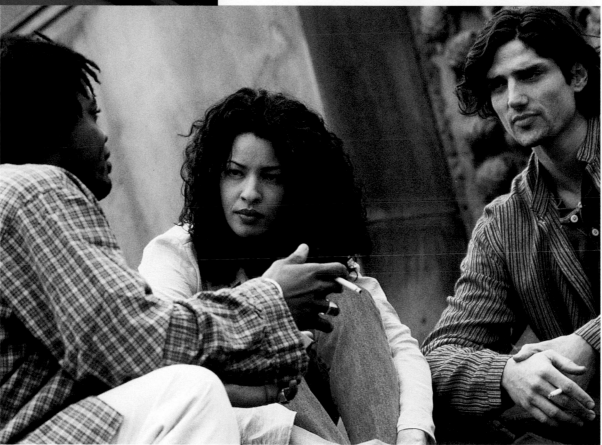

Represented by Case & Partners ▪ (212) 645-6655

David Leach Photography, Inc.

Represented in the Midwest by Vargo Bockos ▪ (312) 661-1717

611 Broadway #407 ▪ New York, New York 10012 ▪ (212) 505-1234

To see a TV reel, call Big Picture Films ▪ Telephone (212) 944-4034

David
Leach

Clients

Anheuser Busch ▪ American Express ▪ Arnold Fortuna Lawner & Cabot ▪ AT&T ▪ BBDO ▪ Chiat/Day ▪ Crispin & Porter ▪ Coca-Cola ▪ DDB Needham Worldwide ▪ DMB&B
FCB/Leber Katz ▪ Fila ▪ Fleet Bank ▪ J Walter Thompson ▪ Ketchum ▪ Lintas ▪ Mazda ▪ McCann Erickson ▪ McCabe & Co. ▪ MCI ▪ Messner Vetere Berger McNamee Schmetterer
Nestle's ▪ Ogilvy & Mather ▪ Pagano Schenk & Kay ▪ RJR Nabisco ▪ Saatchi and Saatchi Advertising ▪ Sony ▪ Toyota ▪ Tracey–Locke ▪ Tylenol ▪ Westin Hotels ▪ Young & Rubicam

David Leach Photography, Inc.
611 Broadway #407 ▪ New York, New York 10012 ▪ (212) 505-1234

Represented by Case & Partners ▪ (212) 645-6655

Represented in the Midwest by Vargo Bockos ▪ (312) 661-1717

To see a TV reel, call Big Picture Films ▪ Telephone (212) 944-4034

408 Vine Street

Philadelphia, PA

19106

215.925.2630

Fax 215.925.2653

408 Vine Street

Philadelphia, PA

19106

215.925.2630

Fax 215.925.2653

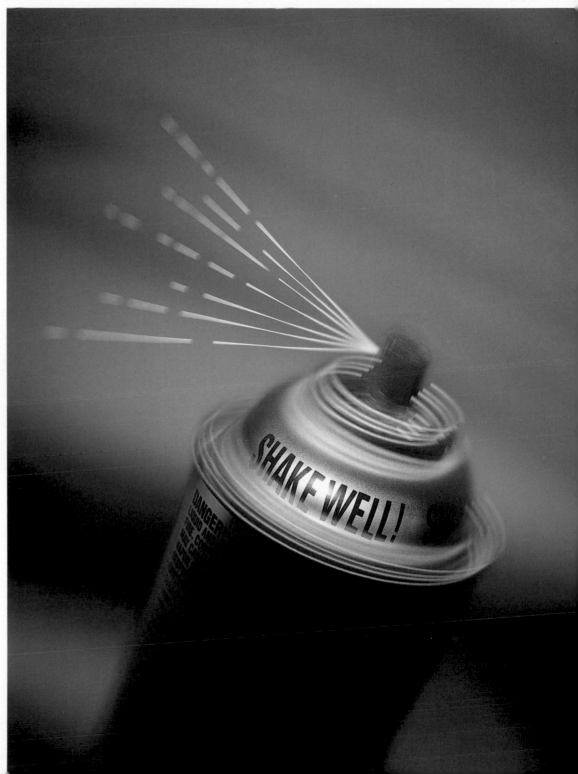

MARC ANTONI

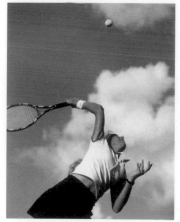

DAVID FOSTER

MICHAEL GOLDMAN

GREG GORMAN

KARI HAAVISTO

KAN

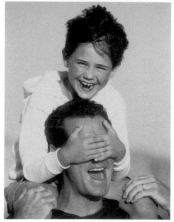

ROB LEWINE

RYAN ROESSLER

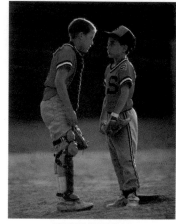

FRANK SITEMAN

DAN COTTON

WATSON & SPIERMAN PRODUCTIONS, INC.
GEORGE WATSON & SHELLEY SPIERMAN
Phone 212•431•4480 FAX 212•431•0405
WWW.WATSONSPIERMAN.COM

MONICA LIND

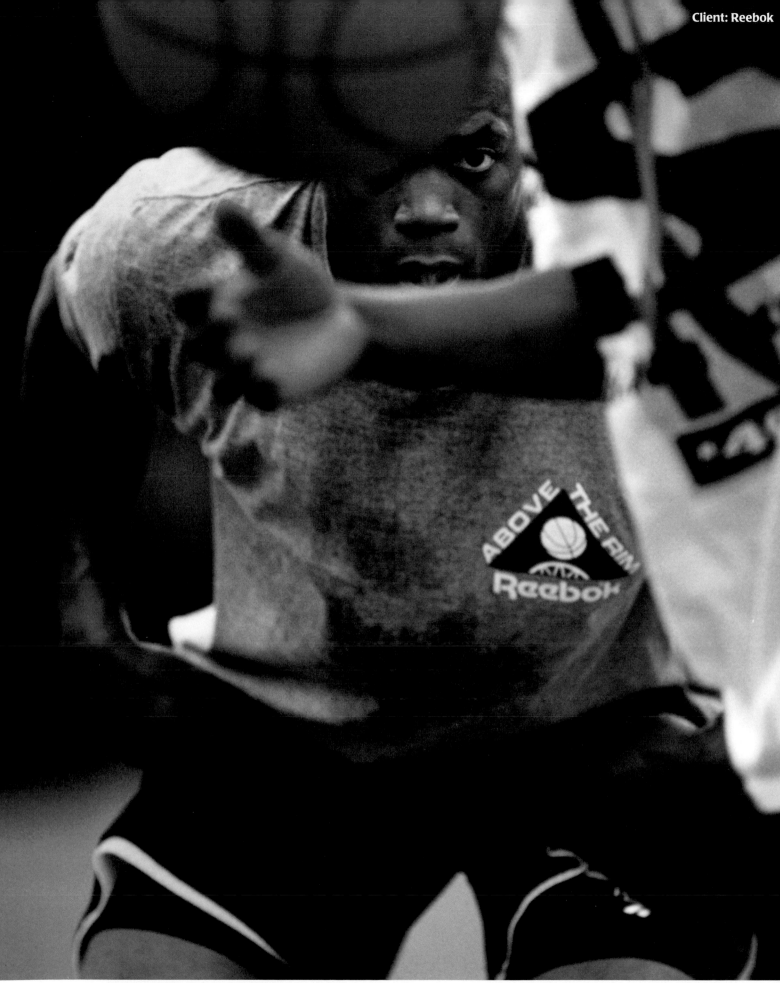

Represented by Watson & Spierman
212.431.4480

DAVID FOSTER

617.464.2295

365

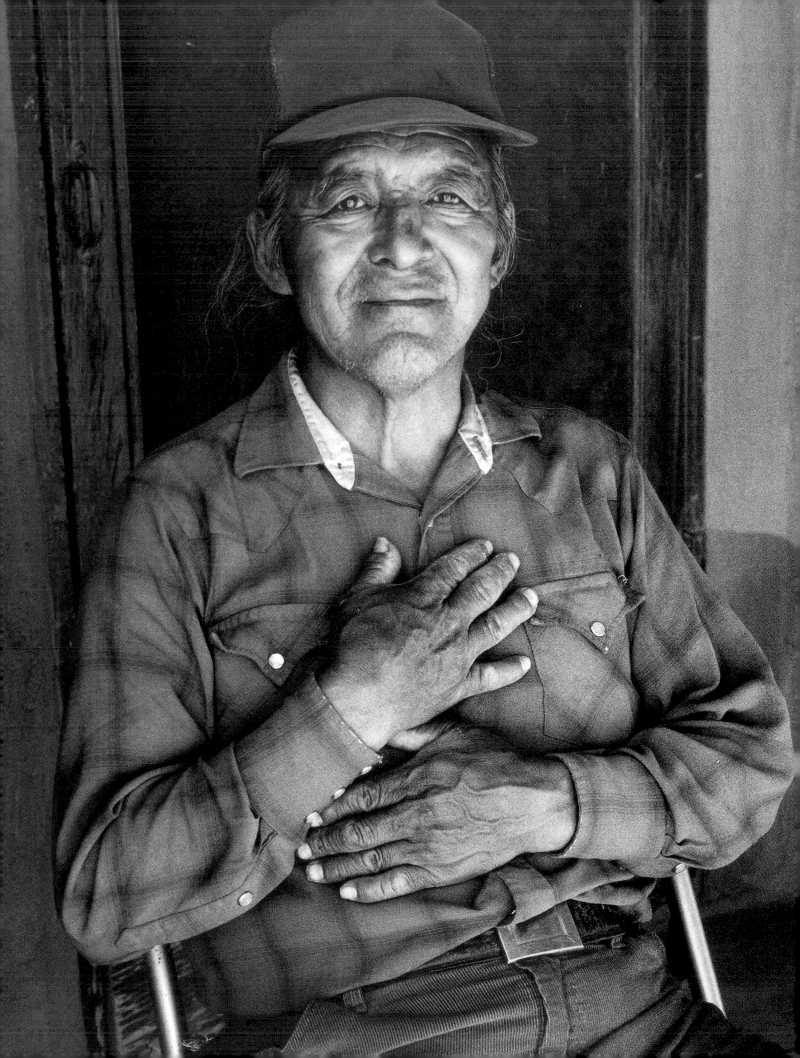

MICHAEL GOLDMAN

PHOTOGRAPHY INC

▼

KARI

HAAVISTO

212·

807·6760

FOOD

REPRESENTED BY WATSON & SPIERMAN 212·431·4480

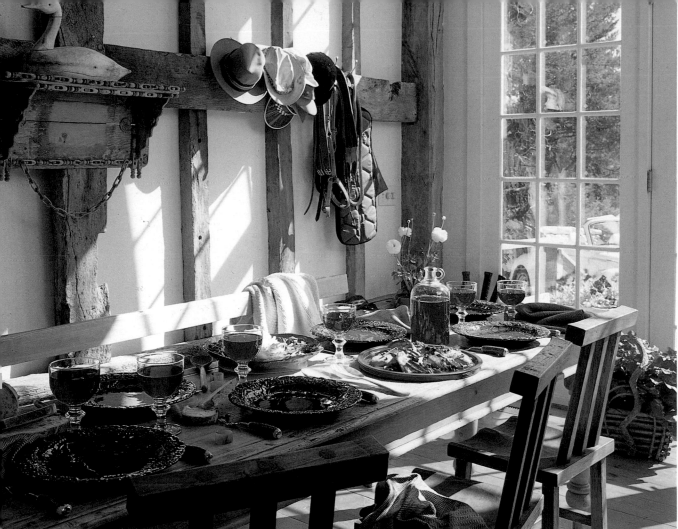

▼

KARI
HAAVISTO
212·
807·6760

INTERIORS

REPRESENTED BY WATSON & SPIERMAN 212·431·4480

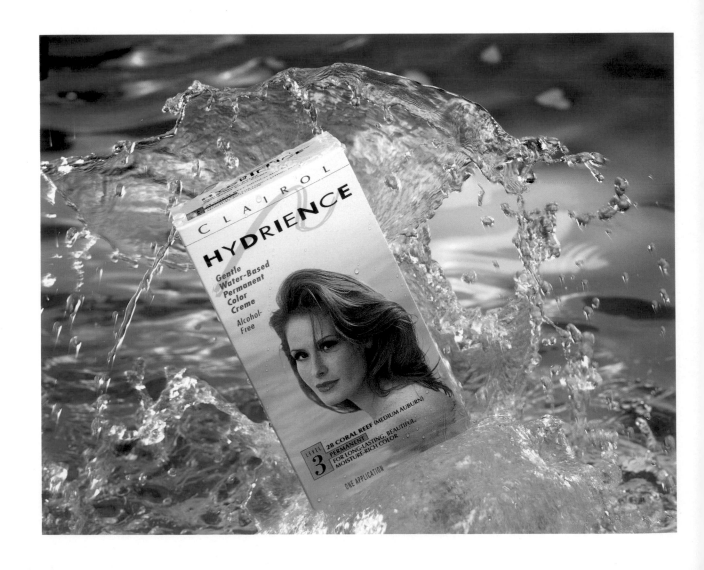

 FRANK SITEMAN

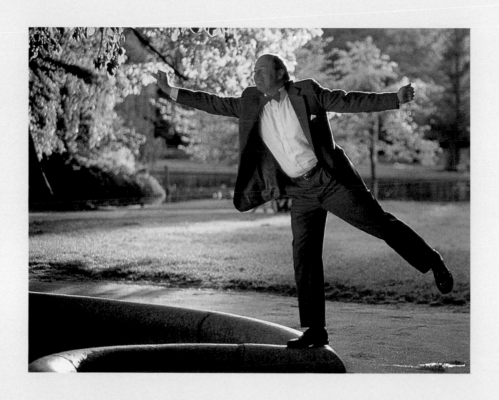

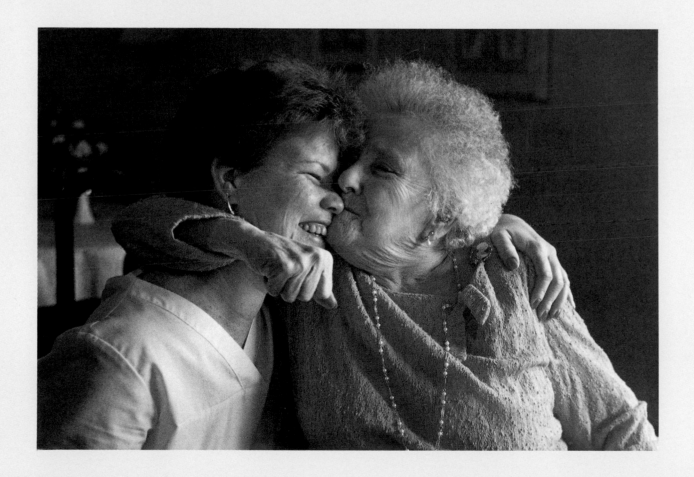

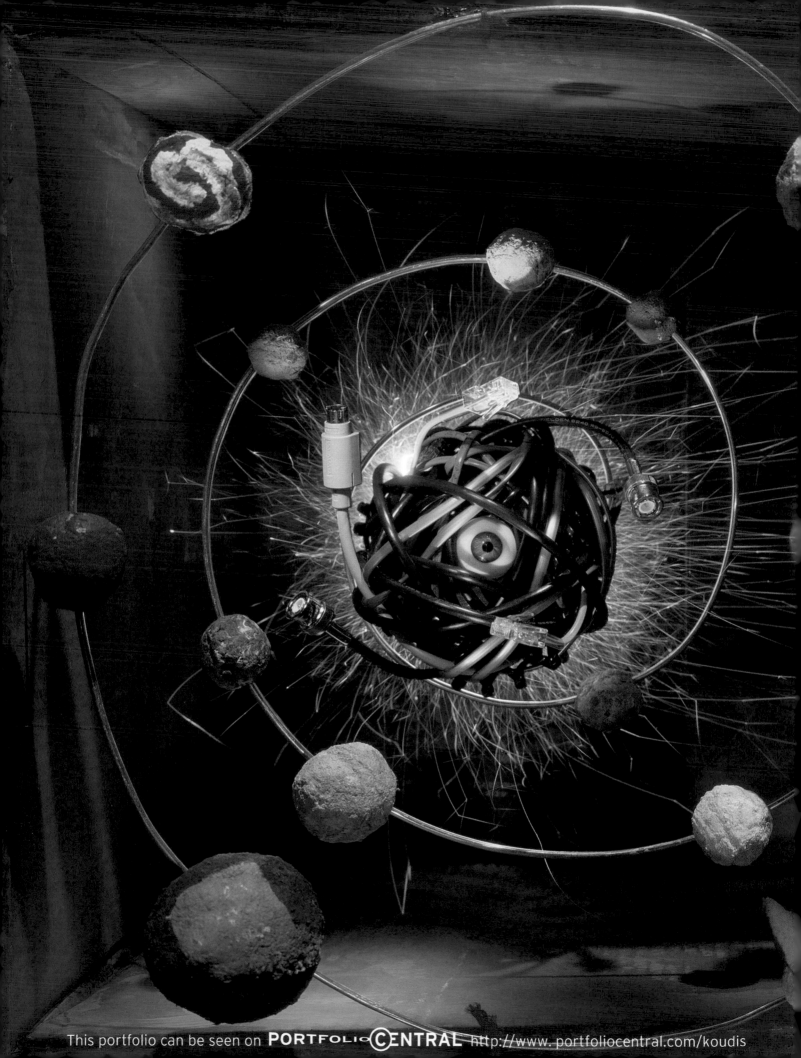

NICK LOUDIS

PHOTOGRAPHER
MODELMAKER
DIGITAL GUY

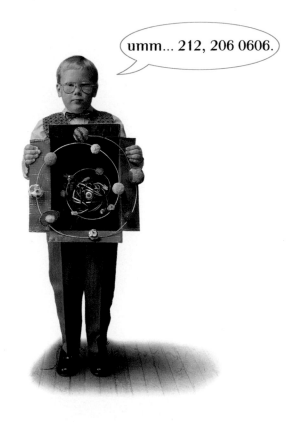

umm... 212, 206 0606.

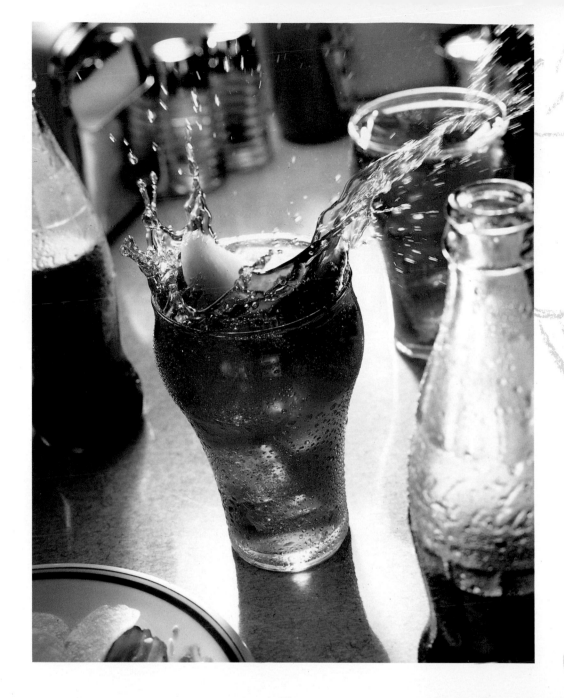

RIC COHN 212 924 4450

377

Representation: Carol Cohn Reps Phone: 212.924.4450 Fax: 212.645.2059

Richard Bowditch

Photographer
212.564.5413

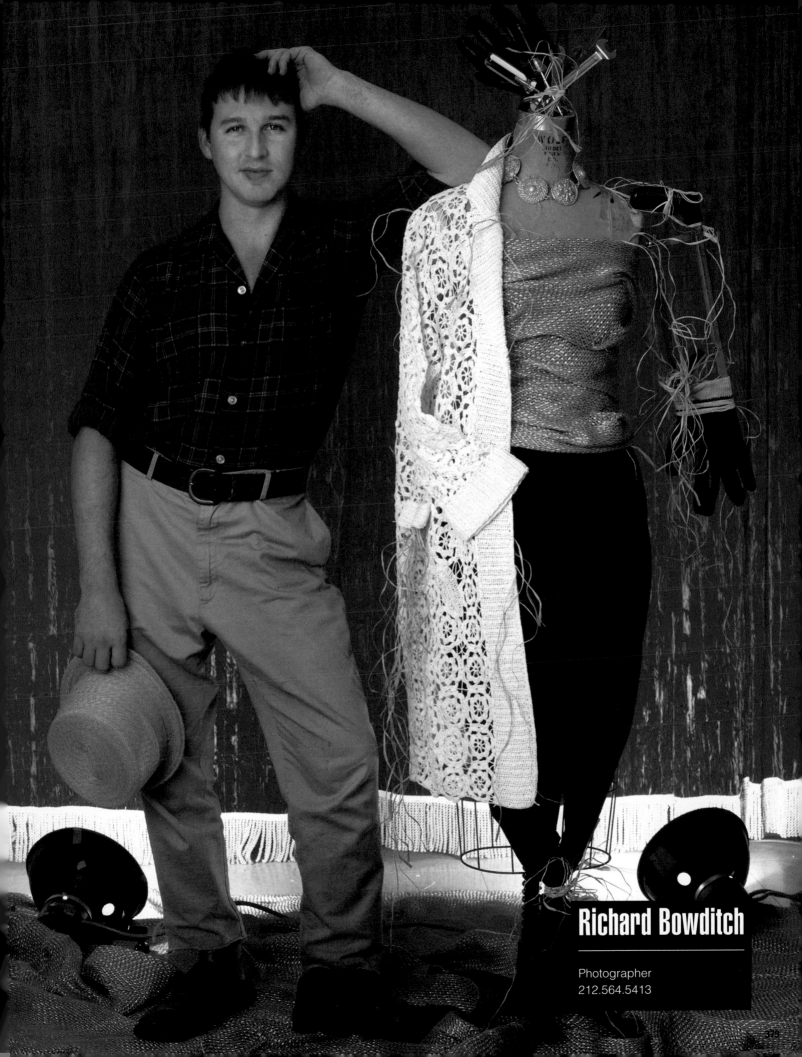

Richard Bowditch

Photographer
212.564.5413

carl zapp

212 727 0001

160 Varick Street 8th Floor New York NY 10013 212 727 0001 Phone 212 691 3833 Fax

HTTP://WWW.PORTFOLIOCENTRAL.COM/EJCPHOTO
EJCPHOTO@AOL.COM

E.J. CARR

2 242 0818

John Fortunato Studios 212.620.7873 fax 212.620.7960

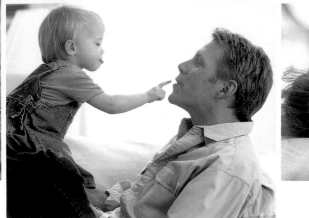

Joe **STANDART**

212 **924 4545**

For portfolio call:

Pomegranate Pictures

Estelle Leeds

212 **633 2313**

Reel available

Stock available

e-mail: jstandart@aol.com

www.pompix.com

212 **924 4545**

For portfolio call:

Pomegranate Pictures

Estelle Leeds

212 **633 2313**

Reel available

Stock available

e-mail: jstandart@aol.com

www.pompix.com

Joe STANDART

CHRISTOPHER HARTING STUDIO 617. 451. 6330

Pepto-Bismol® FOR UPSET STOMACH

CONTROLS
INDIGESTION
NAUSEA
COMMON DIARRHEA

4 FL. OZ.

POUR
LES MALAISES
D'ESTOMAC

Norwich

NORWICH PHARMACAL COMPANY, LTD. • PARIS, CANADA

Christopher
HARTING

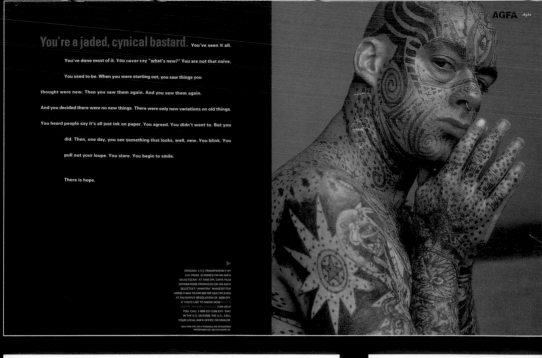

LEE CRUM

D E N N I S
BLACHUT

A G E N T S

DOUG BROWN
2 1 2 9 5 3 - 0 0 8 8

J U D I S H I N
2 1 2 9 8 6 - 5 7 8 2

LILLY DONG

REPRESENTED BY

DOUG BROWN *212-953-0088*
JUDI SHIN *212-986-5782*

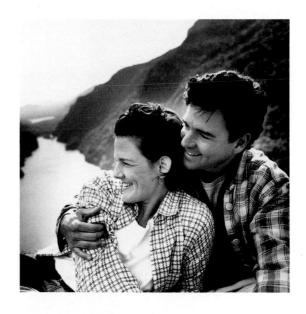

Stewart O'Shields

A G E N T S

DOUG BROWN 212 953•0088

& JUDI SHIN 212 986•5782

Jeff Morgan
New York City
212 924 4000

Montville, NJ
201 402 1984

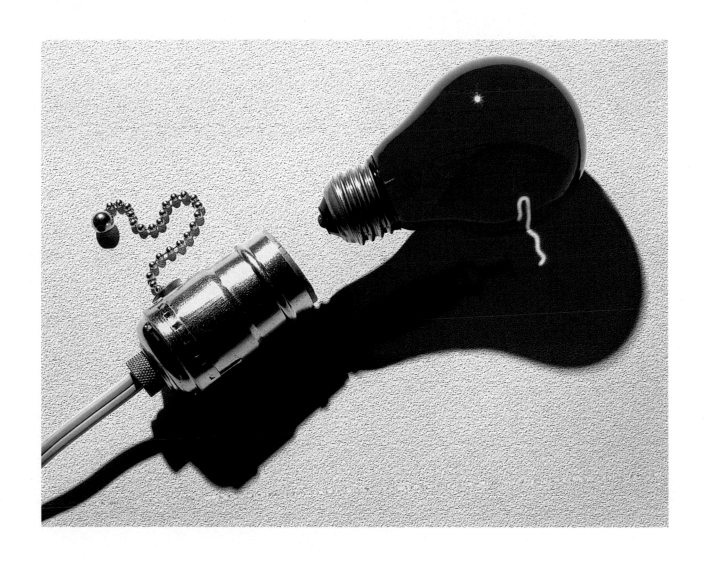

Jeff Morgan
New York City
212 924 4000

Montville, NJ
201 402 1984

401

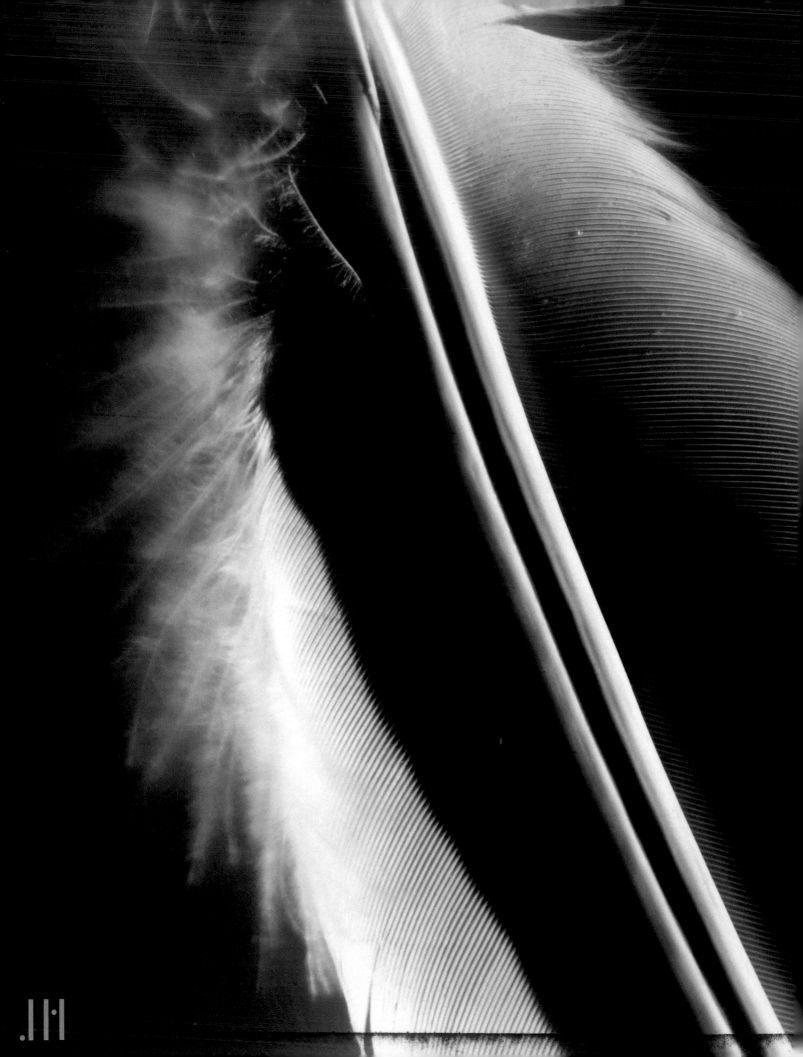

JIM HUIBREGTSE

agent

DOREEN GEBBIA

212 388 2604

studio

212 925 3351

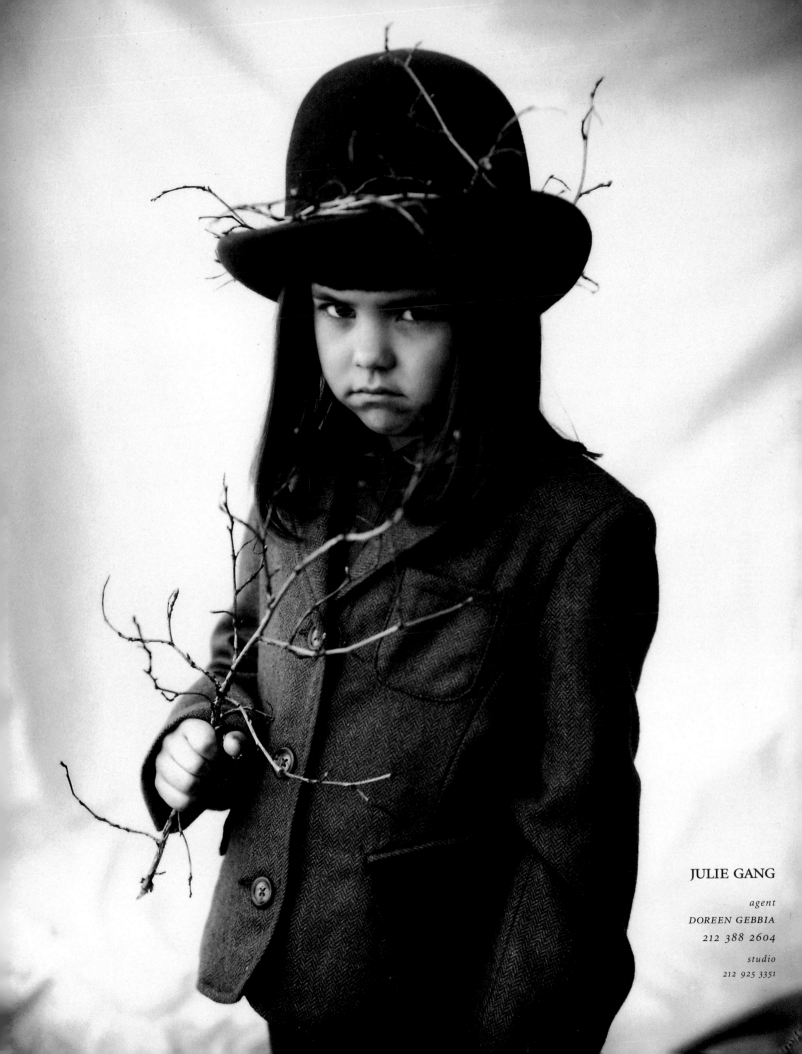

JULIE GANG

agent
DOREEN GEBBIA
212 388 2604
studio
212 925 3351

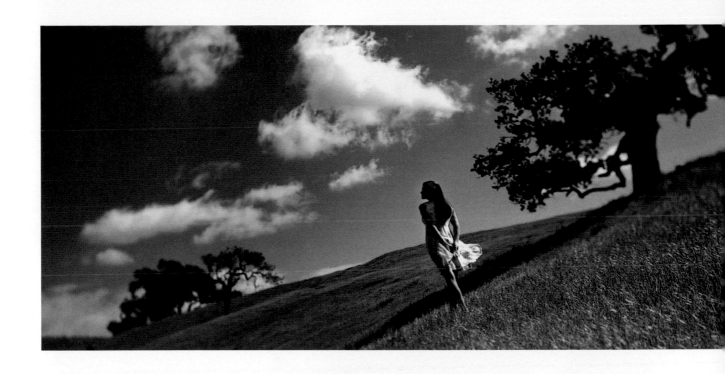

628-30 broadway
10012 new york, new york
212.473.2892 telephone

represented by MARZENA
212.772.2522

client: The Designory, Inc.

craig cutler *studio*

Pushing forward

doesn't mean

being noticed, it means

being remembered.

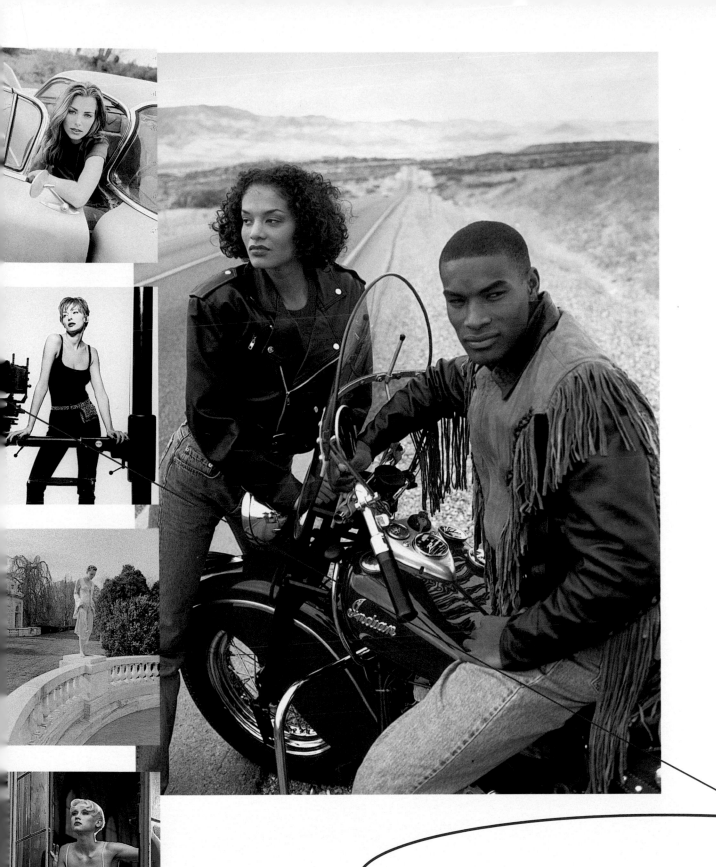

R O B V A N P E T T E N
P H O T O G R A P H E R

2 1 2 - 8 6 9 - 2 1 9 0

6 1 7 - 4 4 3 - 9 2 0 1

MACDUFF EVERTON

~ 805 . 898 . 0658 ~

Represented by Laurie Ketcham
212 . 481 . 9592

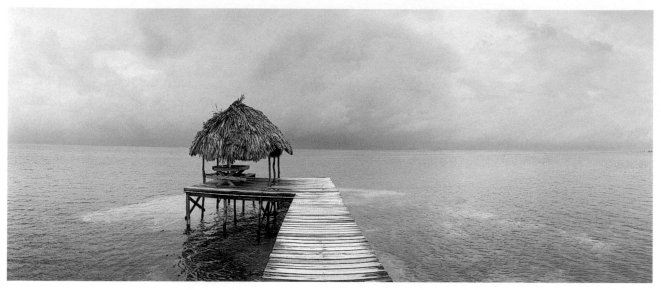

Belize

NATIONAL GEOGRAPHIC TRAVELER

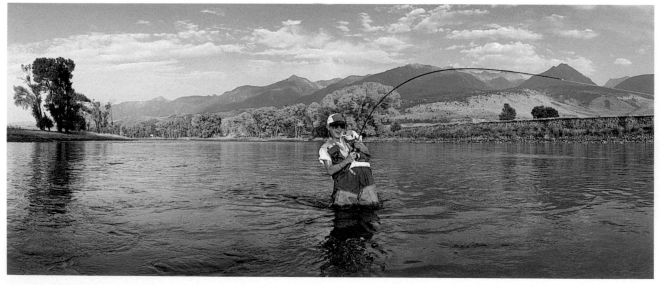

Fly Fishing, Montana

TOWN & COUNTRY

MACDUFF EVERTON

~ 805 . 898 . 0658 ~

Represented by Laurie Ketcham
212 . 481 . 9592

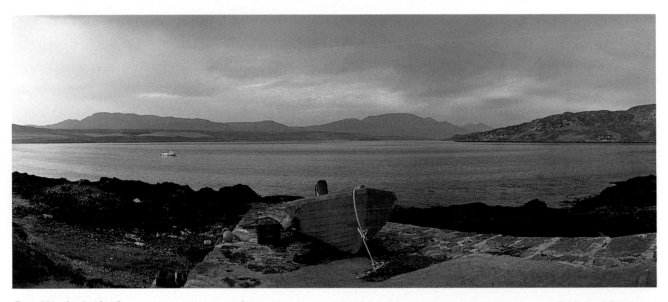

Cape Wrath, Scotland

ISLANDS MAGAZINE

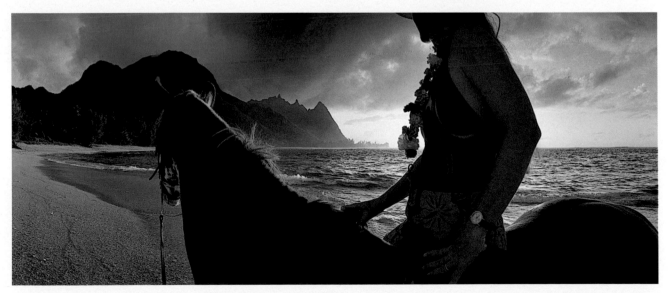

Champion Cowgirl, Hawaii

CONDÉ NAST TRAVELER

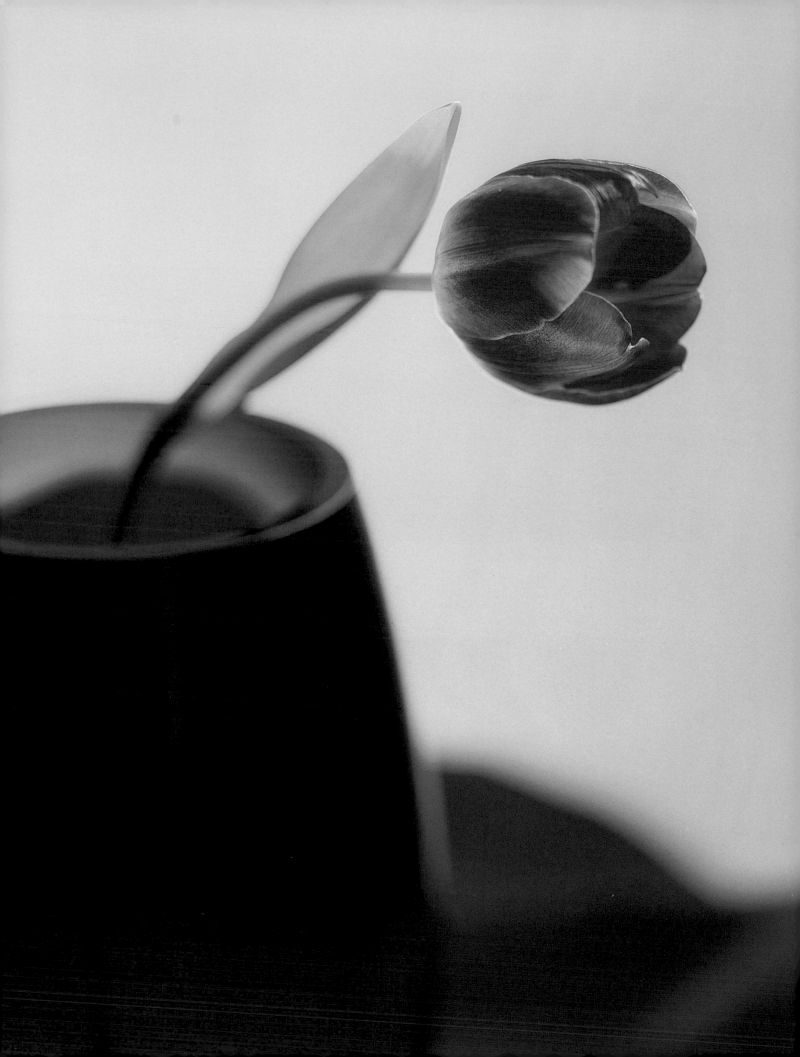

VIKER

Mark Viker Photography 212.243.1268

Represented by Laurie Ketcham 212.481.9592

PETER GREGOIRE

212.967.4969

REPRESENTED BY LAURIE KETCHAM 212.481.9592

Pete M^cArthur.

CAUSE

The Victim Intervention Project,
Family Services Inc., St. Paul
612-222-0311

In memory of Brandon Butler
June 9, 1977–April 29, 1995
Special thanks to Brandon's
father, John Butler

Photography and Digital
Composition: Mark LaFavor.

MIDWESTERN STATES
Illinois
Indiana
Iowa
Kansas
Michigan
Minnesota
Missouri
Nebraska
North Dakota
Ohio
Oklahoma
South Dakota
Wisconsin

*Artist's Rep

*Artist's Rep

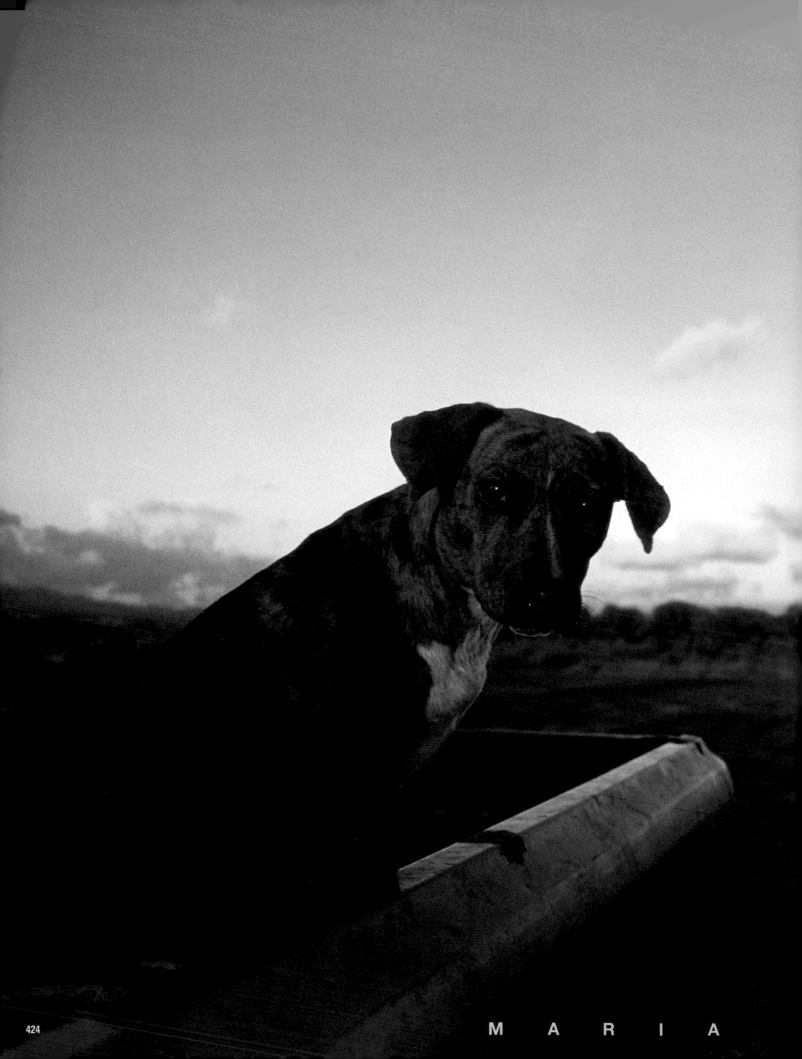

M A R I A

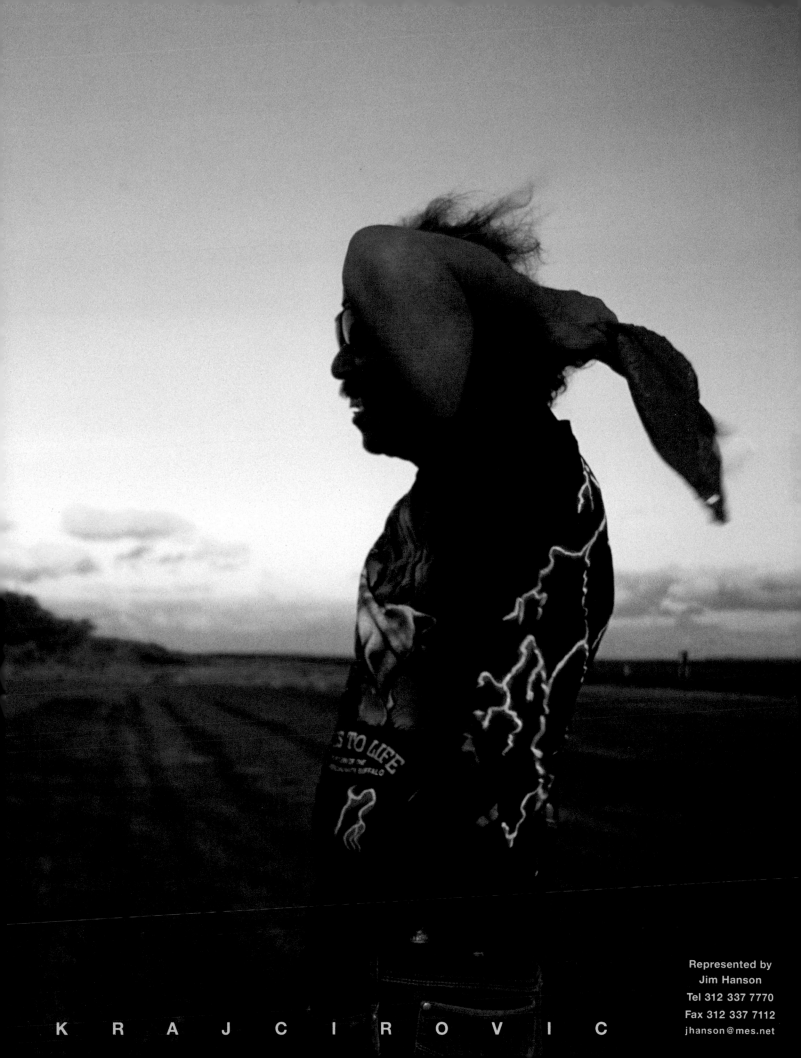

K R A J C I R O V I C

For an alluring combination of people and

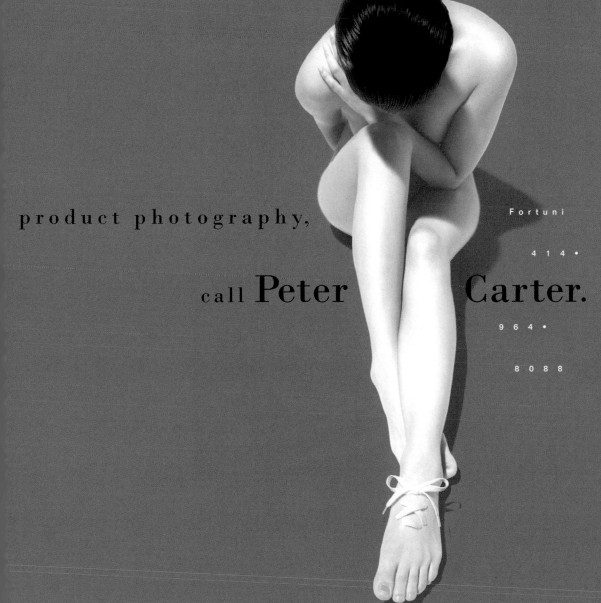

product photography,

call **Peter** **Carter.**

Fortuni

4 1 4 •

9 6 4 •

8 0 8 8

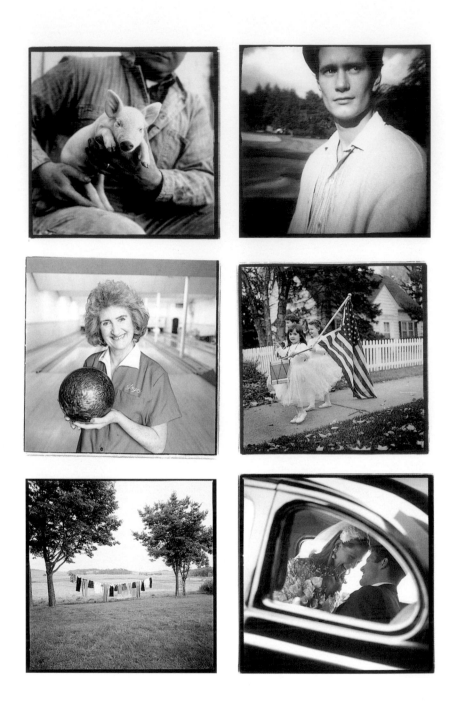

Studio 612·332·2670 Fax 612·339·3974

Represented by Marge Casey 212·486·9575

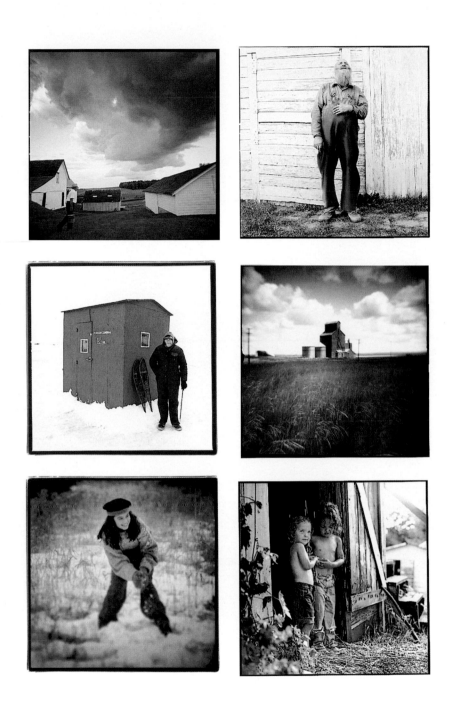

JOEL LARSON
PHOTOGRAPHY • MINNEAPOLIS

Studio 612·332·2670 Fax 612·339·3974

Represented by Marge Casey 212·486·9575

431

DAVE SLIVINSKI REPRESENTED BY CHRIS GLENN 312 670 7737

Jack perno

Represented by Chris Glenn 312 670.7737 Studio contact Holly Kallick 312 666.1495

e r i c p e r r y **p** h o t o g r a p h

Represented by Mid Coast 810·280·0640

PHONE 612-827-6719
FAX 612-824-9211

BUCK HOLZEMER PRODUCTIONS

FILM • PRINT

612.824.2905

3448 Chicago Ave. Mpls., MN 55407

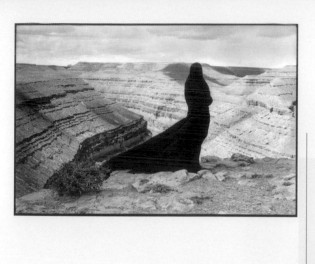

F

FERGUSON & KATZMAN

K

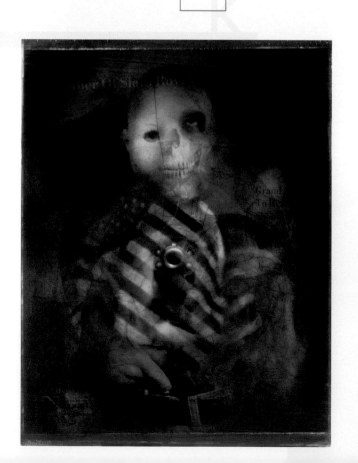

SCOTT FERGUSON

MARK KATZMAN

314.241.3811

fax 314.241.3087

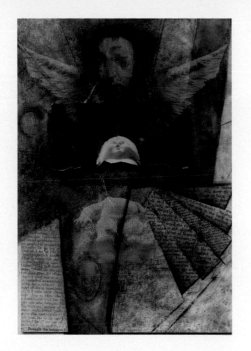

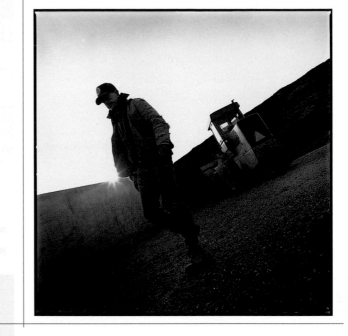

SCOTT FERGUSON

MARK KATZMAN

314.241.3811

fax 314.241.3087

F

FERGUSON & KATZMAN

K

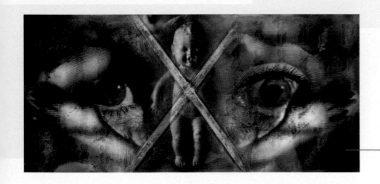

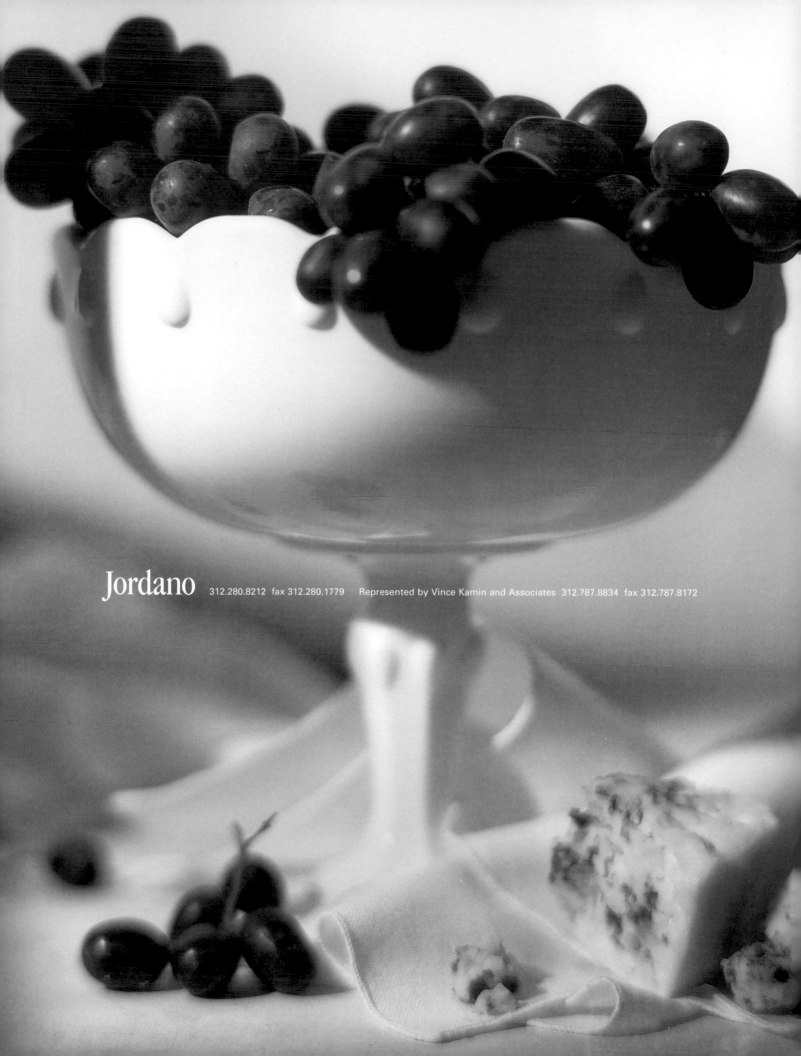

Jordano 312.280.8212 fax 312.280.1779 Represented by Vince Kamin and Associates 312.787.8834 fax 312.787.8172

Jordano 312.280.8212 fax 312.280.1779

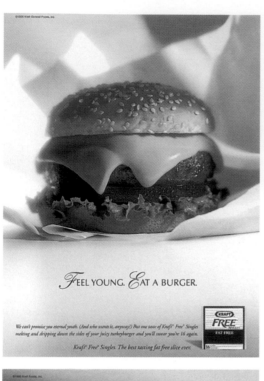

FEEL YOUNG. EAT A BURGER.

We can't promise you eternal youth. (And who wants it, anyway?) But one taste of Kraft® Free® Singles melting and dripping down the sides of your juicy turkeyburger and you'll swear you're 16 again.

Kraft® Free® Singles. The best tasting fat free slice ever.

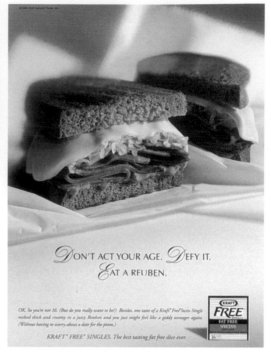

DON'T ACT YOUR AGE. DEFY IT. EAT A REUBEN.

OK. So you're not 16. (But do you really want to be?) Besides, one taste of a Kraft® Free® Swiss Single melted thick and creamy in a juicy Reuben and you just might feel like a giddy teenager again. (Without having to worry about a date for the prom.)

KRAFT® FREE® SINGLES. The best tasting fat free slice ever.

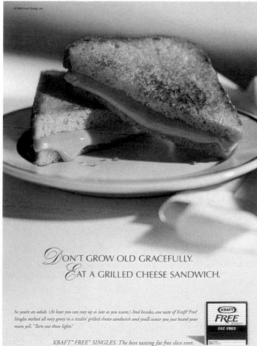

DON'T GROW OLD GRACEFULLY. EAT A GRILLED CHEESE SANDWICH.

So you're an adult. (At least you can stay up as late as you want.) And besides, one taste of Kraft® Free® Singles melted all ooey gooey in a sizzlin' grilled cheese sandwich and you'll swear you just heard your mom yell, "Turn out those lights."

KRAFT® FREE® SINGLES. The best tasting fat free slice ever.

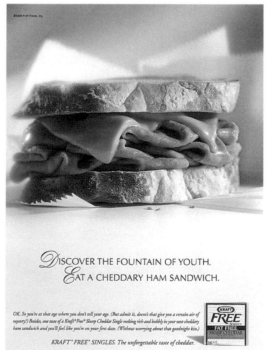

DISCOVER THE FOUNTAIN OF YOUTH. EAT A CHEDDARY HAM SANDWICH.

OK. So you're at that age where you don't tell your age. (But admit it, doesn't that give you a certain air of mystery?) Besides, one taste of a Kraft® Free® Sharp Cheddar Single melting rich and bubbly in your next cheddary ham sandwich and you'll feel like you're on your first date. (Without worrying about that goodnight kiss.)

KRAFT® FREE® SINGLES. The unforgettable taste of cheddar.

Jordano 312.280.8212 fax 312.280.1779

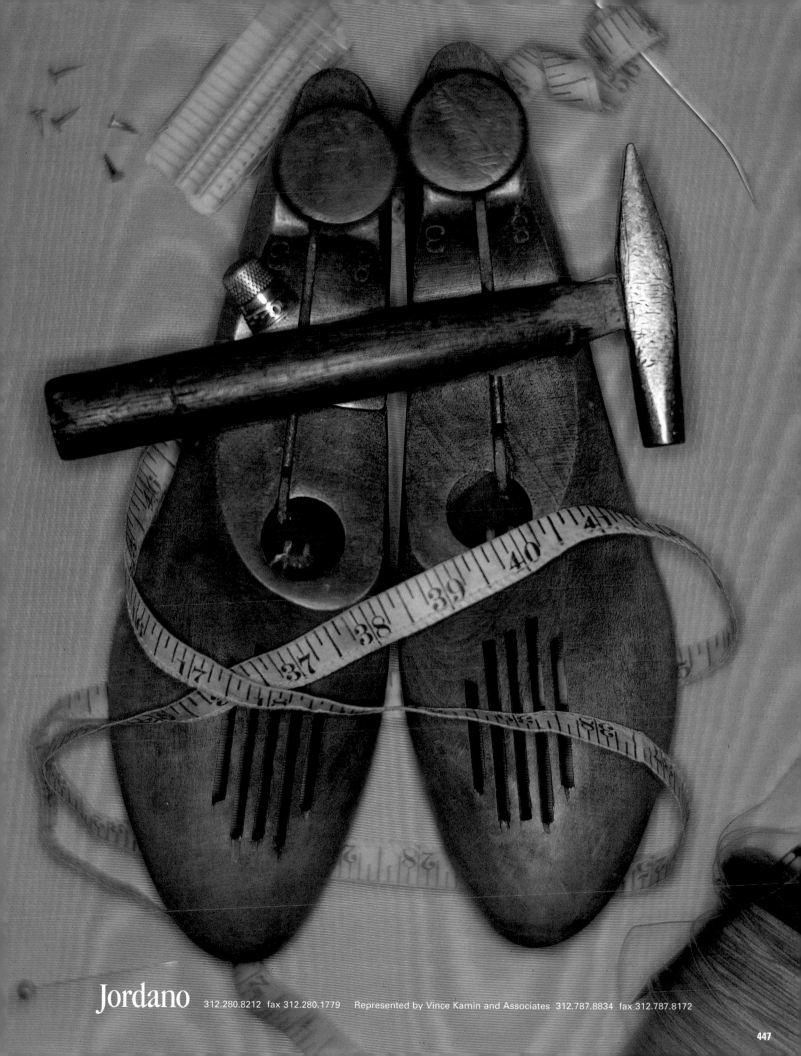

T E R Z E S

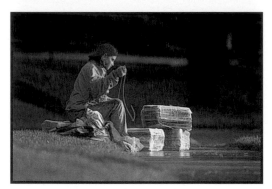

REPRESENTED BY VINCE KAMIN AND ASSOCIATES 312.787.8834 STUDIO 616.454.3153 FAX 616.454.5370

TERZES

REPRESENTED BY ANNA BIERNAT 810-545-2363 *fax* 810-545-0250

BOB **WILLIAMS**

41

JEFF SCIORTINO PHOTOGRAPHY PHONE 773.395.1605 FAX 773.395.1606
REPRESENTED BY HOLLY HAHN PHONE 773.338.7110 FAX 773.338.7004

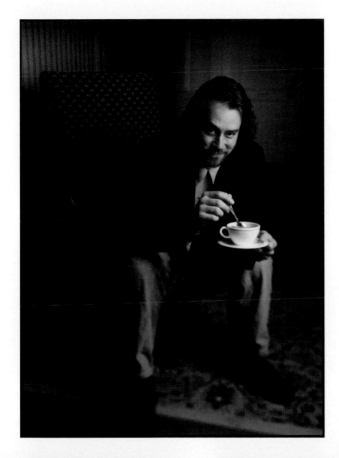

Sciortino

JEFF SCIORTINO PHOTOGRAPHY PHONE 773.395.1605 FAX 773.395.1606
REPRESENTED BY HOLLY HAHN PHONE 773.338.7110 FAX 773.338.7004

KIPLING SWEHLA

GREG WHITAKER

PHOTOGRAPHER **812.988.8808**

PEOPLE
ENVIRONMENTS
BLACK & WHITE
COLOR

REPRESENTED BY

• HOLLY HAHN, CHICAGO
 312.338.7110

• WILLIAMS GROUP WEST, SAN FRANCISCO
 415.388.9391

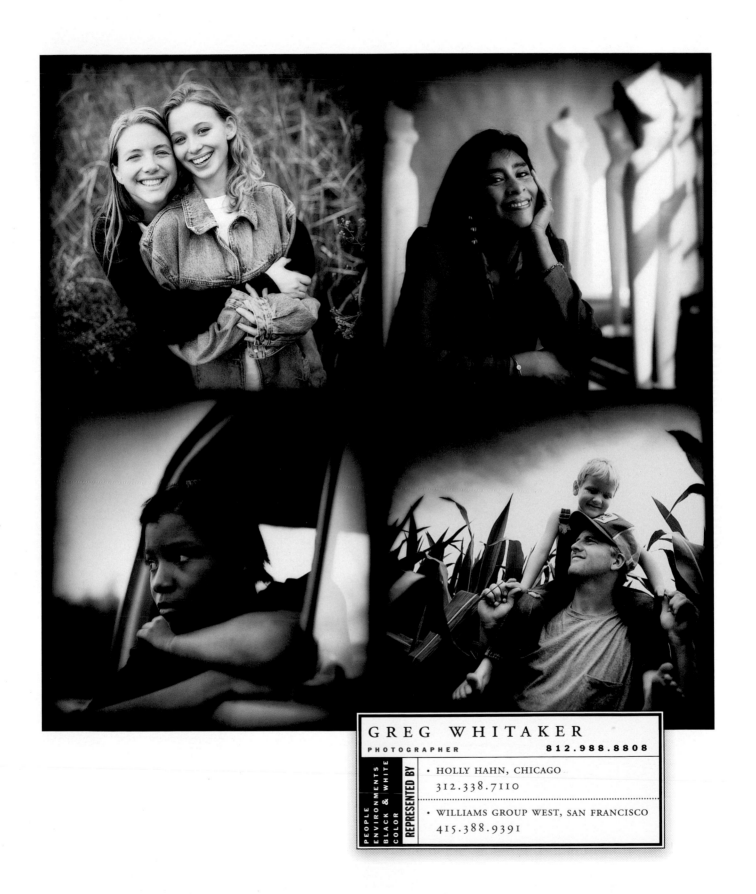

GREG WHITAKER

PHOTOGRAPHER 812.988.8808

• HOLLY HAHN, CHICAGO
 312.338.7110

• WILLIAMS GROUP WEST, SAN FRANCISCO
 415.388.9391

John McCallum

Represented in the Midwest and Chicago by Melissa McCallum 312.787.9300

Outside the Midwest contact Wanda Melendez 212.722.0800

John McCallum

Represented in the Midwest and Chicago by Melissa McCallum 312.787.9300

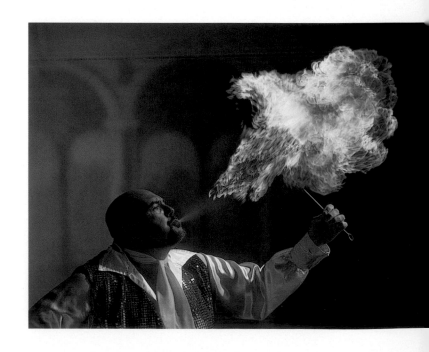

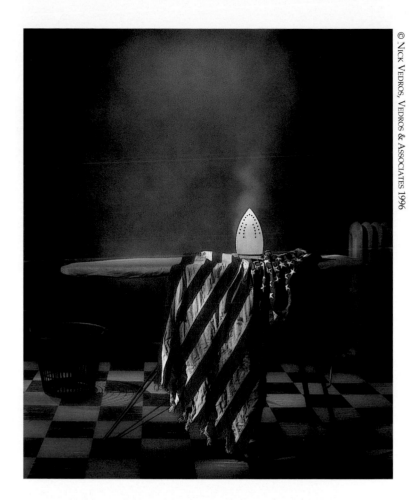

De b ORAH FLETCHER

Voice: 312.421.2530

Fax: 312.421.2536

E-Mail: dfletchr@aol.com

1744 WEST GRAND AVENUE, CHICAGO, ILLINOIS 60622

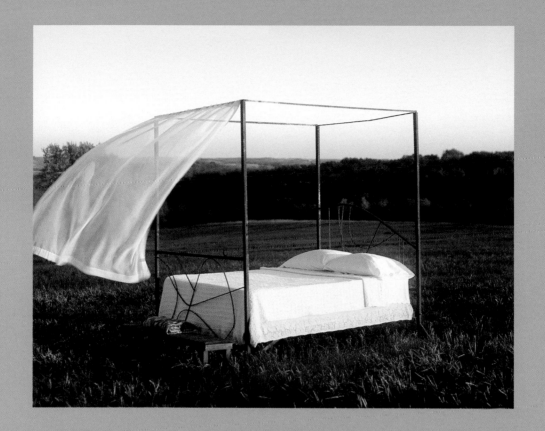

Voice: 312.421.2530

Fax: 312.421.2536

E-Mail: dfletchr@aol.com

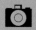

1744 WEST GRAND AVENUE, CHICAGO, ILLINOIS 60622

PHOTOGRAPHY

MARC HAUSER + JOHN DESALVO
PHOTOGRAPHY · DIGITAL ARTISTRY

1810 WEST CORTLAND CHICAGO, ILLINOIS 60622 TEL 312-486-4381 FAX 312-486-2884
REPRESENTED BY JOANNE LEOPOLD TEL 312-486-4381

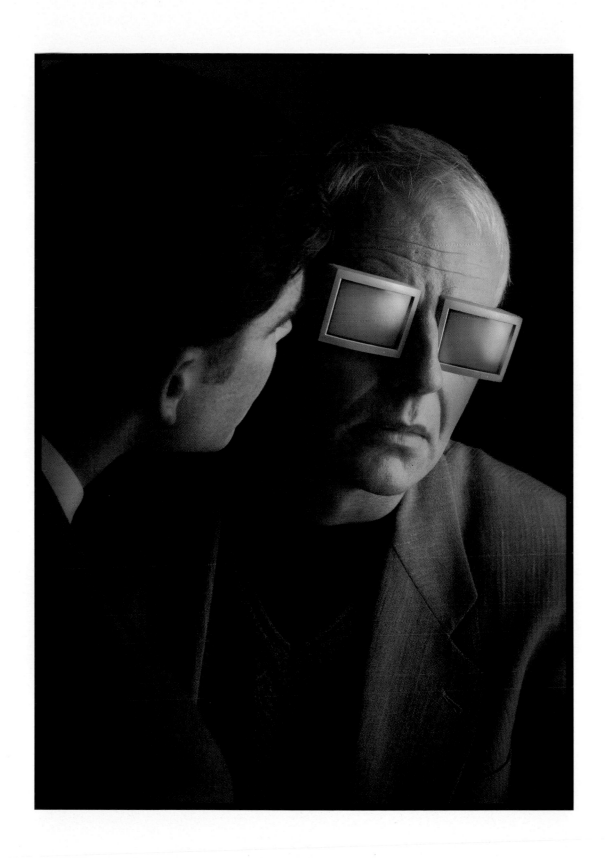

MARC HAUSER + JOHN DESALVO
PHOTOGRAPHY DIGITAL ARTISTRY

1810 WEST CORTLAND CHICAGO, ILLINOIS 60622 TEL 312-486-4381 FAX 312-486-2884
REPRESENTED BY JOANNE LEOPOLD TEL 312-486-4381

GREG HECK photography

312 226 2660 fax 312 226 2777

represented by

VARGO BOCKOS

312 661 1717 fax 312 661 0043

LIPCHIK

BRIAN LIPCHIK | PHOTOGRAPHY

312.243.4404 | FAX 243.0155

represented by

VARGO BOCKOS

312 661 1717 fax 312 661 0043

LIPCHIK

BRIAN LIPCHIK | PHOTOGRAPHY

312.243.4404 | FAX 243.0155

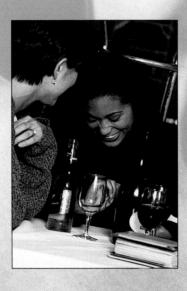

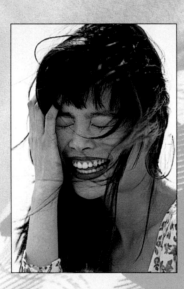

represented by

VARGO BOCKOS

312 661 1717 fax 312 661 0043

TOM CONNORS PHOTOGRAPHY

P 612.339.9838 **F** 612.339.9830

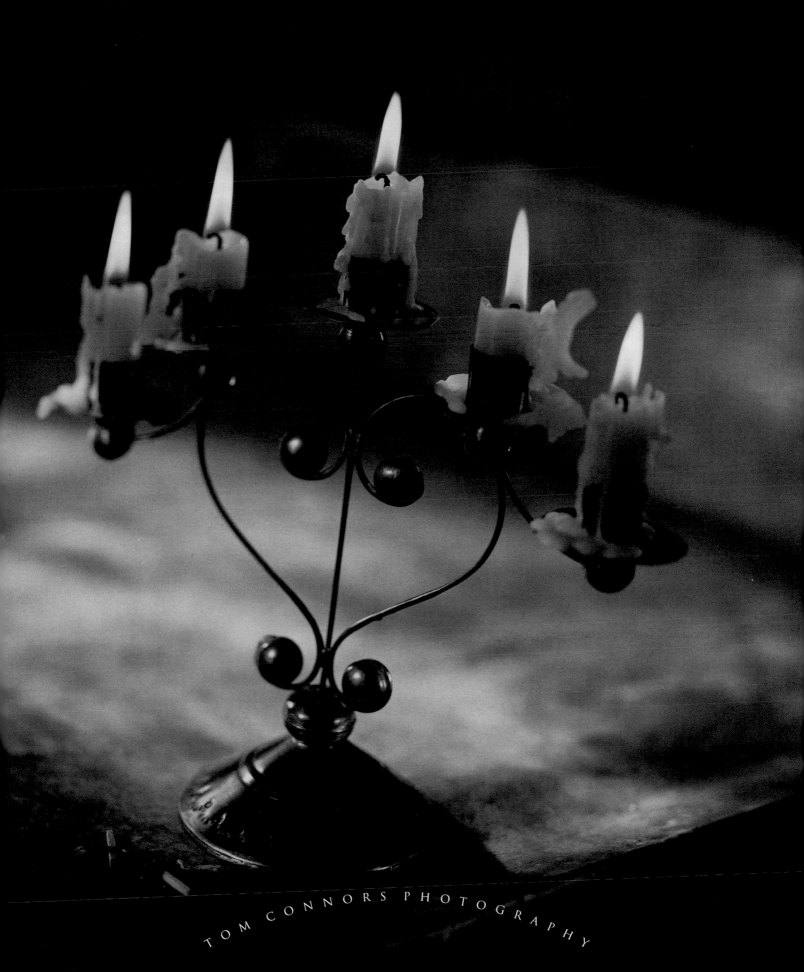

Patience

and the
CAMERA OF CASALINI

There's something truly virtuous about patience. Something about letting the world

rumble and hurtle along without you while you carve out a moment here and a

moment there to watch your children transform from toddlers to teenagers

overnight. Between birthdays and wedding days is where the good stuff lies. And it

all happens in the blink of an eye. The secret is, don't blink. Casalini Photography.

Call 317-873-4858 for a promotional brochure or a customized portfolio.

GLEN GYSSLER • CONTACT JIM HANSON 312 337 7770 • FAX 312 337 7112 • jhanson@mcs.net

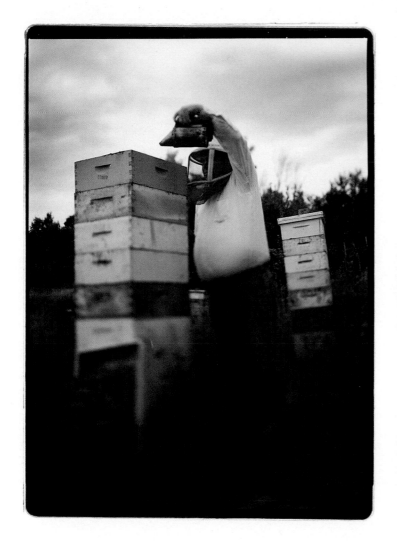

ROBERT NEUMANN PHOTOGRAPHY

TEL 616•454•1001 FAX 616•454•4546

PELLEGRINI

joe pellegrini photography
print • wak pictures
candace gelman • 847•831•3038

DAVID WAGENAAR

DAVID WAGENAAR

SUSAN KINAST

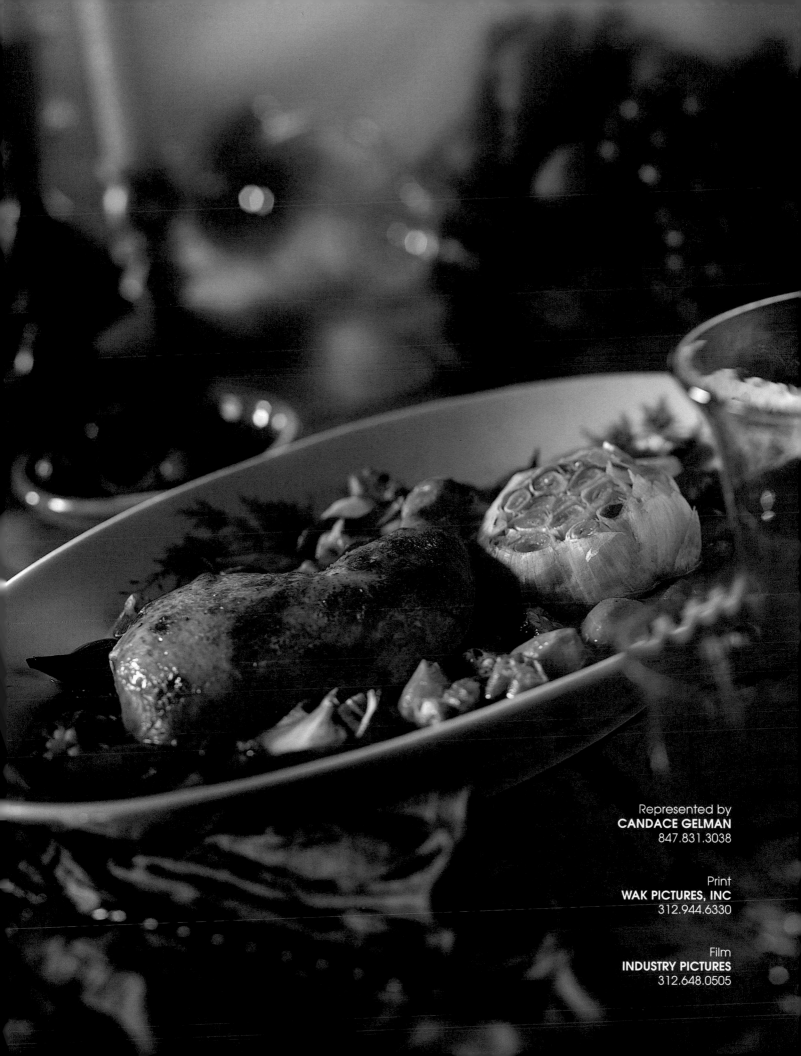

Represented by
CANDACE GELMAN
847.831.3038

Print
WAK PICTURES, INC
312.944.6330

Film
INDUSTRY PICTURES
312.648.0505

CHRIS CASSIDY

(312) 733-4110

MOWERS PHOTOGRAPHY. AT THE VARSITY.

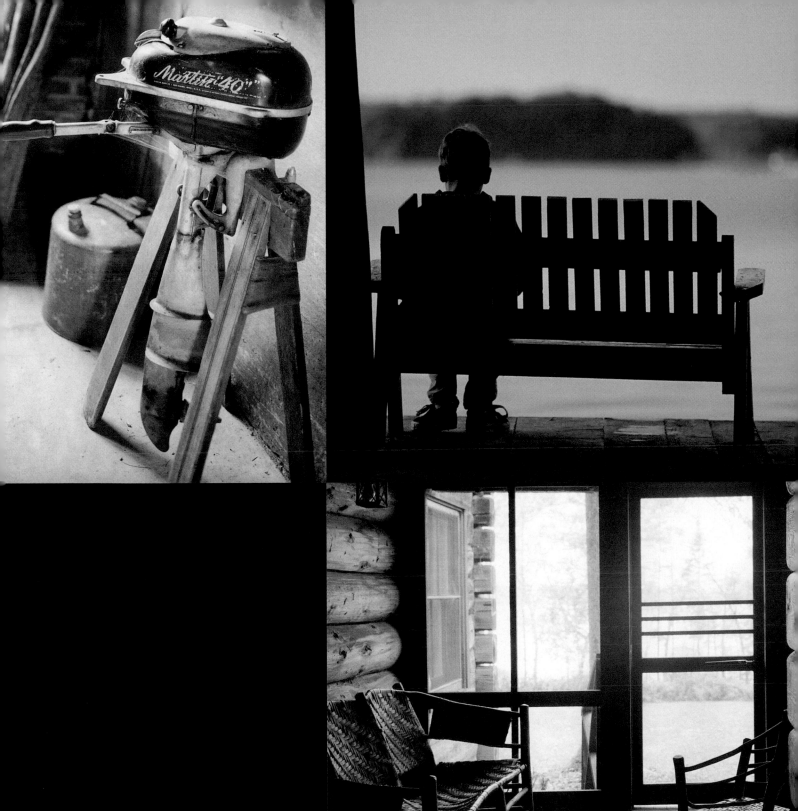

487

K E N D E

Benjamin Kende 2118 W. Superior St. Chicago, IL 60612
Represented by Toni McNaughton 312 . 855 . 1225

K E N D E

Benjamin Kende 2118 W. Superior St. Chicago, IL 60612

Represented by Toni McNaughton 312 . 855 . 1225

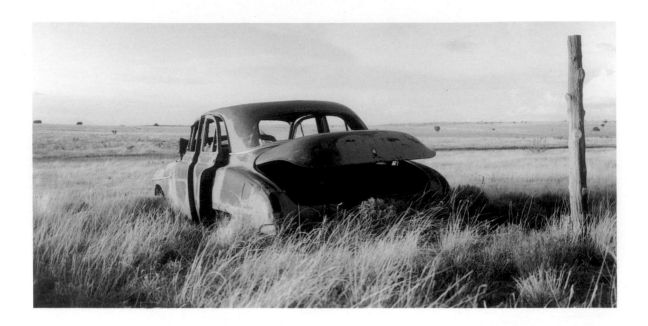

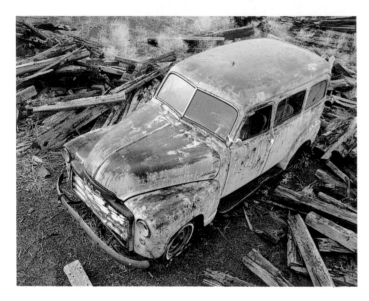

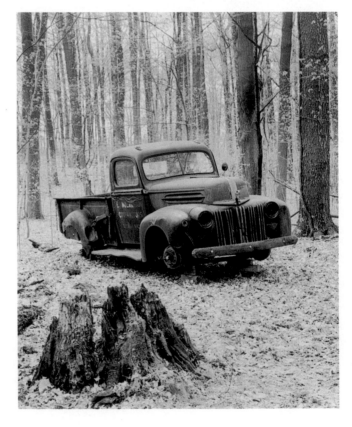

TOM FEDRIGO PHOTOGRAPHY (810) 680-2120 FAX: (810) 680-2142

FEDRIGO

REPRESENTED BY SKB PRODUCTIONS (800) 770-1880

CURTIS JOHNSON

ARNDT PHOTOGRAPHY 113 NO. FIRST STREET

MINNEAPOLIS, MN 55401 (612) 332-5050 FAX (612) 332-8614

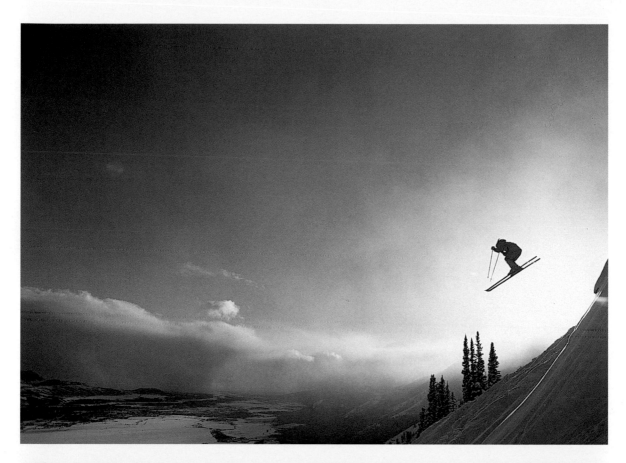

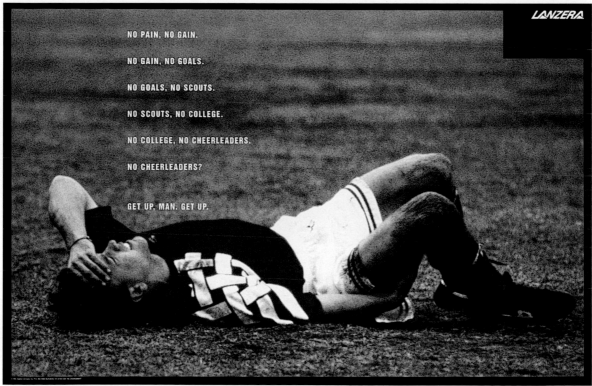

NO PAIN, NO GAIN.

NO GAIN, NO GOALS.

NO GOALS, NO SCOUTS.

NO SCOUTS, NO COLLEGE.

NO COLLEGE, NO CHEERLEADERS.

NO CHEERLEADERS?

GET UP, MAN. GET UP.

LANZERA

ARNDT

JIM ARNDT PHOTOGRAPHY

113 NORTH FIRST STREET, MINNEAPOLIS, MN 55401
(612) 332-5050 • FAX (612) 332-8614

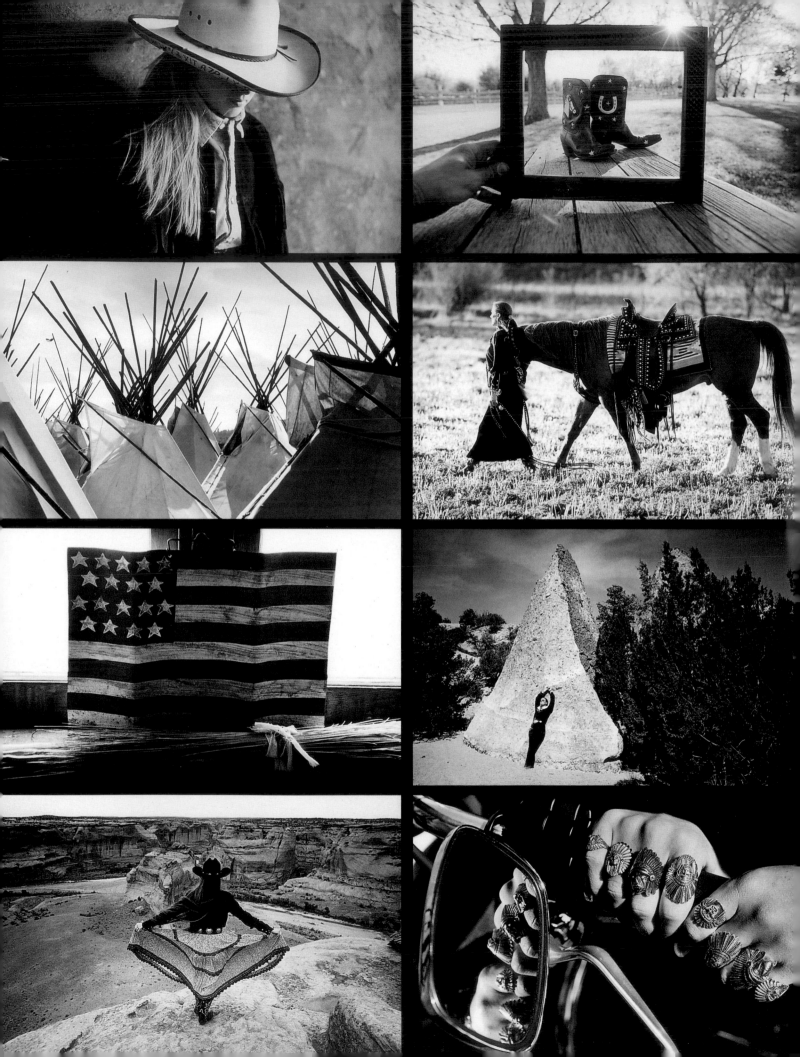

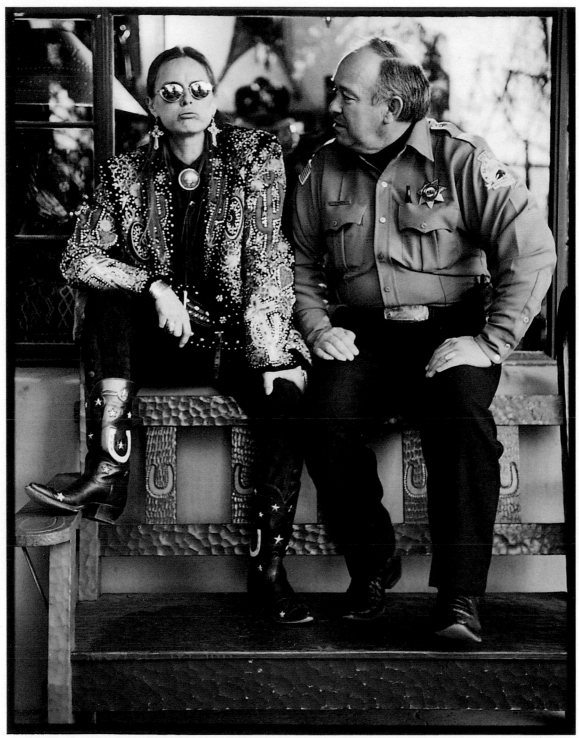

©1996 JIM ARNDT

ARNDT

JIM ARNDT PHOTOGRAPHY

113 NORTH FIRST STREET, MINNEAPOLIS, MN 55401
(612) 332-5050 • FAX (612) 332-8614

497

MARK PRESTON

BLACK WHITE + COLOR

810 795 4620

REPRESENTED BY BILL MESSERLY + ROLF EKLOF

FAX 810 795 4624

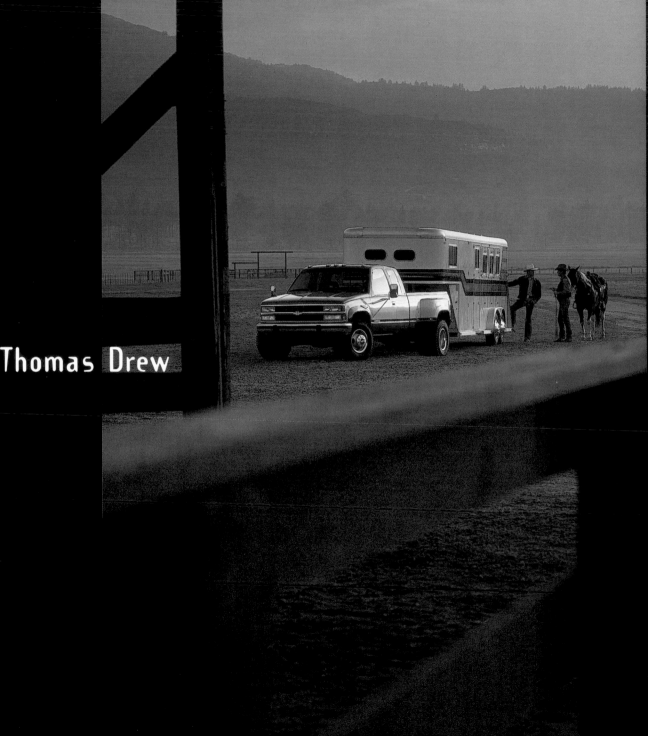

Thomas Drew

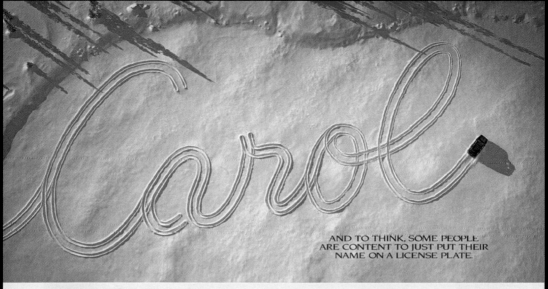

AND TO THINK, SOME PEOPLE
ARE CONTENT TO JUST PUT THEIR
NAME ON A LICENSE PLATE.

THE NEW JEEP. GRAND CHEROKEE

People are always looking for new ways to express their individuality. And nothing separates you from the crowd better than the new Jeep Grand Cherokee 4x4. With its exclusive new "on-demand" Quadra-Trac® system and available high-output 5.2 litre V8, Jeep Grand

Cherokee Limited gives you the unique ability to go where other 4x4 vehicles dare not venture.

Grand Cherokee also offers standard dual front air bags† and meets all 1998 federal passenger car and light truck safety standards.* So you can breeze through some of the most challenging winter terrain.

If you're looking for a way to break away from

the crowd — far, far away — call 1-800-925-JEEP for the dealer nearest you. Chances are, there's a Jeep Grand Cherokee with your name written on it.

Jeep
THERE'S ONLY ONE

*Excludes sunscreen glass. † Always wear your seat belt. Jeep is a registered trademark of Chrysler Corporation.

AS YOU CAN SEE, THE NEW JEEP WRANGLER NOW HAS ONE OF THE MOST ADVANCED SUSPENSION SYSTEMS EVER.

THE ALL-NEW JEEP WRANGLER

It's a thing of beauty. A suspension system more capable, more functional, and now nestled beneath the body of a totally new '97 Jeep Wrangler.

We began from the ground up with our new exclusive Quadra-Coil™ suspension. It gives the driver maximum off-highway toughness and control. This system also provides excellent dynamic running-

ground clearance and diagonal articulation. Which means, simply put, you can crawl over terrain with all four wheels more firmly planted. And heck, if you get all muddy while you're out crawling around, the interior can be easily hosed down.

The all-new Jeep Wrangler also has the only available 6-cylinder engine in its class and the most powerful too.* Plus, Command-Trac,® a responsive shift-on-the-fly four-wheel drive system. It doesn't

seem much different from any other Jeep vehicle. But it is. Sort of. Let's just say, one ride in the new Jeep Wrangler and it all becomes perfectly clear.

For more information, call 1-800-925-JEEP, or visit our Web site at http://www.jeepunpaved.com

Jeep
THERE'S ONLY ONE

*Wrangler SE shown. 4.0 litre 6-cylinder engine not available on Wrangler SE, standard on Wrangler Sport and Sahara. Ward's 1996 Small Sport Utility class. Always wear your seat belt. Jeep is a registered trademark of Chrysler Corporation.

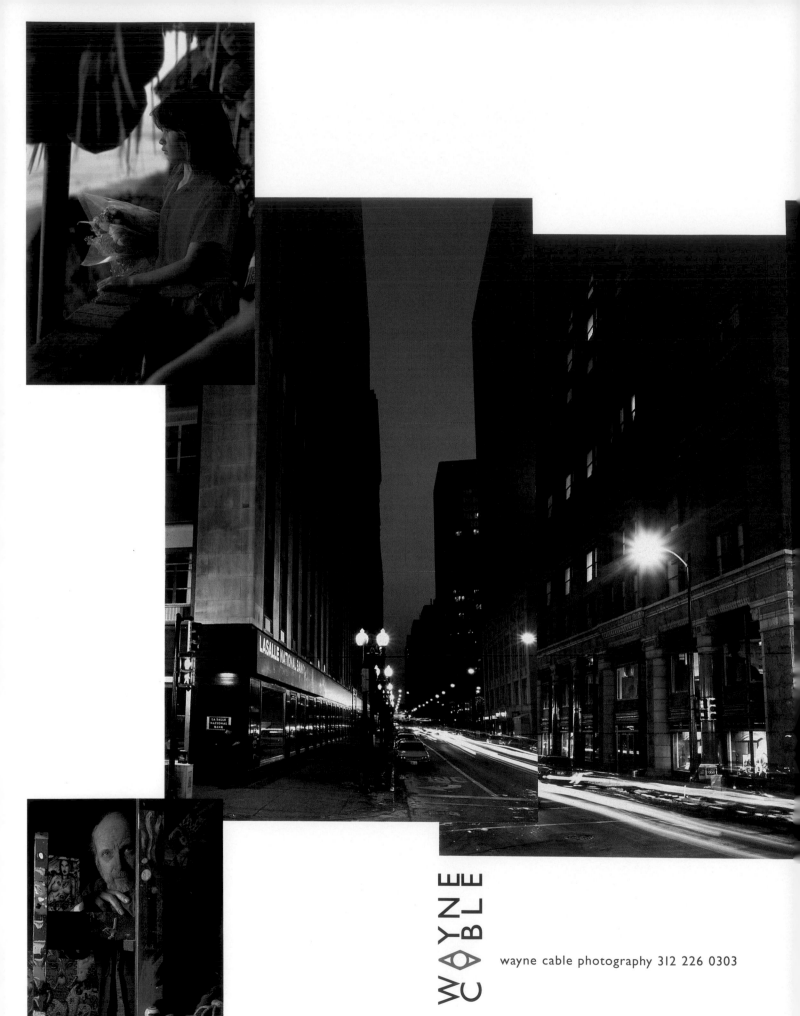

LASALLE NATIONAL BANK

LA SALLE NATIONAL BANK

WAYNE CABLE

wayne cable photography 312 226 0303

WAYNE
CABLE

wayne cable photography 312 226 0303

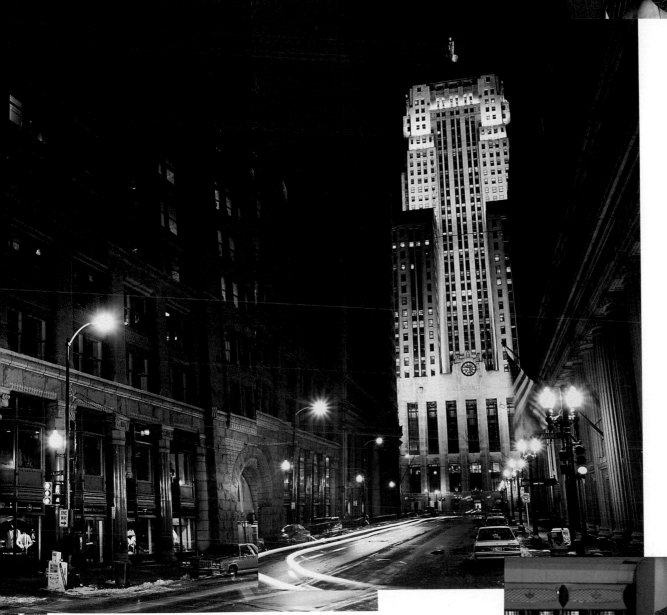

CHICAGO 312.786.1560

BRUTON
STROUBE

REPRESENTED BY CECI BARTELS ASSOCIATES

NEW YORK 212.912.1877

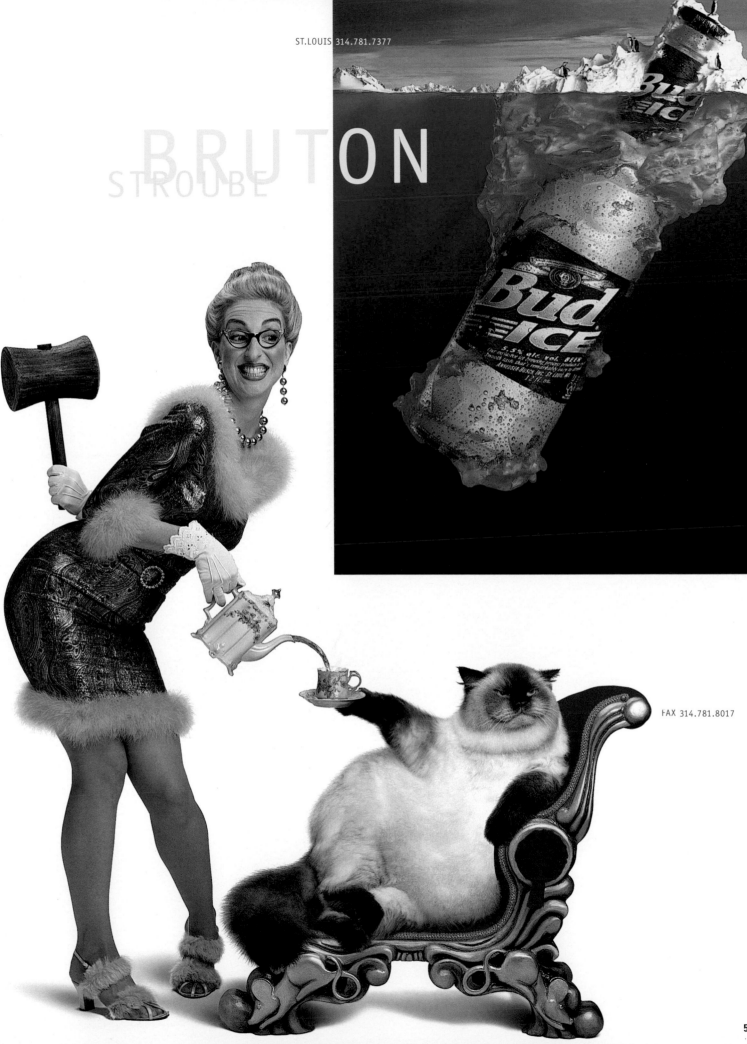

BRUTON
STROUBE

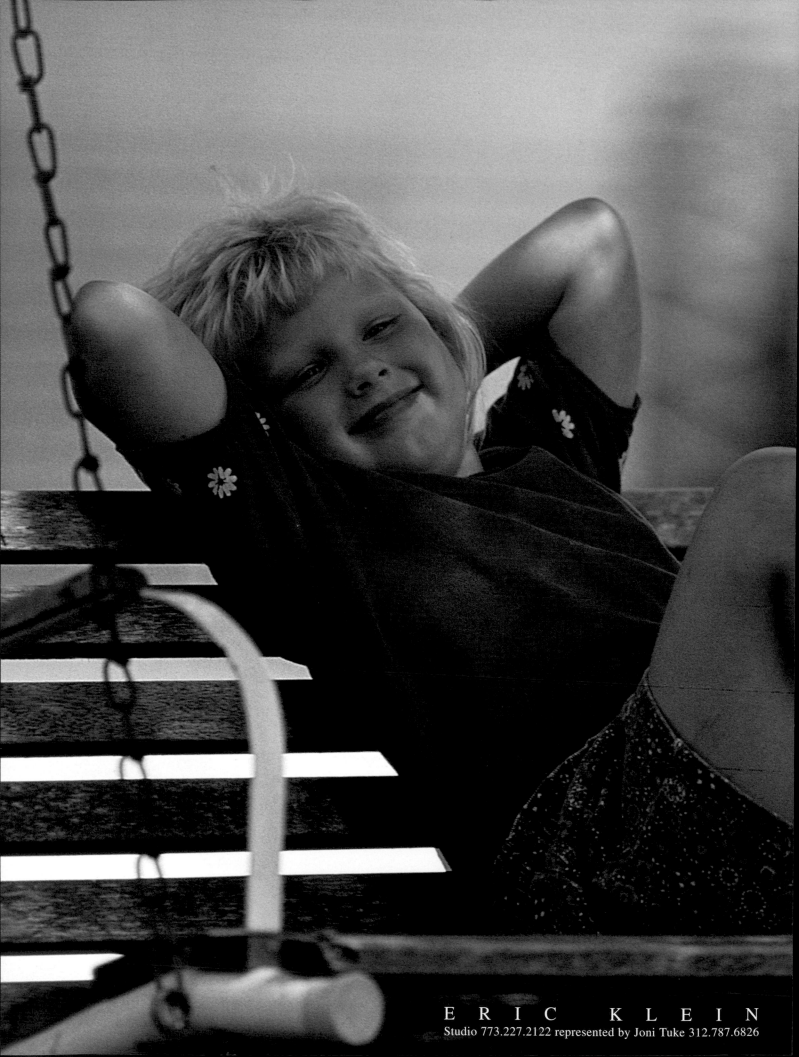

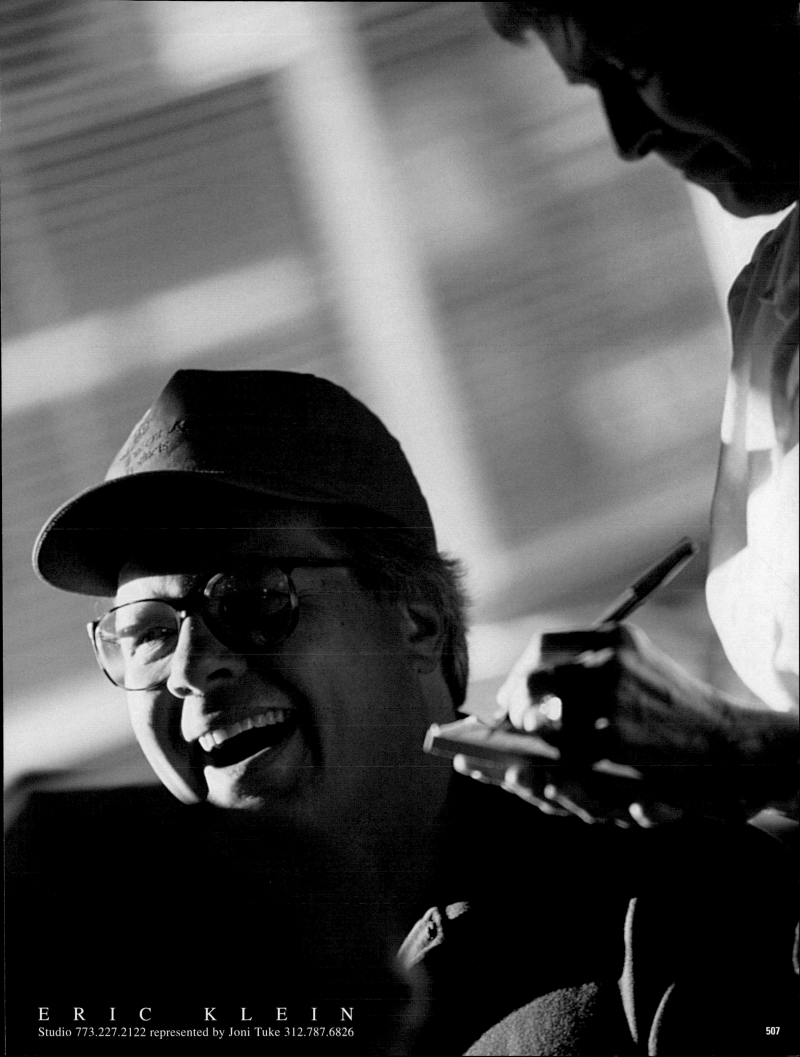

ERIC KLEIN
Studio 773.227.2122 represented by Joni Tuke 312.787.6826

507

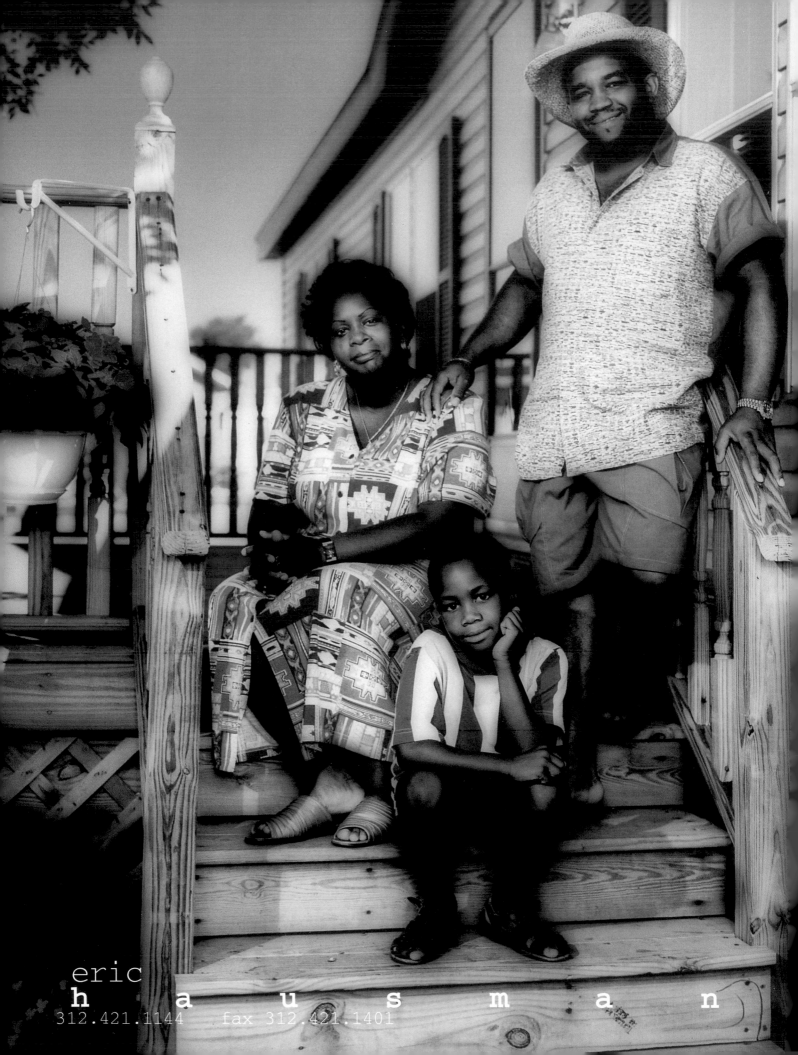

eric
h a u s m a n
312.421.1144 fax 312.421.1401

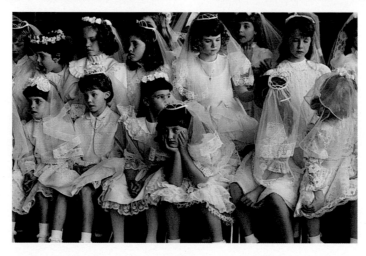

eric
h a u s m a n
312.421.1144 fax 312.421.1401

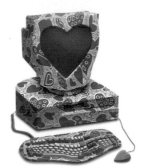

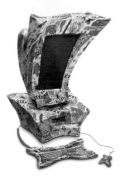

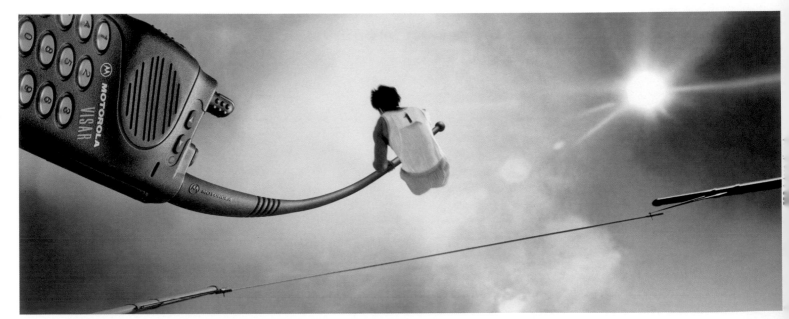

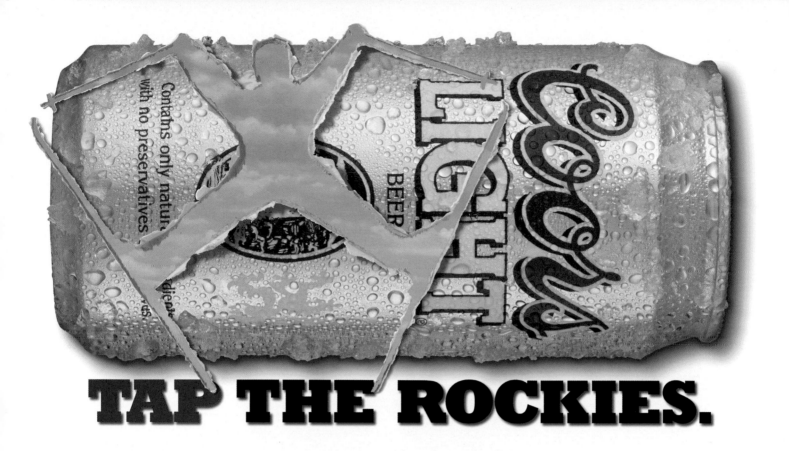

TAP THE ROCKIES.

Jeff Schewe Photography 624 West Willow Chicago, Illinois 60614 312-787-6814 fax 312-951-6334 ph email:schewe@aol.com

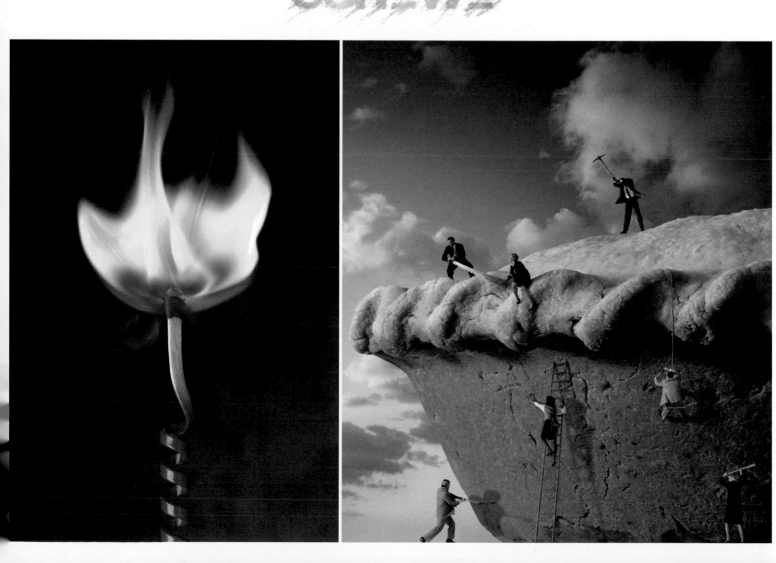

RODNEY OMAN BRADLEY TELEPHONE: 312.395.9211 FACSIMILE: 312.395.2440

REPRESENTED BY JIM HANSON TELEPHONE: 312.337.7770 FACSIMILE: 312.337.7112

OMAN

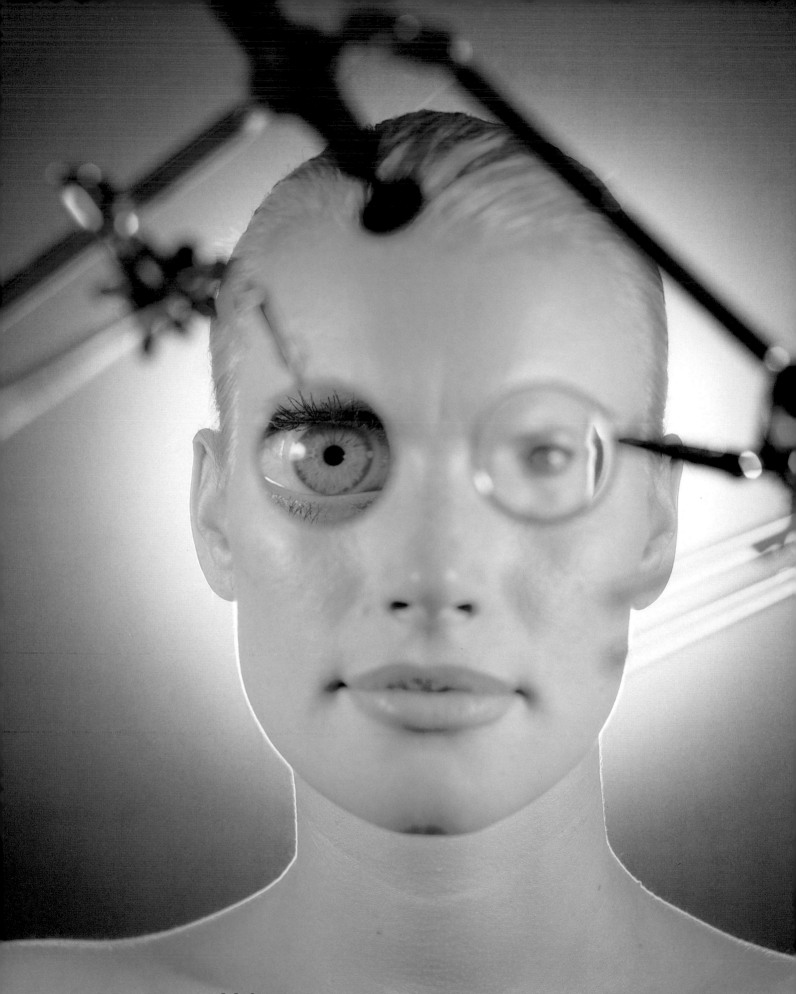

RODNEY OMAN BRADLEY TELEPHONE: 312.395.9211 FAX 312.395.2440

OMAN

ANDREA MANDEL

ANDREA MANDEL

REPRESENTED BY REPTILE ARTISTS AGENT
CALL CAROLYN SOMLO 773 477 5372
452 NORTH MORGAN STREET CHICAGO IL 60622 312 829 4002

GRUBMAN.

Steve Grubman Photography Inc. 456 North Morgan Chicago, IL 60622 Tel 312 226-2272 Fax 312 226-5587

Represented by Reptile Artists Agent • Call Carolyn Somlo 773 477-5372

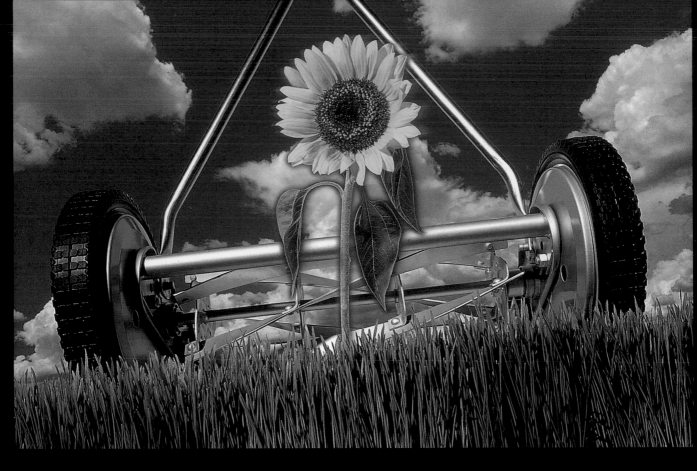

525

K A R A NT

BARBARA KARANT, KARANT + ASSOCIATES, CHICAGO, T 312.733.0891, F 312.733.1781
AD AGENCIES CONTACT EMILY INMAN, T 773.792.9169, F 773.792.9189

M E O L I

710 NORTH TUCKER
SUITE 306
ST. LOUIS, MO. 63101
PHONE: 314/231/6038
FACSIMILE: 314/231/4301

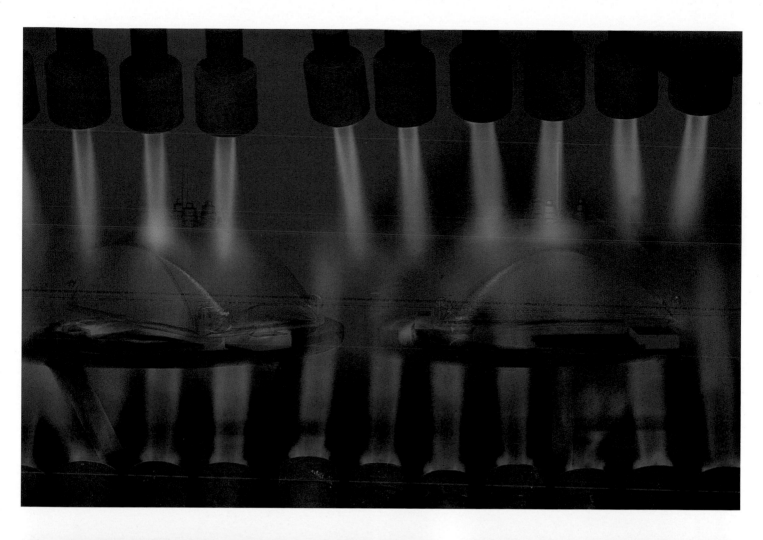

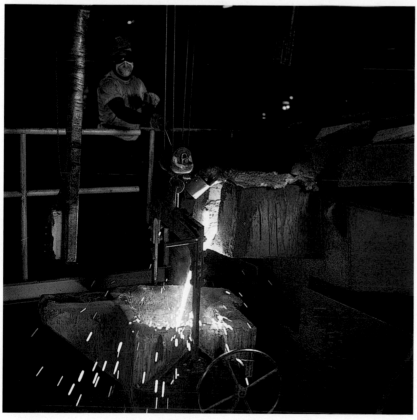

Kazu Okutomi Photography KAZU tel 773 348-5393 fax 773 348-2703

Kazu Okutomi Photography tel 733 348-5393 fax 733 348-2703

531

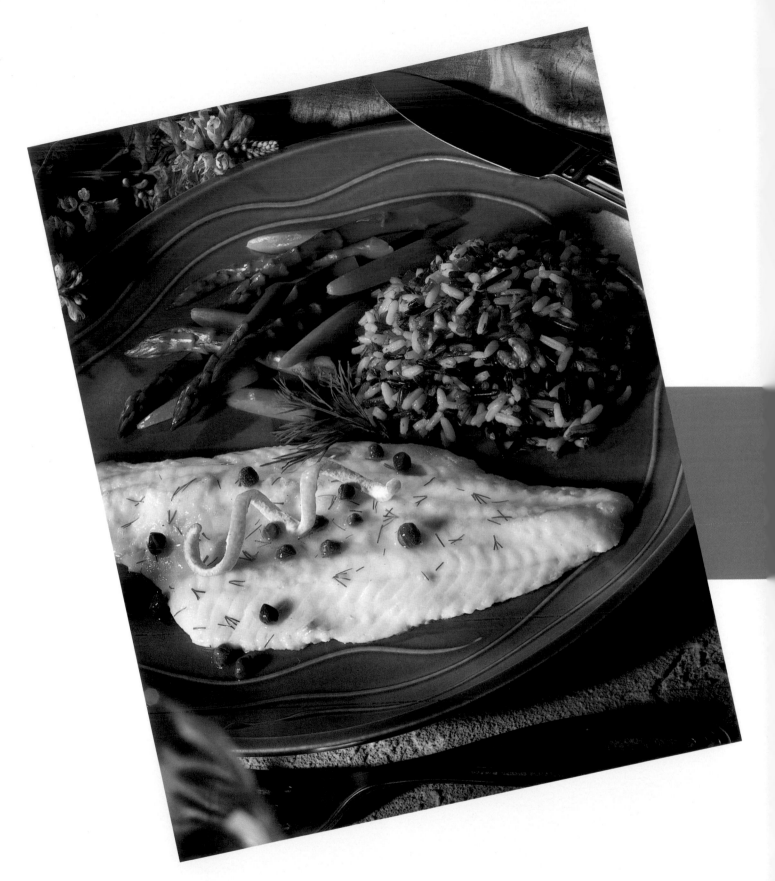

Scott Payne Studios

Scott Payne Studios

400 N. Racine
Chicago. 60622

Voice 312 829.8520
Fax 312.829.8530

To View My Portfolio
Call:
Jeannie Will
312.942.1949

S U S A N

773·235·9386

Susan Reich

is represented

in Chicago

by Susan Katz

773·549·5379

J

Mark Segal Photography

studio 312.263.1027 Midwest:Susan Katz 773.549.5379 West Coast:Debra Weiss 213.656.5029

Southwest:Marla Matson 602.252.5072 East Coast:Judi Giannini 301.439.0103

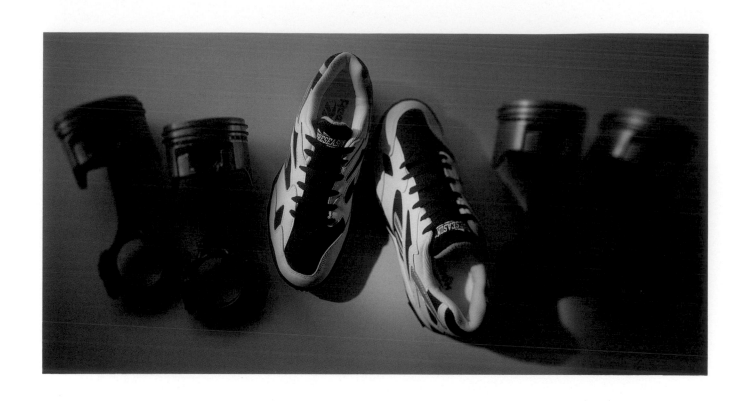

JIM WHITE

PHOTOGRAPHY

2246 West Grand Avenue • Chicago, Illinois 60612
tel: 312.942.0258 fax: 312.942.2621

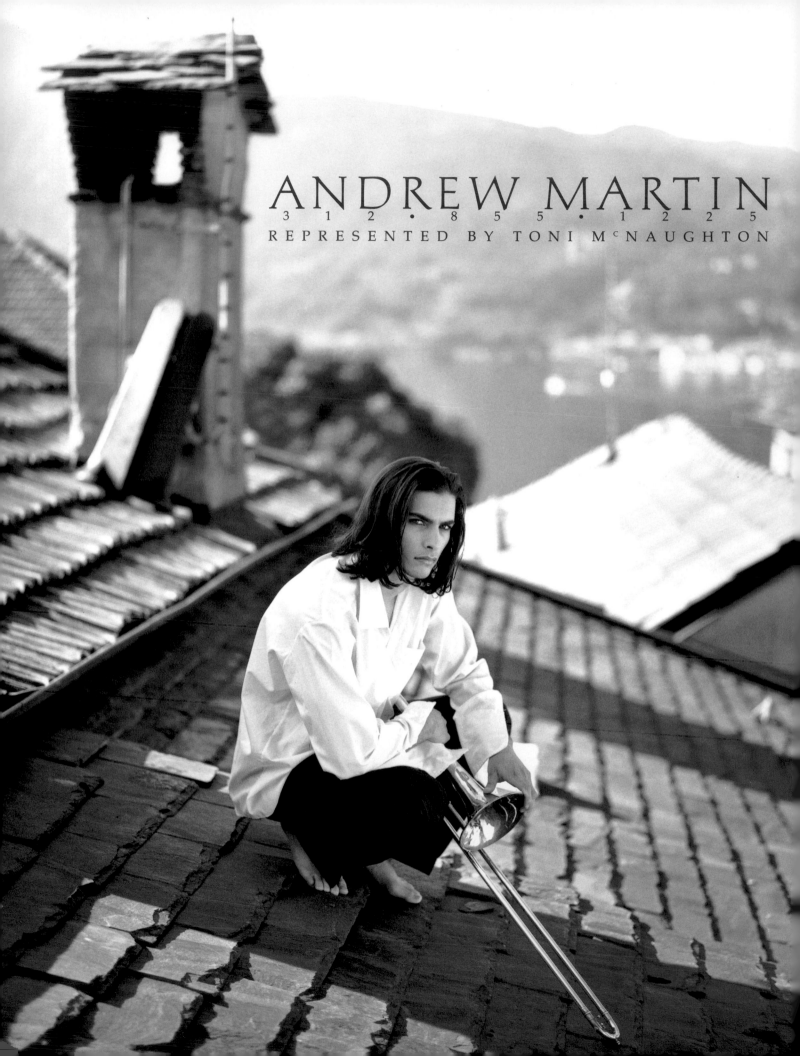

ANDREW MARTIN
312 • 855 • 1225
REPRESENTED BY TONI MCNAUGHTON

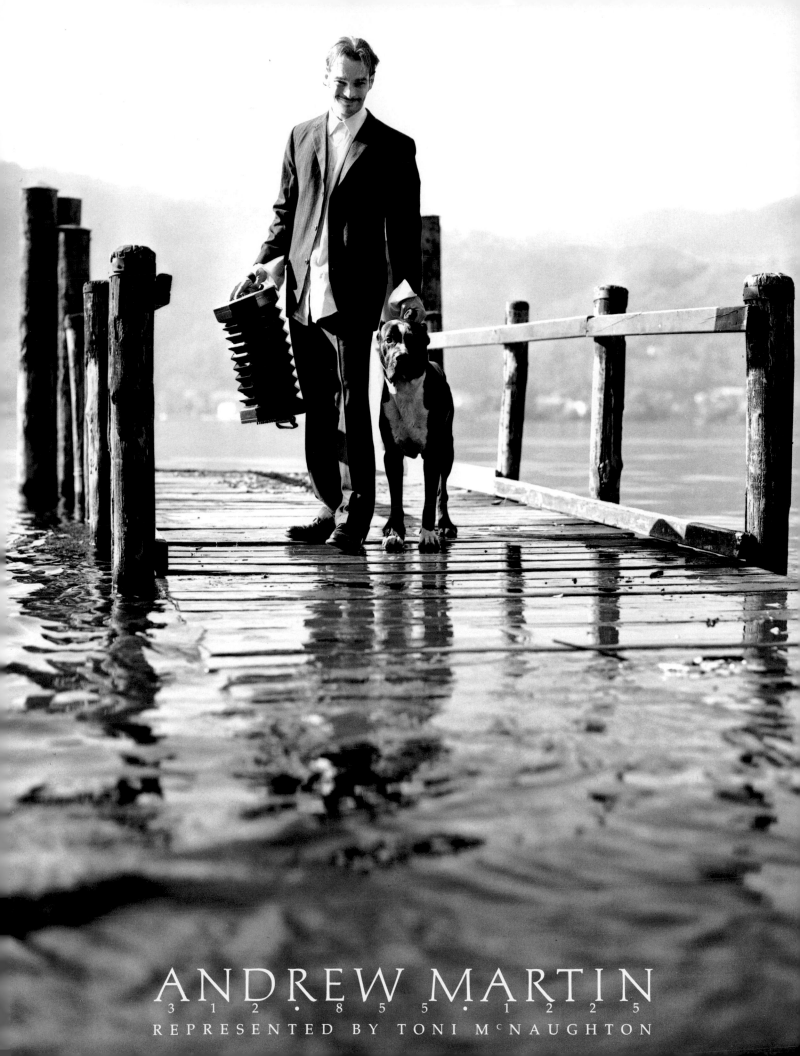

ANDREW MARTIN

312 · 855 · 1225

REPRESENTED BY TONI M^cNAUGHTON

VAN DER LENDE

STUDIO 616 459 2880 FAX 616 459 6666

REPRESENTED BY CAROLYN POTTS & ASSOCIATES 773 935 8840 FAX 773 935 6191

VAN DER LENDE

STUDIO 616 459 2880 FAX 616 459 6666

VIT○ Vito Palmisano Voice Mail/Pager 800-921-8116 4262 DeFeyter Holland, MI 49424 616-738-8530 Fax: 616-738-8608

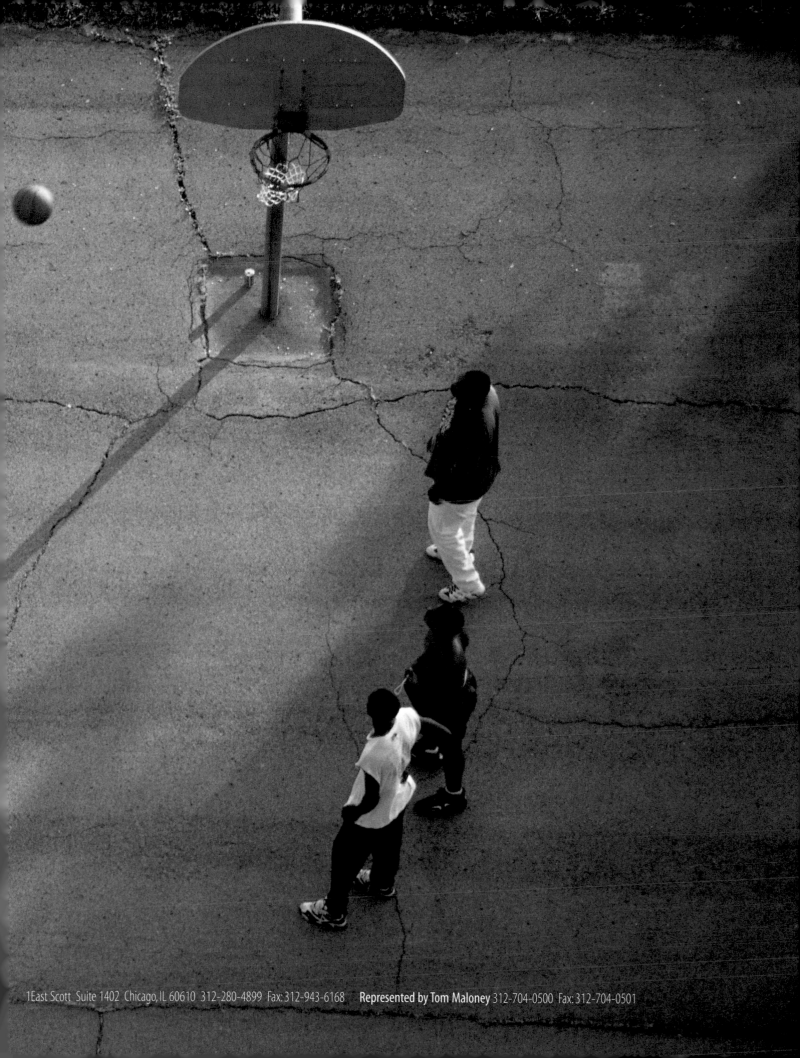

1East Scott Suite 1402 Chicago, IL 60610 312-280-4899 Fax: 312-943-6168 **Represented by Tom Maloney** 312-704-0500 Fax: 312-704-0501

TERI SHOOTS FOOD!

Wendy's International Hillshire Farm KitchenAid

Skyline Chili United Dairy Farmers Kroger Archway Cookies Star-Kist

TERI STUDIOS

PHONE 513 **784 9696** • FAX 513 **784 9737** • TOLL FREE 1 888 **784 9696**

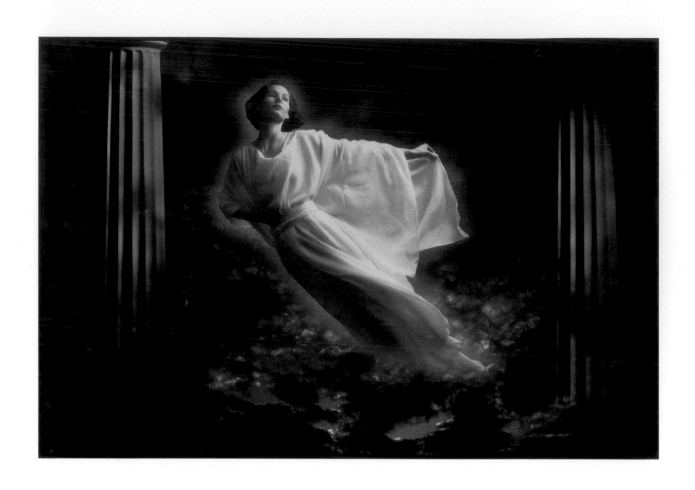

Peter Wong Photography • Tel 612-340-0798 • Fax 612-340-9294
email: pwong@winternet.com • Web site: http://www.winternet.com/~pwong/

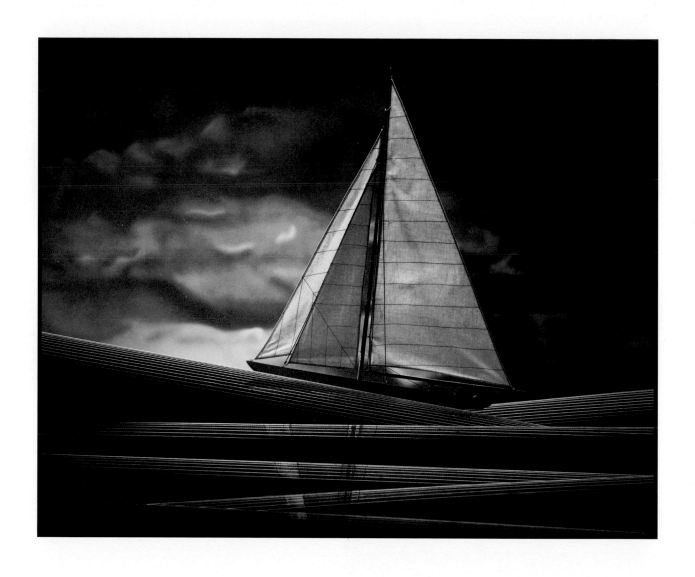

Peter Wong Photography • Tel 612-340-0798 • Fax 612-340-9294
email: pwong@winternet.com • Web site: http://www.winternet.com/~pwong/

F

R O B E R T G R I M M

K

ROBERT GRIMM

AT FERGUSON &

KATZMAN STUDIO

3 1 4 . 2 4 1 . 3 8 1 1

fax 314.241.3087

GREG RANNELLS
AT FERGUSON &
KATZMAN STUDIO
314.241.3811
fax 314.241.3087

F

K

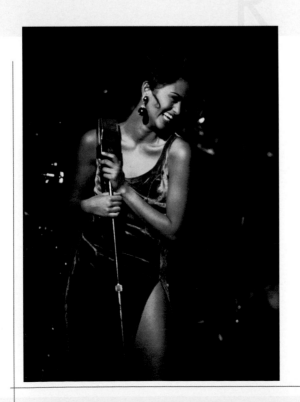

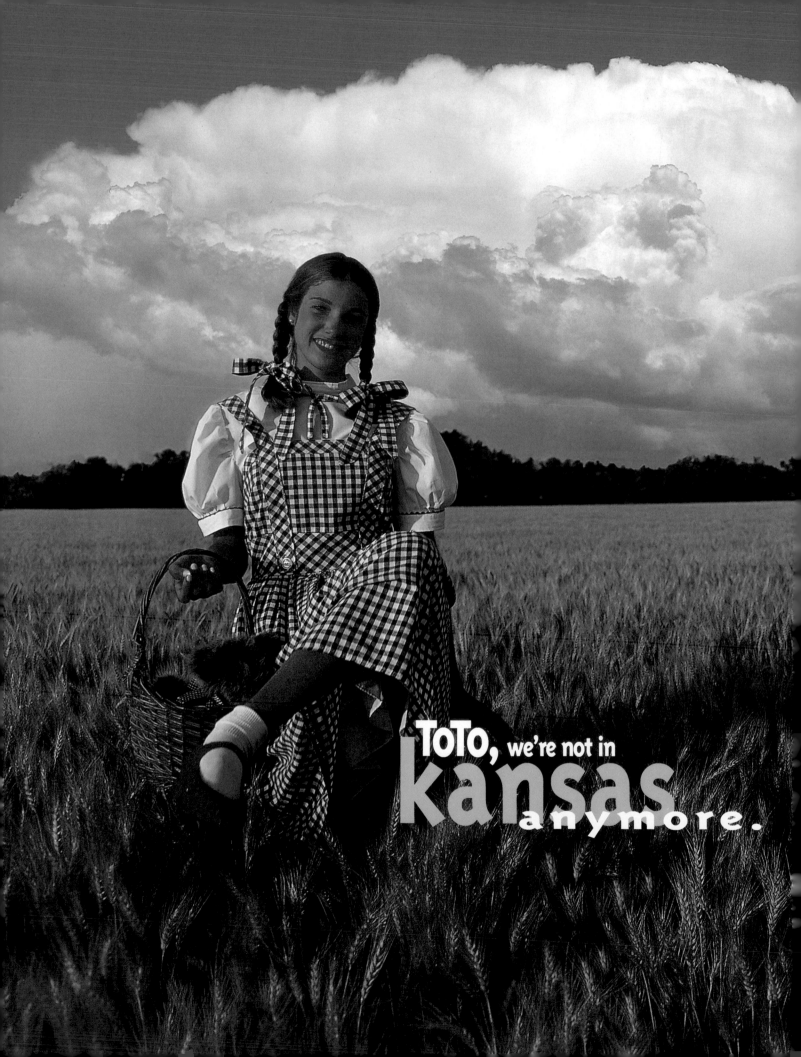

ToTo, we're not in kansas anymore.

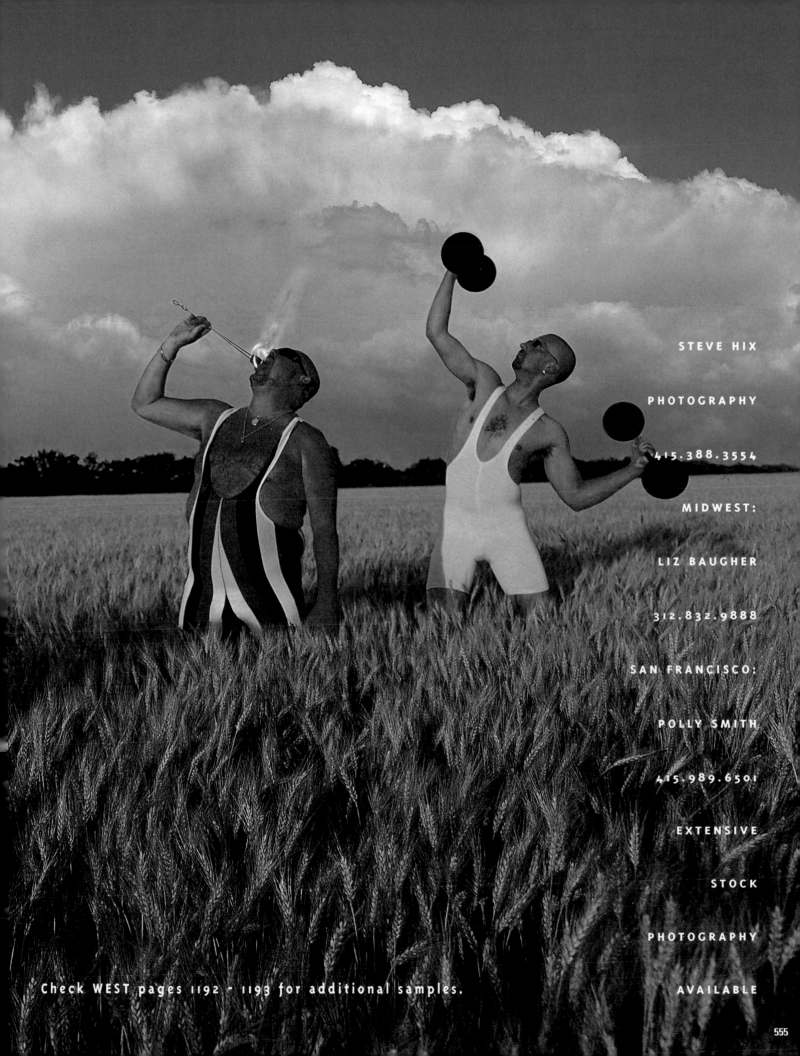

STEVE HIX

PHOTOGRAPHY

415.388.3554

MIDWEST:

LIZ BAUGHER

312.832.9888

SAN FRANCISCO:

POLLY SMITH

415.989.6501

EXTENSIVE

STOCK

PHOTOGRAPHY

AVAILABLE

Check WEST pages 1192 - 1193 for additional samples.

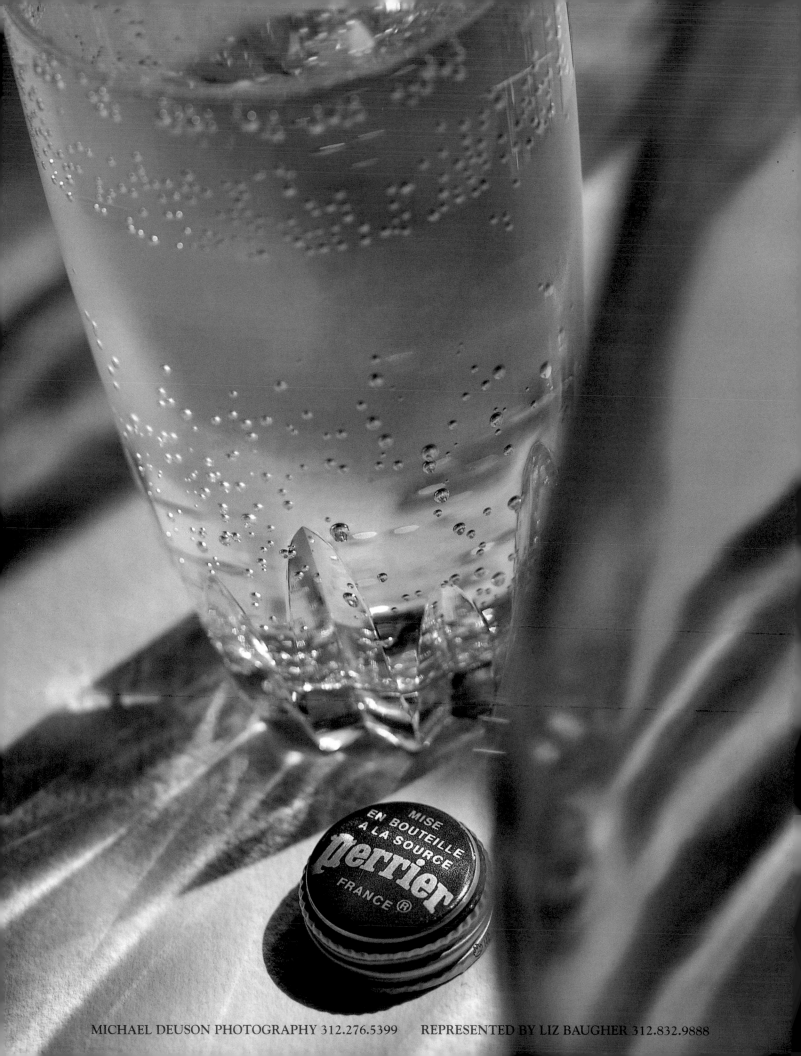

MISE
EN BOUTEILLE
A LA SOURCE
perrier
FRANCE ®

MICHAEL DEUSON PHOTOGRAPHY 312.276.5399 REPRESENTED BY LIZ BAUGHER 312.832.9888

DEUSON

MICHAEL DEUSON PHOTOGRAPHY 312.276.5399 REPRESENTED BY LIZ BAUGHER 312.832.9888

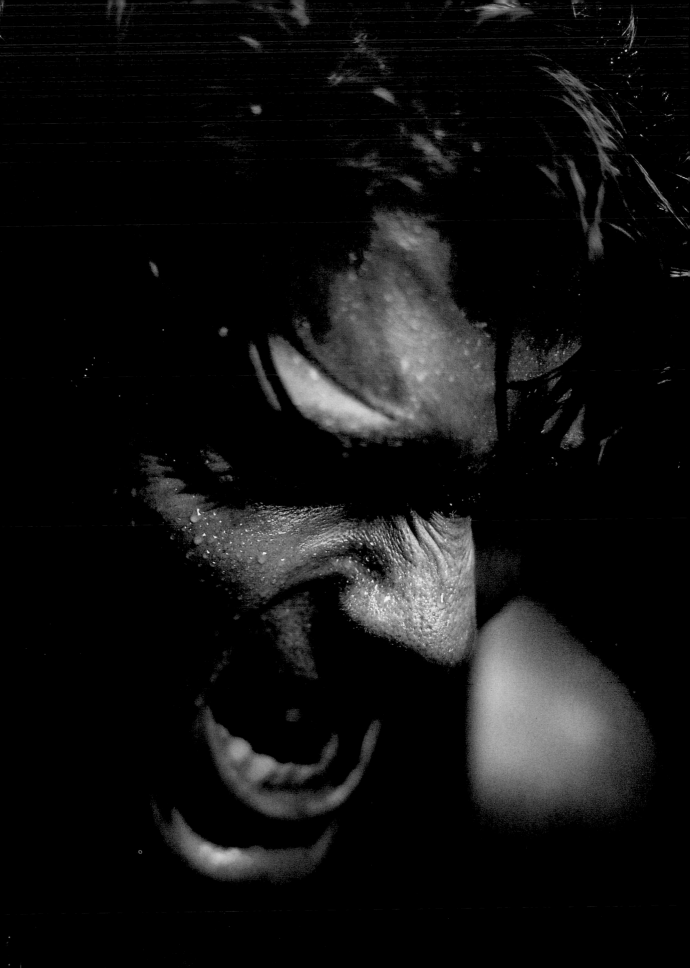

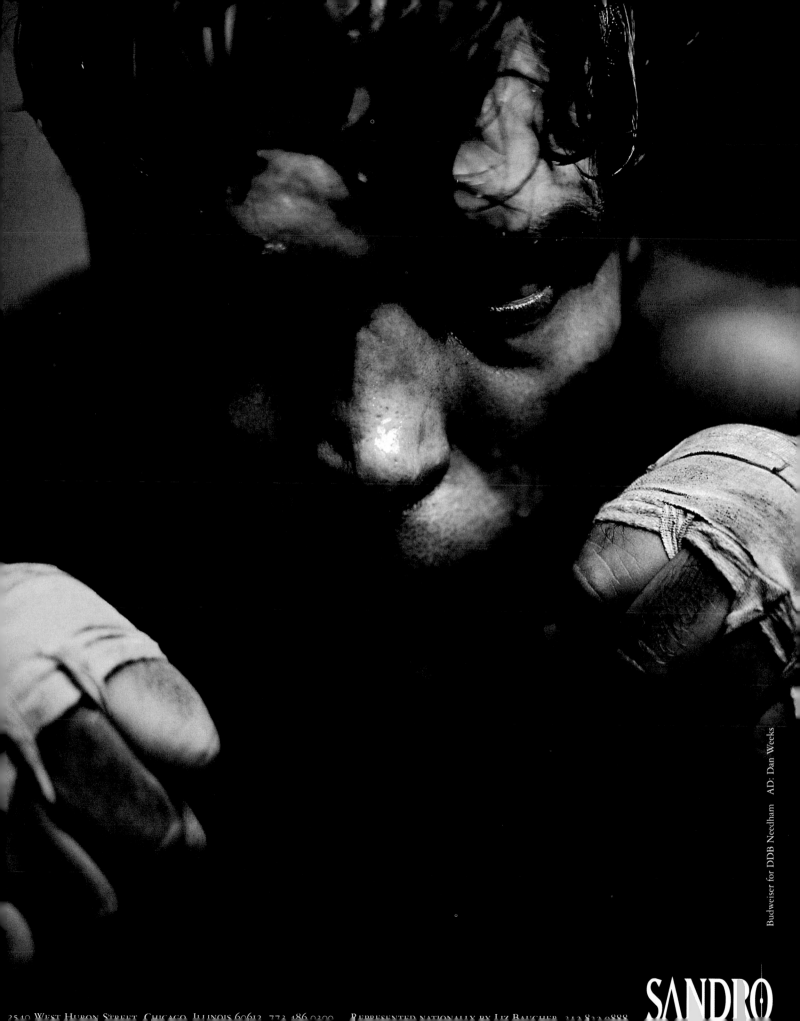

SANDRO

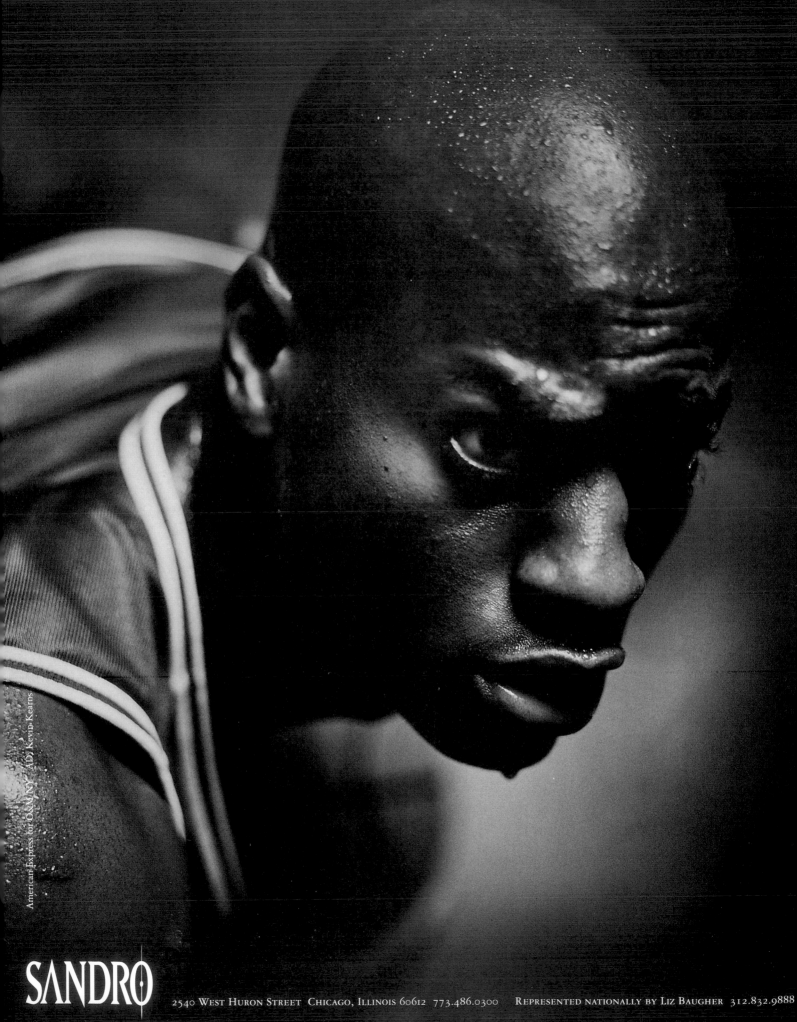

American Express for O&M/NY AD: Kevin Kearns

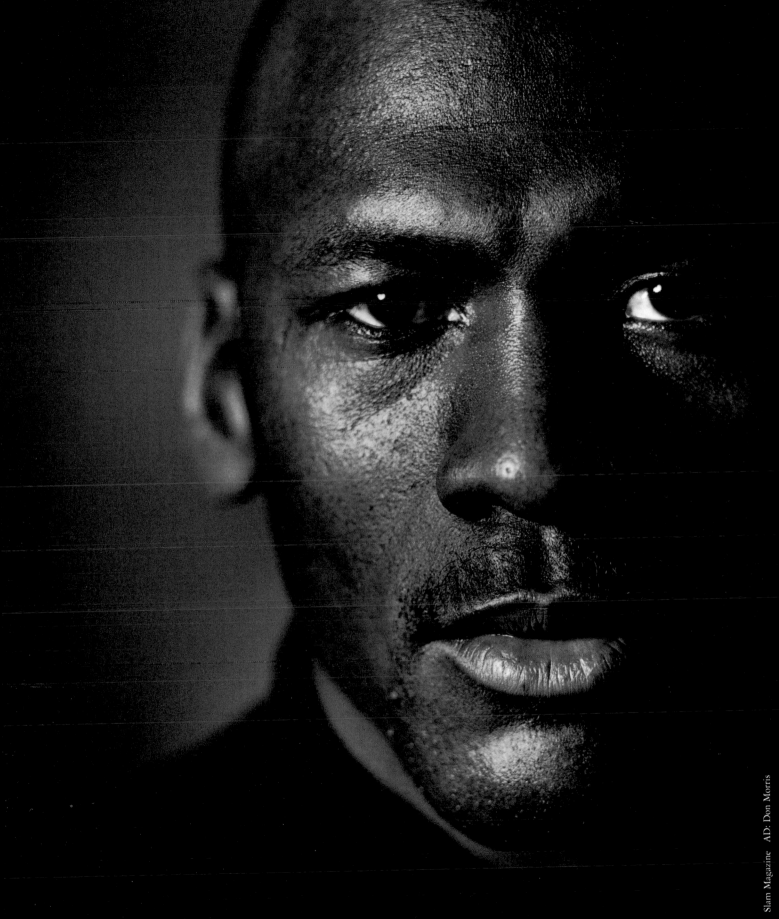

SANDRO

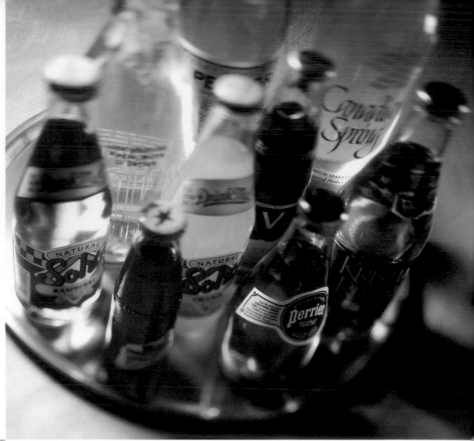

Scott Lanza

Studio 414-482-4114
Fax 414-482-3930

Represented by
Sandie Borowski 414-482-2941

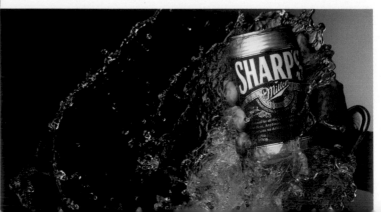

563

TRACEY THOMPSON SHOOTS:

food

still life

animals

products

J. Q. HAMMONS HOTELS, INC.

ITT SHERATON

HOLIDAY INN WORLDWIDE

REPRESENTED BY DIANN ROCHE
816-822-2024

1730 BROADWAY ▲ KANSAS CITY ▲ MISSOURI 64108 ▲ 816-221-5094

THOMPSON PHOTOGRAPHY

LALLO
■ ■ ■ ■ ■
PHOTOGRAPHY

Ed Lallo
816-523-6222
Represented by Diann Roche
816-822-2024

LALLO
PHOTOGRAPHY

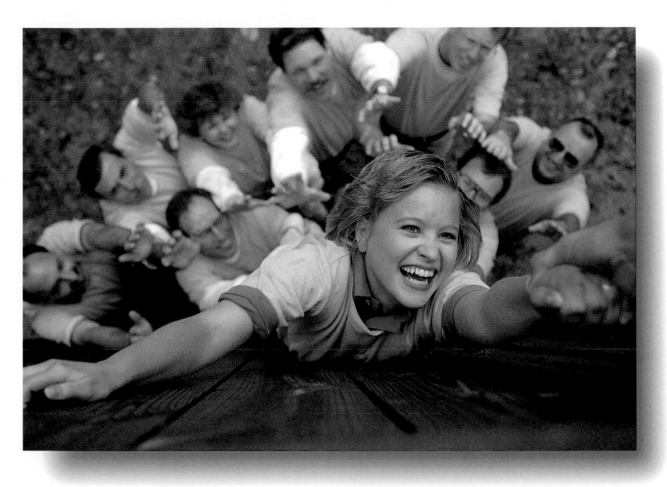

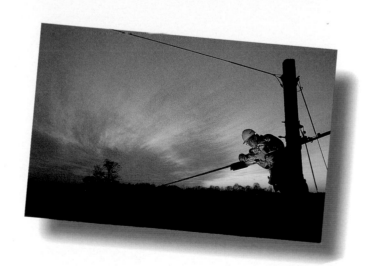

Ed Lallo
816-523-6222
Represented by Diann Roche
816-822-2024

567

Kathy Sanders

411 S. Sangamon St. • Chicago, IL 60607
312.829.3100 • Fax 312.829.3120

©Meredith Corp.

©Meredith Corp.

Kathy Sanders

411 S. Sangamon St. • Chicago, IL 60607
312.829.3100 • Fax 312.829.3120

©Meredith Corp.

©Meredith Corp.

JOEL
SHEAGREN

SACCO

Sacco Productions Limited

2035 West Grand Avenue

Chicago, Illinois 60612

Telephone: 312/243-5757

Fax: 312/243-5778

E mail: saccophoto@aol.com

Artist Representative Bob Wolter Telephone: 312/670-8770 Fax: 312/670-0905

Artist Representative Bob Wolter Telephone: 312/670-8770 Fax: 312/670-0909

SACCO

Sacco Productions Limited

2035 West Grand Avenue

Chicago, Illinois 60612

Telephone: 312/243-5757

Fax: 312/243-5778

E mail: saccophoto@aol.com

IF IT'S MOVING…

...I SHOOT IT!

RADLER

print and film

DAVID RADLER STUDIO 402-342-6230 FAX 402-342-3379
REPRESENTED IN NEW YORK BY GLYNIS VALENTI 800-950-7006

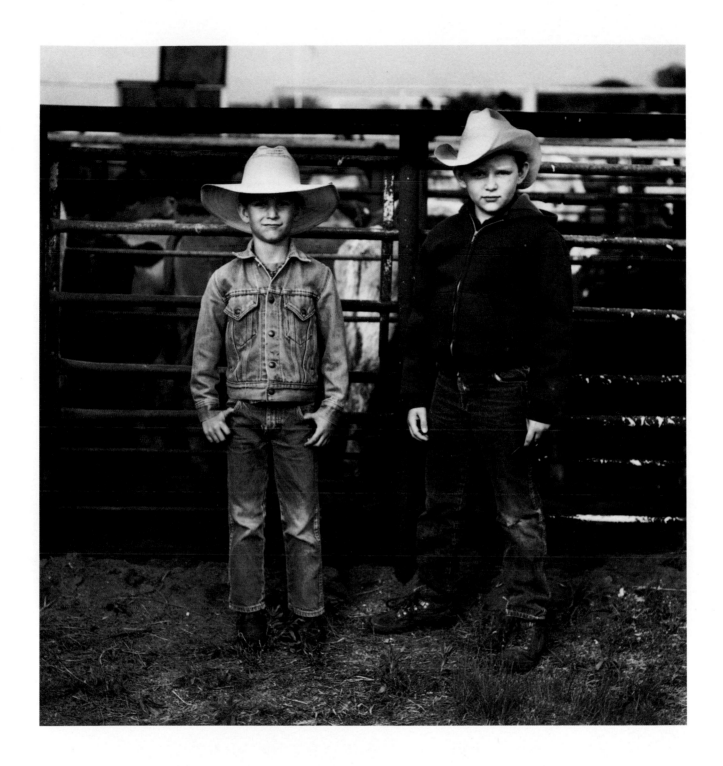

RADLER

print and film

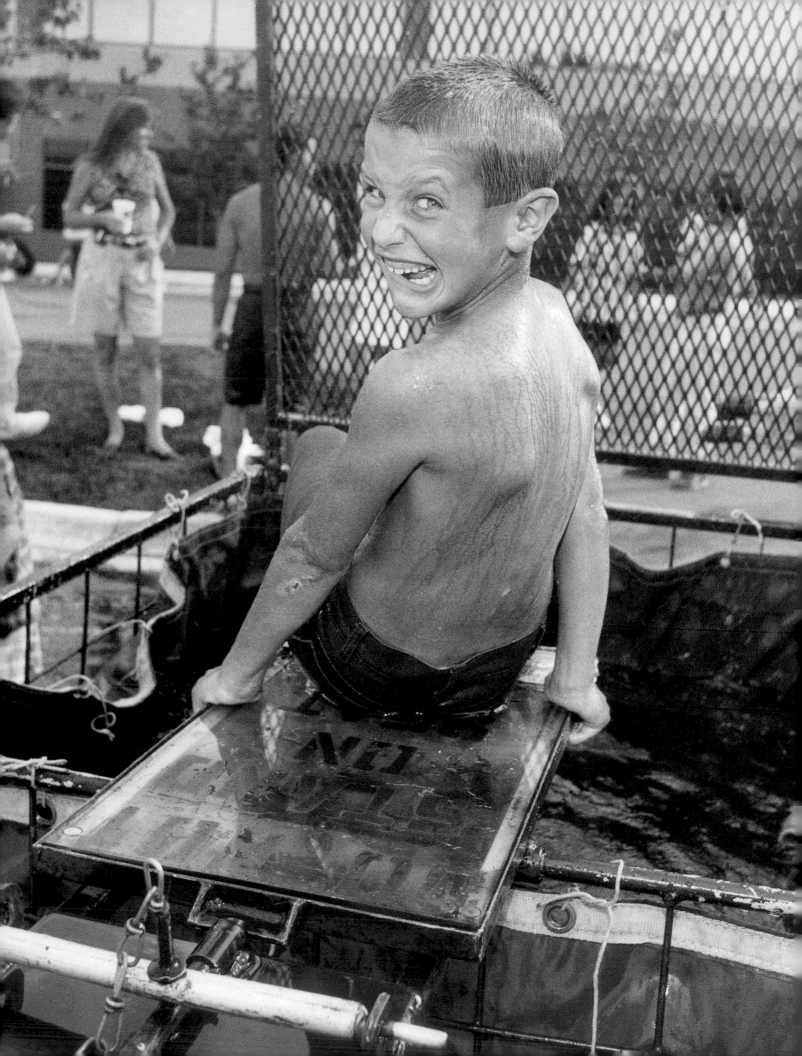

PETER THURIN PHOTOGRAPHY

312.957.1190

MIKE DITZ

PHOTOGRAPHY

photo Kevin Smith

Represented by
Anne Albrecht
312 595-0300
·
Studio
773 772-1113

Represented by Anne Albrecht
312 595-0300
Studio 773 772-1113

GARY HANNABARGER PHOTOGRAPHY
phone: 773.202.8197

represented by ANNE ALBRECHT AND ASSOCIATES
phone: 312.595.0300

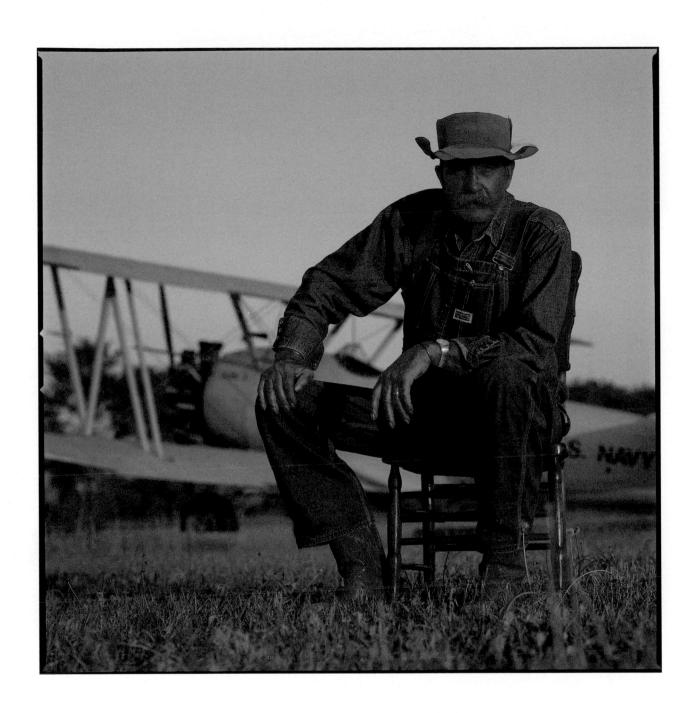

GARY HANNABARGER PHOTOGRAPHY
phone: 773.202.8197

represented by ANNE ALBRECHT AND ASSOCIATES
phone: 312.595.0300

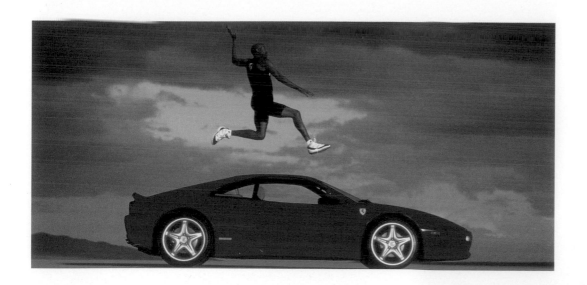

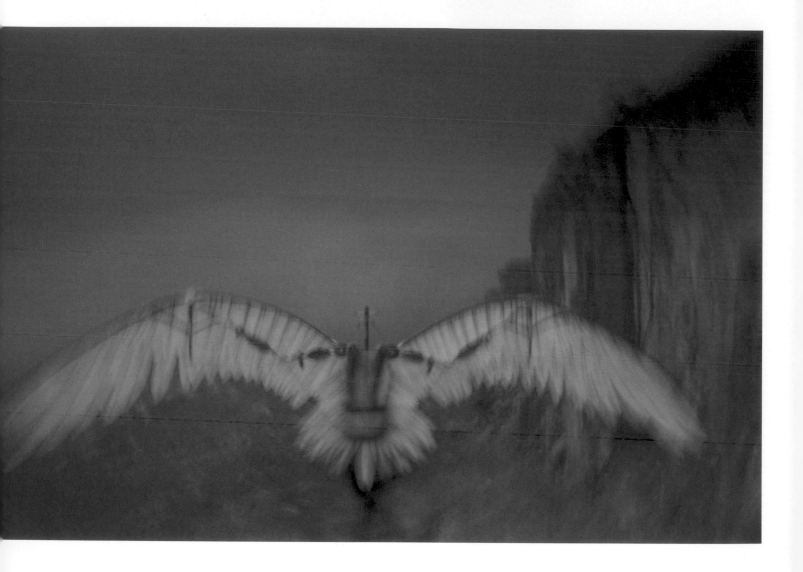

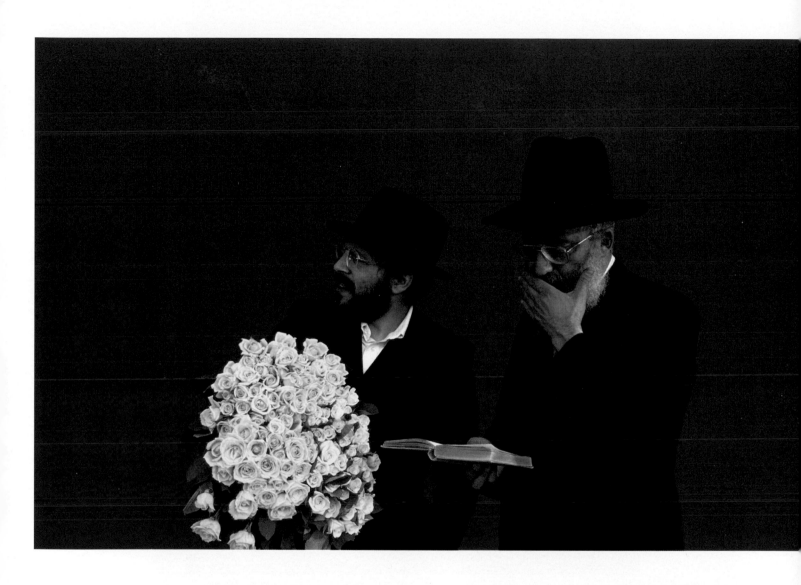

TONY D'ORIO

Studio (312) 421-5532 *Fax (312) 421-8063*

Represented by: Atols & Hoffman (312) 222-0504 Fax (312) 222-0503
In the East: Gary Hurewitz & Associates (212) 764-0004 Fax (212) 764-0002

TONY D'ORIO

Studio (312) 421-5532 Fax (312) 421-8063

Represented by: Atols & Hoffman (312) 222-0504 Fax (312) 222-0503
In the East: Gary Hurewitz & Associates (212) 764-0004 Fax (212) 764-0002

ARCIERO

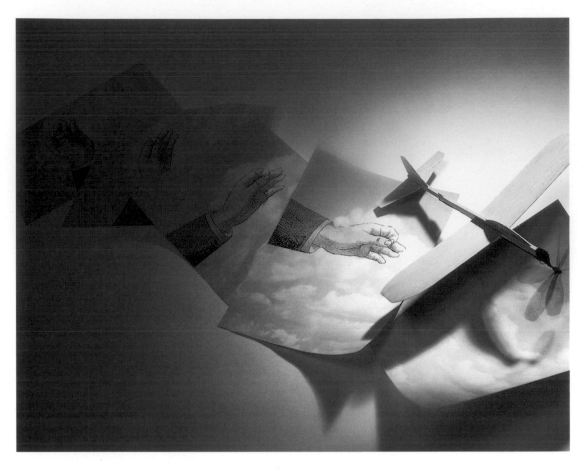

TODD DAVIS
PHOTOGRAPHY

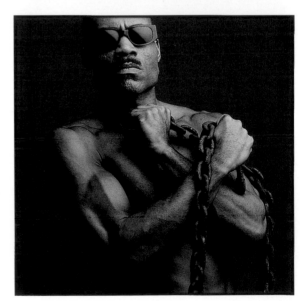

REPRESENTED BY JON MENDELSON
P 314.241.6767 F 314.241.6355

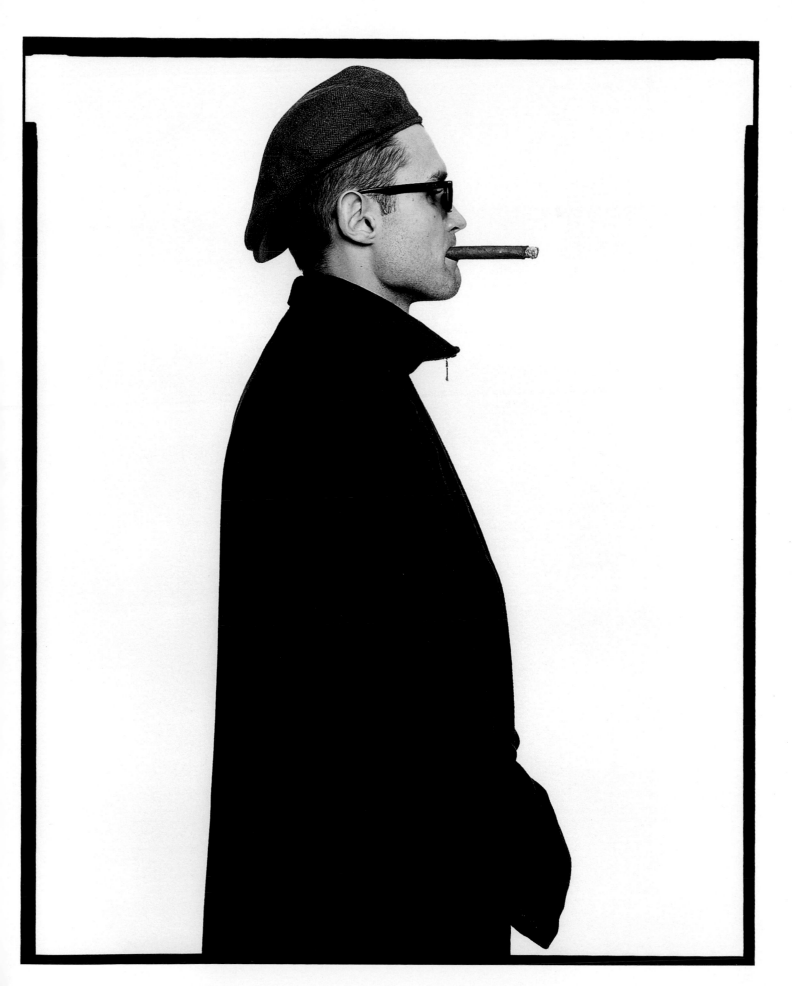

595

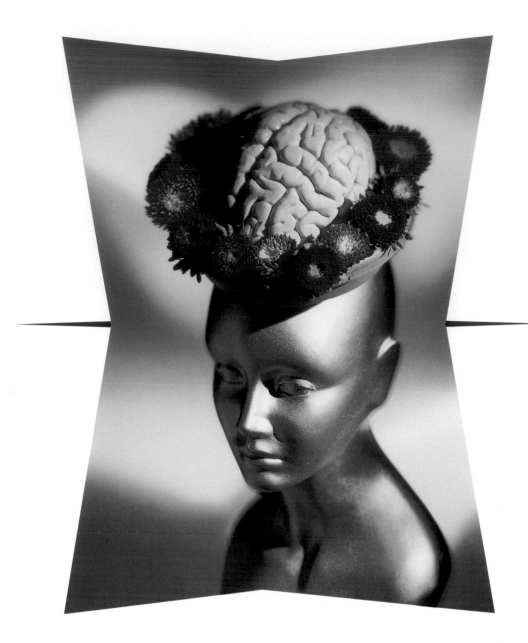

Ellie.

ELLIE KINGSBURY PICTURES

tel 612.926.7705
fax 612.926.7721

SHIGETA REPRESENTS
312-642-8715

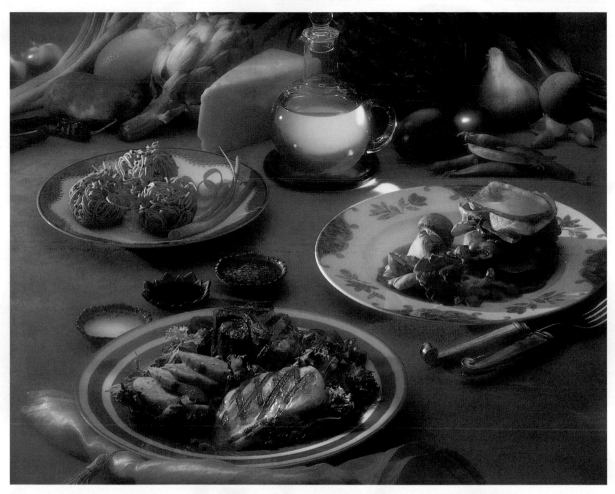

BRUCE ANDREWS

DAVID MOREY

BRUCE ANDREWS
REPRESENTED BY SHIGETA 312-642-8715

DAVID MOREY
REPRESENTED BY SHIGETA 312-642-8715

DREW ENDICOTT

t. 317-841-0057 *f.* 317-841-3592

www.elpimagesight.com

larry ladig t.317-841-0057 f.317-841-3592
www.elpimagesight.com

LADIG

▣ PAUL POPLIS PHOTOGRAPHY 614·860·0088 FAX: 614·860·0155 COLUMBUS

PAUL POPLIS PHOTOGRAPHY 614·860·0088 FAX: 614·860·0155 COLUMBUS

PHOTOGRAPHY
STAGE 3 PRODUCTIONS
CONVENTIONAL.
DIGITAL. VIRTUAL.

CHRISTOPHER CLOR
810.978.7373

CHRISTOPHER CLOR

810.978.7373

PHOTOGRAPHY
STAGE 3 PRODUCTIONS
CONVENTIONAL.
DIGITAL. VIRTUAL.

GRAND PRIX SE

1001 washington ave so

minneapolis mn 55415

phone 612-339-9191

fax 612-339-9009

WESTERMAN

WESTERMAN

RYAN ROESSLER

Studio: 773-404-2300 East Coast: Watson & Speirman 212-431-4480 West Coast: Marni Hall & Assoc. 310-652-7322
United Kingdom: The Special Photographers Company 0171-221-3489

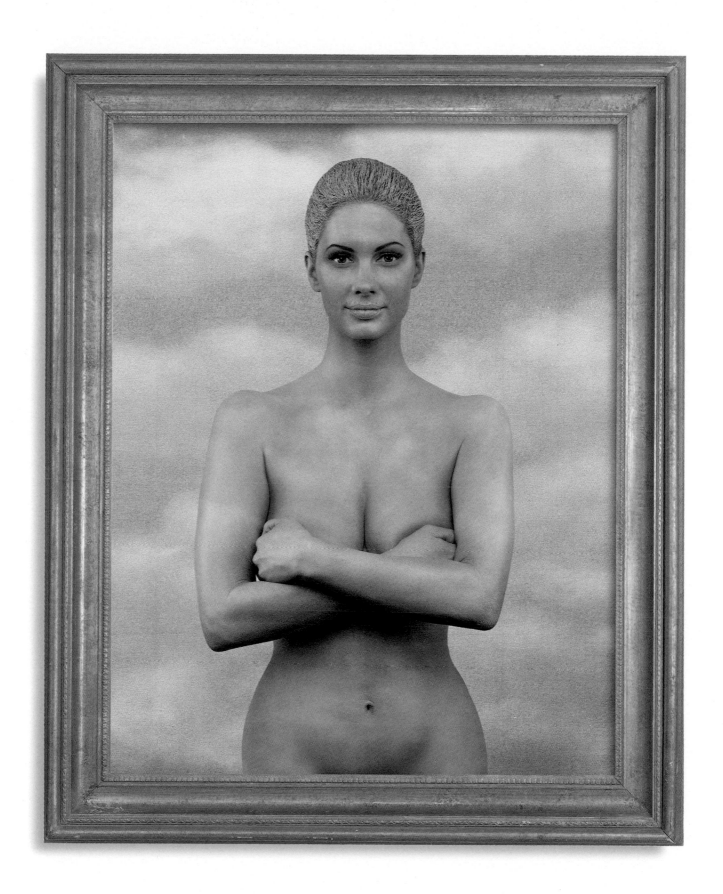

RYAN ROESSLER

Studio: 773-404-2300 East Coast: Watson & Speirman 212-431-4480 West Coast: Marni Hall & Assoc. 310-652-7322
United Kingdom: The Special Photographers Company 0171-221-3489

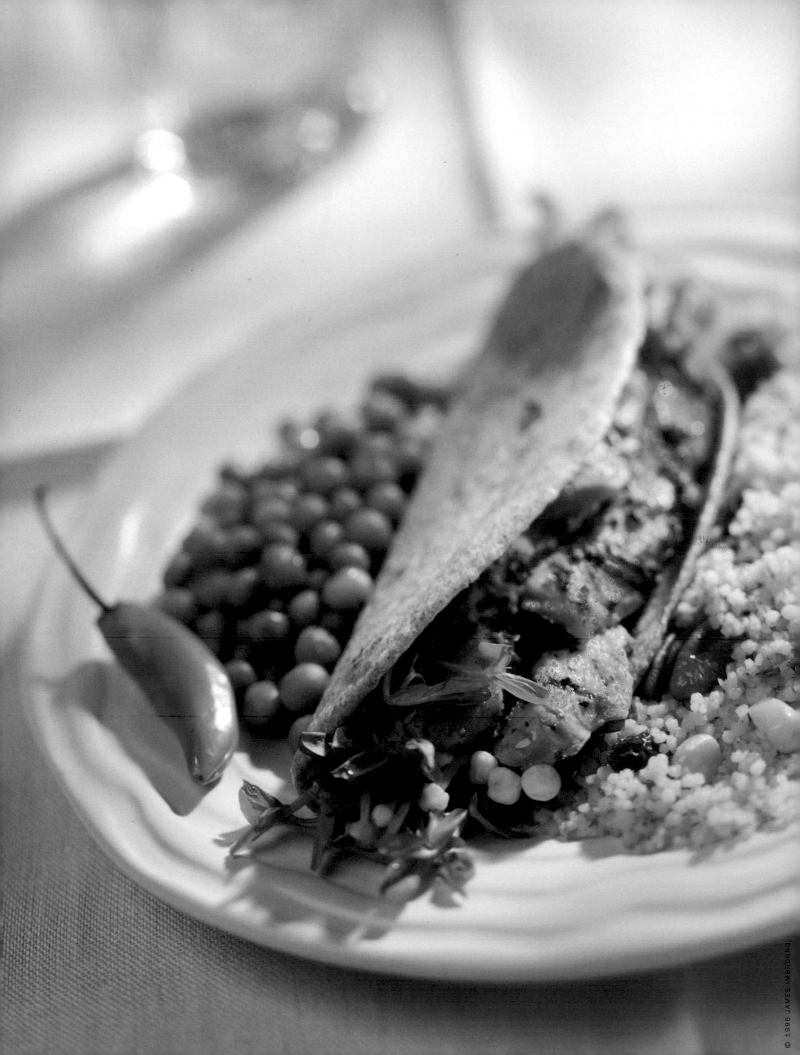

EWERT

Steve Ewert Productions 17 North Elizabeth, Chicago, 312.733.5762 Web Page: http://www.creativedir.com

Baditoi

DAVID BADITOI 810•628•1050

CLIENT LIST: AT&T · GENERAL MOTORS · EXXON CORP · IBM · CAR & DRIVER MAGAZINE · FORD MOTOR CO
ENTREPRENEUR MAGAZINE · PPG INDUSTRIES · SELF MAGAZINE · CHRYSLER CORP · AUTOMOBILE MAGAZINE
MASCO CORP · CIO MAGAZINE · BEYOND COMPUTING MAGAZINE · UNISYS CORP

ZALBEN
DAVID ZALBEN PHOTOGRAPHY

312 226-7521

STEPHEN KENNEDY PHOTOGRAPHY
ST. LOUIS, MISSOURI. 314 621-6545

Location: ST. CHARLES, MISSOURI

Subject: FLOOD FISHERMAN

5-5327

| 1 | 2 | 3 | 4 | 5 | 6 | 7 | 8 | 9 | 10 | 11 | 12 | AM | P |

Represented in the West by Freda Scott, San Francisco, 415 398-9121

STEPHEN KENNEDY PHOTOGRAPHY
ST. LOUIS, MISSOURI. 314 621-6545

Location: **POCAHONTAS, ILLINOIS**

Subject: **LICENSE PLATE MAN**

5-5552

| 1 | 2 | 3 | 4 | 5 | 6 | 7 | 8 | 9 | 10 | 11 | 12 | AM | FM |

Represented in the West by Freda Scott, San Francisco, 415 398-9121

Mark LaFavor
514 North Third Street Minneapolis, MN 55401
Ph. 612.904.1750 Fax 612.904.0594

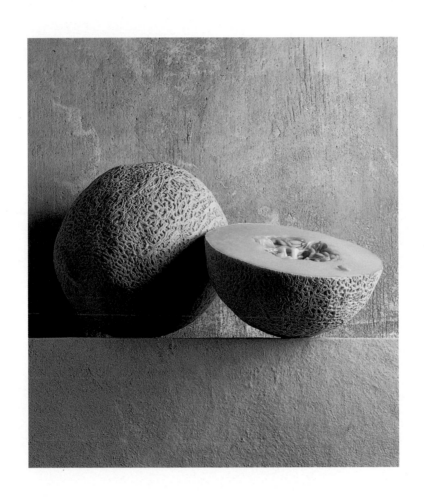

HOWARD BJORNSON INC.
PHONE 312.243.8200
REPRESENTED BY
LINDA THOMSEN
PHONE 312.832.1155

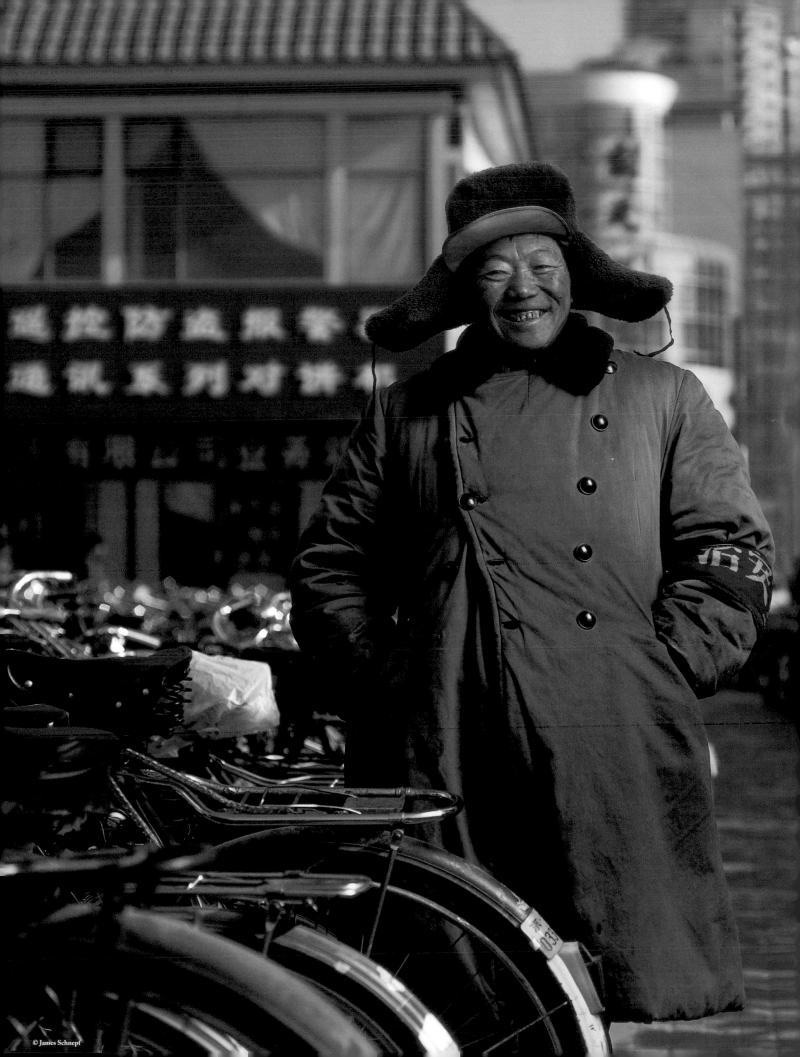

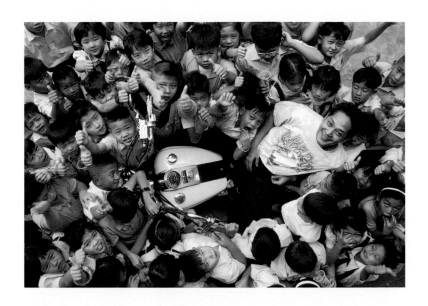

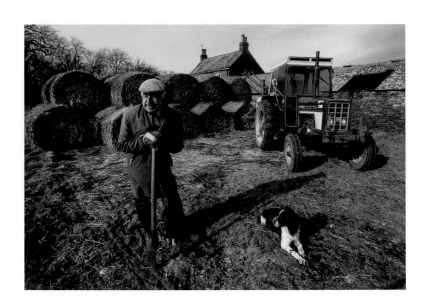

JAMES
SCHNEPF

414 691 3980

In Chicago call LINDA THOMSEN *312 832 1155*

SCOTT SIMMS

312 633 0955

SCOTT SIMMS

312 633 0955

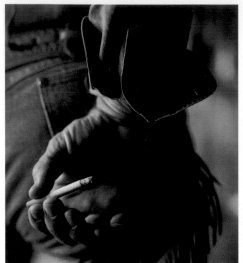

©Philip Morris

KRANTZ

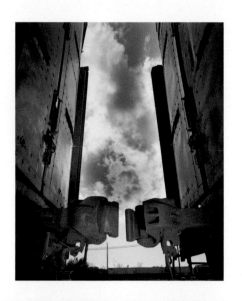

KRANTZ

JIM KRANTZ 402 734-4848

Perman.

Craig Perman Pictures, Minneapolis 612.338.7727 Represented in the east by John Kenney 914.962.0002

Pictures.

Craig Perman Pictures, Minneapolis 612.338.7727 Represented in the east by John Kenney 914.962.0002

SCOTT LANE

REPRESENTED BY

MORAWSKI

MORAWSKI AND ASSOCIATES

810.589.8050

FAX 810.589.8052

http://www.morawski.com

STEVE PETROVICH

REPRESENTED BY

MORAWSKI

MORAWSKI AND ASSOCIATES

810.589.8050

FAX 810.589.8052

http://www.morawski.com

Karen Melvin

612 • 379 • 7925

TONY GLASER PHOTOGRAPHY

TELEPHONE 312.421.1518 TELEFAX 312.733.4488
REPRESENTED BY BUNNY FISHER 312.280.1961

TONY GLASER PHOTOGRAPHY

TELEPHONE 312.421.1518 TELEFAX 312.733.4488

REPRESENTED BY BUNNY FISHER 312.280.1961

649

PAUL ELLEDGE PHOTOGRAPHY
1808 WEST GRAND AVENUE
CHICAGO ILLINOIS 60622
TEL 312 733 8021 FAX 312 733 3547
REPRESENTED IN THE EAST BY
JOHN KENNEY & DEBORAH CLIFFORD
TEL 212 517 4714 TEL 914 962 0002

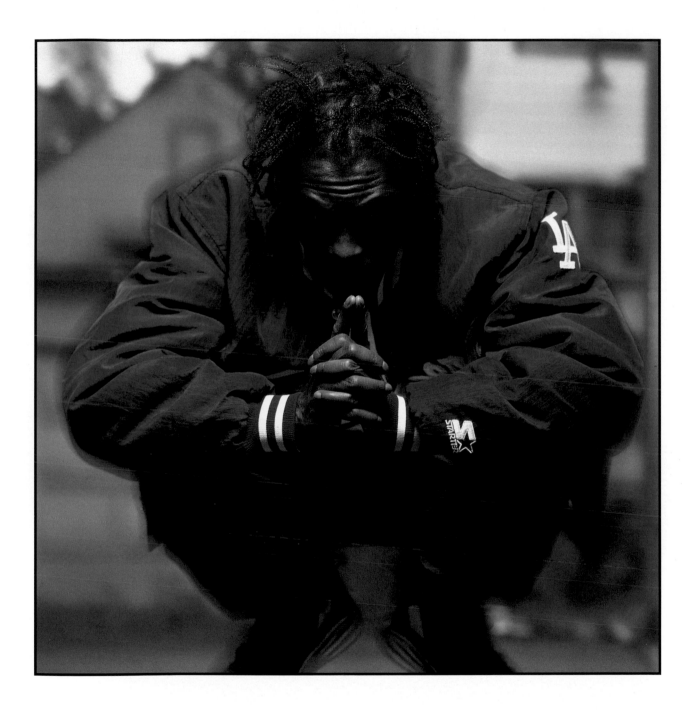

PAUL ELLEDGE PHOTOGRAPHY
1808 WEST GRAND AVENUE
CHICAGO ILLINOIS 60622
TEL 312 733 8021 FAX 312 733 3547
REPRESENTED IN THE EAST BY
JOHN KENNEY & DEBORAH CLIFFORD
TEL 212 517 4714 TEL 914 962 0002

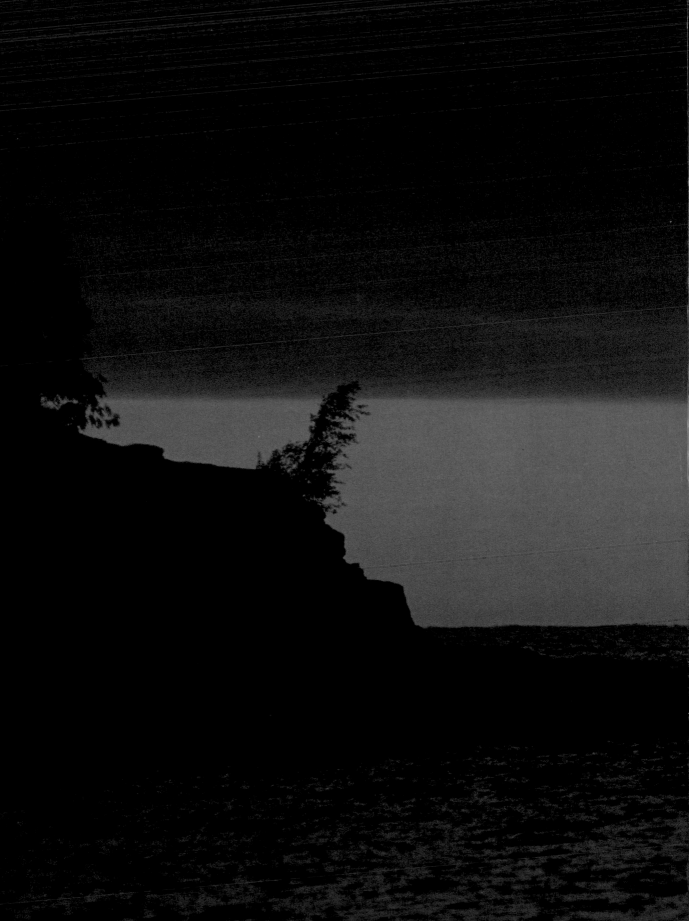

association with Rajtar Productions | Doug Baartman [612] 542-1972, John Rajtar [612] 376-7637

forget about

the awards

the flight out here

the weather

consume your surroundings

trust your instincts

be real

BARTMAN

PHOTOGRAPHY

what are you feeling

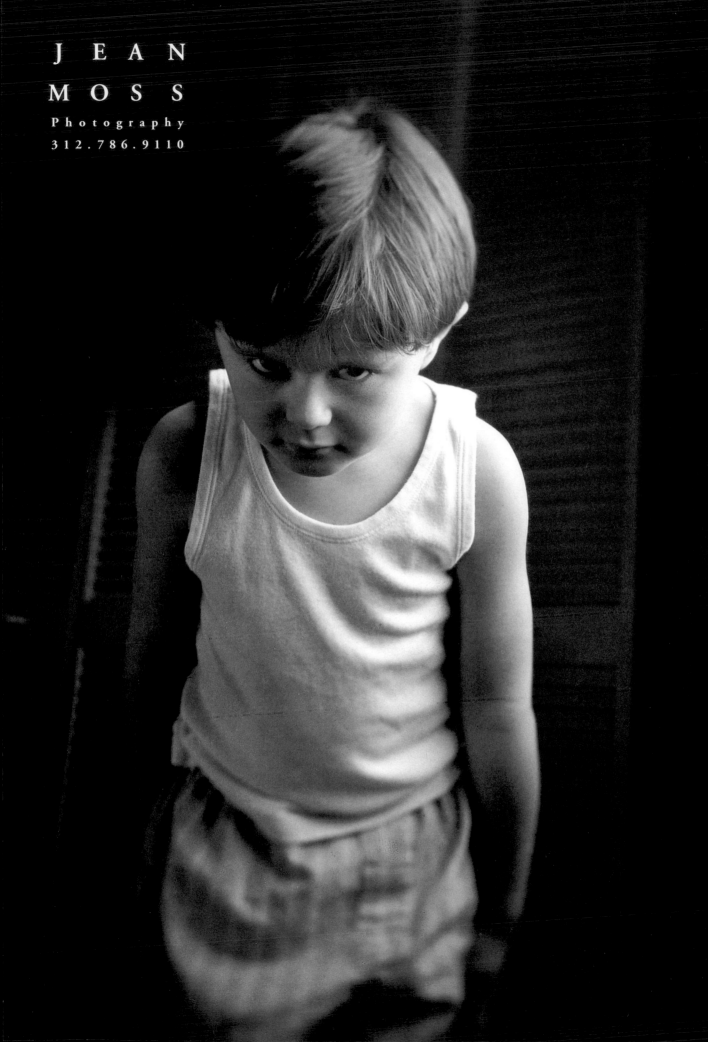

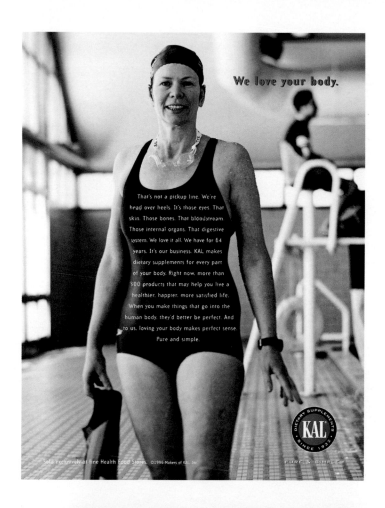

We love your body.

That's not a pickup line. We're head over heels. It's those eyes. That skin. Those bones. That bloodstream. Those internal organs. That digestive system. We love it all. We have for 64 years. It's our business. KAL makes dietary supplements for every part of your body. Right now, more than 300 products that may help you live a healthier, happier, more satisfied life. When you make things that go into the human body, they'd better be perfect. And to us, loving your body makes perfect sense. Pure and simple.

KAL
DIETARY SUPPLEMENTS
SINCE 1932
PURE & SIMPLE™

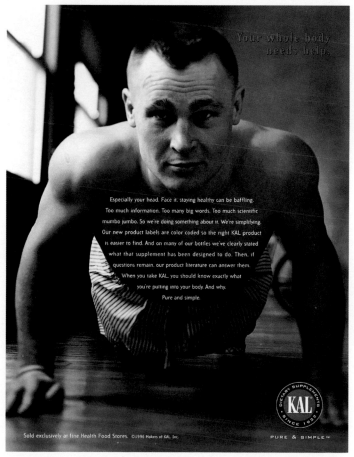

Your whole body needs help.

Especially your head. Face it, staying healthy can be baffling. Too much information. Too many big words. Too much scientific mumbo jumbo. So we're doing something about it. We're simplifying. Our new product labels are color coded so the right KAL product is easier to find. And on many of our bottles we've clearly stated what that supplement has been designed to do. Then, if questions remain, our product literature can answer them. When you take KAL, you should know exactly what you're putting into your body. And why. Pure and simple.

KAL
DIETARY SUPPLEMENTS
SINCE 1932
PURE & SIMPLE™

Nationally represented by Joel Harlib 312.573.1370 fax 312.573.1445

markWiens
photography

Linda Pool Represents 816.761.7314 Studio 816.931.4447

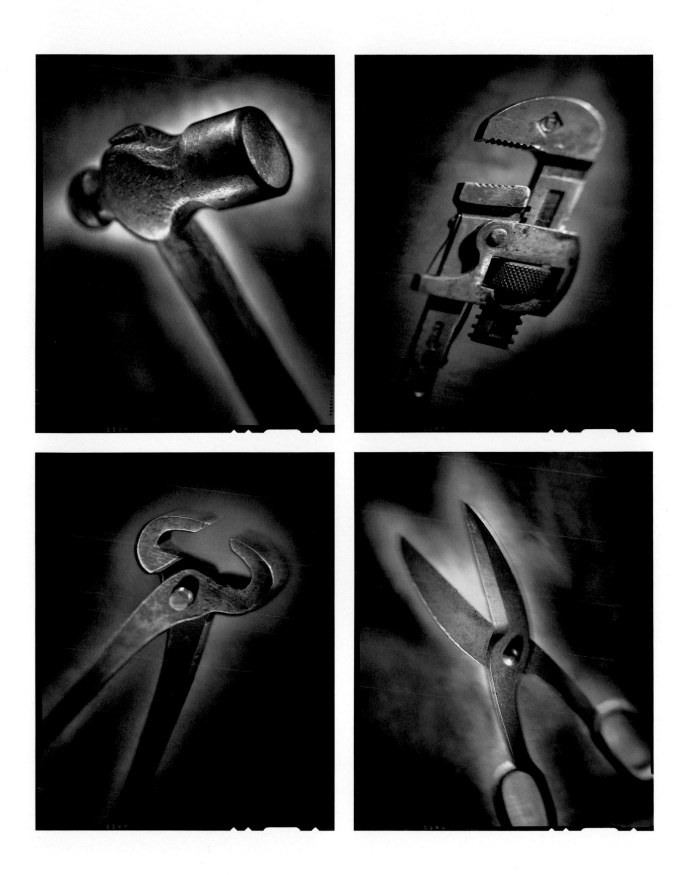

MARKWIENS
photography

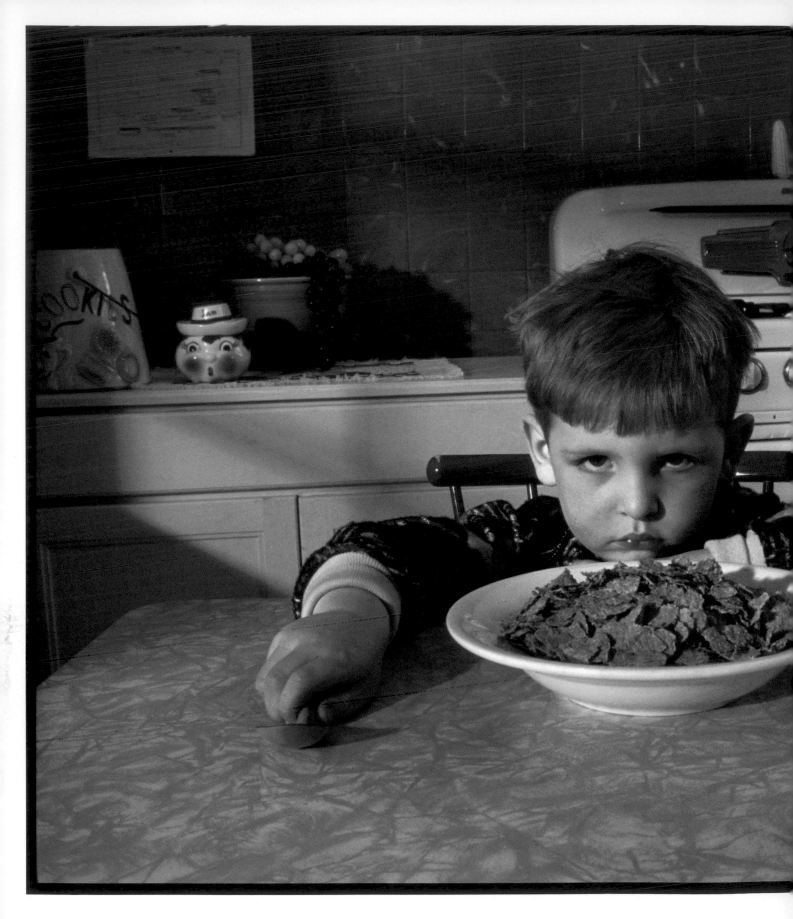

CARL
COREY

V 612 225 8384 F 612 225 8630

CAUSE

The New Orleans Artists
Against Hunger and
Homelessness, NOAHH
504-861-5834

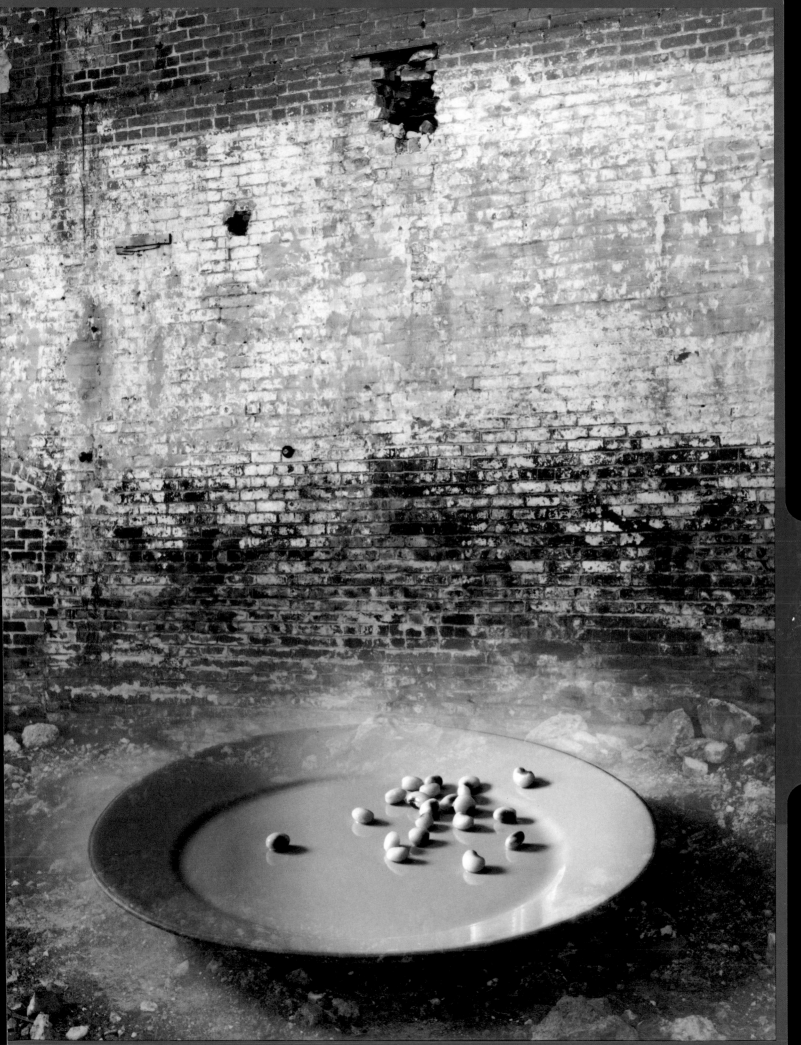

SOUTHERN STATES
Alabama
Arkansas
Florida
Georgia
Kentucky
Louisiana
Mississippi
North Carolina
South Carolina
Tennessee
Texas
Virginia

*Artist's Rep

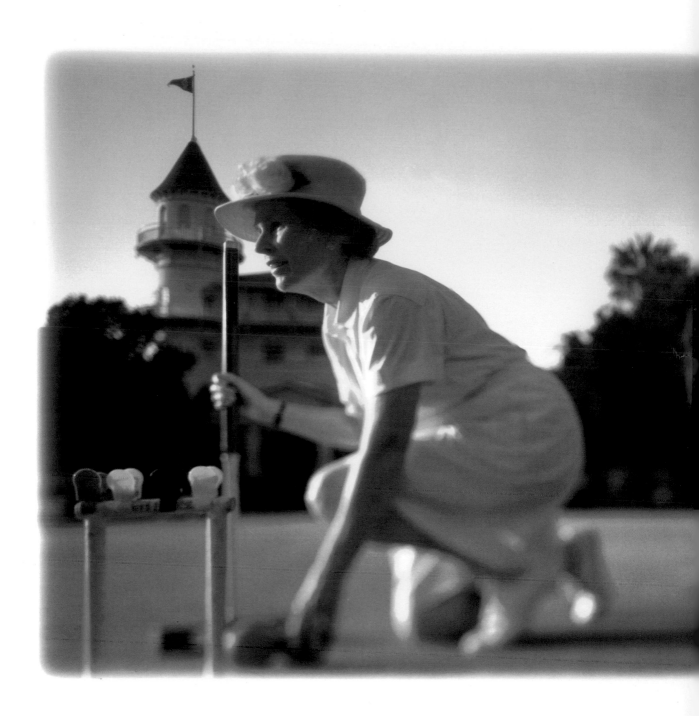

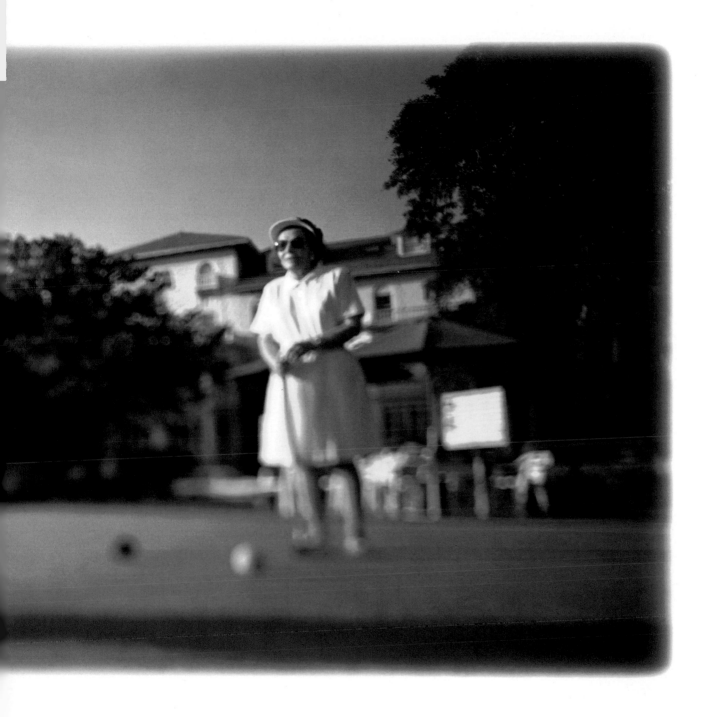

JAYTHOMAS PRODUCTIONS

ATLANTA, GEORGIA 770-429-8870

[Dick Patrick]

Representative / Denise Ford Studio / 214 / 638 / 8394

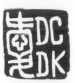

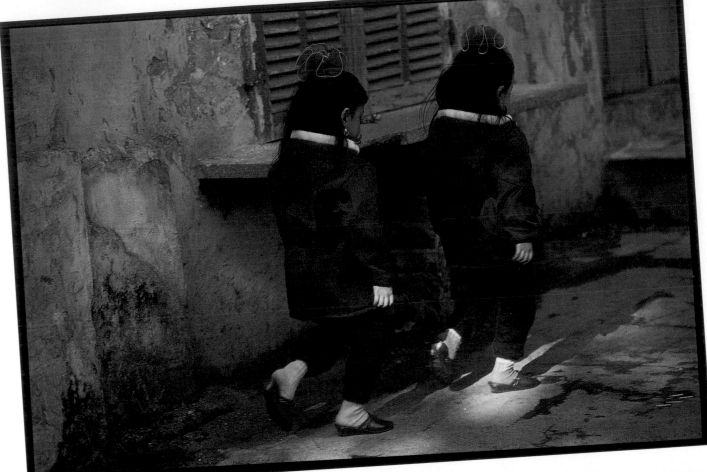

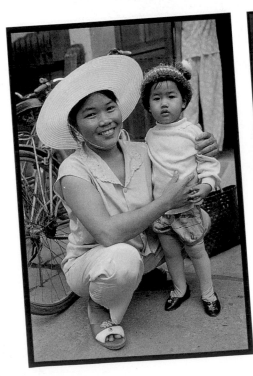

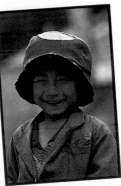

CODY

CODY

dennie & d.k.
on the go
©
305-666-0247

669

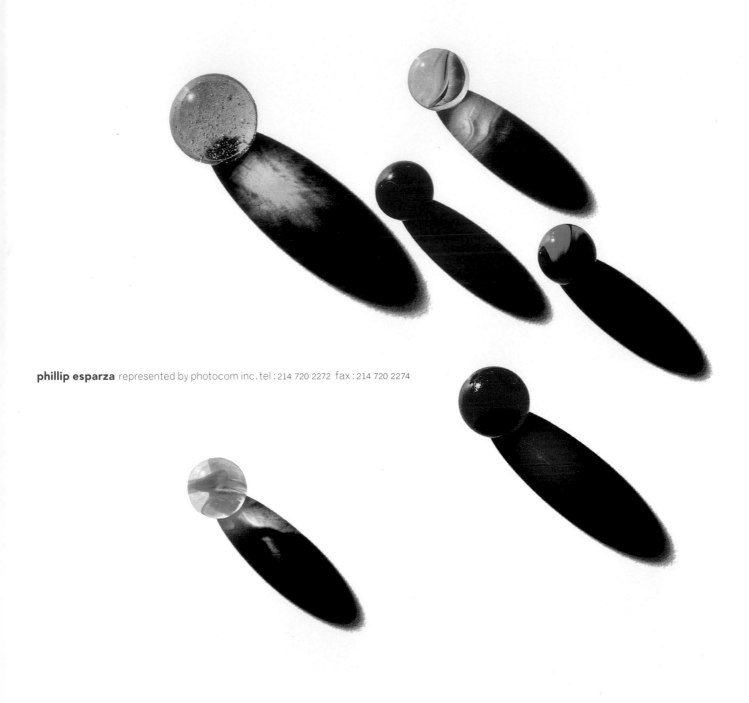

phillip esparza represented by photocom inc.tel : 214 720 2272 fax : 214 720 2274

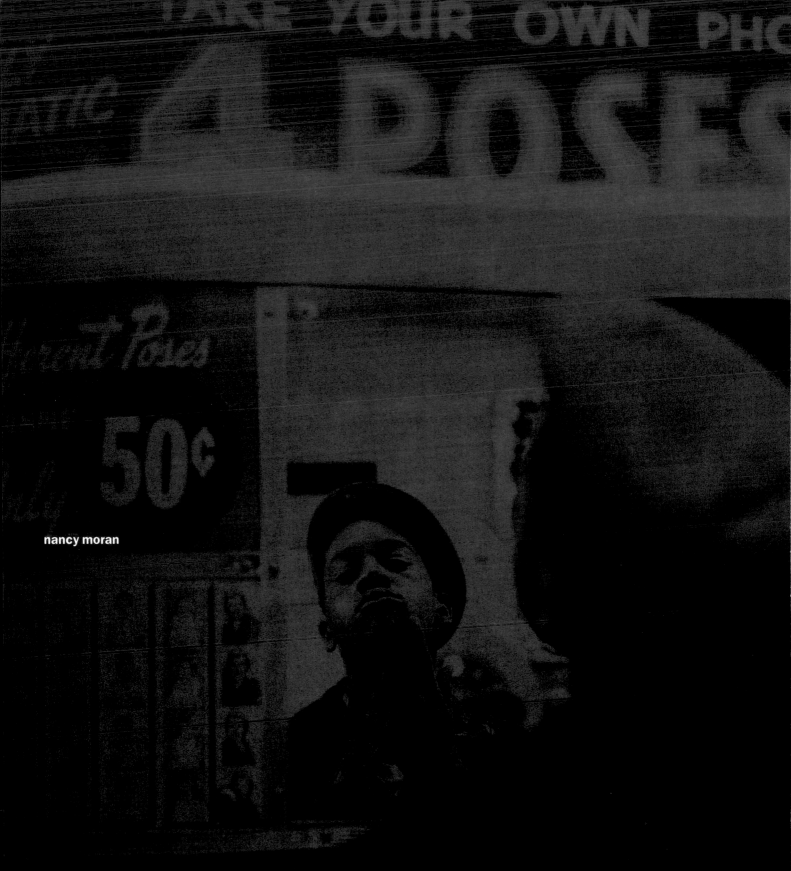

represented by photocom inc.tel : 214 720 2272 fax : 214 720 2274

in new york by carol cohn reps tel : 212 924 4450 fax : 212 645 2059

STEVE UZZELL
703.709.1139

STEVE UZZELL
703.709.1139

675

STEVE CHENN
FAX (713) 271-5918
(713) 271-0631

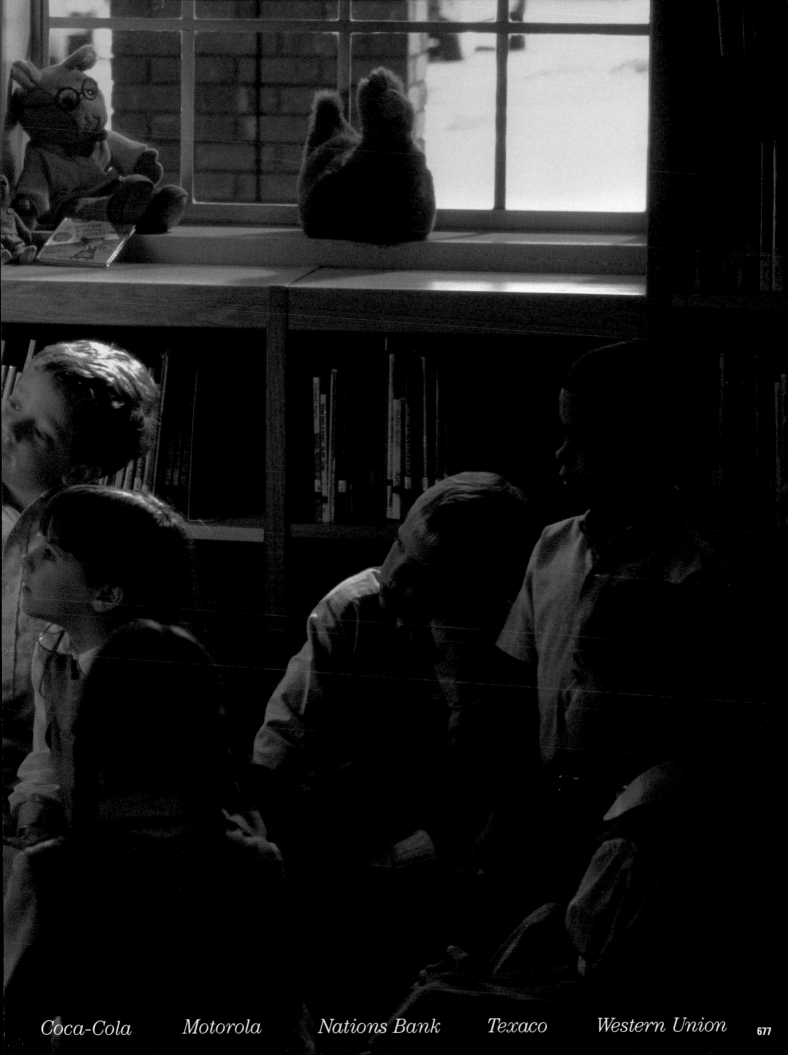

Coca-Cola Motorola Nations Bank Texaco Western Union 677

WiLL WILL CROCKER

504 522 2651

NEW ORLEANS

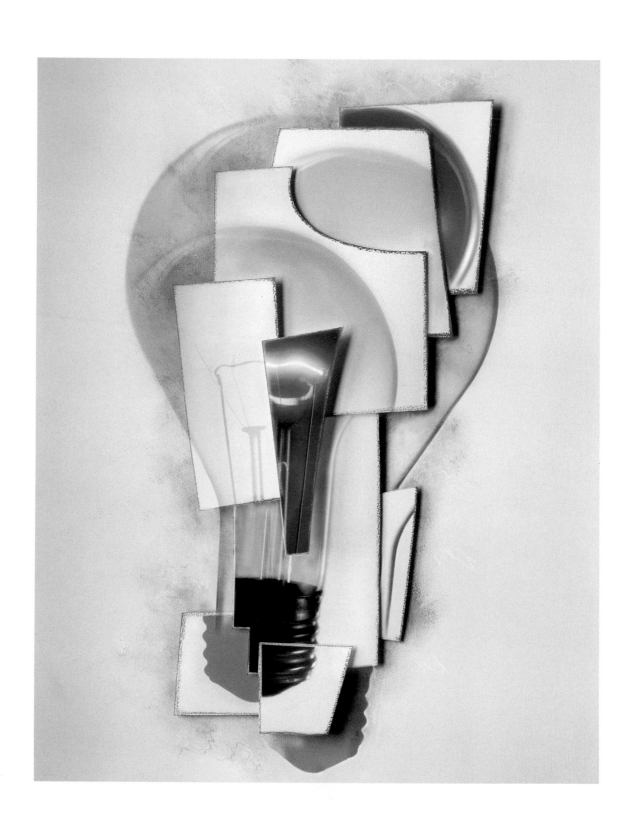

504 522 2651 WILL CROCKER

NEW ORLEANS

ROSSANDERSON

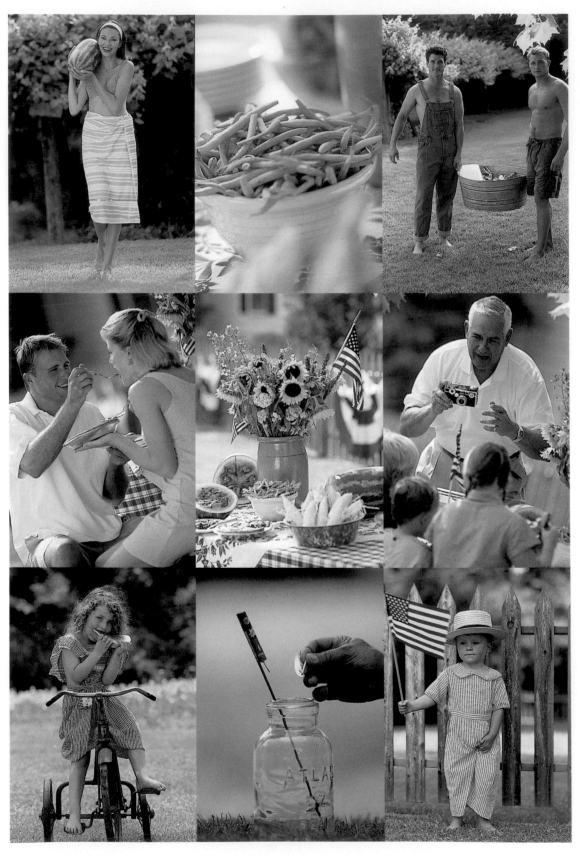

ATLANTA

4 0 4 • 8 8 1 • 5 3 0 3

PRINT & FILM

ROSSANDERSON

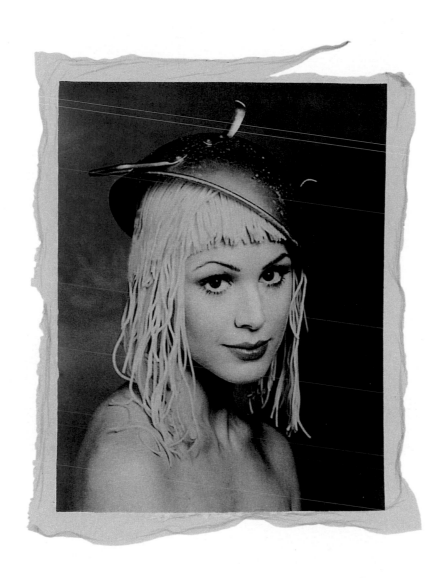

ATLANTA

4 0 4 • 8 8 1 • 5 3 0 3

PRINT & FILM

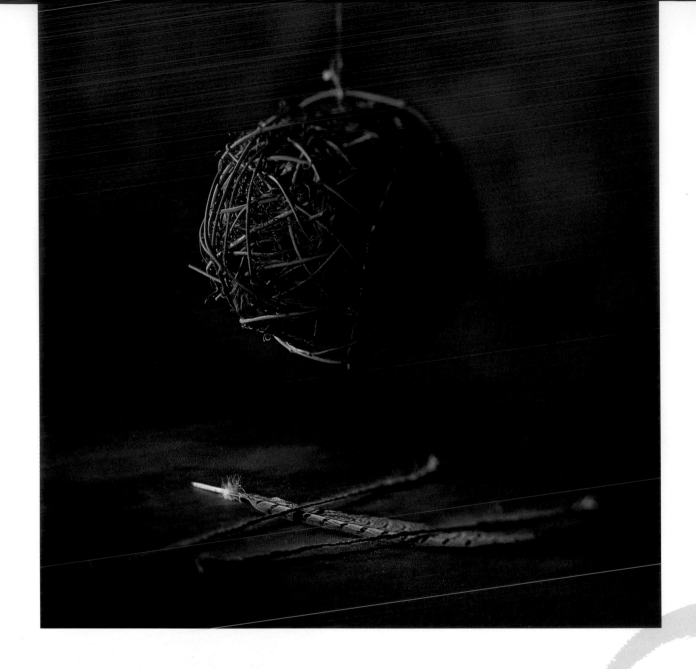

Bruce DeBoer
STONE SOUP PRODUCTIONS
Raleigh, North Carolina
Represented by
Joan Carelas and David Custack: 919 833-6659
fax: 919 833-7767 e-mail: StoneSoupP@aol.com

Charles Harris
STONE SOUP PRODUCTIONS
Raleigh, North Carolina
Represented by
Joan Carelas and David Custack: 919 833-6659
fax: 919 833-7767 e-mail: StoneSoupP@aol.com

Robert Holland, South Florida 561 220 3667

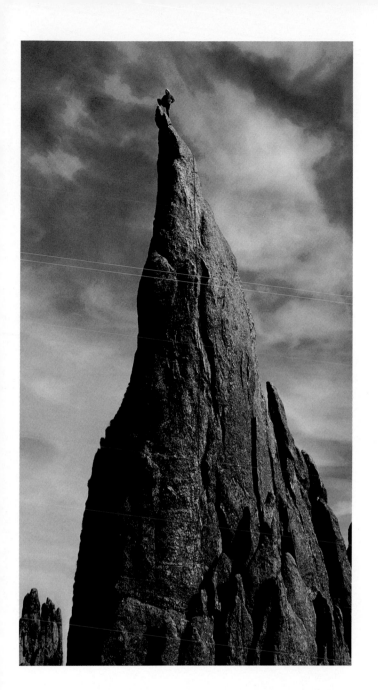

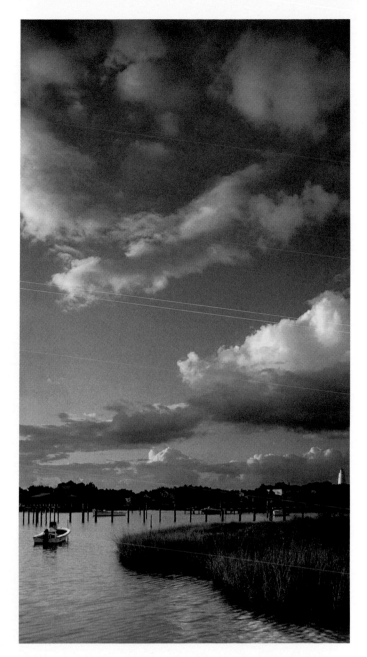

STEVE MURRAY

World Class Location Photography™

TELEPHONE: 919 828 0653

FAXIMILE: 919 828 8635

STOCK AVAILABLE THROUGH

PICTURESQUE: 800 450 3377

REPRESENTED IN THE SOUTH

BY ARTLINE: 704 376 7609

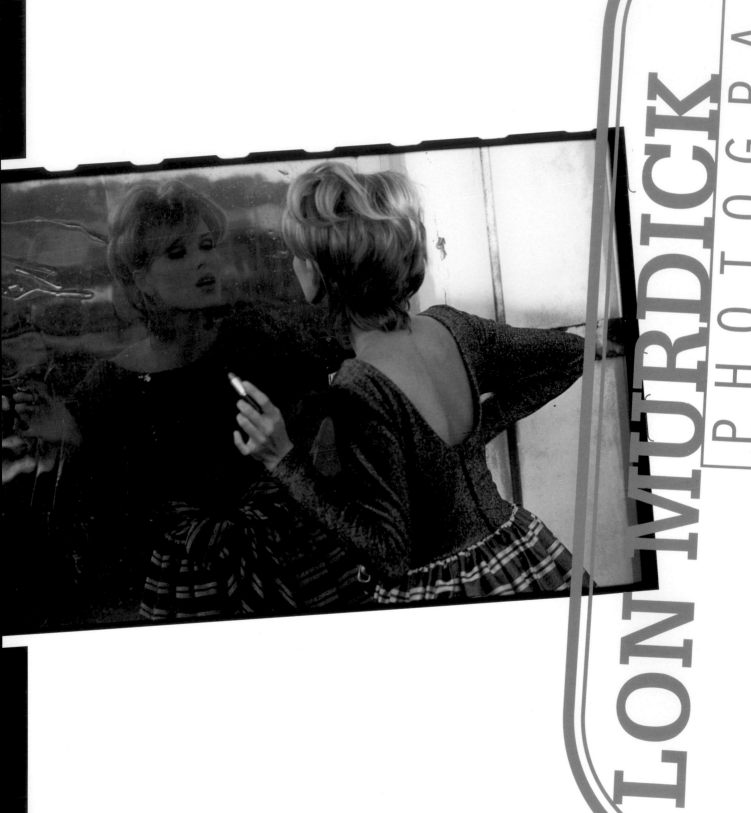

LON MURDDICK PHOTOGRAPHY

PHOTOGRAPHY IS NOT A MIRROR.

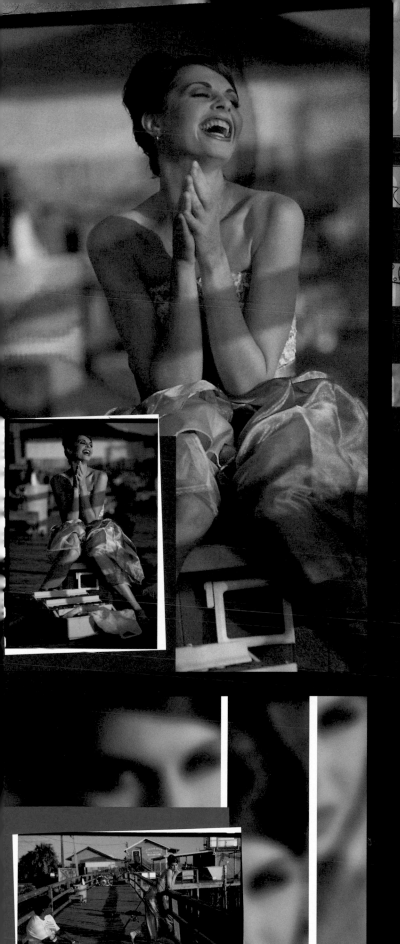

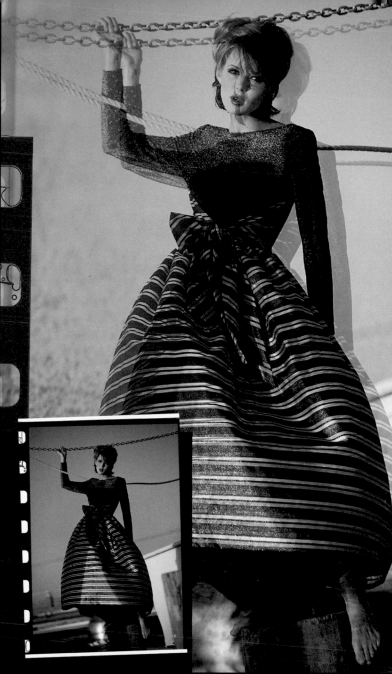

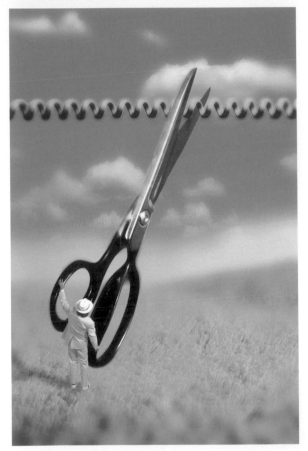

PEARLE PRODUCTIONS

REPRESENTED BY
L. JANE MILLS CO.
214-946-6569
FAX 214-946-6568
STUDIO 214-943-1339
HTTP://RAMPAGES.ONRAMP.NET/~PEARLE

CLIENTS INCLUDE: PEPSI, NIKE, GTE, NORTEL, McCANN ERICKSON, DDB NEEDHAM, KNIGHT RIDDER & SONY

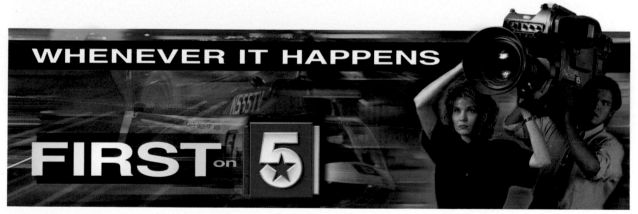

WHENEVER IT HAPPENS
FIRST on 5

PEARLE PRODUCTIONS

REPRESENTED BY
L. JANE MILLS CO.
214-946-6569
FAX 214-946-6568
STUDIO 214-943-1339
HTTP://RAMPAGES.ONRAMP.NET/~PEARLE

CLIENTS INCLUDE: TEXAS INSTRUMENTS, AMERICAN AIRLINES, MCI, ADIDAS, GATORADE, GSD&M, BANK ONE

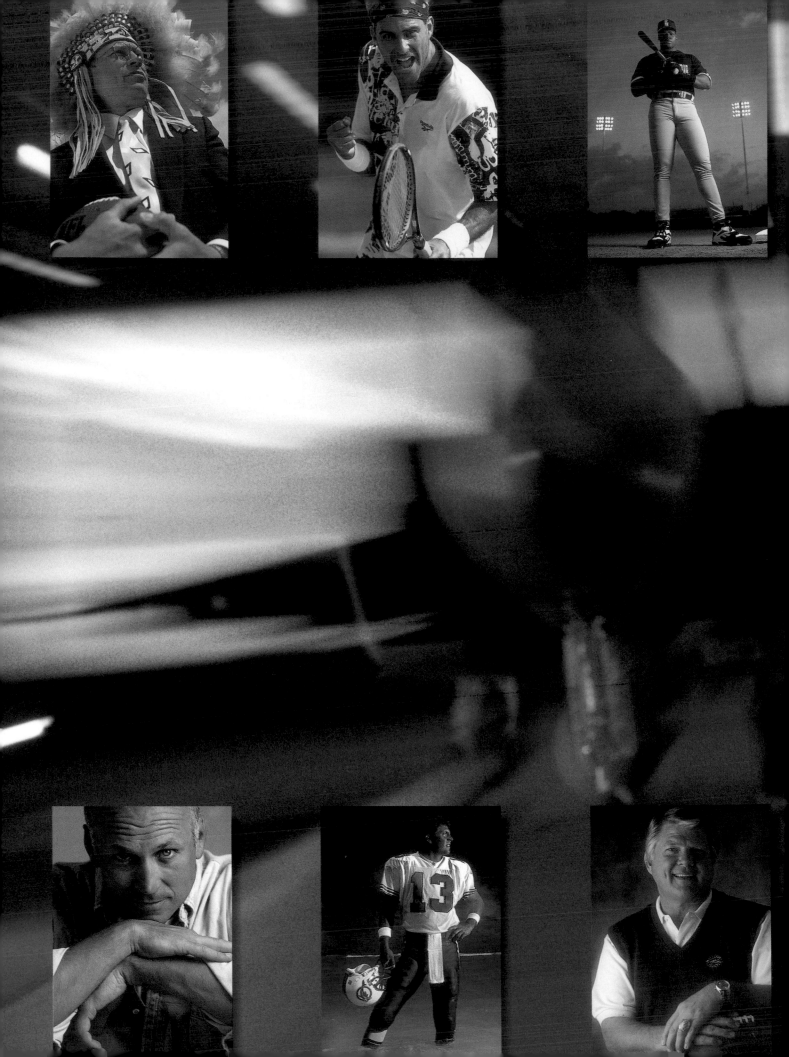

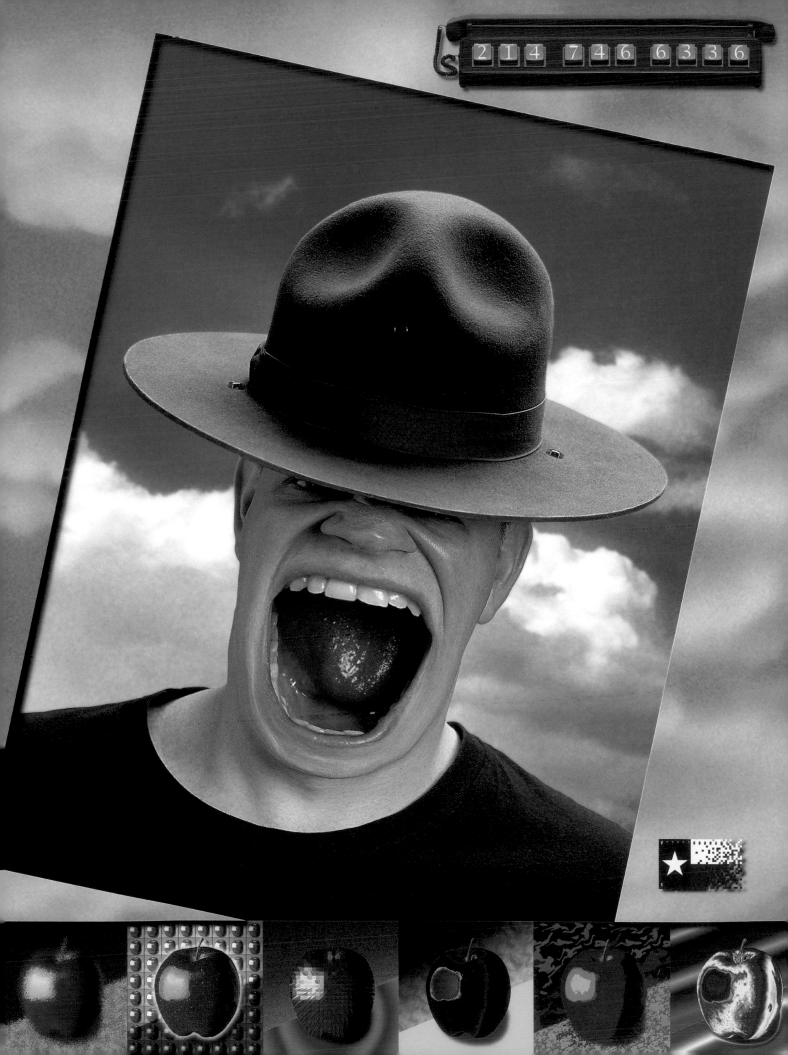

214 746 6336

J. W. BURKEY

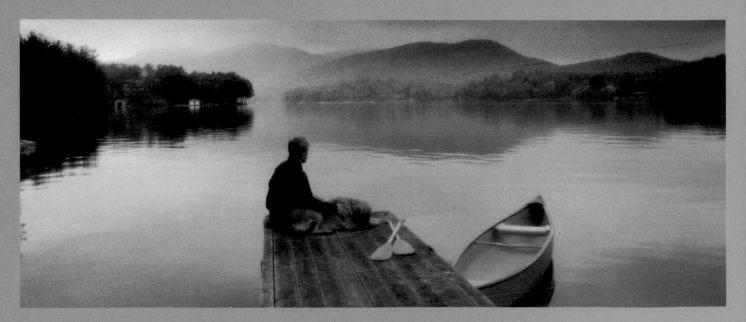

C H I P H E
103 QUID COURT CARY, NORTH CAROLINA 27513

Tom King 407.856.0618 fax 407.855.3873 fotoking @ magicnet.net

Tom King 407.856.0618 fax 407.855.3873 fotoking @ magicnet.net

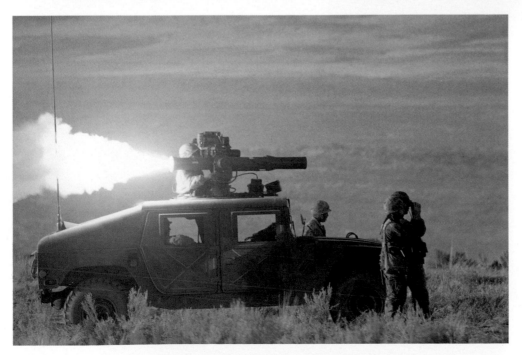

CHIPP
JAMISON
P H O T O G R A P H Y

ASSIGNMENT & EXTENSIVE STOCK
TEL: 404-873-3636
FAX: 404-873-4034
ATLANTA, GEORGIA

© CHIPP JAMISON, 1997

TOM RICKLES
MIAMI BEACH FLORIDA
305 866 5762 FAX: 305 861 1517

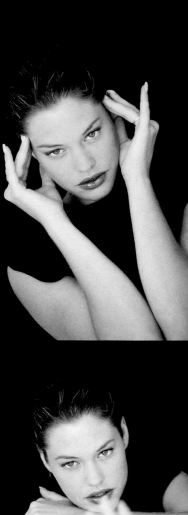

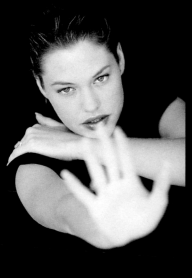

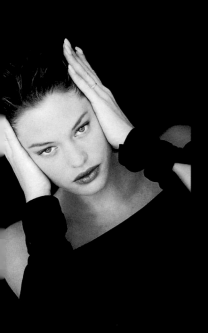

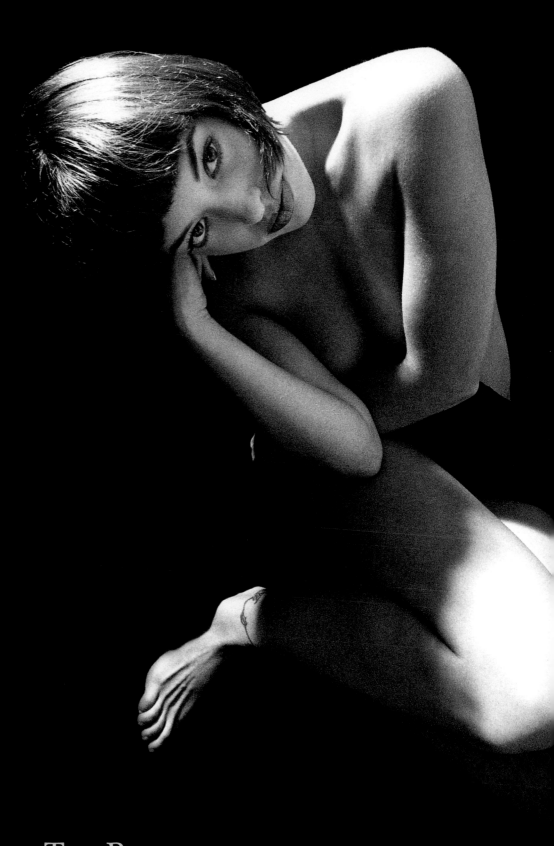

TOM RICKLES
MIAMI BEACH FLORIDA
305 866 5762 FAX: 305 861 1517

214.381.6684 214.381.1113 FAX

JOE PATRONITE

214.381.6684 214.381.1113 FAX

PELOSI & CHAMBERS

684 GREENWOOD AVENUE
ATLANTA, GEORGIA
404-872-8117
Fax 404·872·2992

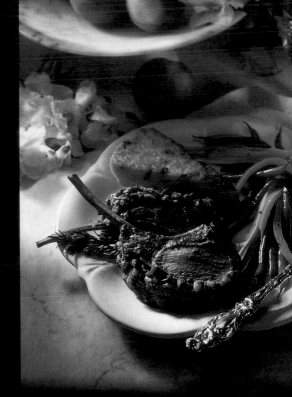

S
T
I
L
L

S

{ TEVE PELOSI }

L
I
F
E

P
E
O
P

{ *D* ON CHAMBERS }

L

E

707

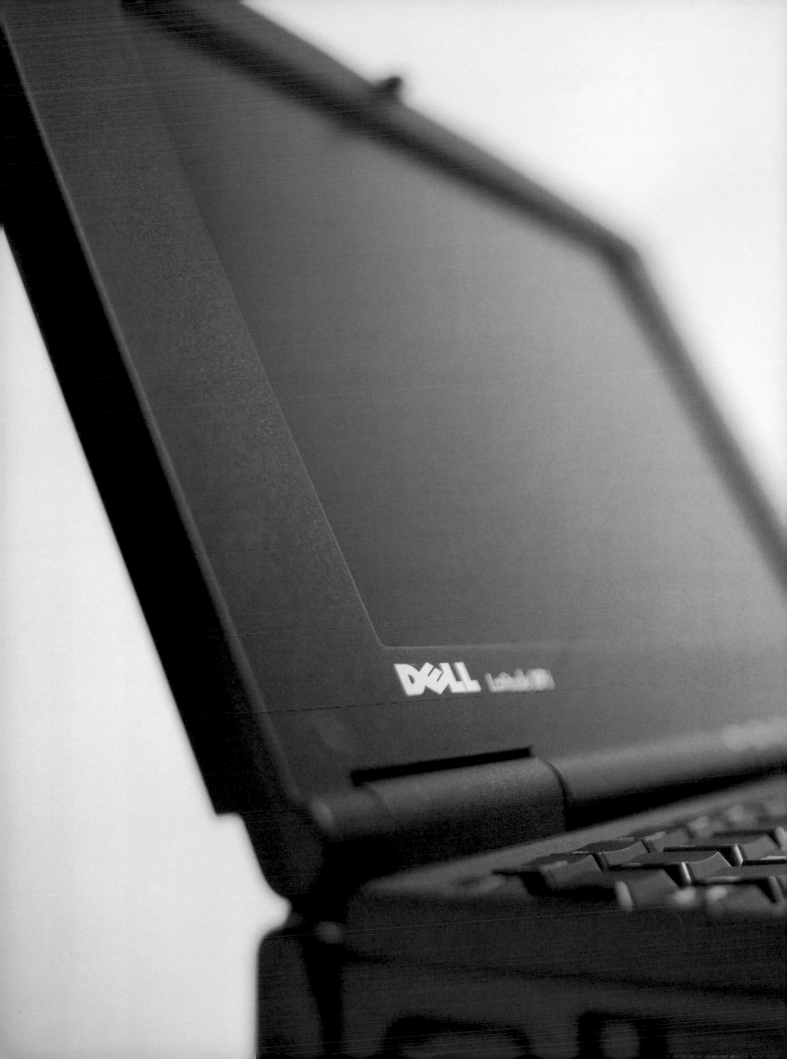

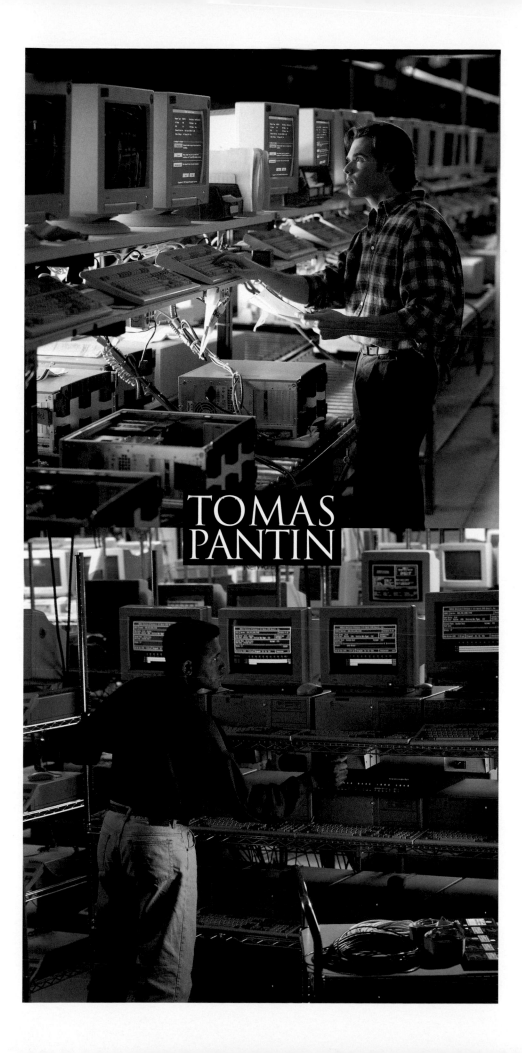

TOMAS PANTIN

Tomás Pantin, Inc. 1601 E. 7th St. Suite 100 Austin, Texas 78702 (512) 474-9968 Fax (512) 474-9191 In the South and Southwest contact Suzanne Craig (918) 749-9424

ANDREW VRACIN

ANDREW VRACIN

MYHRA

GREG MYHRA
TEL: 919.828.1699
FAX: 919.828.3398
R A L E I G H

BILL SCHILD

MIAMI

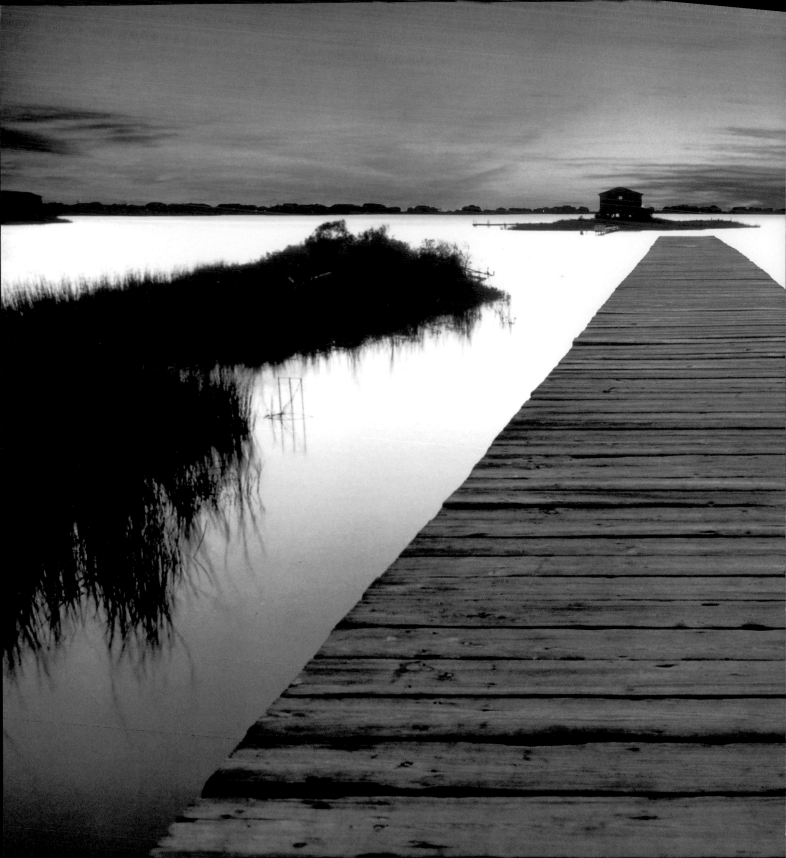

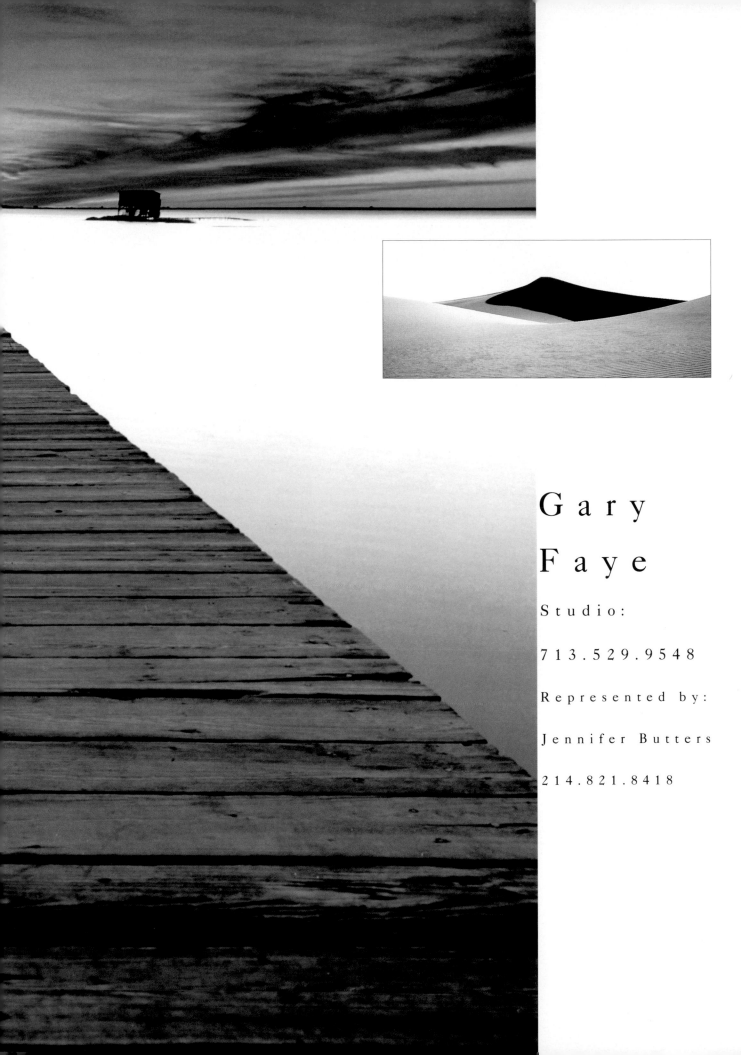

Gary
Faye

Studio:

713.529.9548

Represented by:

Jennifer Butters

214.821.8418

STEWART

CHARLES

COHEN

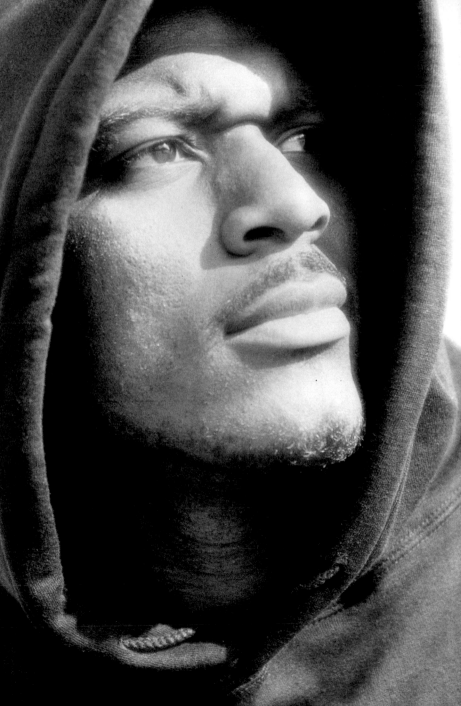

214-421-2186

Represented by

South
Denise Ford 214-821-6788

Midwest
Melissa McCallum 312-787-9300

New England
Victoria Schuh 508-362-0183

DIGIT AL

大打

DiVitale

F O

ATLANTA 404·892·7973 E·MAIL DIVITALE@MINDSPRINC.COM

toe

DIGITAL PHOTOGRAPHY

DiVitale

John J. Unrue

Orlando, Florida

407-629-5292 · e-mail: Unruephoto @ aol.com

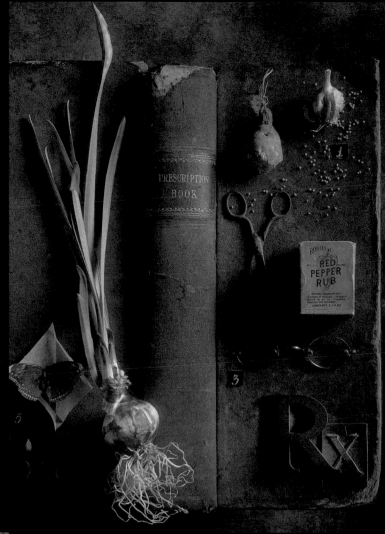

Rusty Hill Photography VA Reps 214 826 7063

Reel 214 871 9191

Studio 214 761 1761

"A diner; but the client wants something that looks really European - not shot in America."

"I know a hotel room sounds pretty dull, but the client really needs it."

"A wide body, L10-11 or DC10...passengers snoozing and our lady working away. Try Delta."

CD/AD Lee St. James Agency Zimmerman Client XcelleNet

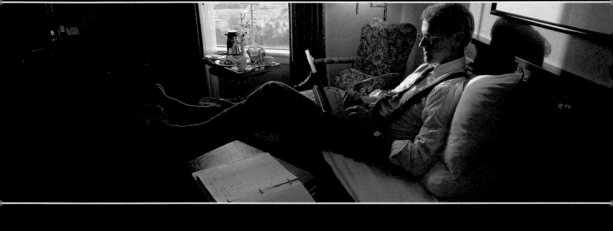

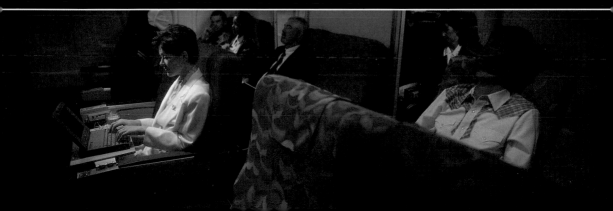

P A U L
S W E N

4229 BELLAIRE BLVD.
STUDIO B
HOUSTON, TEXAS 77025
PHONE: 713-667-4448
FAX: 713-667-4449

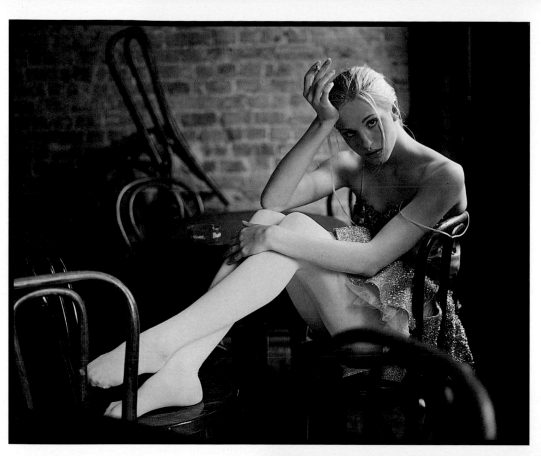

SWEN

YOU ARE TOO KIND.

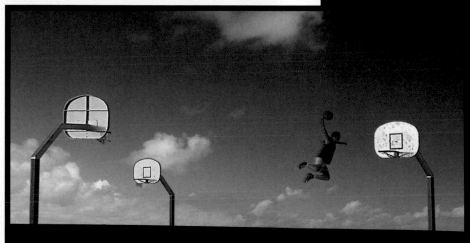

PAUL SWEN

4229 BELLAIRE BLVD.
STUDIO B
HOUSTON, TEXAS 77025
PHONE: 713-667-4448
FAX: 713-667-4449
PORTFOLIO & REEL ON REQUEST

727

 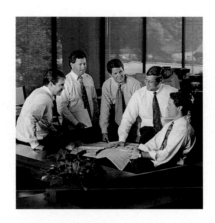

Pete Winkel Photography, Ltd.
75 Bennett Street, NW, Suite H2
Atlanta, Georgia 30309

Phone 404 352 8779
Fax 404 609 9912

Jose **MOLINA**

MIKE HAMEL

PAUL BARTON

NEW YORK : 212 . 691 . 1999

PHOTOGRAPHY

MIAMI: 305.665.0942

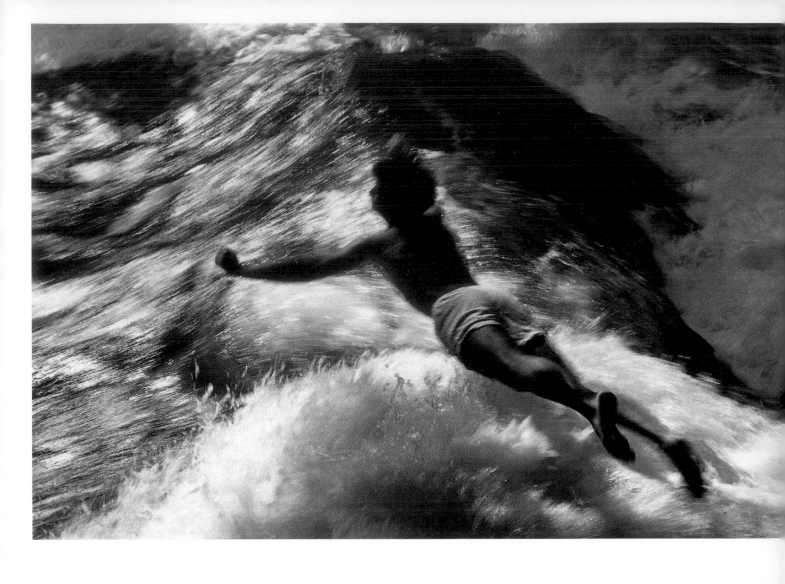

CHARLES FORD 212 675-7425
214 265-9704

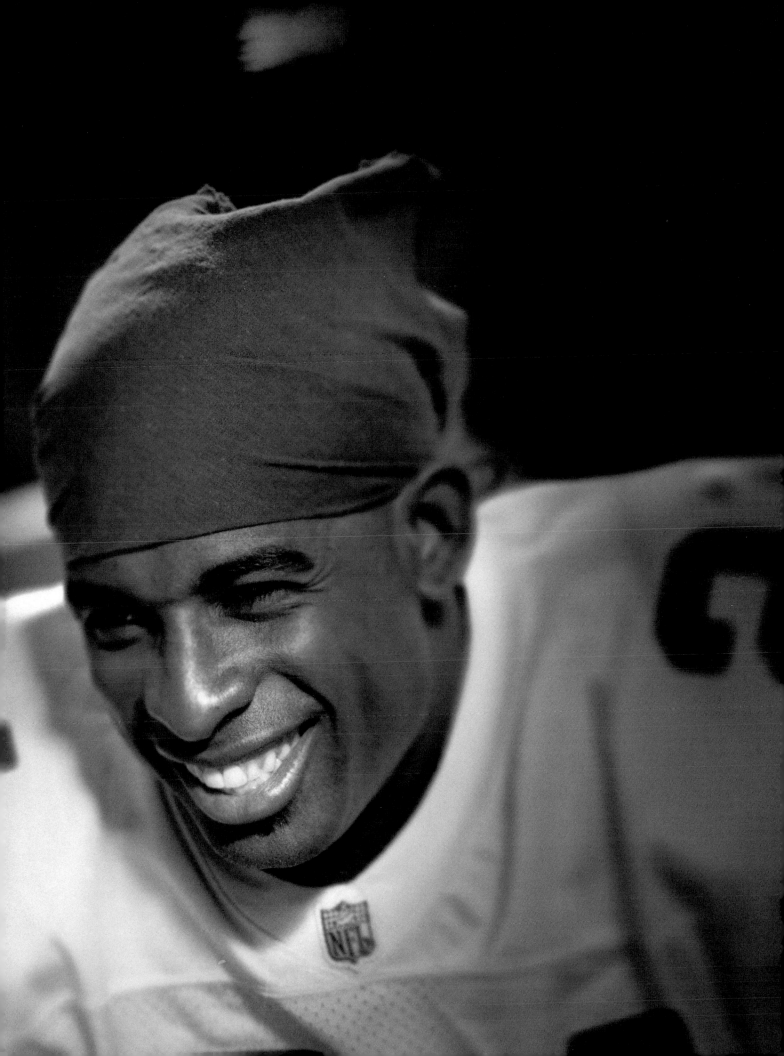

GUGGENHEIM

linda

34 *years old*

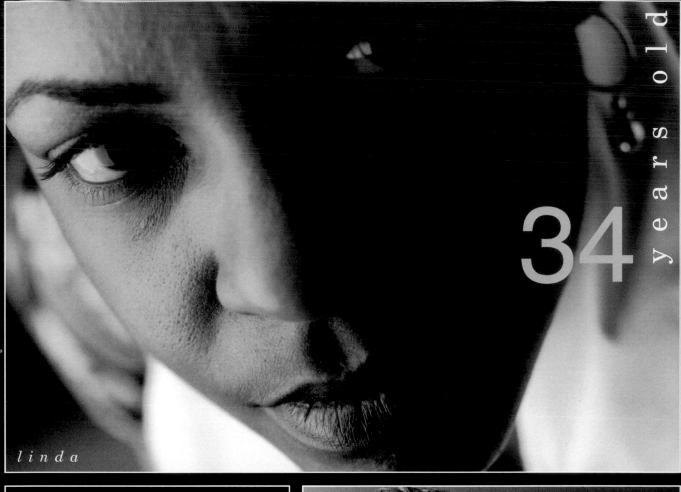

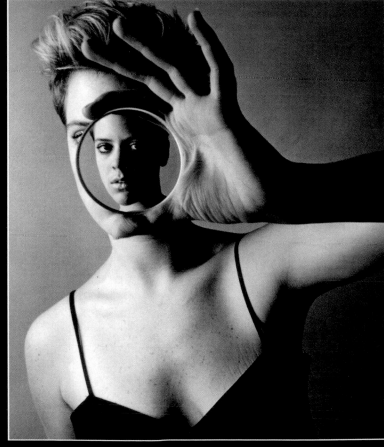

David Guggenheim Photography
Represented by Alexander/Pollard

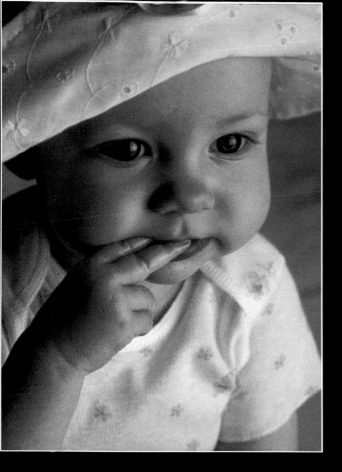

 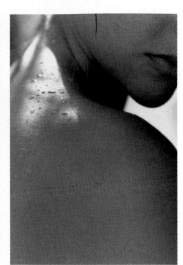

r e p r e s e n t e d b y s c h u m a n n & c o m p a n y 7 1 3 • 8 6 2 • 8 5 8 8

s t u d i o 7 1 3 • 5 2 8 • 6 7 8 8

represented by schumann & company 713•862•8588

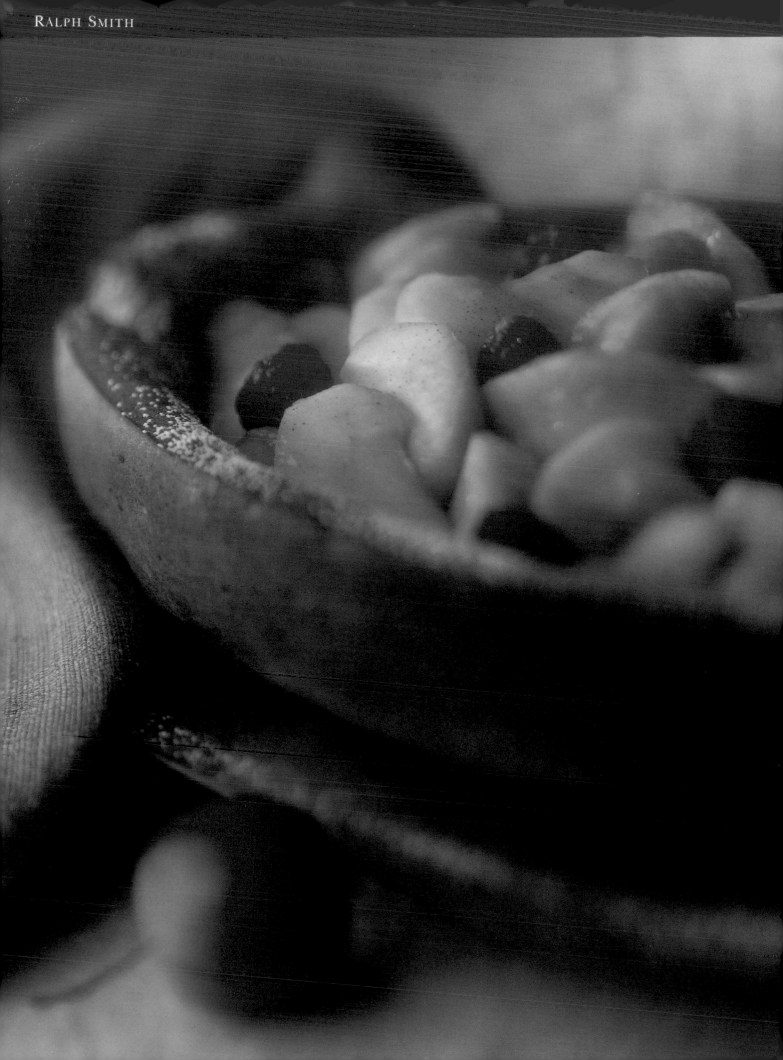

RALPH SMITH

Matthew Barnes Photography

521 8th Avenue South ➤ Suite 308 ➤ Nashville, TN 37203

➤ tele. **615 254 1050** ➤ fax 615 242 0700

PORTRAITS Brian Smith 305 534 3130

Fernando Diez

Represented by: Gene Martinez
212-666-8151 Fax 212-666-8239

Fernando Diez
Miami Studio
305-661-9909 Fax 305-661-1992

R A L P H D A N I E L

In Atlanta: (404) 872-3946
In Chicago: Represented by Carolyn Potts

(404) 872-5366 Fax
& Associates (773) 935-8840 / (773) 935-6191 Fax

R A L P H D A N I E L

In Atlanta: (404) 872-3946 (404) 872-5366 Fax
In Chicago: Represented by Carolyn Potts & Associates (773) 935-8840 / (773) 935-6191 Fax

Bb

alex <u>b</u>ee 919.821.1661 f/821.4115

nted in the south by artline 704.376.76

PETER LANGONĒ 954.467.0654 FAX: 954.522.2562 NEW YORK: JACKIE PAGE 212.772.0346

Kent Cigarettes, Grey Advertising, Jeffery Hill - Art Director

CALIFORNIA: SUE BARTON 800.484.8520 CODE #1464

ST. LOUIS: MARY WILLIAMS 314.872.2660

LANGONĒ
ON
LOCATION

PETER LANGONĒ 954.467.0654 FAX: 954.522.2562 NEW YORK: JACKIE PAGE 212.772.0346

Couples, Jamacia

CALIFORNIA: SUE BARTON 800.484.8520 CODE #1464

ST. LOUIS: MARY WILLIAMS 314.872.2660

BILL LISENBY
P H O T O G R A P H Y

522 TRABERT AVENUE, NW ❑ ATLANTA, GEORGIA 30309 ❑ 404-874-7921 FAX 404-873-3449

IRA KERNS
954.467.0654 - PHONE
954.522.2562 - FAX

TONAL VALUES, INC.

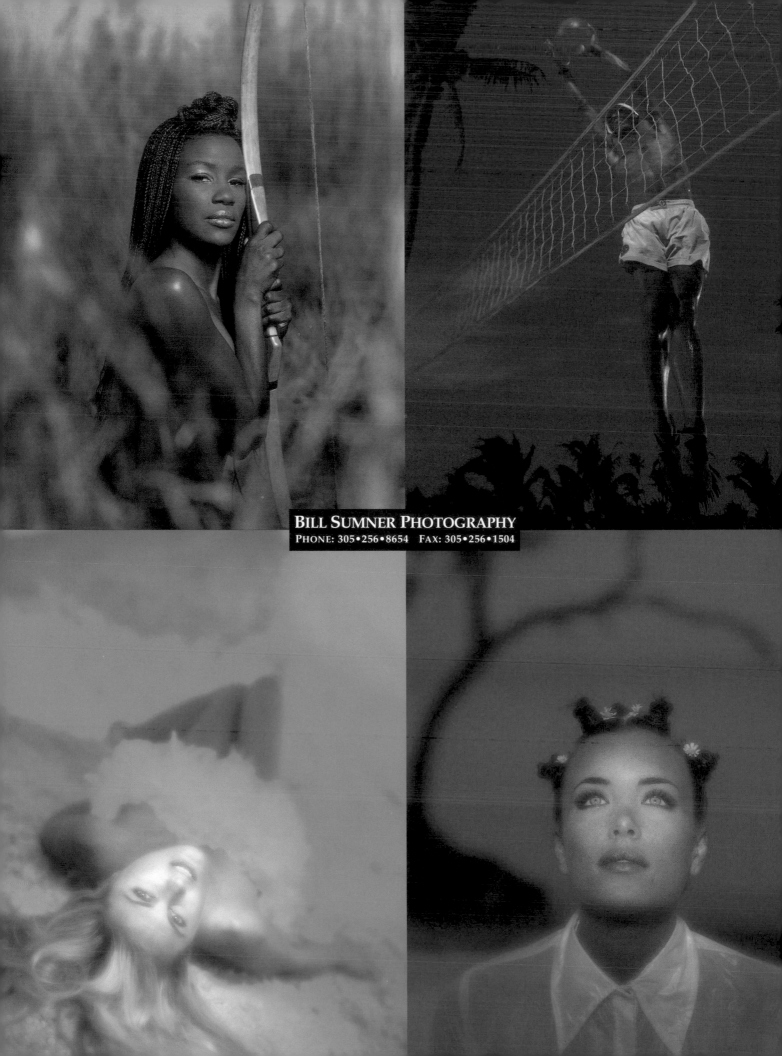

BILL SUMNER PHOTOGRAPHY
PHONE: 305•256•8654 FAX: 305•256•1504

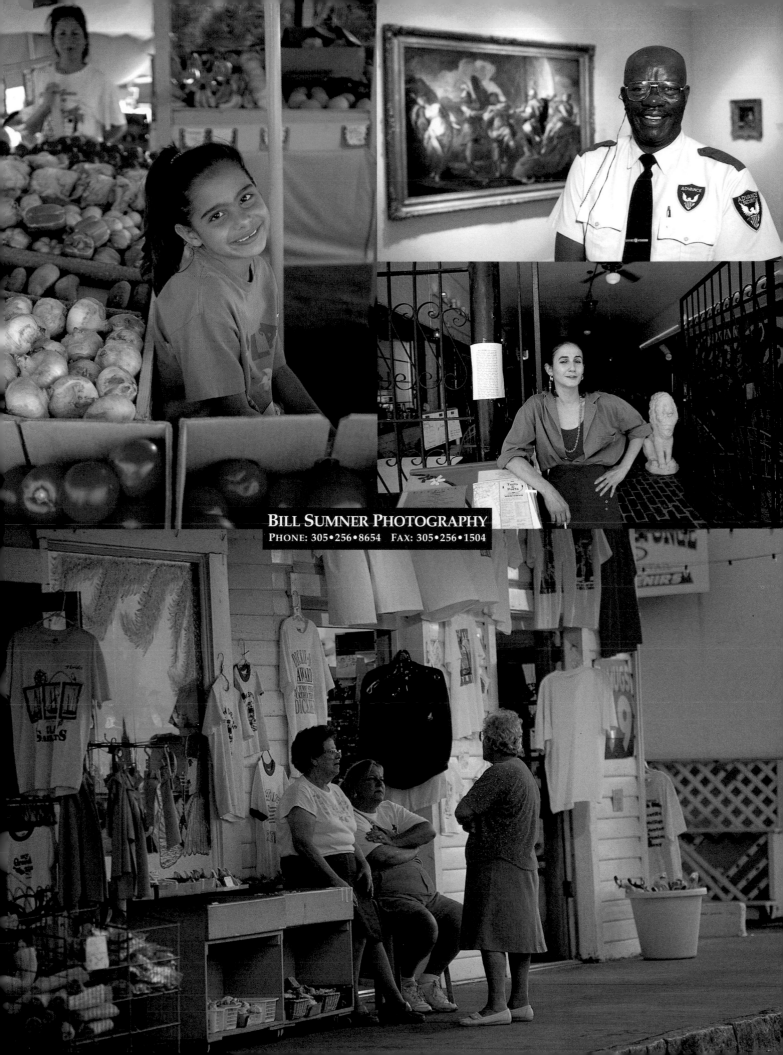

BILL SUMNER PHOTOGRAPHY
PHONE: 305•256•8654 FAX: 305•256•1504

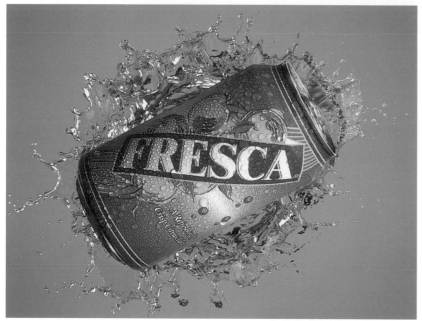

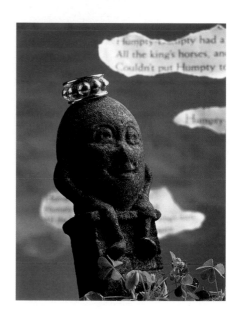

TOP DOGS
PRODUCTIONS

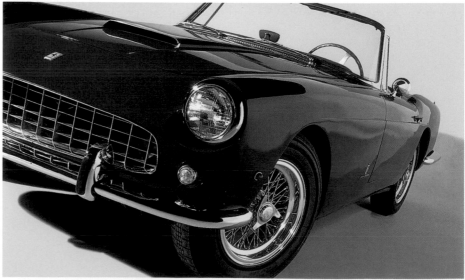

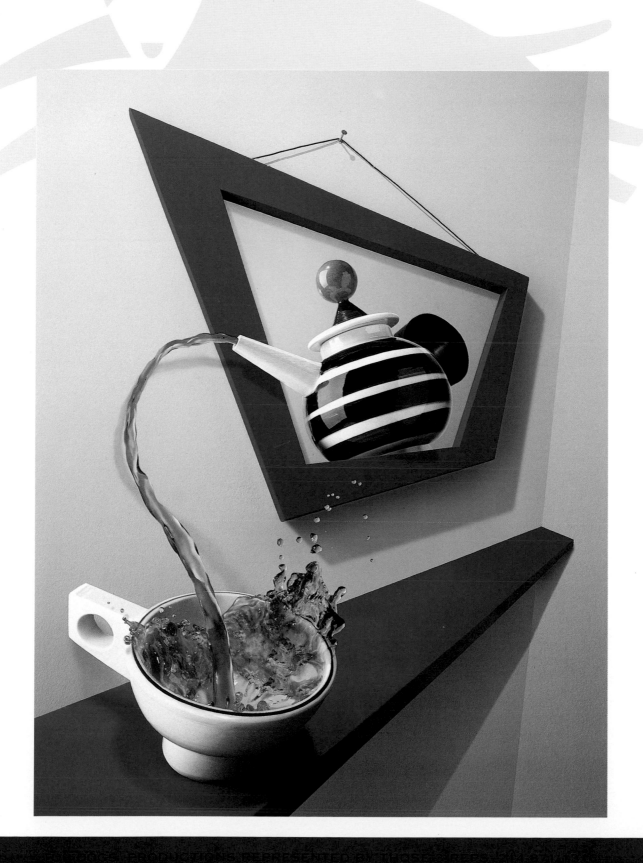

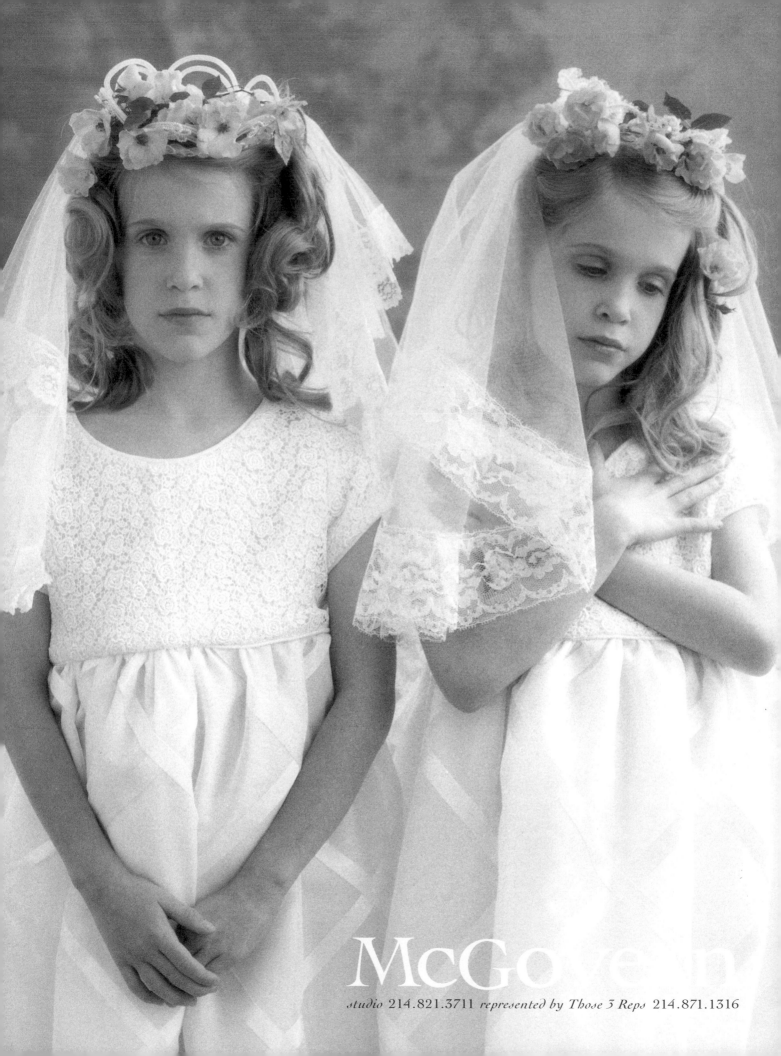

McGo
studio 214.821.3711 *represented by Those 3 Reps* 214.871.1316

McGovern

studio 214.821.3711 represented by Those 3 Reps 214.871.1316

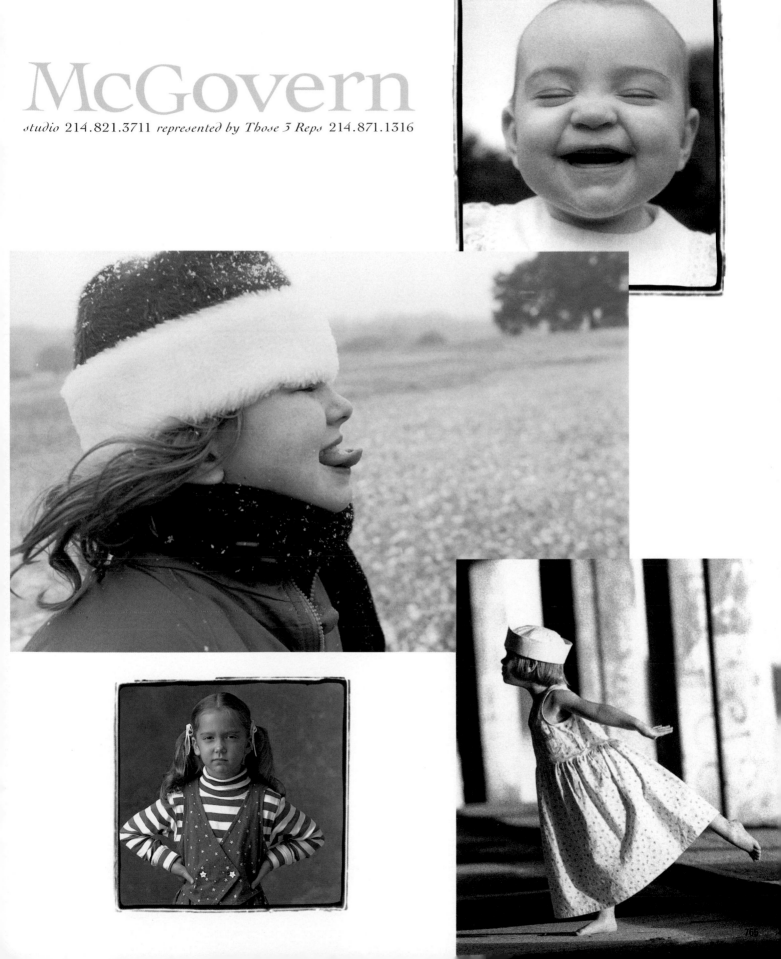

FLIP CHALFANT

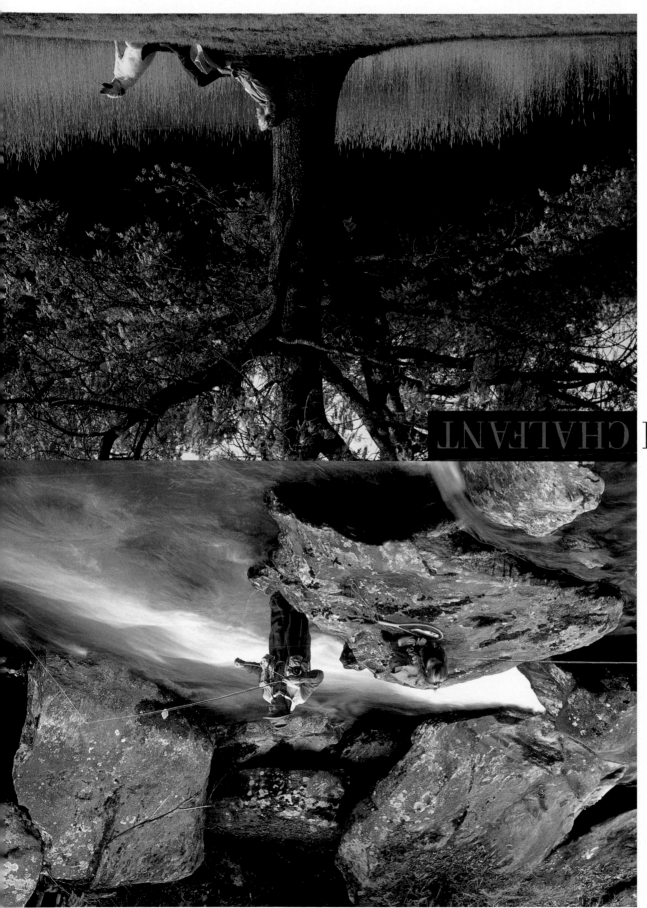

CHALFANT FLIP

ATLANTA 404·881·8510

REP: WILL SUMPTER 770·460·8438

767

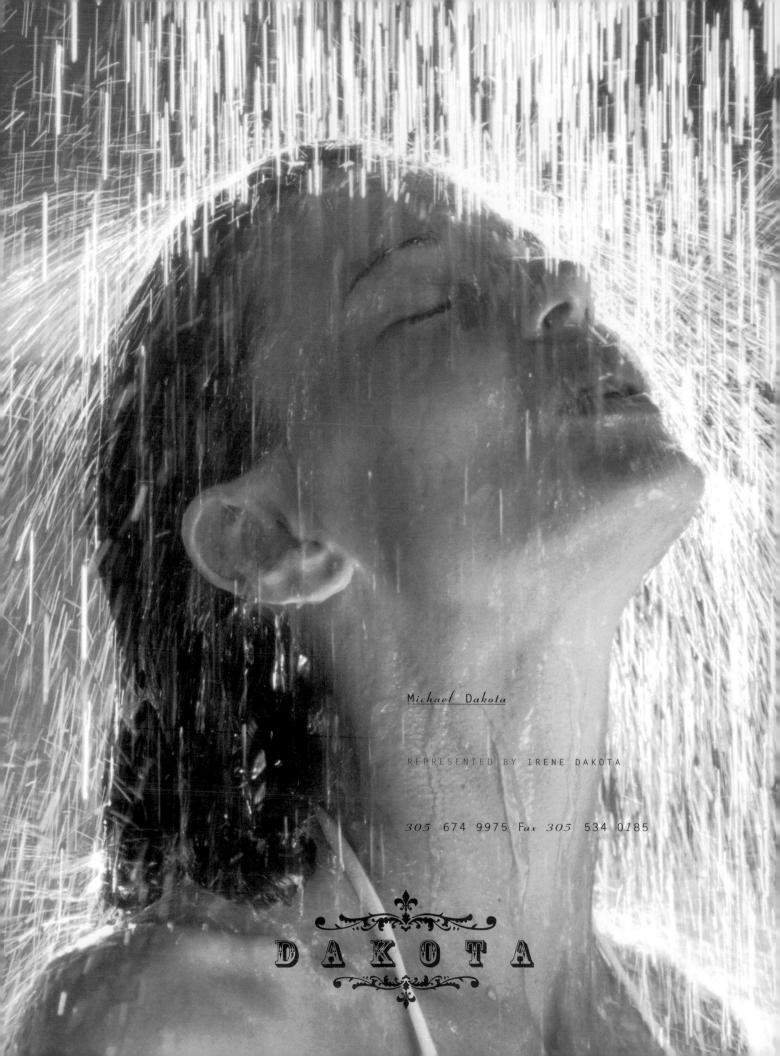

Michael Dakota

REPRESENTED BY IRENE DAKOTA

305 674 9975 Fax 305 534 0185

DAKOTA

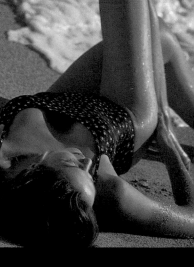
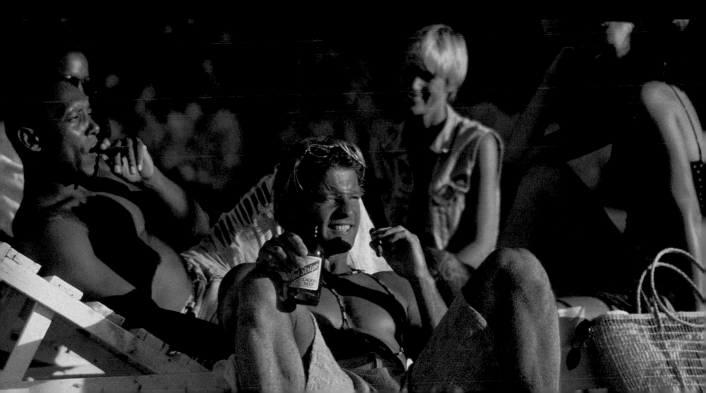

lynn
SUGARMAN

1.212.807.777

Representati

at

HOME

ew york 1.214.827.2559 dallas

n Kenney & Jo Weinberg Ally Godfrey

udio phone 214.748.1019 studio fax 214.748.0080

ALEX MCKNIGHT

KELLY REPS/TAMPA
813-872-9996

STUDIO/TAMPA
813-871-3929

Jim Vecchione

Neal Farris

Jake Wallis

Jeff Stephens

Tom Hussey

ally godfrey
represents

TEL 214 827 2559 FAX 214 827 2573

NEAL FARRIS

PHOTO DESIGN

214 821 5612
FAX 214 821 9631
REPRESENTED BY
ALLY GODFREY
214 827 2559

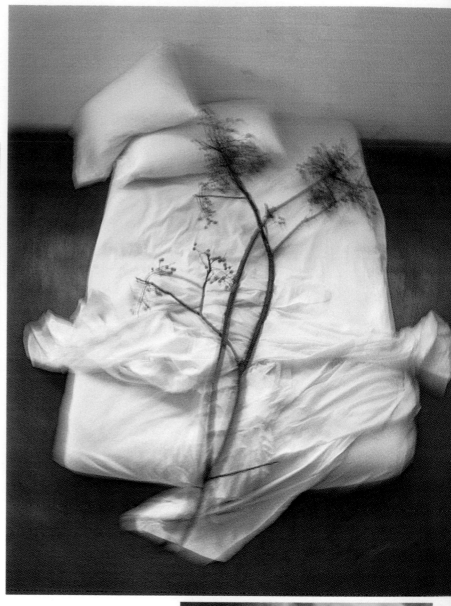

JEFF STEPHENS PHOTOGRAPHY

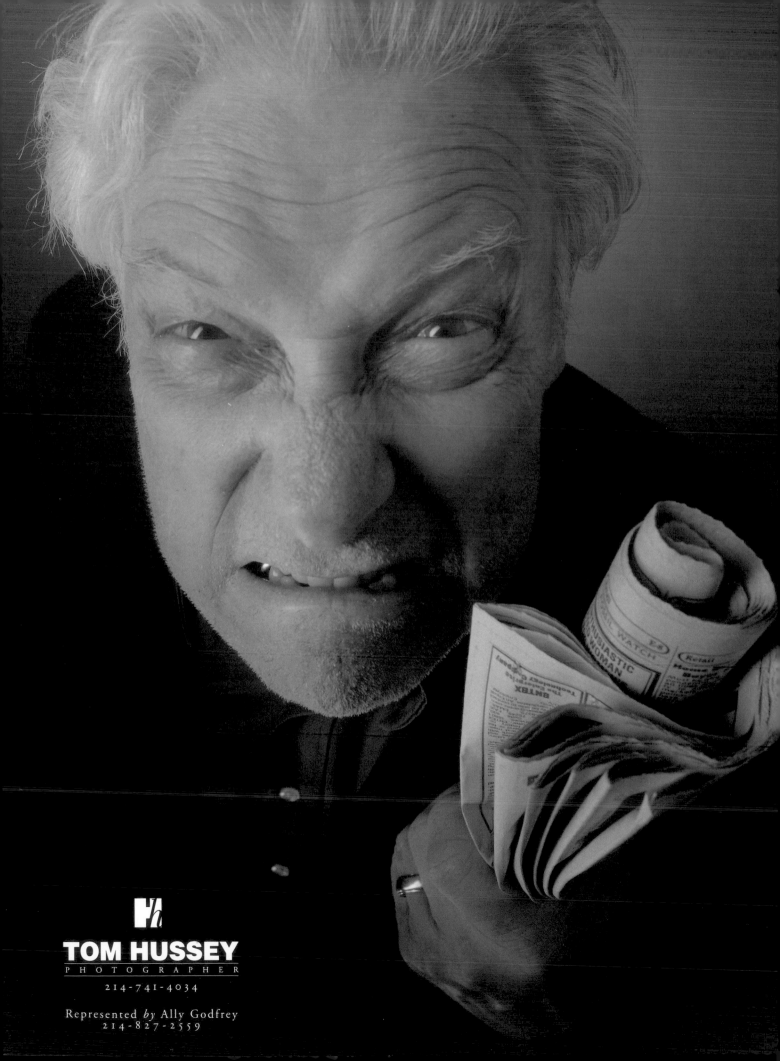

TOM HUSSEY

404.522.9377

JERRYBURNS

JERRYBURNS

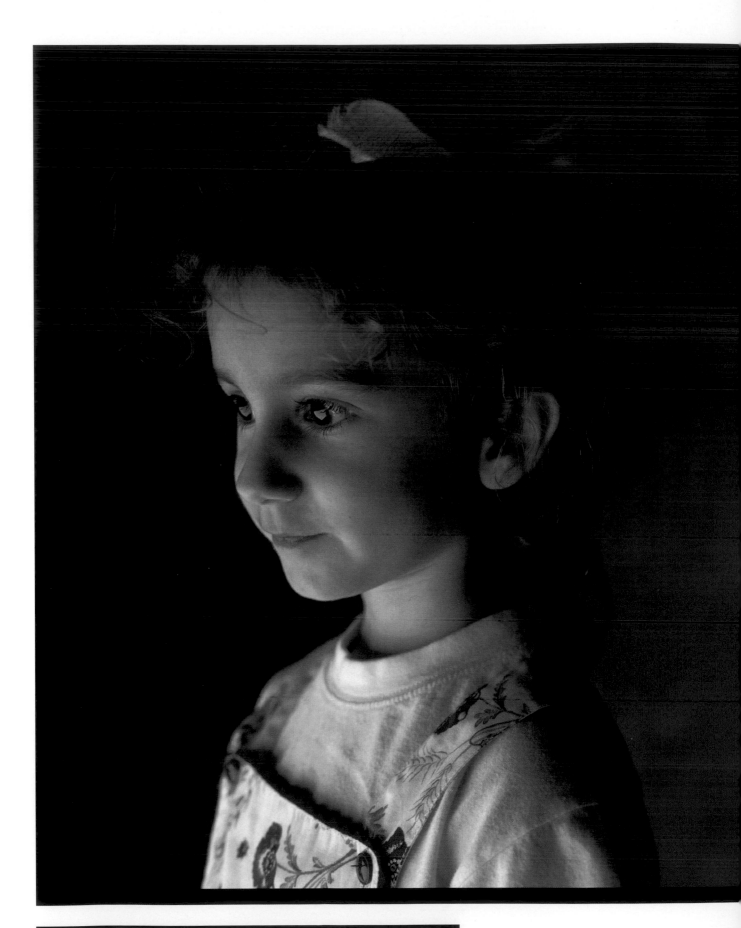

JIMMY WILLIAMS HAS A SPLIT PERSONALITY. *There's a refined side, sure. But also a streak of wildne*

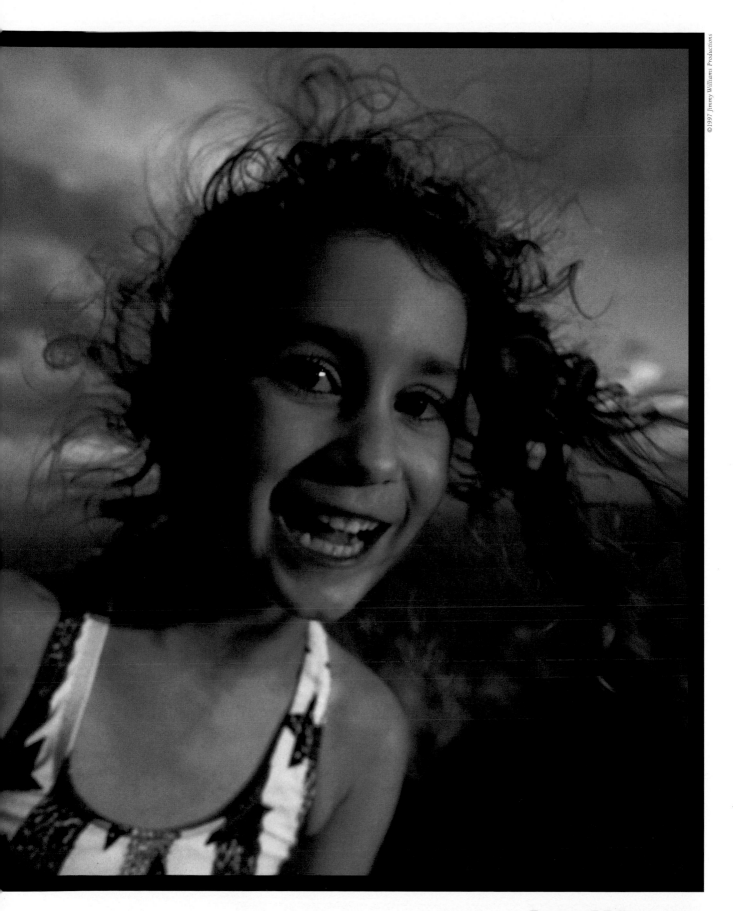

hat's got to get out now and then. Whichever side you're interested in, call us in Raleigh at (919) 832-5971.

JIMMYWILLIAMS

JIMMY WILLIAMS PRODUCTIONS

THIS IS TONY, FLYING BY THE SEAT OF HIS PANTS. *Looking for fun? Motion? Something a litt*

different? You've come to the right spread. Call us in Raleigh at (919) 832-5971 and we'll tell you more.

TONY PEARCE

JIMMY WILLIAMS PRODUCTIONS

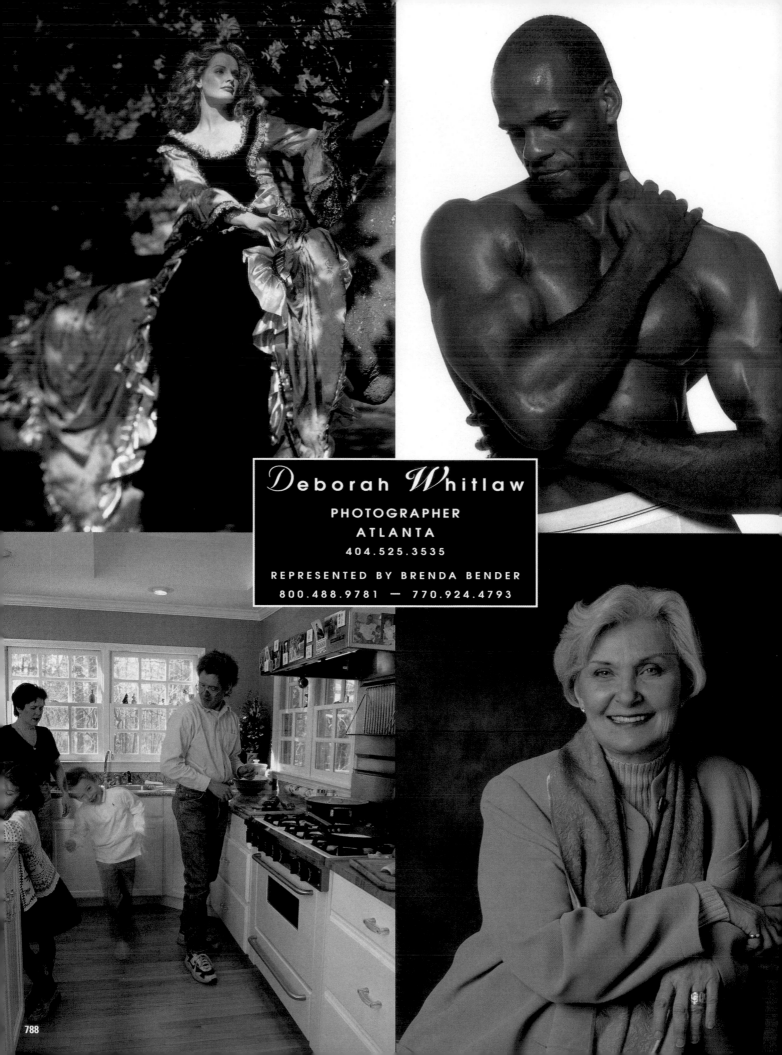

LARRY GATZ

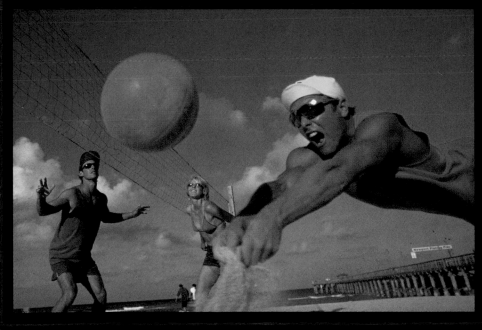

305-866-1244
Miami, Ft. Lauderdale

Partial Client List: *Alamo Rent-A-Car, American Airlines, Ameritec, Baptist Hospital, Chivas Regal, Coca-Cola, Compaq Computer, Costa Cruise Lines, Eastman Kodak, Hewlett Packard, Miller Brewing Company, MinuteMaid.*

Uncompromising Accuracy,

\blacktriangleright *Shot*

$\blacktriangleright\!\!\blacktriangleright$ *After Shot*

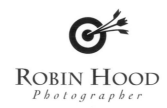

ROBIN HOOD
Photographer

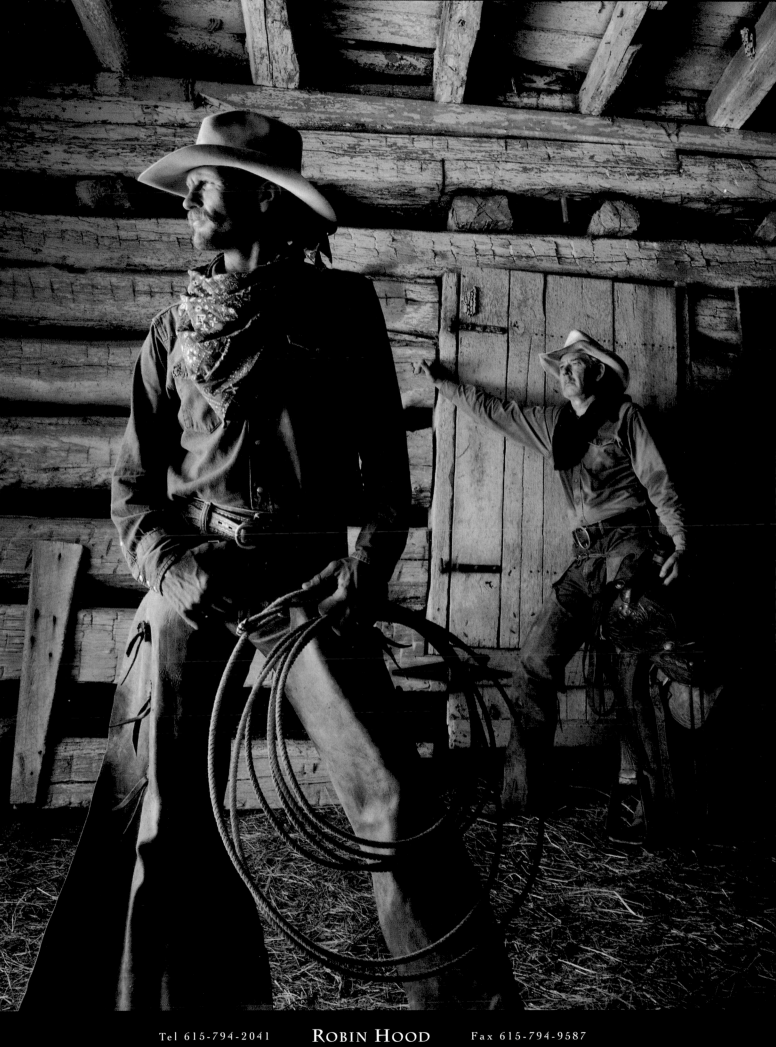

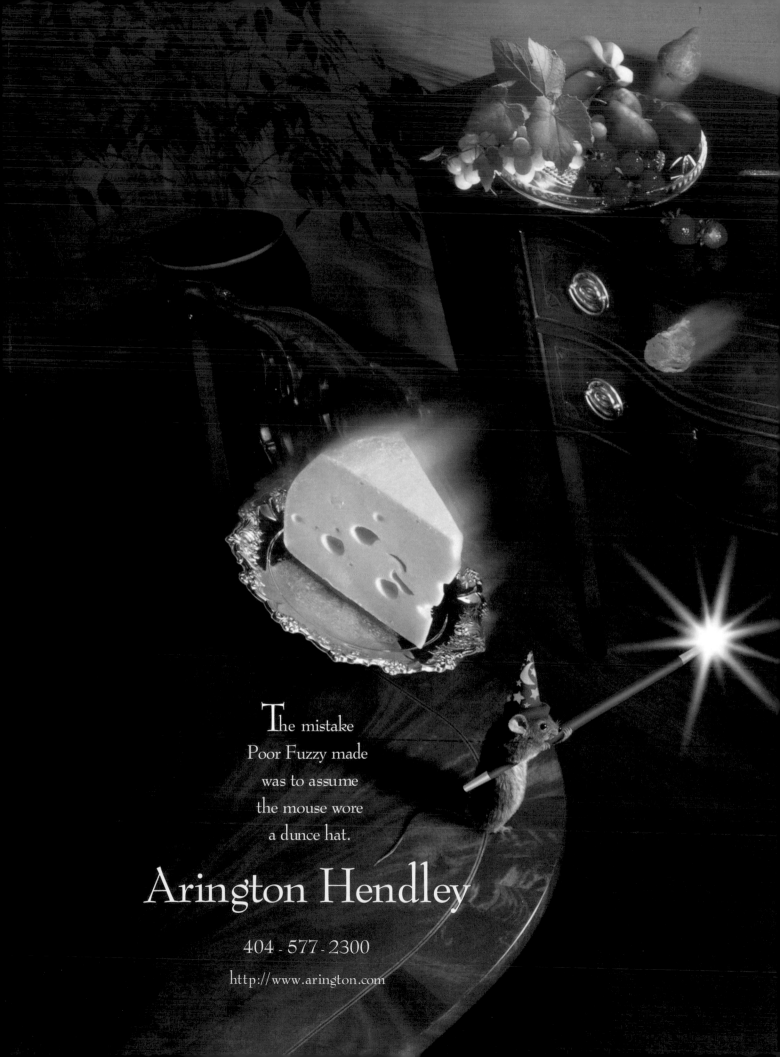

GRANBERRY

404 • 874 • 2426

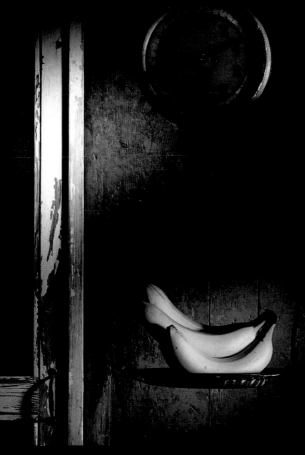
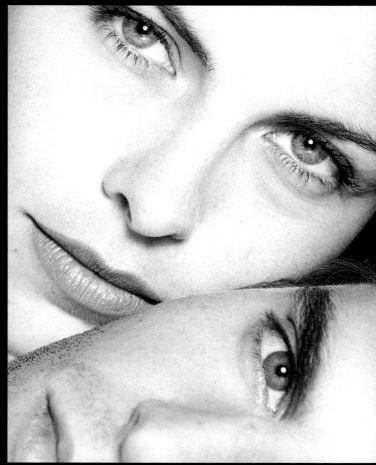

GRANBERRY

404 • 874 • 2426

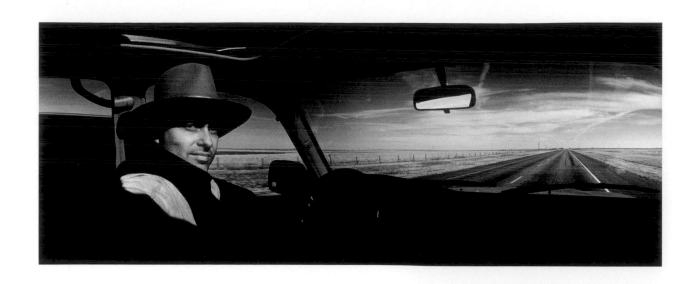

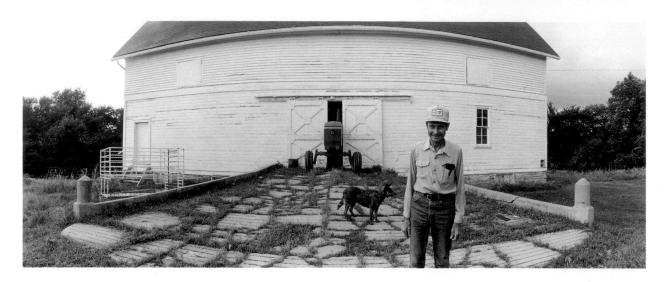

JEREMY GREEN PHOTOGRAPHY

410.732.5614

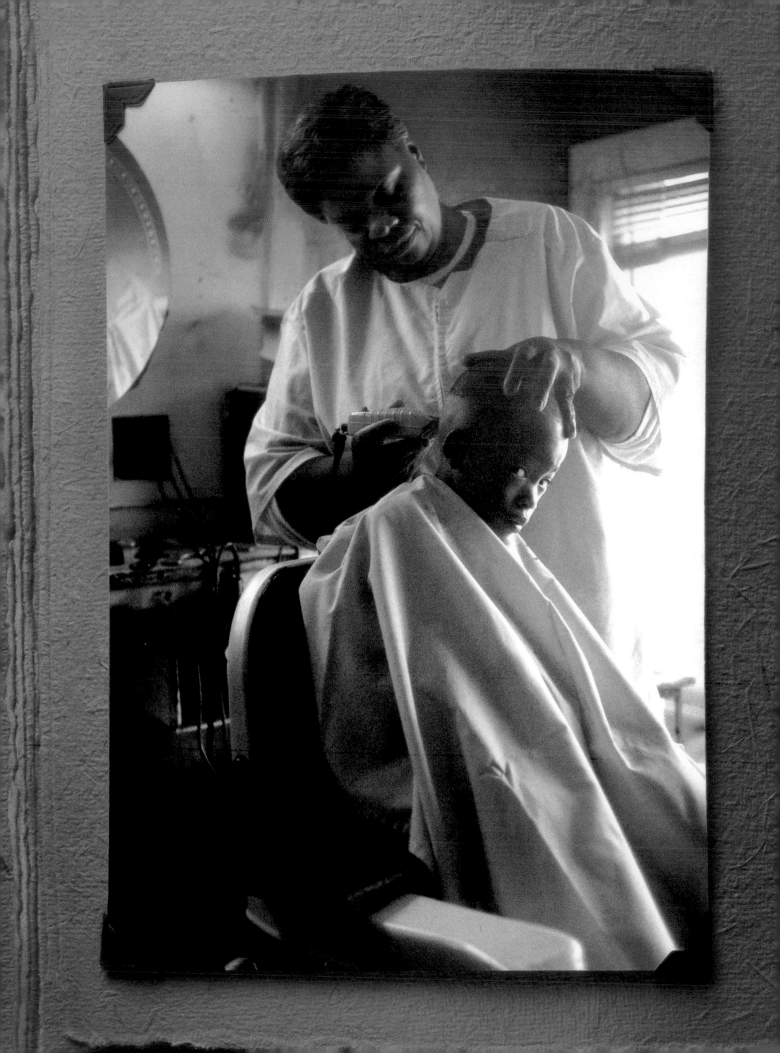

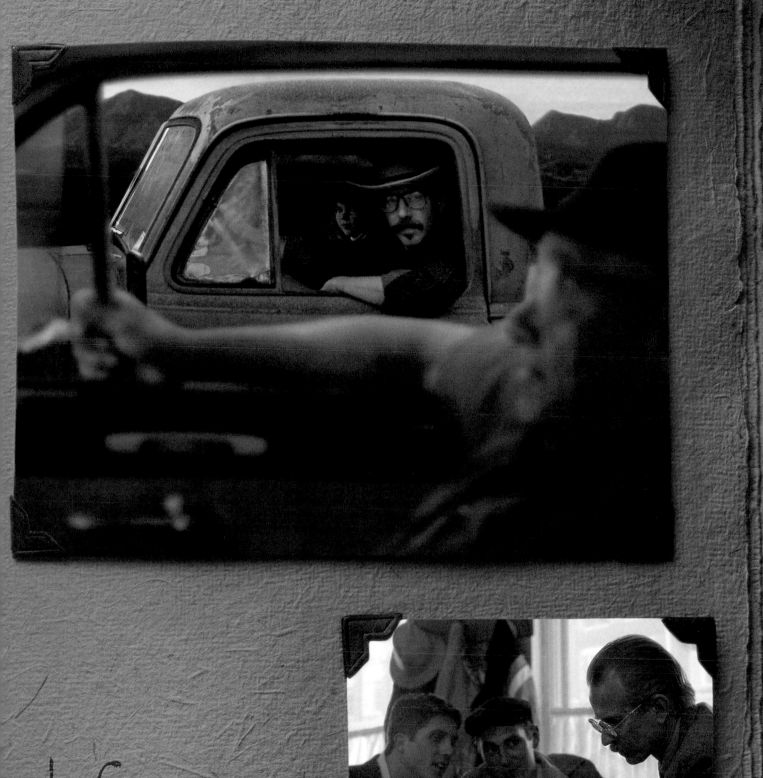

Jim Fiscus
1-800-270-4101

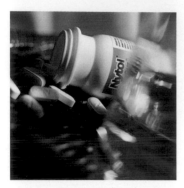

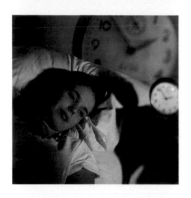

parish kohanim

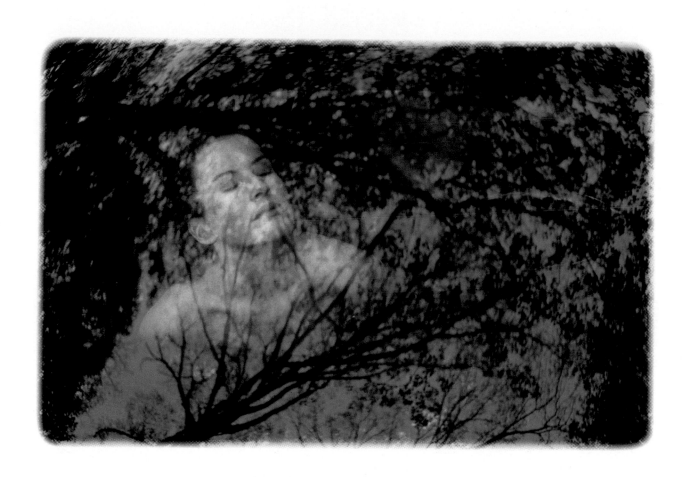

parish kohanim

TEL 404 892-0099

FAX 404 892-0156

San Francisco Sue Barton 800 · 484 · 8520 Code #1464

CAUSE

*Gateways Beit T'Shuvah, a
residential rehabilitation program
for addiction, Los Angeles
213-644-2026*

*Gateways Beit T'Shuvah helped
to open my brother's eyes.*

WORK
BOOK
ADVERTISERS

WESTERN STATES
Alaska
Arizona
California
Colorado
Hawaii
Idaho
Montana
Nevada
New Mexico
Oregon
Utah
Washington
Wyoming

*Artist's Rep

Artist's Rep

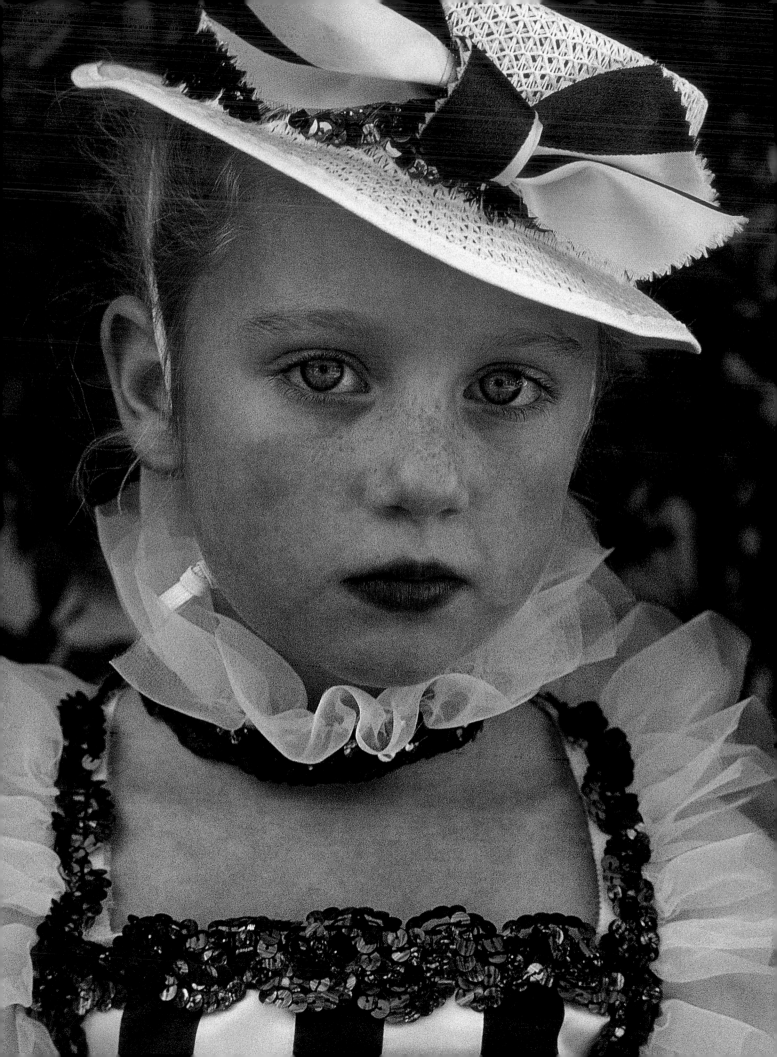

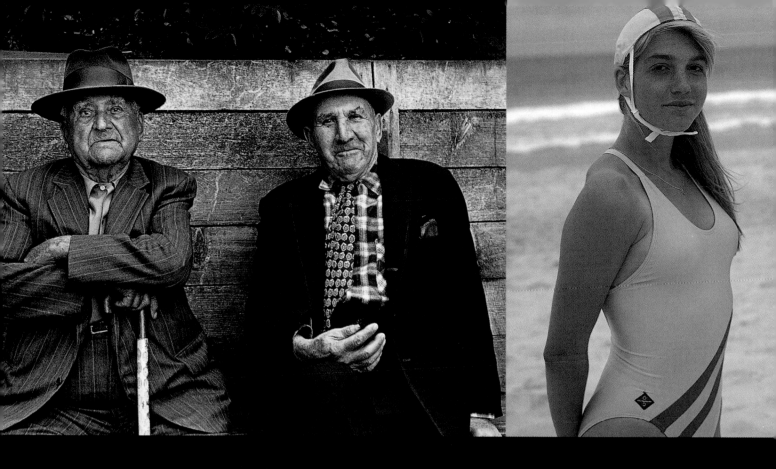

t r u d i U n g e r

San Francisco 415 381 5683

New York 212 740 7678

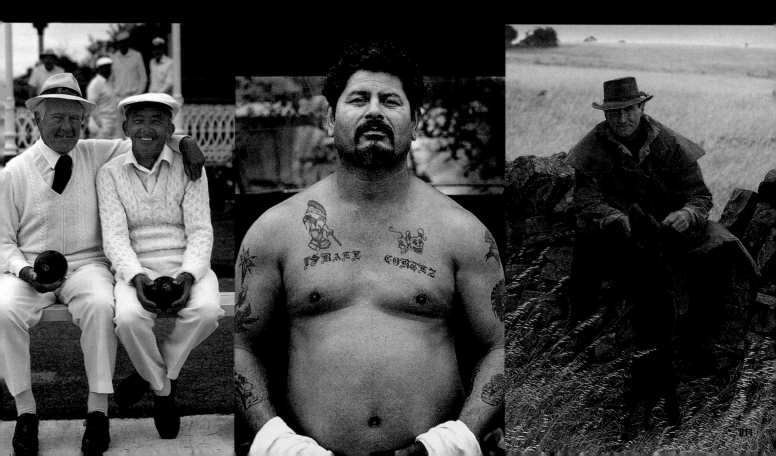

Dave Crosier Photography Inc.

Tel 206.439.1655 Fax 206.439.1607

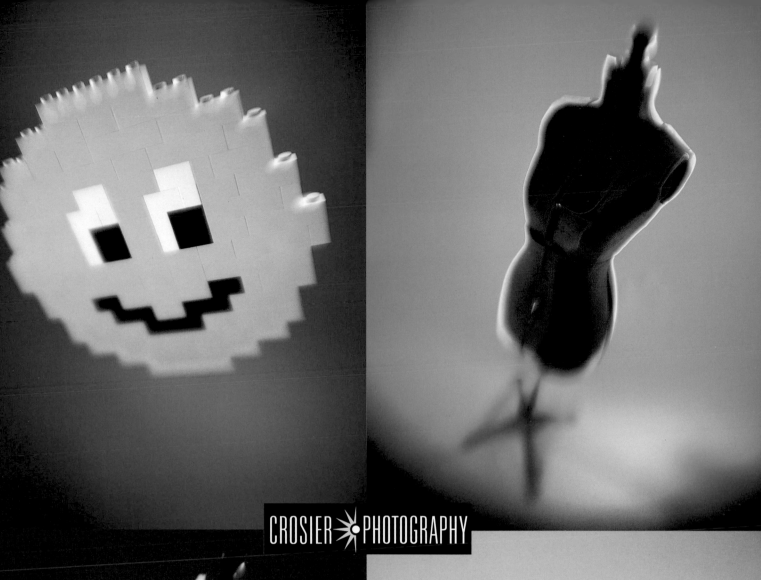

CROSIER PHOTOGRAPHY

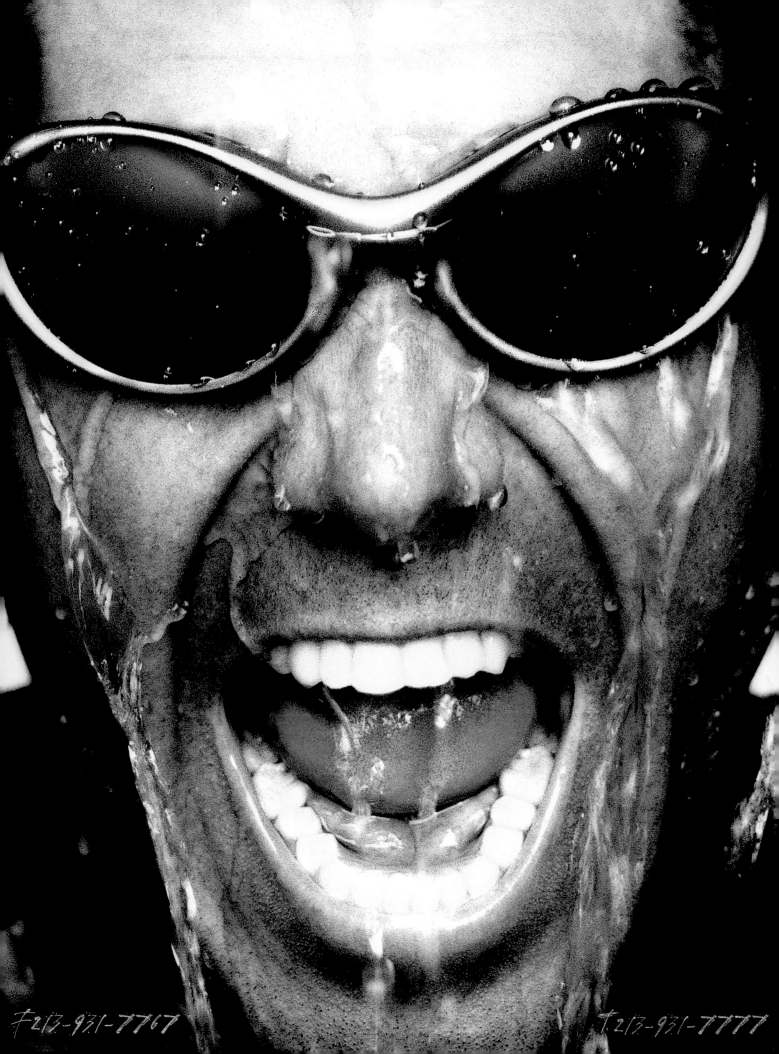

T 213-931-7767 T 213-931-7777

K O N K A L

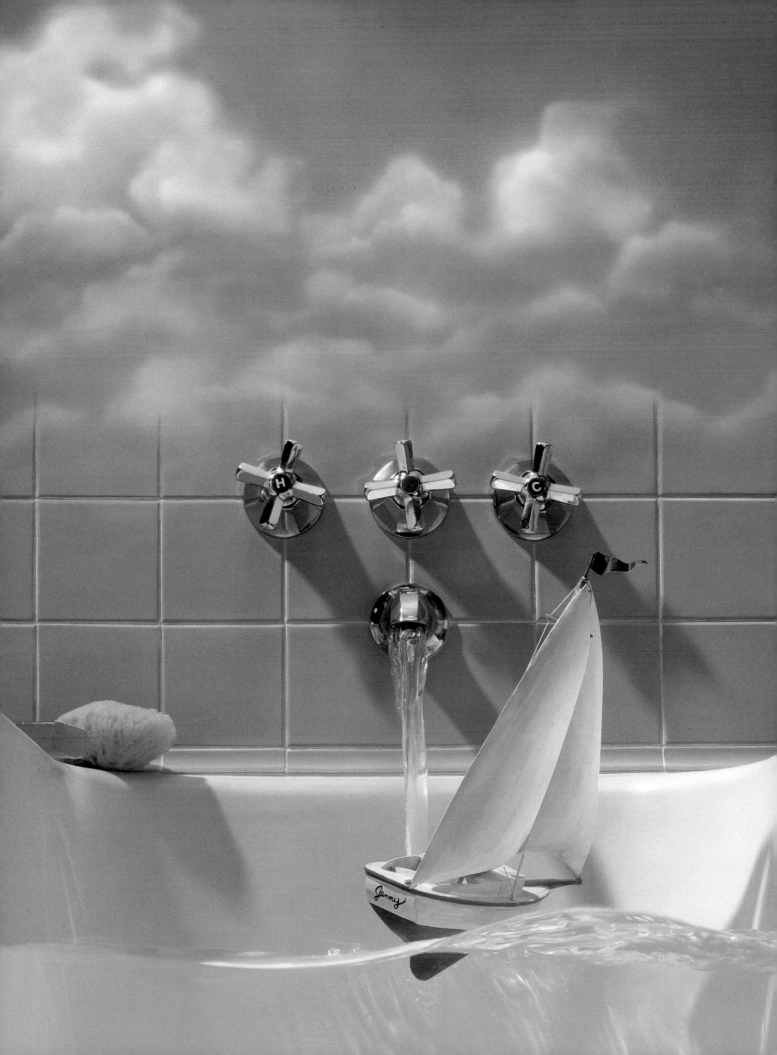

Pete McArthur.

represented **EAST**: Laurie Ketcham 212-481-9592 ℰ represented **WEST**: Kathee Toyama 818-440-0333

set by Rick Elden

GLEN WEXLER STUDIO · 213 465.0268

791 N.W. TRENTON AVE. BEND, OREGON 97701 PH. 800•274•5823 FAX 541•317•1803

MARKGAMBA

P H O T O G R A P H S

Philip Salaverry Photography

415.252.8090

2325 3rd St. | San Francisco, CA 94107

825

RASCONA

Victoria Pearson

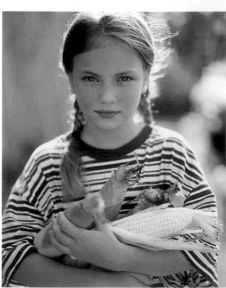

represented by

michele karpé

USA

818·760·0491

fax 818·760·8379

STILL

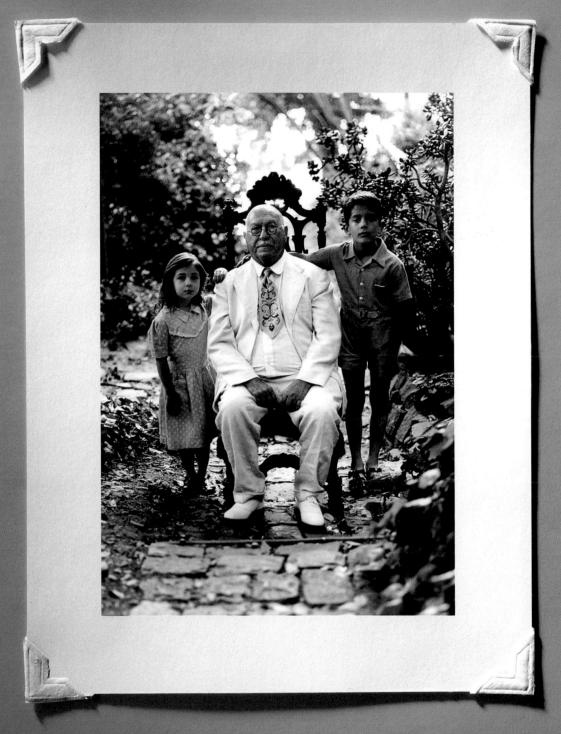

MICHELE
CLEMENT

MICHELE
PRINT # CLEMENT FILM

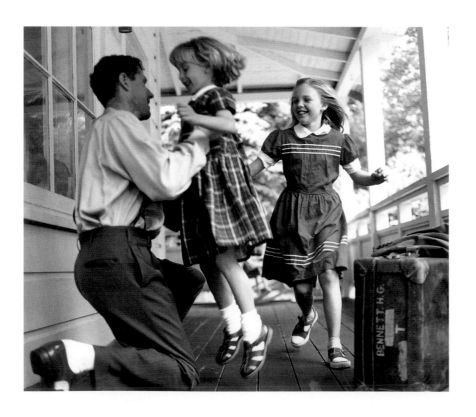

AGENT: NORMAN MASLOV 415. 641. 4376

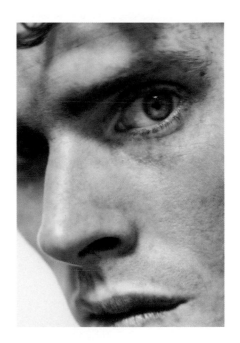

MICHELE CLEMENT

PRINT FILM

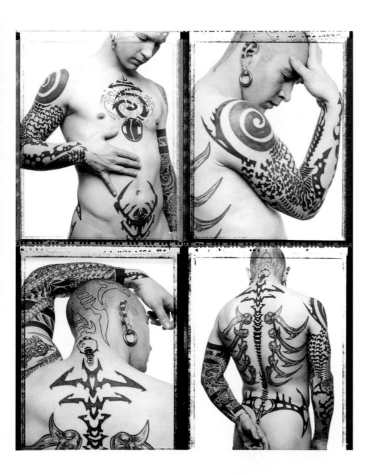

MICHELE CLEMENT STUDIOS, INC. SAN FRANCISCO, CA — STUDIO: 415. 695. 0100

DEBORAH JONES

DEBORAH JONES

studio

415 648 1991

agent

NORMAN MASLOV

telephone

415 641 4376

833

cristiana ceppas │ studio: tel 415·543·3993 fax 415·543·4063 │ agent: **norman maslov** tel 415·641·4376

Reebok

david maisel photography

West Coast Agent: Norman Maslov 415.641.4376. East Coast Agent: Amy Sosinsky @ Edge 212.343.2260

david maisel photography

West Coast Agent: Norman Maslov 415.641.4376. East Coast Agent: Amy Sosinsky @ Edge 212.343.2260

NOEL BARNHURST
PHOTOGRAPHER
415·206·9384 • REPRESENTED BY JIM LILIE • 415·441·4384

GILES
HANCOCK

Photography 2565 T HIRD S TREET S TUDIO 303 S AN F RANCISCO C ALIFORNIA 94107 Telephone 415.550.9220 Facsimile 415.550.1664
Represented by C OREY G RAHAM *Telephone* 415.956.4750 *Facsimile* 415.956.4750

GILES
H A N C O C K

Photography 2565 THIRD STREET STUDIO 303 SAN FRANCISCO CALIFORNIA 94107 Telephone 415.550.9220 Facsimile 415.550.1664
Represented by COREY GRAHAM *Telephone* 415.956.4750 *Facsimile* 415.956.4750

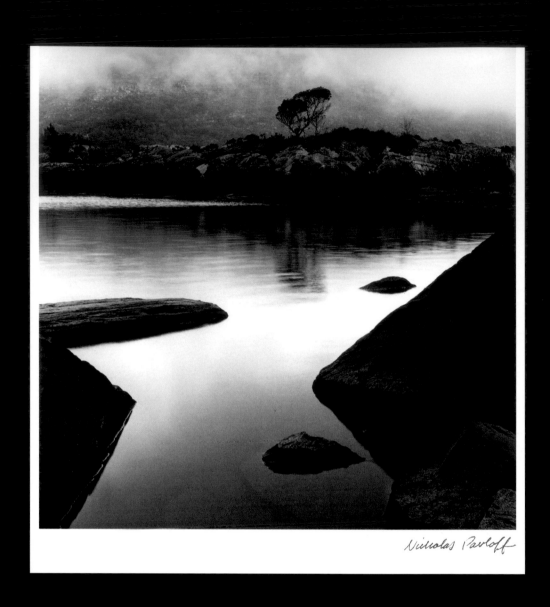

N I C H O L A S P A V L O F F

NICHOLAS PAVLOFF PHOTOGRAPHER BOX 2339 SAN FRANCISCO, CALIFORNIA 94126 TELEPHONE: 510 452-2468 FAX: 510 654-055

REPRESENTED BY COREY GRAHAM TELEPHONE: 415 956 4759 FAX: 415 391 6104

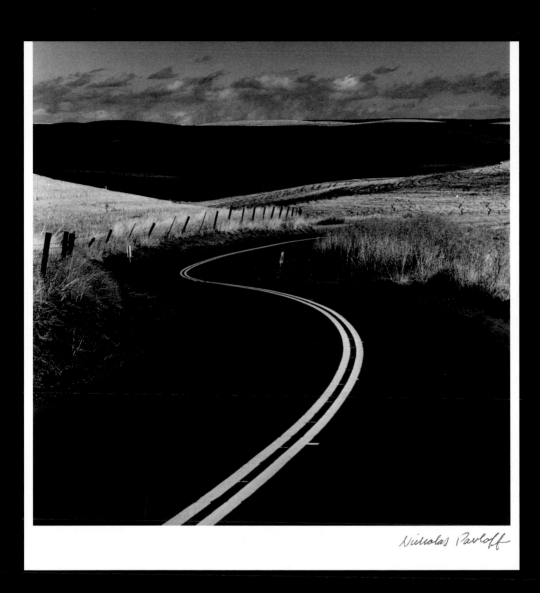

N I C H O L A S P A V L O F F

ICHOLAS PAVLOFF PHOTOGRAPHER BOX 2339 SAN FRANCISCO, CALIFORNIA 94126 TELEPHONE: 510 452-2468 FAX: 510 654-0557

REPRESENTED BY COREY GRAHAM TELEPHONE: 415 956-4750 FAX: 415 391-6104

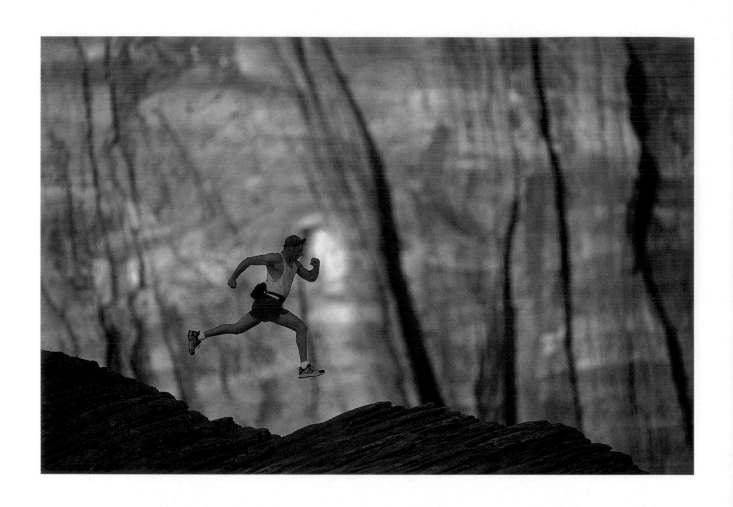

BRIAN BAILEY

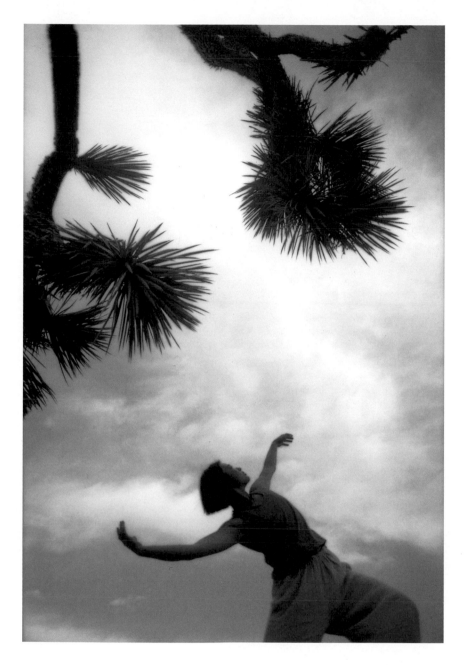

FOR PORTFOLIO CALL:

970.920.7839

FAX: 970.920.7849
email: bbailey@rof.net

CLIENTS

BUDWEISER

MEN'S JOURNAL

GATORADE

OUTSIDE

THE NORTH FACE

WOLVERINE

WILDERNESS

AMERICAN AIRLINES

 mark cooper photography & imaging san francisco 415 552 3881 mcoop@sirius.com

mark cooper photography & imaging san francisco 415 552 3881 mcoop@sirius.com

Leeann Angel Cornell & Co. 310 301-8059

Morawski & Associates 810 589-8050

PAUL FRANZ-MOORE

STUDIO 415-495-6421

REPRESENTATIVE

NANCY SHANAHAN SF
415-243-8283

PAUL FRANZ-MOORE

STUDIO 415-495-6421

REPRESENTATIVE

NANCY SHANAHAN SF
415-243-8283

MIZONO

TEL 415 648 3993 FAX 415 648 2163

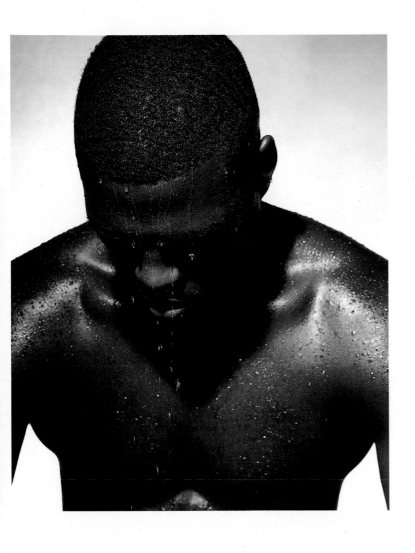

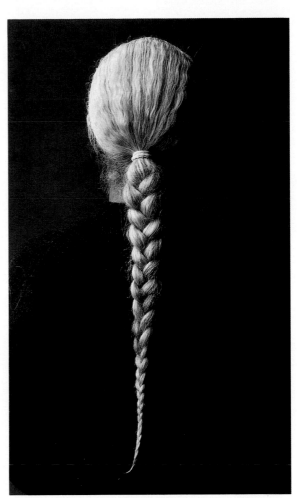

3rd St. Station

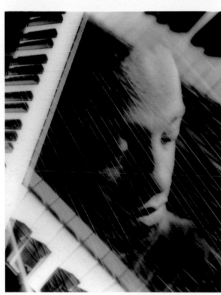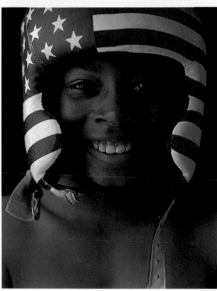

SEDLIK
PHOTOGRAPHY

LOS ANGELES 213·6263323 · NEW YORK CITY 212·4471255

PARTIAL CLIENT LIST

MICROSOFT · SONY · BANK OF AMERICA · LEVI-STRAUSS · CAREAMERICA · PACIFIC-BELL · AT&T · GTE · KRAFT · YAMAHA · SMITHSONIAN INSTITUTION · WARNER BROTHERS · CONROY'S · LIFE

CHESEBROUGH-POND'S · MCA · HANNA-BARBERA · GEORGIA-PACIFIC · DOUBLEDAY · POLYGRAM · NEWSWEEK · COMPUTER ASSOCIATES · BMG/RCA · INFINITI · CHEROKEE · ARTS & ENTERTAINMENT

CENTURY 21 · ZIFF-DAVIS · NBC · BLUE CROSS · ARISTA · UNITED AIRLINES · DREYFUS · ROLLING STONE · TACO BELL · ENTERTAINMENT WEEKLY · TWENTIETH CENTURY FOX

SOUTHERN NATURAL GAS · DETAILS · POTLATCH · WINDHAM HILL · BBC · AMSOUTH BANK · GEFFEN · PEOPLE · JVC · WORLD SAVINGS · TURNER BROADCASTING

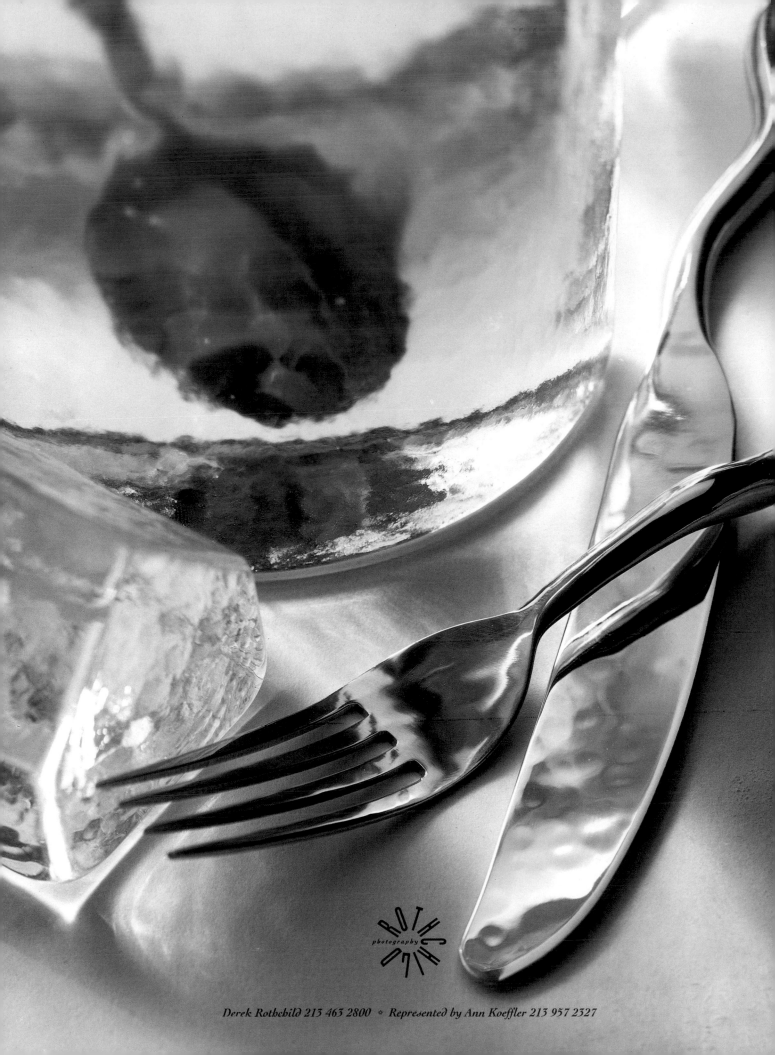

Derek Rothchild 213 463 2800 ✲ Represented by Ann Koeffler 213 957 2327

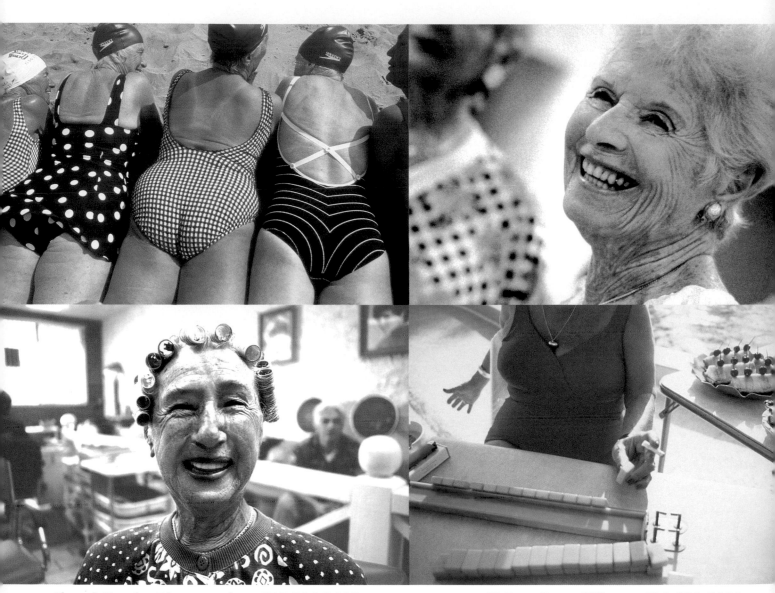

Cheryl Maeder Photographer 415.546.0445 **SF Rep. Betsy Hillman 415.391.1181**

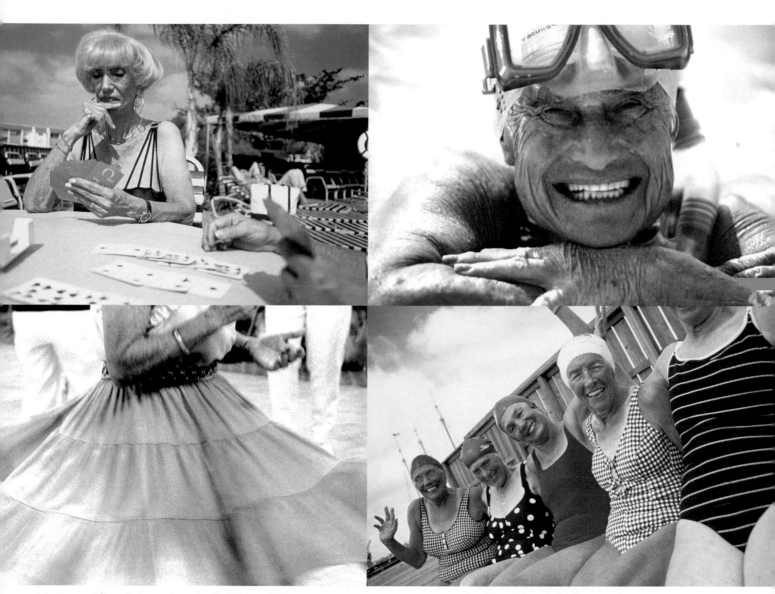

LA Rep. Rhoni Epstein 310.207.5937

NY Rep. Carol Cohn 212.924.4450

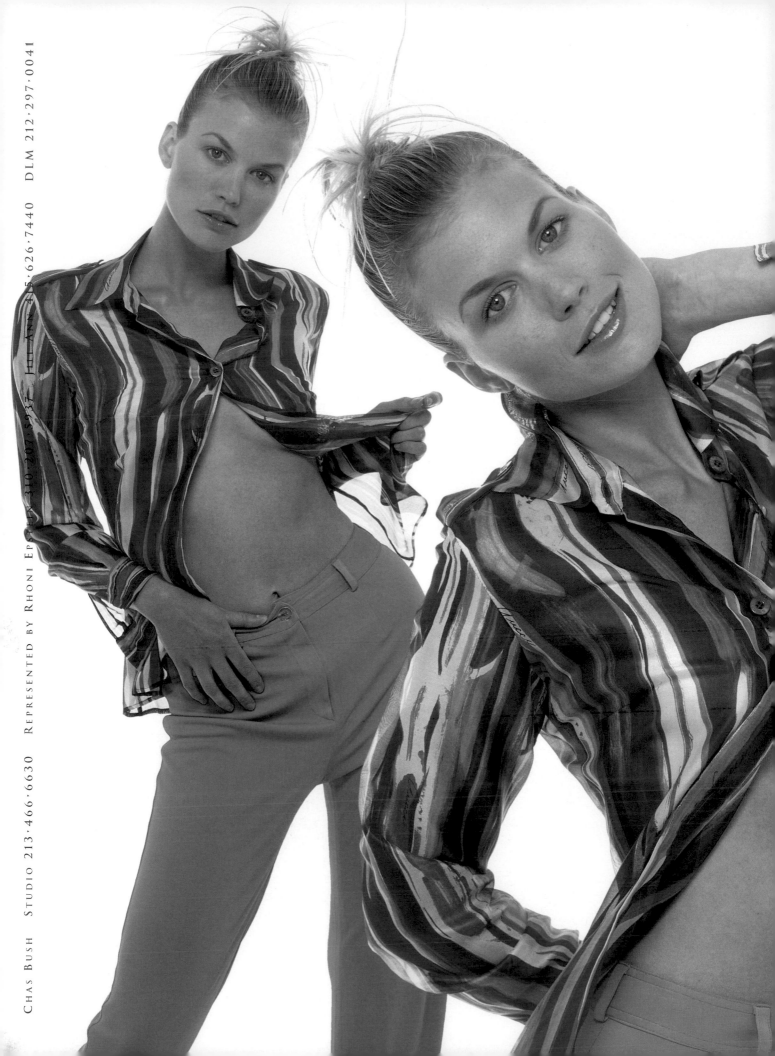

CHAS BUSH STUDIO 213·466·6630 REPRESENTED BY RHONI EPSTEIN 310·207·5937 JILL ANN 415·626·7440 DLM 212·297·0041

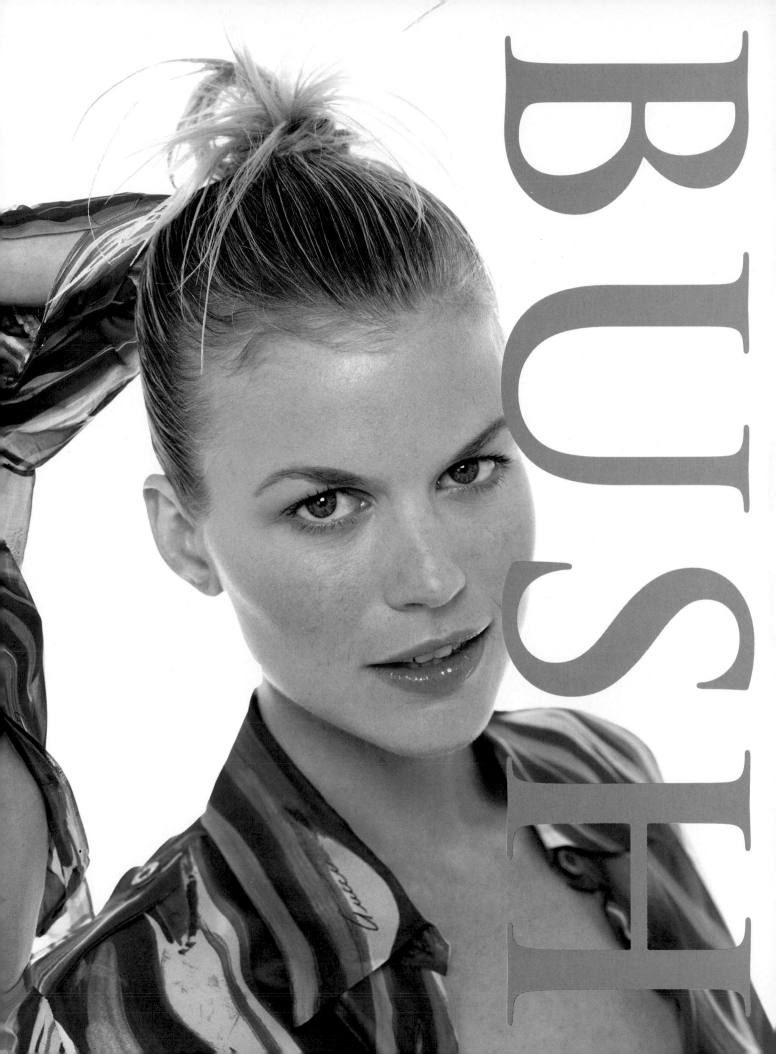

PENGUIN USA

375 HUDSON STREET, NEW YORK, NY 10014 3557 · TELEPHONE: 2-366-2000 FAX:

-20, 1996

Mr. Charles Bush
940 North Highland Avenu
Los Angeles, CA 90038

Dear Charles:

Th last shoot you did for us o
Ev yone is talking about eather C
eve with
are i

As al ys, thank you for making every shoot si
results

est regards,

ADMARKETING INC.

Pierre Fabre

harles,

hank you. Thank you. Thank you for another
reat job. Just one problem...too many terrific
hots to choose from.

n you've made me look great back at the agency.
all the credit.

ur team for the terrific work
e over the past couple of ye
eight images in one day on
iation on behalf of our organ
beautiful, and will help us

GRIFFIN B

4 Grant & Associat
Public Relations

96

Bush
IOS
ighland
les, CA 90038

Charle

Where were Ia
Henry So was Montgo
Los.
ore me.

is always a joy to work with y
lients.

KNOW ME, I DOIN
D WORK WITH YO

GRETZKY/VIEWCA
ED, AND THEY ARE
ERS. NATURAL
SUCCESS
HA

CBS GROUP

use much

ONS AND MARKETING

WHY YOU SHOULD SHOOT WITH CHARLES BUSH.
BY DEXTER FEDOR, CREATIVE DIRECTOR, KETCHUM S.F.

CHARLES WEARS GOOD SHOES.
HE IS SOFTSPOKEN, BUT PERFECTLY OPINIONATED.
HE UNDERSTANDS GOOD TASTE,
NOT FROM THE LABELS, BUT WHAT'S BENEATH THEM.
HE LIKES A DECENT COCKTAIL.
HE LOVES FOOD.

CHARLES HATES ANYTHING CHEESY.
CHARLES IS HOPELESSLY ROMANTIC.

CHARLES IS NOT TARDY.
HE CROSSES HIS "T"S, DOTS HIS "I"S.
HE GOES DIRECTLY HOME.
HE ALWAYS FLUSHES.

CHARLES WILL TAKE A PICTURE THAT YOU WILL REMEMBER.
HREE YEARS LATER.
ND YOU'LL ACTUALLY HAVE FUN DOING IT,
VEN IF THE CLIENT IS THERE.
KNOW.

f Lisa Kudrow I want to th
standing cover you shot for
It is truly beautiful.

to work with you again in t

regards,

phy

JACLYN SMITH

s take his long to get t
say "th ion with Dan Aykroyd. I
was good to see you ag
ntastic

Y YEARS THERE HAS BEEN VERY LITTL
OGRAPHS, AND DEFINITELY NONE ON OUR FRIEND

What I appreciate most about w rking with you is knowing that I can be 100% sure of
getting a terrific photo, and havi g fun doing it. It was true at Max Factor and now Iso
with Physicians Formula. I'm gl d we've got you in L.A.

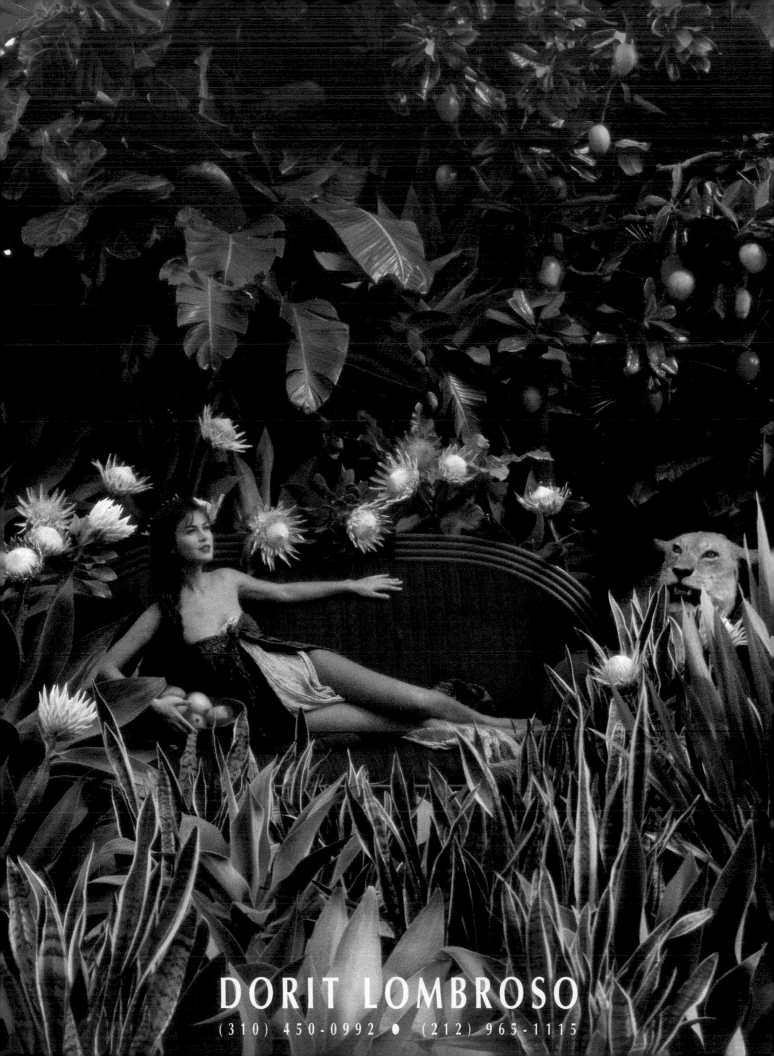

DORIT LOMBROSO

(310) 450-0992 ● (212) 965-1115

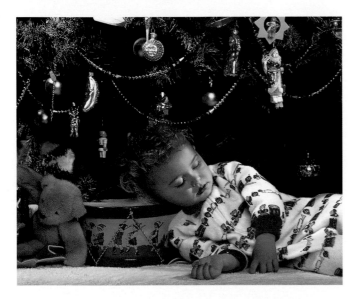

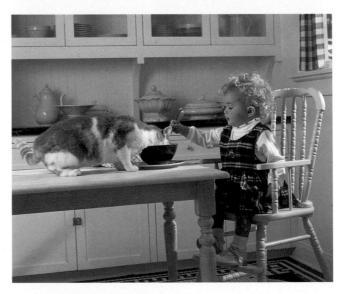

DORIT LOMBROSO

(310) 450-0992 ● (212) 965-1115

BRET LOPEZ

310-393-8841

RHONI EPSTEIN 310-207-5937

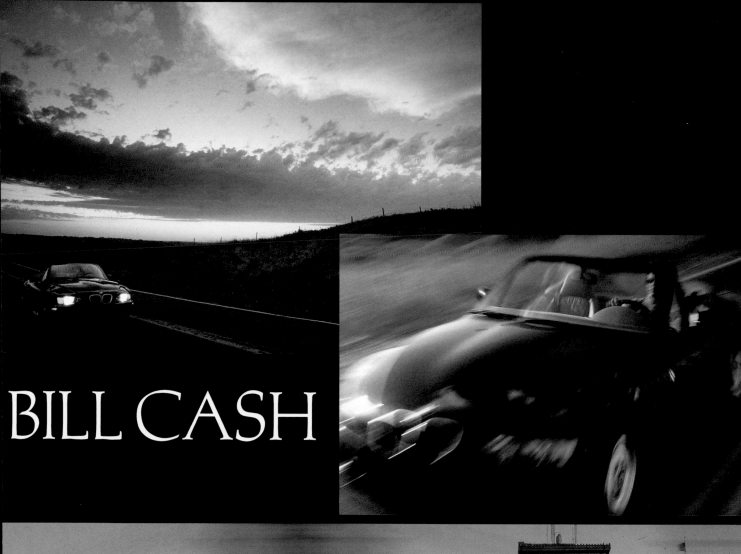

BILL CASH

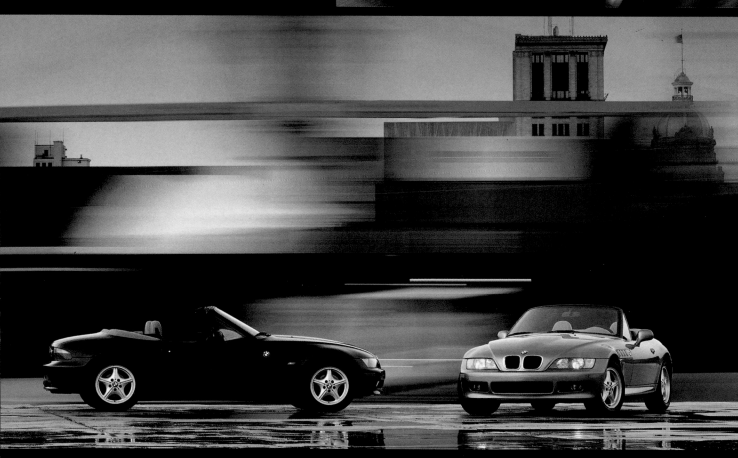

Represented by Shelly Steichen 714.261.5844 714.261.5973 fax

8

PETER
READ
MILLER
310
545 7511

ESKITE

RICHARD ESKITE PHOTOGRAPHY

TELEPHONE: 415.626.9606

ESKITE

RICHARD ESKITE PHOTOGRAPHY

TELEPHONE: 415.626.9606

KEVIN
CRUFF
PHOTO

3219 37TH AVENUE WEST
SEATTLE, WASHINGTON 98199
TELEPHONE 206.282.4726
http://www.cruffphoto.com/cruff/

IN ARIZONA CONTACT:
ATELIER KIMBERLY BOEGE
TELEPHONE 602.265.4389

two views

one ship

still passing

in the night

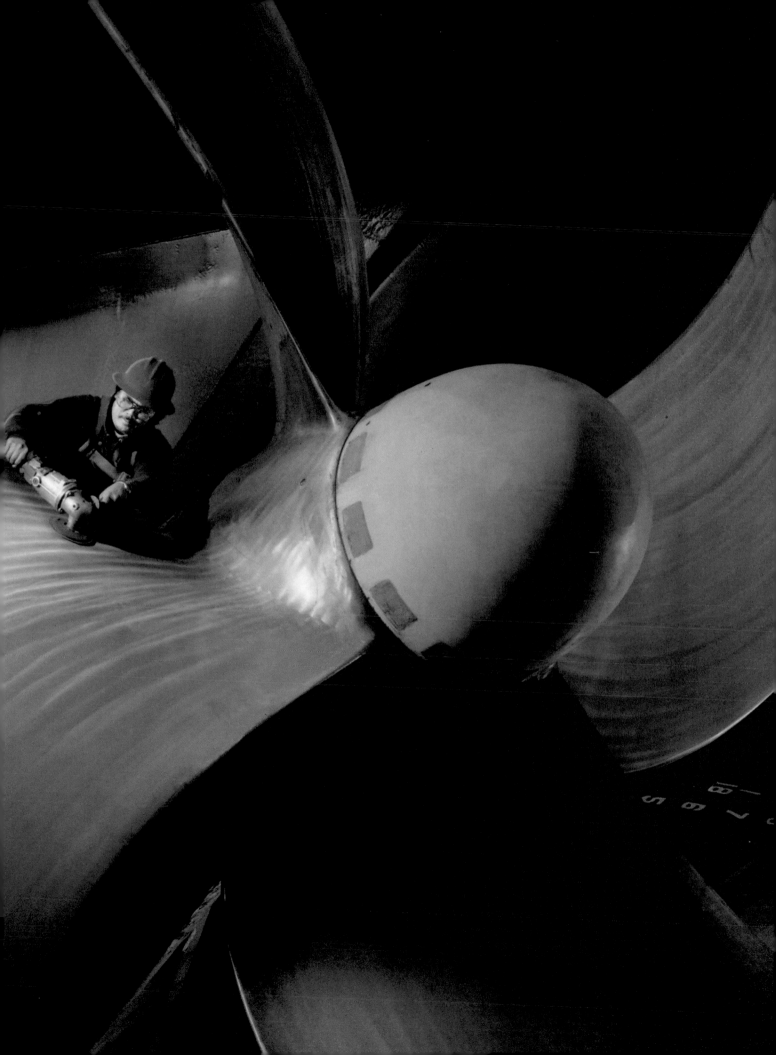

In Los Angeles: Lee+Lou 310·287·1542

CHUCK KUHN

Print and Film Images *of* America

Seattle: 206·842·1996 fax: 206·842·1265

Dennis Atkinson **THE DESIGNORY**

Ron Berry **THE DESIGNORY**

G R A V E S

Rick Graves Photography • 441 East Columbine, Suite H, Santa Ana, California 92707 • 714/662/2623 • Represented by **LEE◆LOU** Productions Incorporated 310/287/1542 • FAX: 310/287/1814

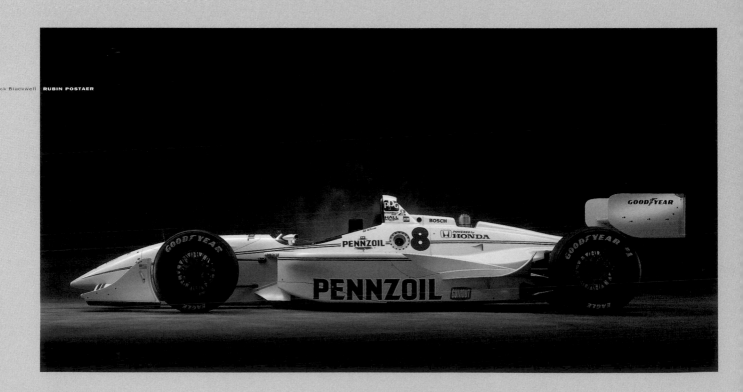

Chuck Blackwell **RUBIN POSTAER**

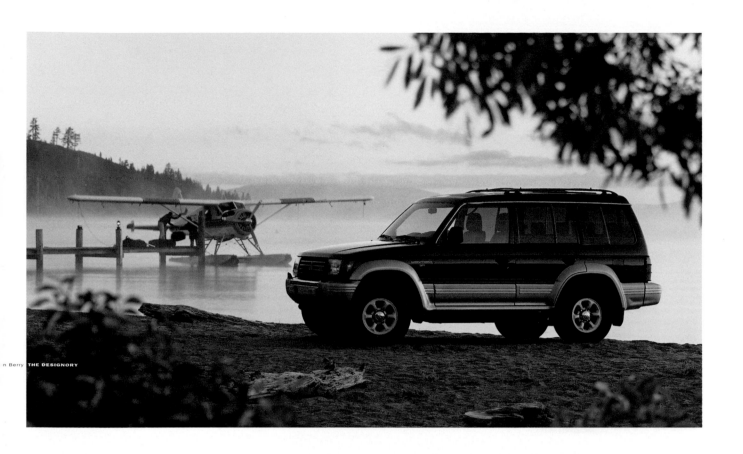

n Berry **THE DESIGNORY**

G R A V E S

Rick Graves Photography • 441 East Columbine, Suite H, Santa Ana, California 92707 • 714/662/2623 • Represented by **LEE●LOU** Productions Incorporated 310/287/1542 • FAX: 310/287/1814

Larry Corby **FOOTE CONE & BELDING**

Dennis Atkinson **THE DESIGNORY**

885

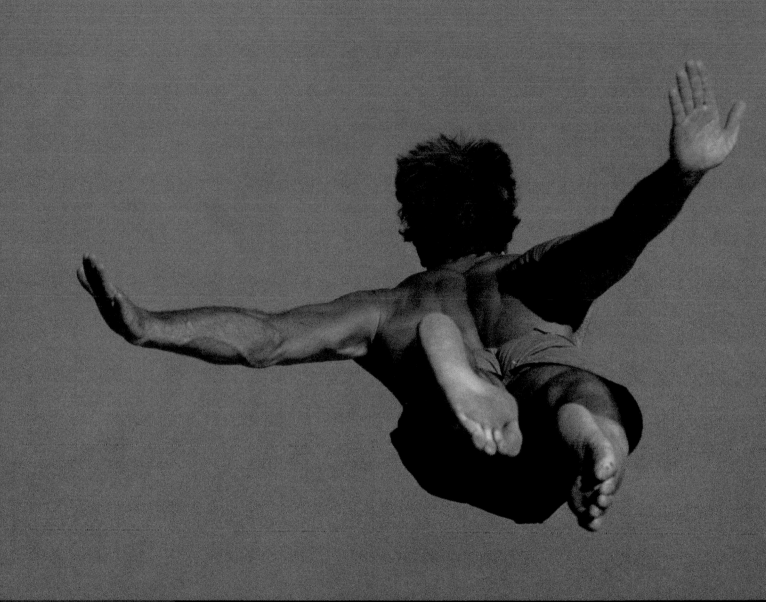

SONY

COORS

MICROSOFT

NIKON

CHRYSLER

AMERICAN EXPRESS

CONDE NAST

AMERICA WEST AIRLINES

NATIONAL GEOGRAPHIC

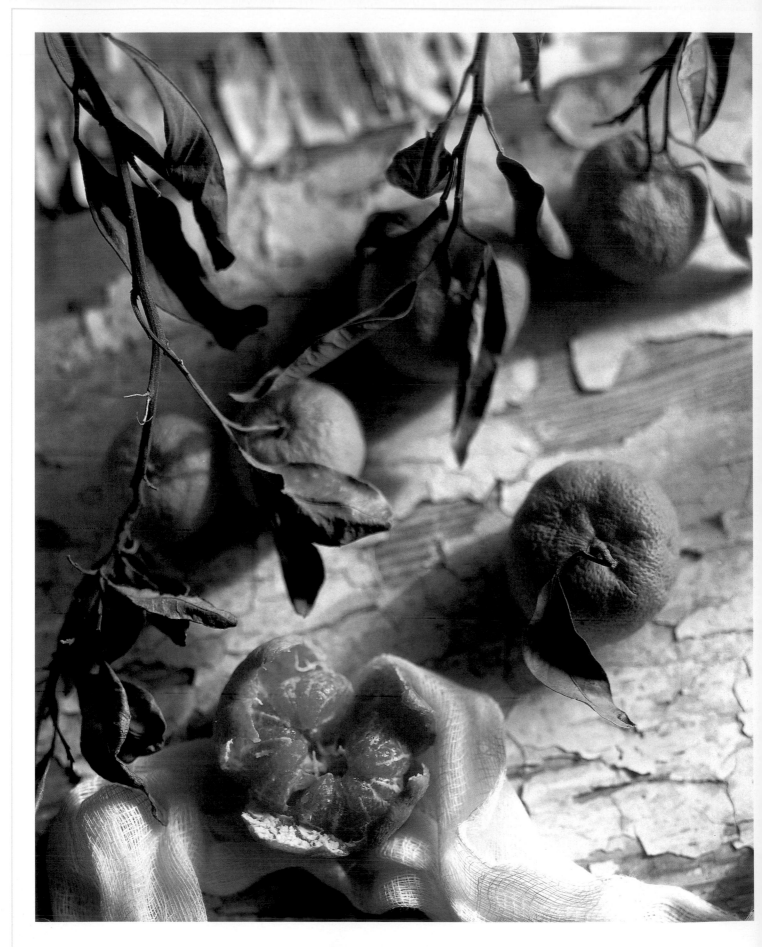

Dannehl

Dannehl

ennis Dannehl Photography Los Angeles, CA 213.388.3888 FAX: 213.388.7187

DAVID CAMPBELL

244 NINTH STREET SAN FRANCISCO CALIFORNIA 94103 TELEPHONE 415 864 2556 FAX 415 864 5865

DAVID CAMPBELL

346 NINTH STREET SAN FRANCISCO CALIFORNIA 94103 TELEPHONE 415 864 2556 FAX 415 864 5865

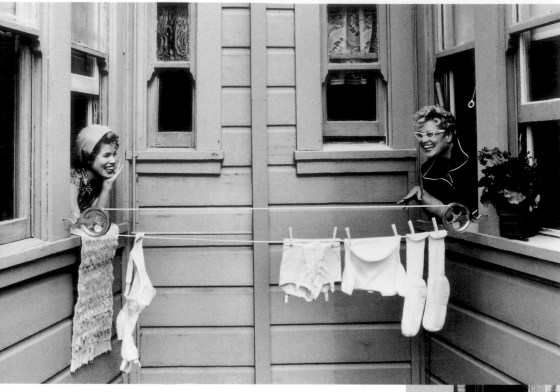

KEVIN SANCHEZ STUDIOS

MIDWEST:
ANNE ALBRECHT
312 595 0300
312 595 0378 FAX

SAN FRANCISCO:
BARB HAUSER
415 647 5660
415 285 1102 FAX

STUDIO
DENISE BOHART
415 285 1770
415 285 1102 FAX

MIDWEST:
ANNE ALBRECHT
312 595 0300
312 595 0378 FAX

SAN FRANCISCO:
BARB HAUSER
415 647 5660
415 285 1102 FAX

STUDIO
DENISE BOHART
415 285 1770
415 285 1102 FAX

KEVIN SANCHEZ STUDIOS

ANN ELLIOTT CUTTING

represented by:

SHARPE + ASSOCIATES

Los Angeles 310.641.8556

New York 212.595.1125

Studio 818.440.1974

http://www.cutting.com/

ANN ELLIOTT CUTTING

represented by:

SHARPE + ASSOCIATES

Los Angeles 310.641.8556

New York 212.595.1125

Studio 818.440.1974

http://www.cutting.com/

NEAL BROWN

represented by:

SHARPE + ASSOCIATES

Los Angeles 310.641.8556

New York 212.595.1125

Studio 213.934.5324

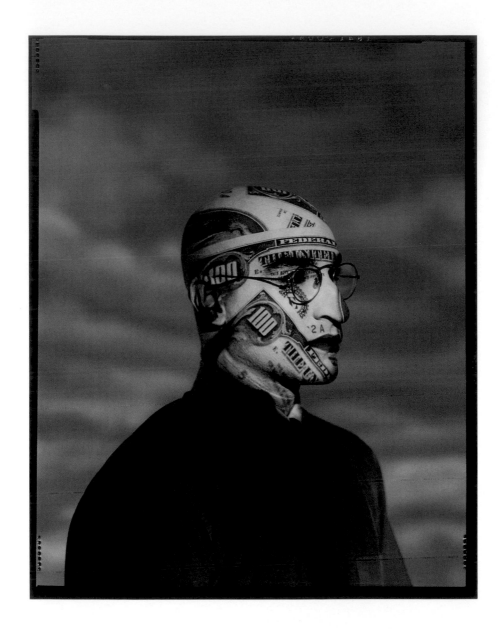

represented by:

SHARPE + ASSOCIATES

Los Angeles 310.641.8556

New York 212.595.1125

Studio 818.683.3900

represented by:

SHARPE + ASSOCIATES

Los Angeles 310.641.8556

New York 212.595.1125

Studio 818.683.3900

EliotCrowley
PHOTOGRAPHER
(800) 720-2769

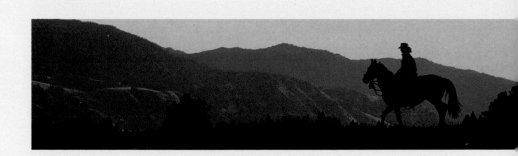

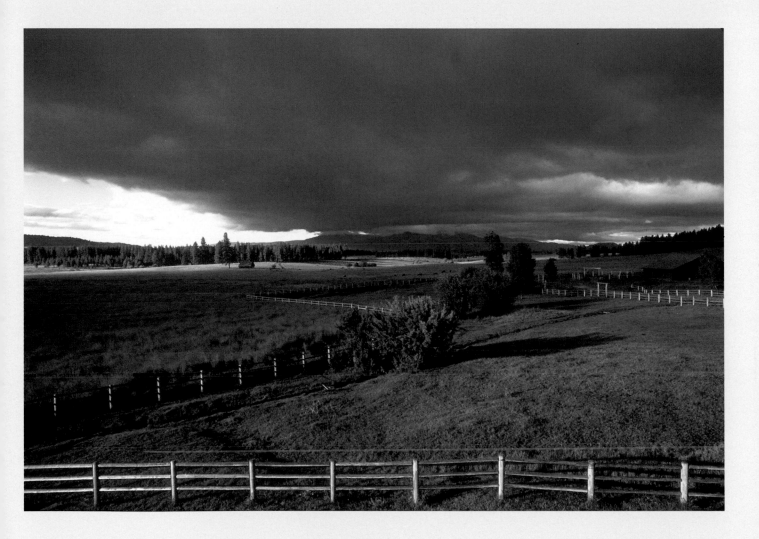

EliotCrowley
PHOTOGRAPHER
(800) 720-2769

S^teve H^atha^wa^y

400 Treat Ave., Suite F, San Francisco, CA 94110

Tel. 415-255-2100 **Fax:** 415-255-5960

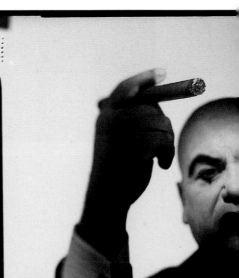

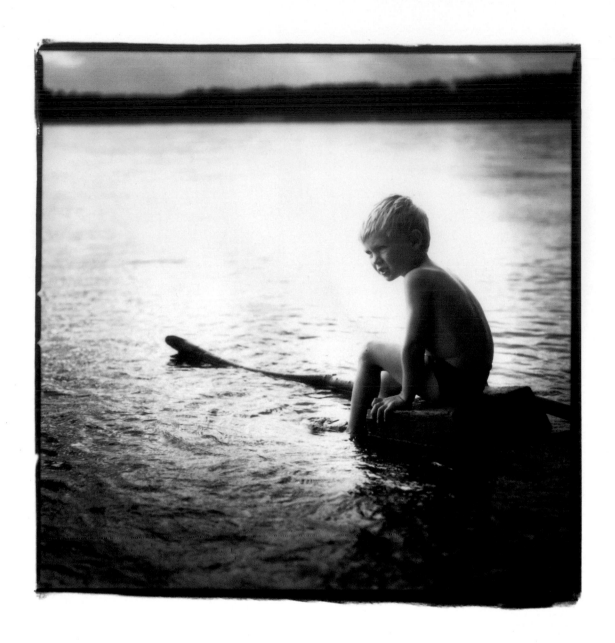

Erik Ostling 801.364.3686

JENNIFER
DURHAM
PHOTOGRAPHY

810-839-8191

COOPER

LE COQ

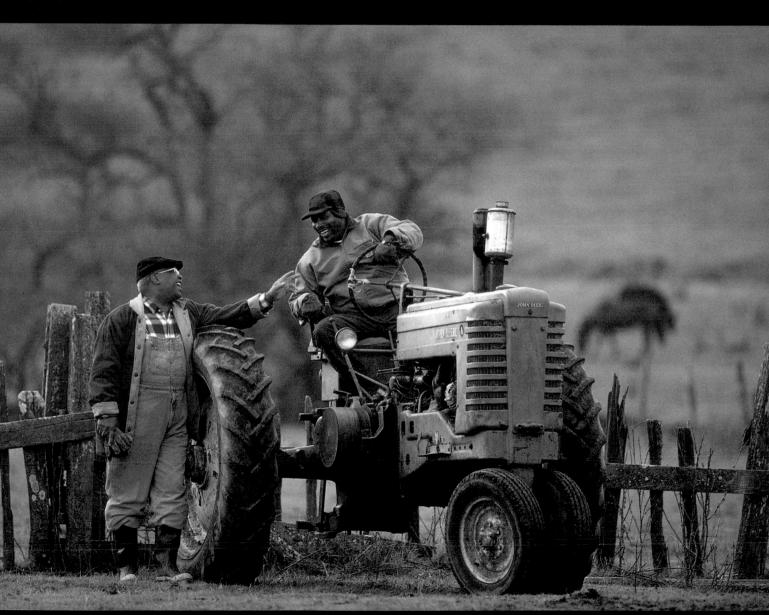

LE COQ

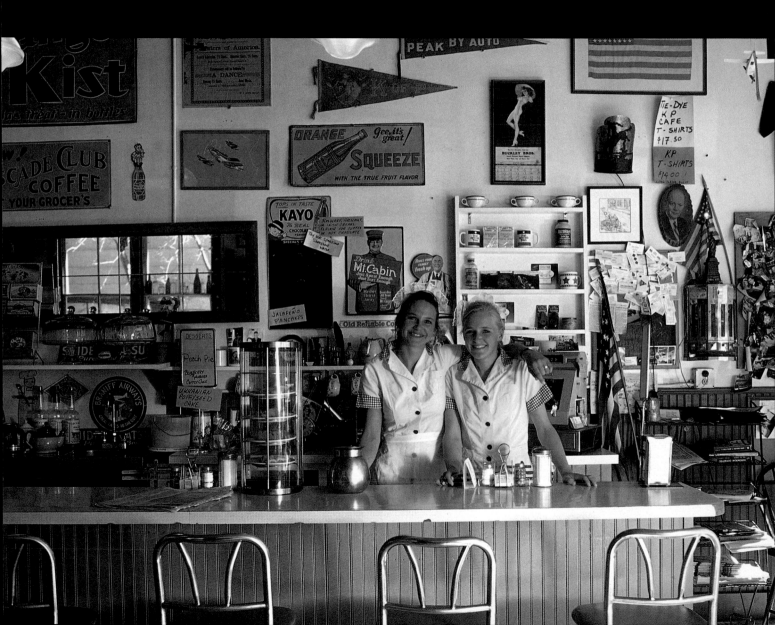

Eric Myer Photography, Inc.

Los Angeles, California

Telephone 310 589 5092

Facsimile 310 589 5192

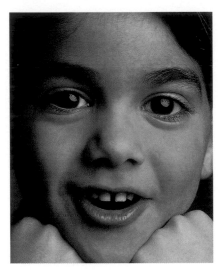

[1]

[2]

[3]

[4]

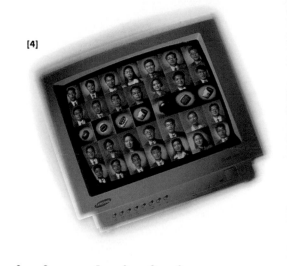

3 1 0 5 8 9 5 0 9 2

Mattel

Mead

Searle

5] Samsung [5]

QSC QSC QSC QSC QSC

SD SD SD SD

LA 전기 동경 반도체동경

RD RD RD RD

CH 1 CH 1 CH 1 CH 1

SD SD SD SD

홍콩 가전 홍콩

RD RD RD RD

CH 2 CH 2 CH 2 CH 2

SD SD SD SD

LA 중공업동경

RD RD RD RD

CH 3 CH 3 CH 3 CH 3

SD SD SD SD

호주 가전파나마 제지 동경

RD RD RD RD

CH 4 CH 4 CH 4 CH 4

911

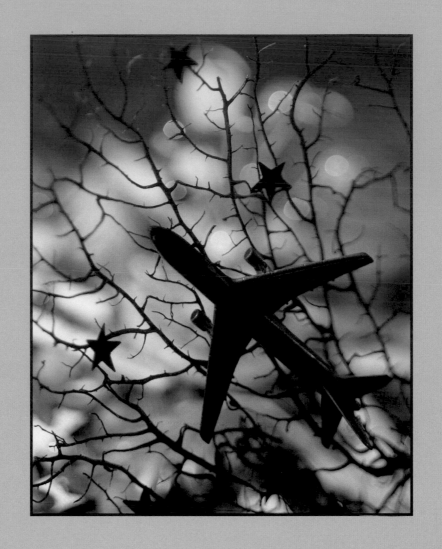

JENNIFER CHEUNG
photography

STUDIO 213 342-9458

REPRESENTED BY VALERIE LONDON

310 278-6633

JENNIFER CHEUNG
photography

STUDIO 213 342-9458

REPRESENTED BY VALERIE LONDON

310 278-6633

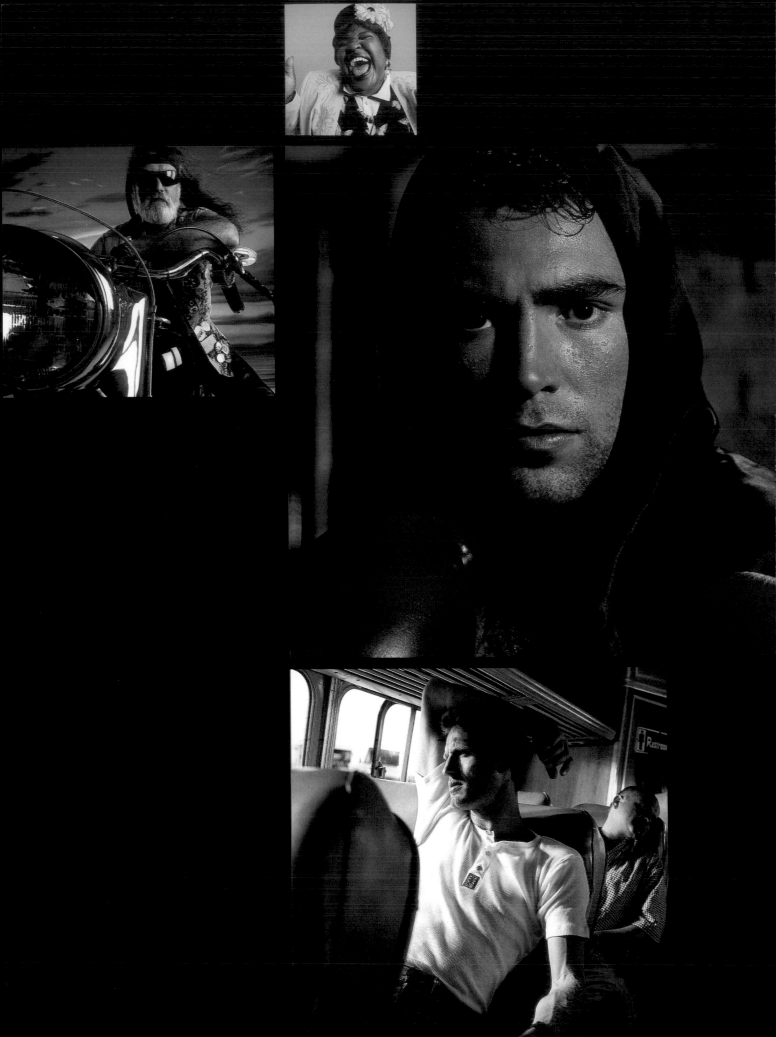

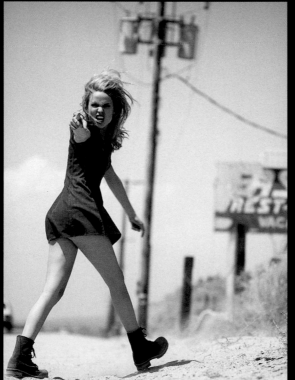

SILVERM**N**

Jay Silverman Productions
920 North Citrus Avenue
Hollywood, CA 90038
Fax: 213 466 7139
Phone: 213 466 6030
Call for our reel!
Contact: Cheryl Smith
jsilver433@aol.com

SILVERM**N

Jay Silverman Productions
920 North Citrus Avenue
Hollywood, CA 90038
Fax: 213 466 7139
Phone: 213 466 6030

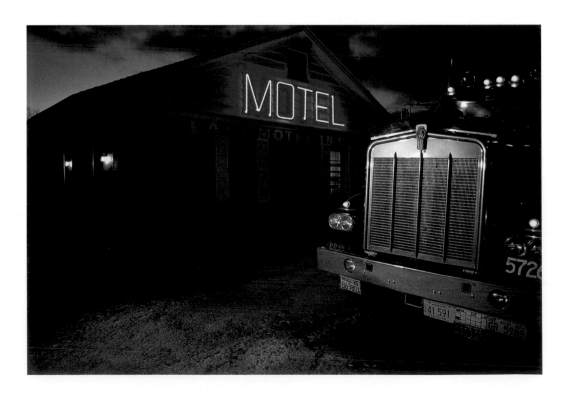

GEOFFREY CLIFFORD

415-457-7489

WORLDWIDE REPRESENTATION: MARGE CASEY 212-486-9575

IN CALIFORNIA: ROB LAWRENCE 310-838-1704

Irion

FREDA SCOTT
Representative
415.398.9121

Irion

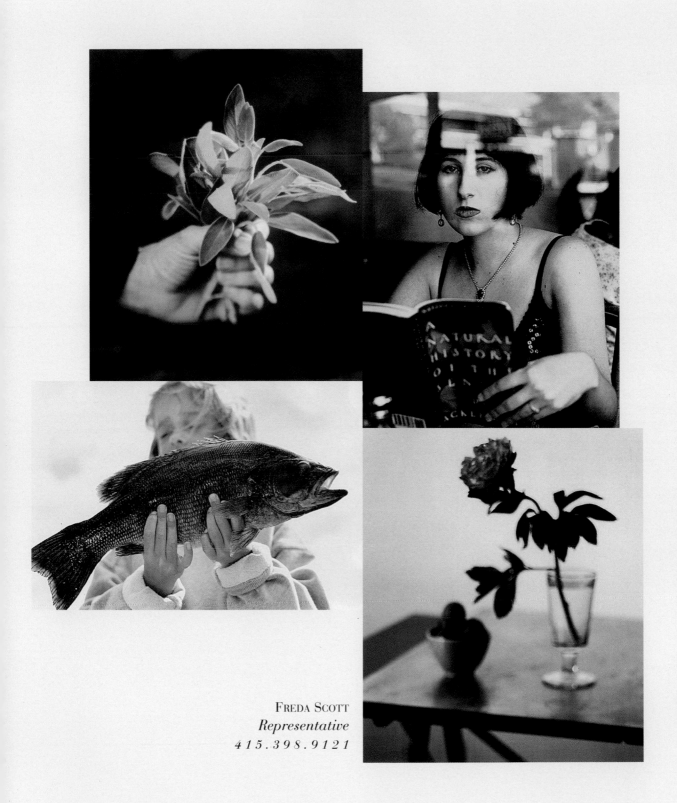

FREDA SCOTT
Representative
415.398.9121

CHRISTOPHER IRION
415.896.0752

Travel & Leisure *Giorgio* *Armani* *Herman Miller*

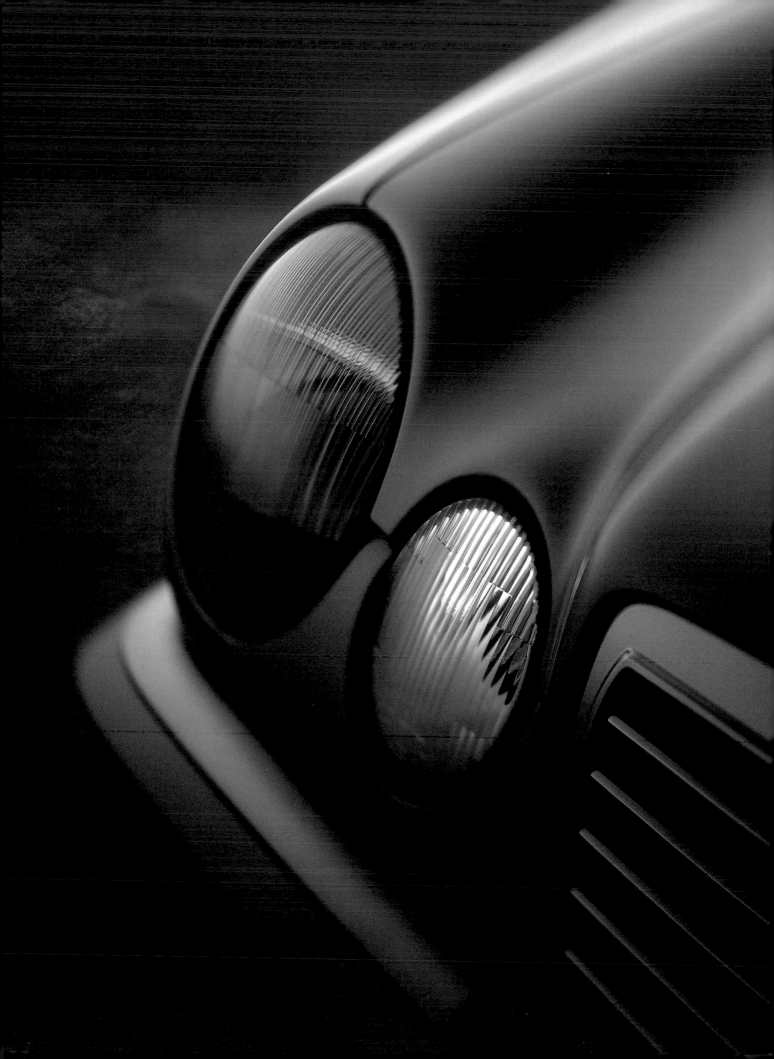

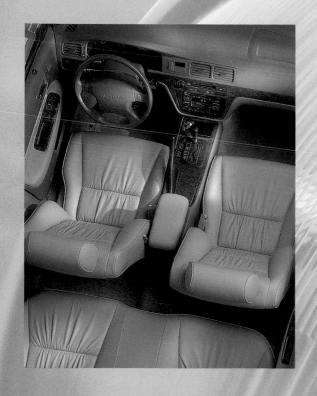

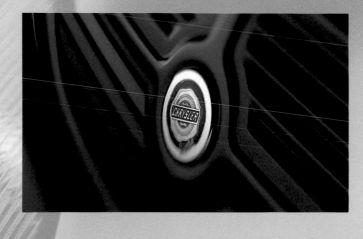

JoeCarlsonStudio

RŌBIE PRICE

P h o t o g r a p h y

Jane Klein Represents

5 1 0 • 5 3 5 • 0 4 9 5

Studio

4 1 5 • 7 2 8 • 5 4 4 5

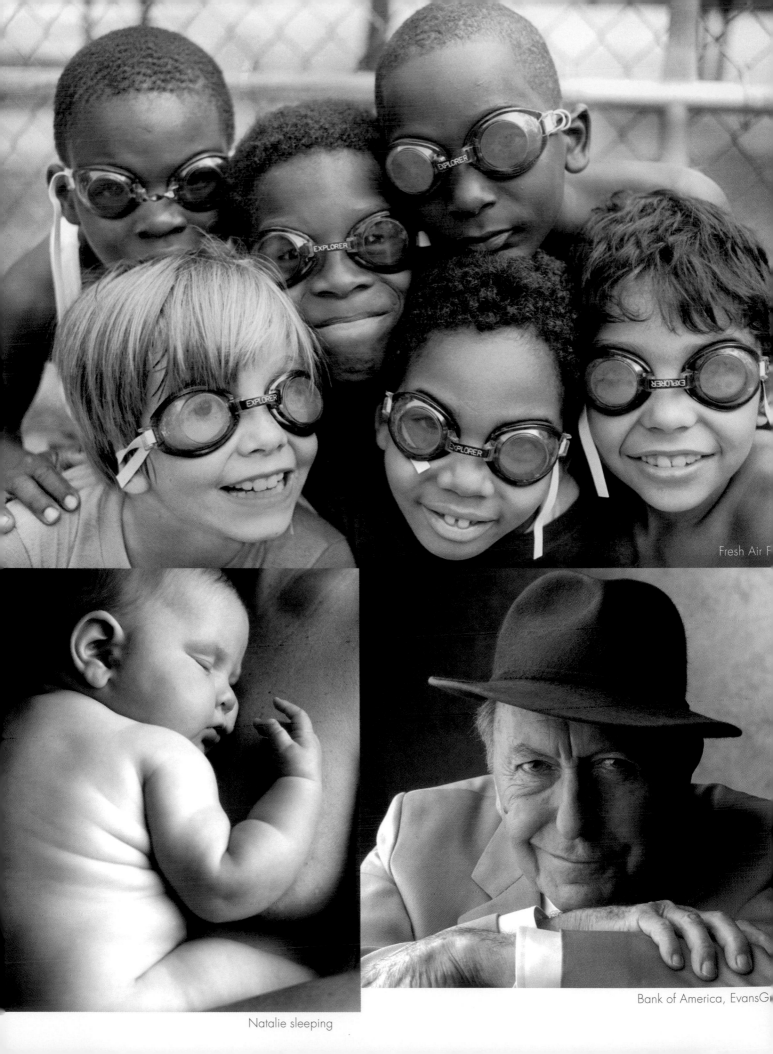

Fresh Air F

Bank of America, EvansG

Natalie sleeping

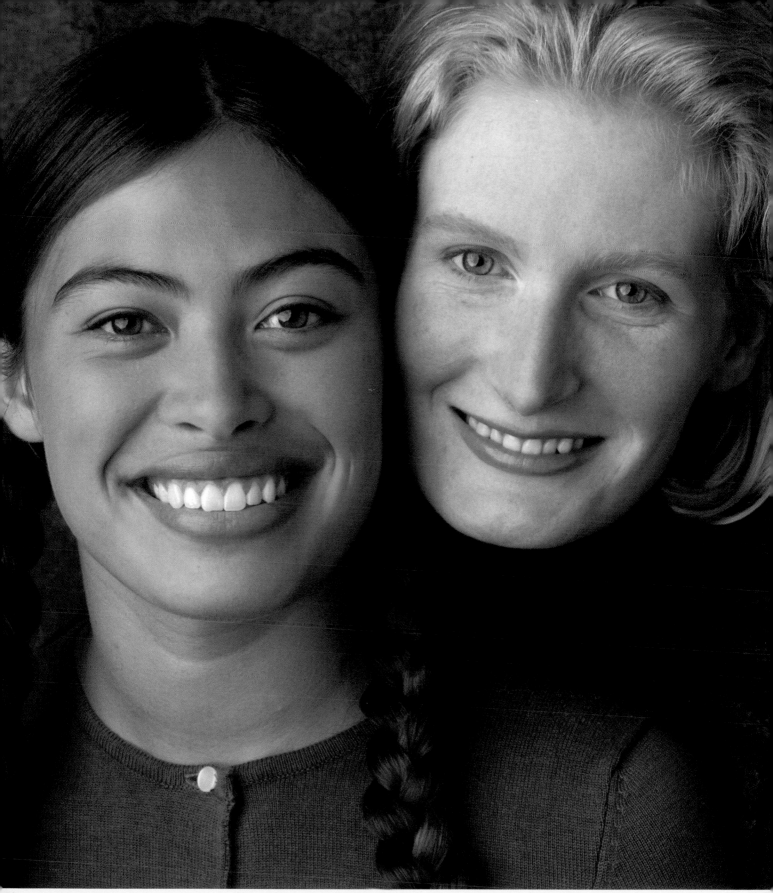

ashi, Mark Oliver, Inc.

CHRISTIAN PEACOCK

Photography

Jane Klein Represents 510.535.0495 studio 415.641.8088

marc solomon

213-935-1771

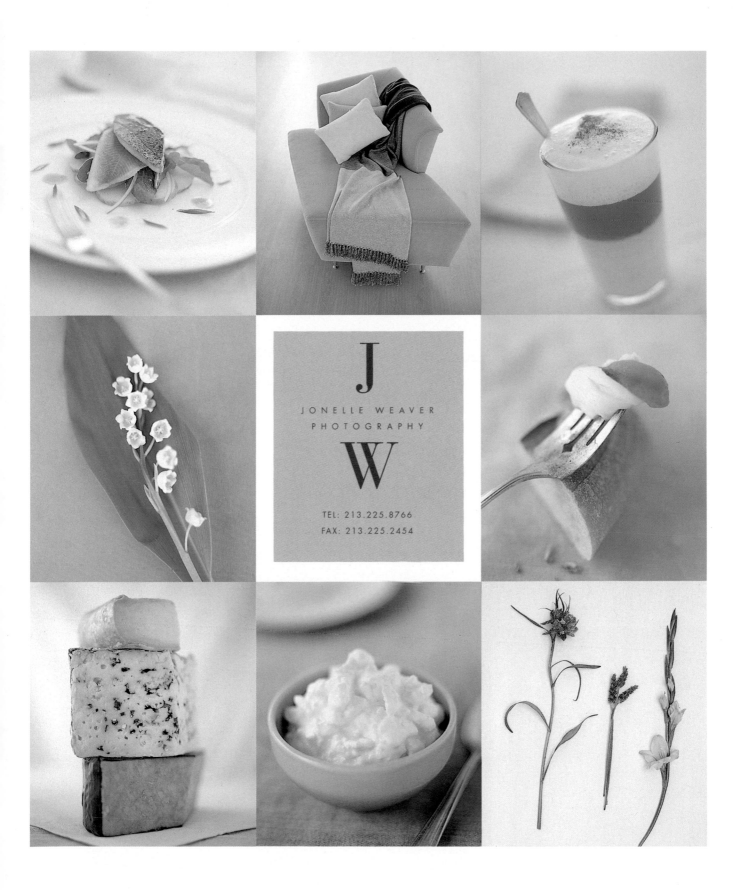

JONELLE WEAVER
PHOTOGRAPHY

JW

TEL: 213.225.8766
FAX: 213.225.2454

Dennis Murphy

101 Howell, Dallas, TX 75207, (214) 651-7516 FAX (214) 748-0856
West Coast: call Lisa Grafton (714) 960-8908
NYC: call The Arts Counsel (212) 777-6777

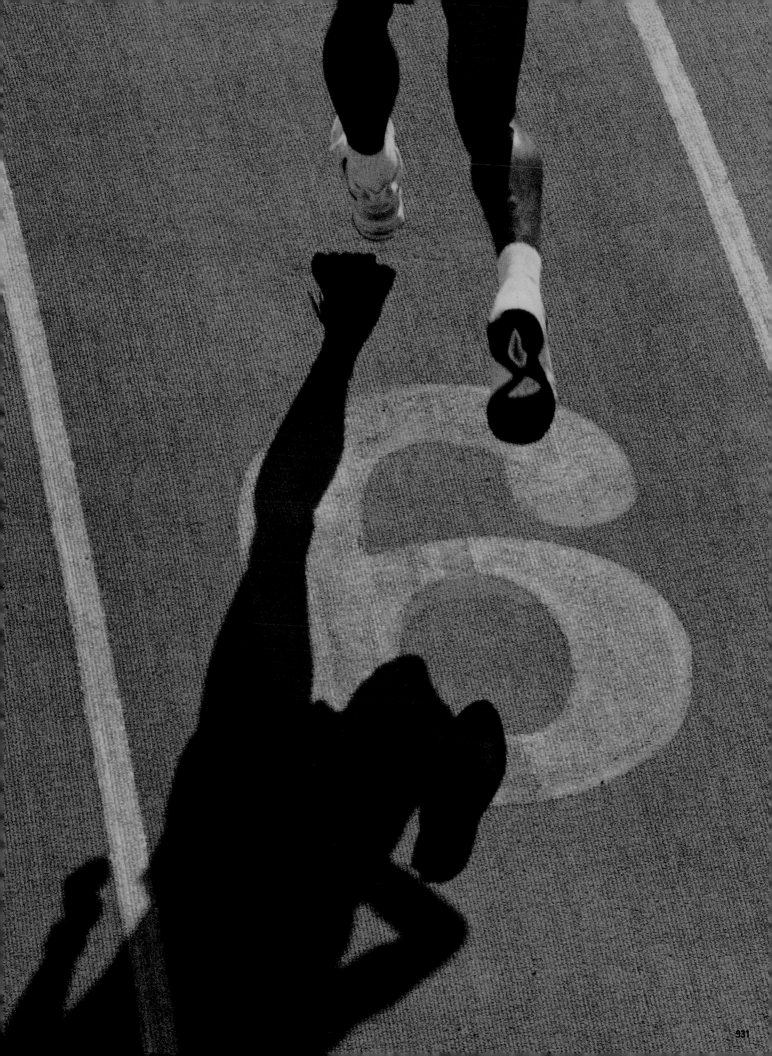

james connelly jr.

2636 BROADWAY

REDWOOD CITY, CA 94063

415.306.9563 FAX 415.365.1955

2636 BROADWAY

REDWOOD CITY, CA 94063

415.306.9563 FAX 415.365.1955

MARSHALL HARRINGTON PHOTOGRAPHER
TELEPHONE 619 291 2775 FACSIMILE 619 291 8466

MARSHALL HARRINGTON PHOTOGRAPHER
TELEPHONE 619 291 2775 FACSIMILE 619 291 8466

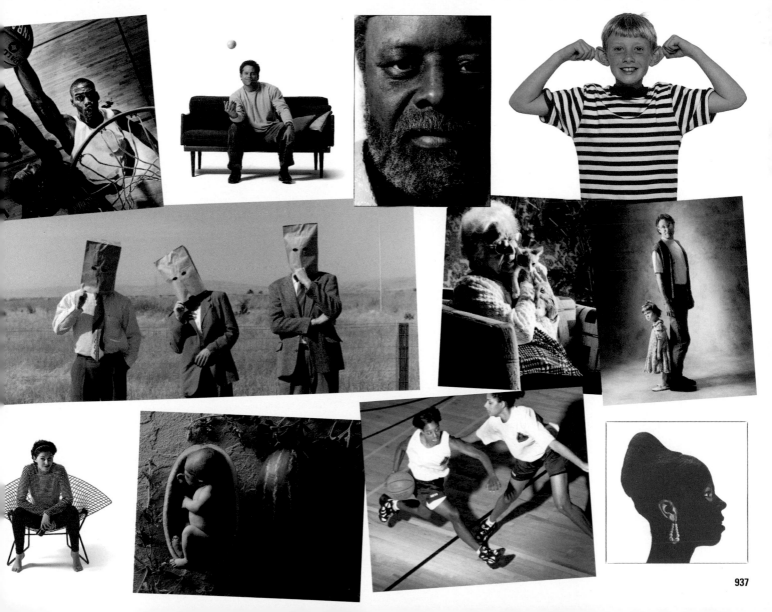

Mark Mercier / Jim Wimberg
Studio 310.839.7521

Represented by Carole Newman & Associates
310.394.5031

Mark Mercier / Jim Wimberg
Studio 310.839.7521

Represented by Carole Newman & Associates
310.394.5031

MERCIER
PHOTOGRAPHY
WIMBERG

BELVEDERE
VODKA
DISTILLED AND BOTTLED IN
BY POLMOS ZYR
IMP

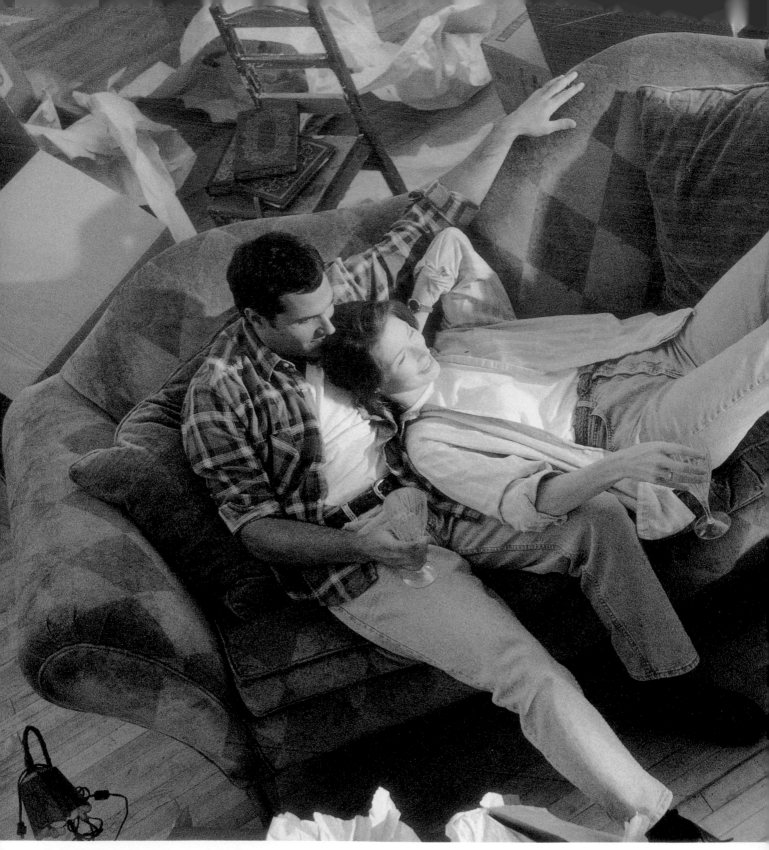

DAVID HANOVER
PHOTOGRAPHY INC.

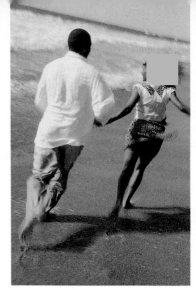
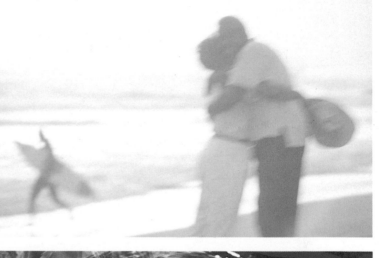

STUDIO 213 462-5695 · FAX 213 462-6360 · REPRESENTED ON THE WEST COAST BY ELLEN KNABLE & ASSOCIATES 310 855-8855

DEREK GARDNER PRODUCTIONS

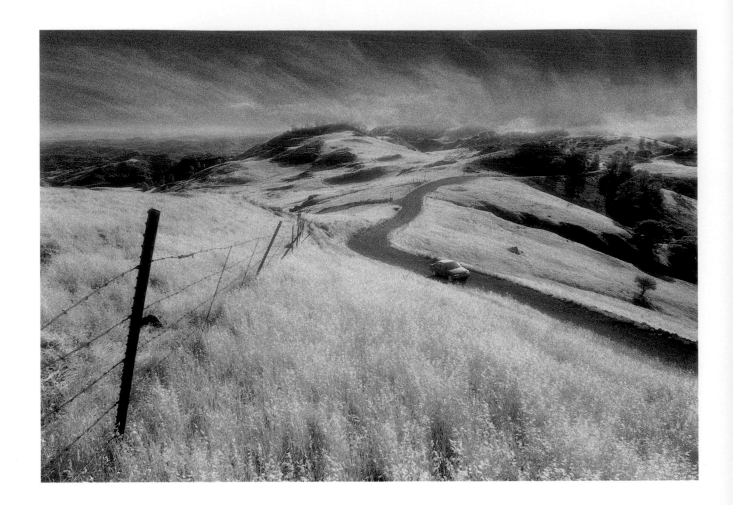

REPRESENTED BY REPRESENTED BY FILM REPRESENTATION

ROBERT LAWRENCE JONI HUGHES LOVINGER/COHN & ASSOC

LOS ANGELES NEW YORK NEW YORK

310 838 1704 212 366 9385 212 941 7900

FAX 838 2608 FAX 366 9386 FAX 941 7916

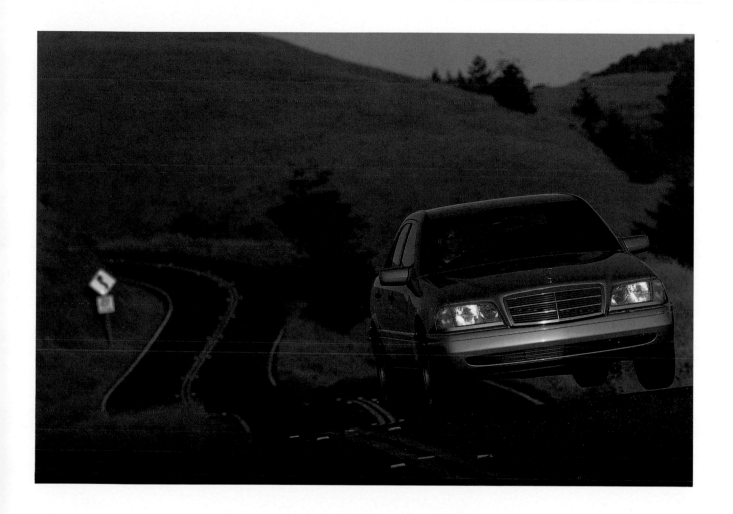

Derek Gardner

REPRESENTED BY

ROBERT LAWRENCE

LOS ANGELES

310 838 1704

FAX 838 2608

REPRESENTED BY

JONI HUGHES

NEW YORK

212 366 9385

FAX 366 9386

FILM REPRESENTATION

LOVINGER/COHN & ASSOC

NEW YORK

212 941 7900

FAX 941 7916

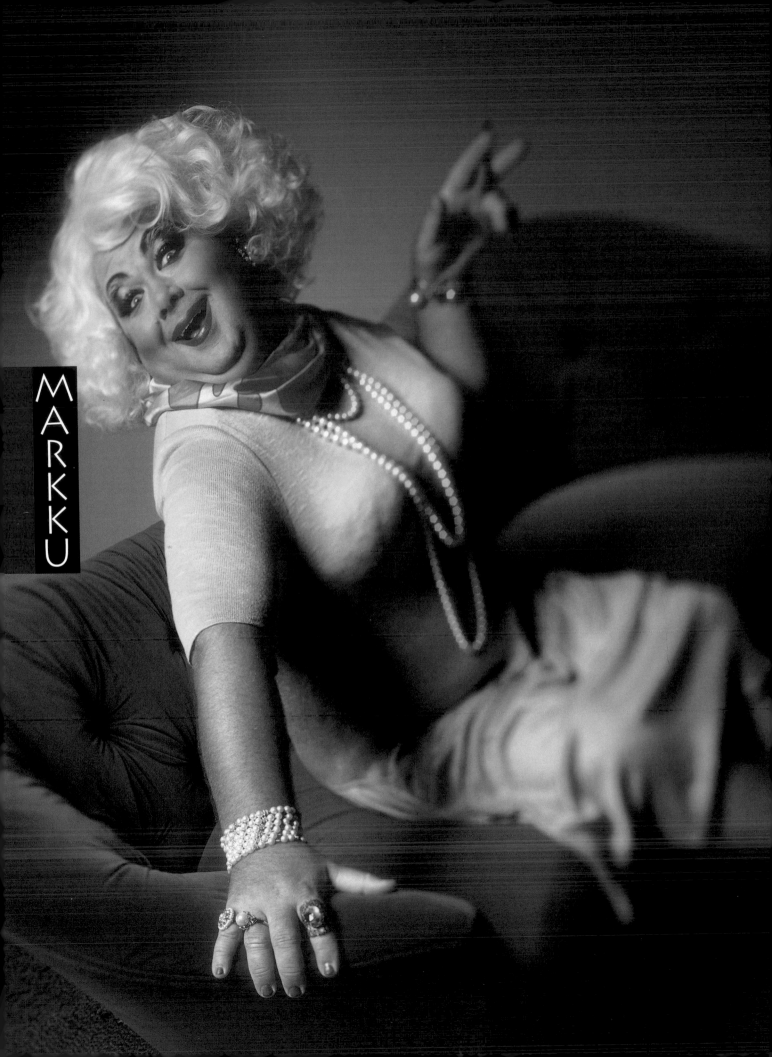

MARKKU

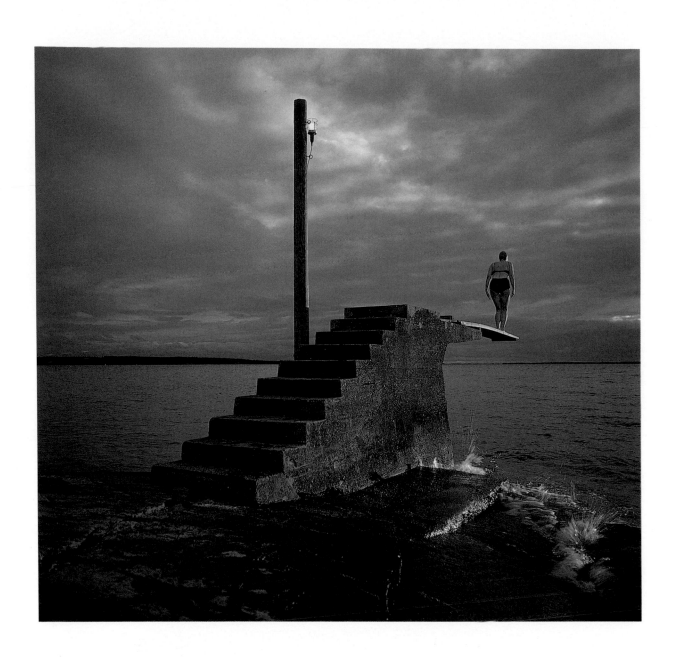

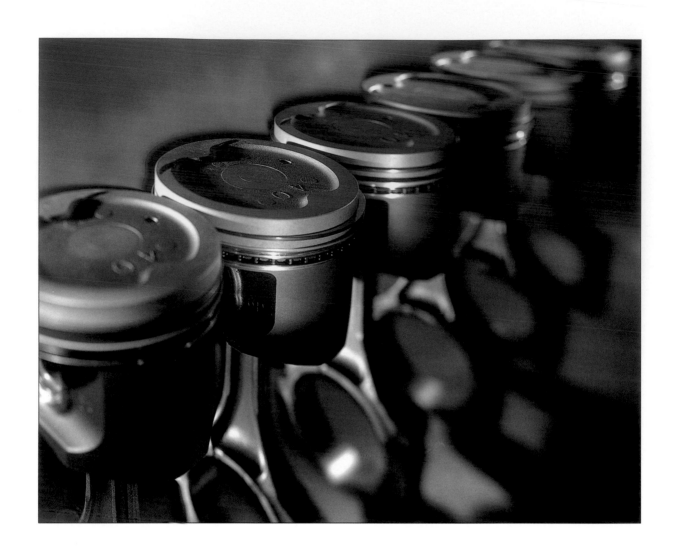

RICHARD DAILEY

MICHAEL RUPPERT STUDIOS INC.

12130 Washington Place • Los Angeles • California 90066
Tel: 310/390-1950 • Fax: 310/390-1883

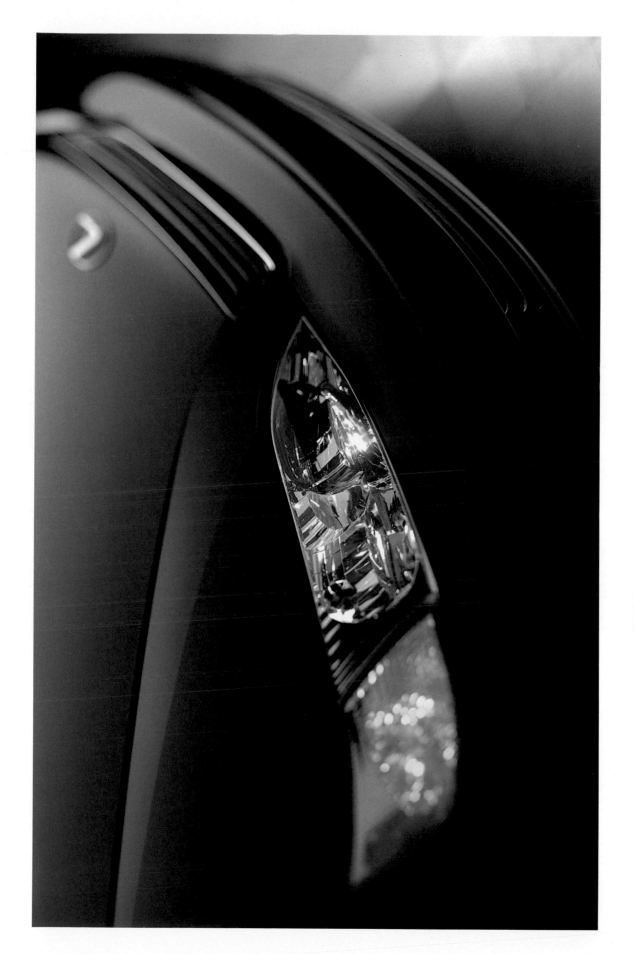

MICHAEL RUPPERT STUDIOS INC.

12130 Washington Place • Los Angeles • California 90066

Tel: 310/390-1950 • Fax: 310/390-1883

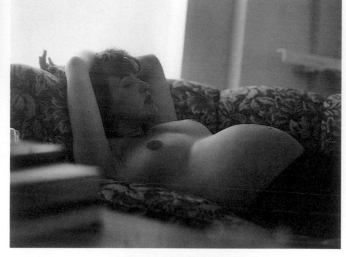

N I C O L A D I L L

2 1 3 - 9 6 4 - 2 2 0 4

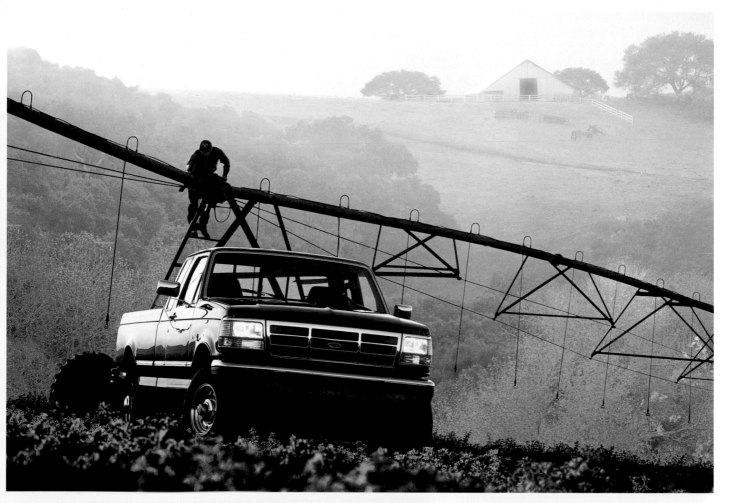

CHARLIE SCHRIDDE

124 Sunset Terrace Laguna Beach, CA. 92651 (714) 494-5709

Represented by

PHOTOGRAPHY DIGITAL FILM REEL ON REQUEST

IMSTEPF

e-mail • imstepf@aol.com

CHARLES IMSTEPF STUDIOS • 608 MOULTON AVE.• LOS ANGELES • CALIFORNIA • 90031-3237• PHONE: 213.222.8773 FAX: 213.222.9698

PHOTOGRAPHY

DIGITAL

FILM

REEL ON REQUEST

e-mail• imstepf@aol.com

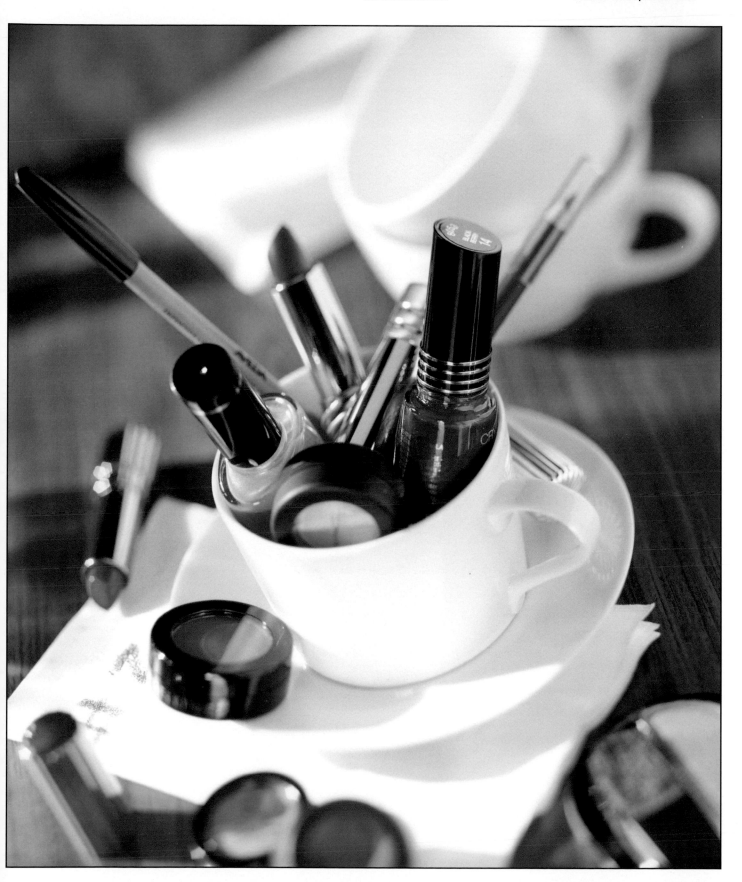

[PERU]

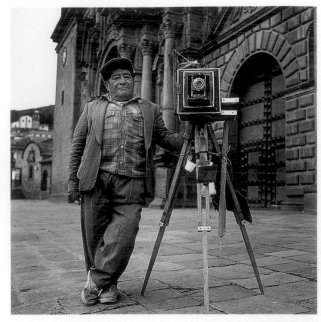
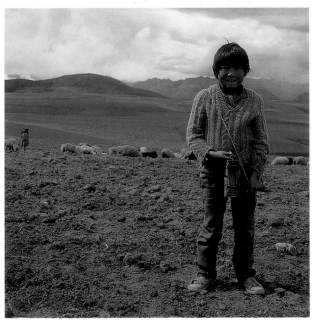

ROBB SCHARETG

[LOCATION PHOTOGRAPHY]

SAN FRANCISCO
PH:415.751.0313 FX:415.751.0314

REPRESENTATION: EAST COAST, DAVID CUSTACK PH:919.833.5522

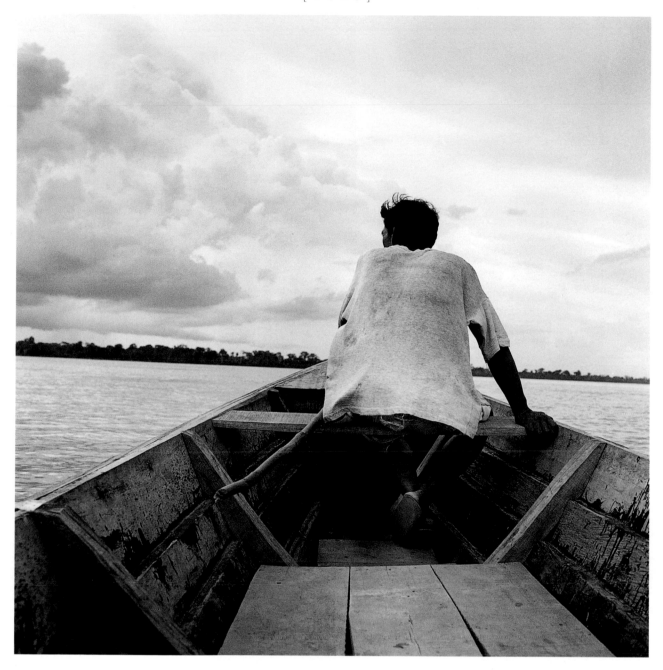

ROBB SCHARETG

[L O C A T I O N P H O T O G R A P H Y]

S A N F R A N C I S C O

PH:415.751.0313 FX:415.751.0314

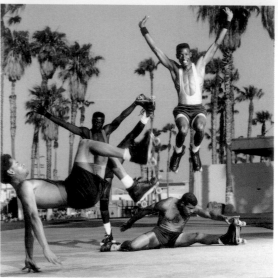

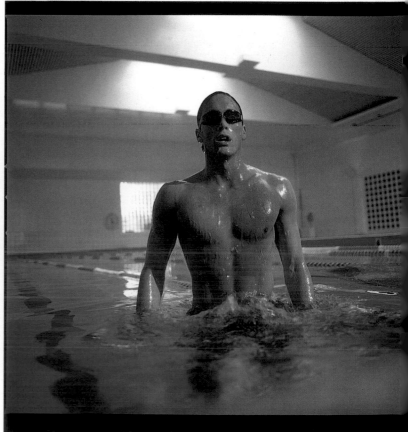

BLAKE LITTLE

FON: 213 466 9453
FAX: 213 466 8409
REPRESENTED BY
FOX ART INC
FON: 213 662 0020
FAX: 213 666 5135

BLAKE LITTLE • FON: 213 466 9453 • FAX: 213 466 8409 • REPRESENTED BY • FOX ART INC • FON: 213 662 0020 • FAX: 213 666 5135

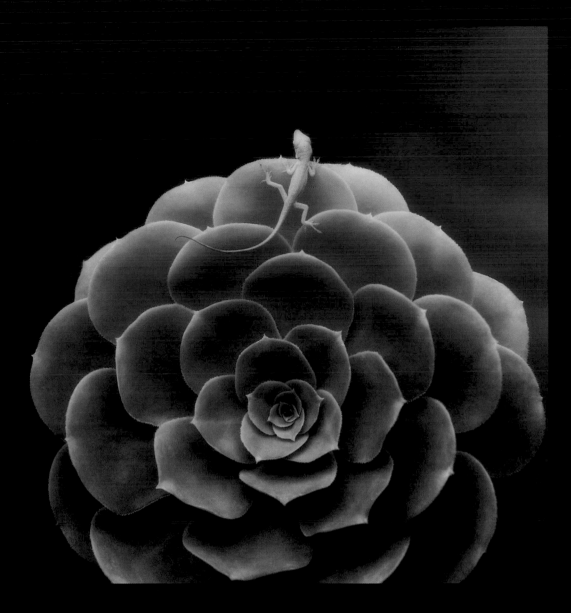

LAITA
mark laita photography
310 836 1645

robin dictenberg 212 620 0995 LA marsha fox 213 662 0020 CHI atols & hoffman 312 222 0504

LAITA
mark laita photography
310 836 1645

DAVID GUILBURT
PHOTOGRAPHY

Quincy Jones

Harrison Ford

Paula Abdul	Wayne Gretzky	Joan Baez	Tammy Wynette
Michael Douglas	Michael Eisner	Whoopi Goldberg	Jane Fonda
Faye Dunaway	Howie Long	HRH Prince Charles	Joseph Sargent
Anne Archer	Julie Brown	Ashley Montana	B-52's
Natalie Cole	Rosanna Arquette	Ernie Banks	Grace Mirabella
Quincy Jones	Emmylou Harris	Harrison Ford	Rick Dees
Wilt Chamberlain	James Earl Jones	Karl Malden	Greg Lemond
Pat Riley	Whitney Houston	George Burns	Corie Everson
Chris Lemmon	Leigh McCloskey	Magic Johnson	Dolff Lundgren

DAVID GUILBURT
PHOTOGRAPHY

Ashley Montana

David Arquette

Michael Jordan

Gordon Jump	The Rolling Stones	Jerry Brown	Willie Nelson
M.C. Hammer	David Arquette	David Bowie	Rita Moreno
Rodney Crowell	Bette Midler	Tony Perkins	Emma Samms
Andy Warhol	Farrah Fawcett	Gavin McCleod	John Corbett
Dennis Weaver	Ryan O'Neal	Alyce Beasley	Michael Jordan
Willard Scott	Sidney Poitier	Courtney Gibbs	Phil Hartman
Charles Aznavour	David Robinson	Levar Burton	Denis Leary
Little Feat	Ray Charles	Tina Turner	Racquel Welch
Jane Asher	Ronald Reagan	Rosanne Cash	Clyde Drexler

FULL IN HOUSE DIGITAL STUDIO

DGP/LA • MALIBU • 310.457.8260

SOUTH EAST: MICHAEL HOWELL 404.592.0058 • MID-WEST: VINCE KAMIN 312.787.8834

959

Ahrend

Jay Ahrend Photography (213) 462-5256 Fax (213) 856-4328 Represented by Marsha Fox & Paige Long (213) 662-0020

Ahrend

Jay Ahrend Photography (213) 462-5256 Fax (213) 856-4328 Represented by Marsha Fox & Paige Long (213) 662-0020

KIRK WEDDLE PHOTOGRAPHY

LOS ANGELES: 818 797 4567
PARIS: 41 18 33 33

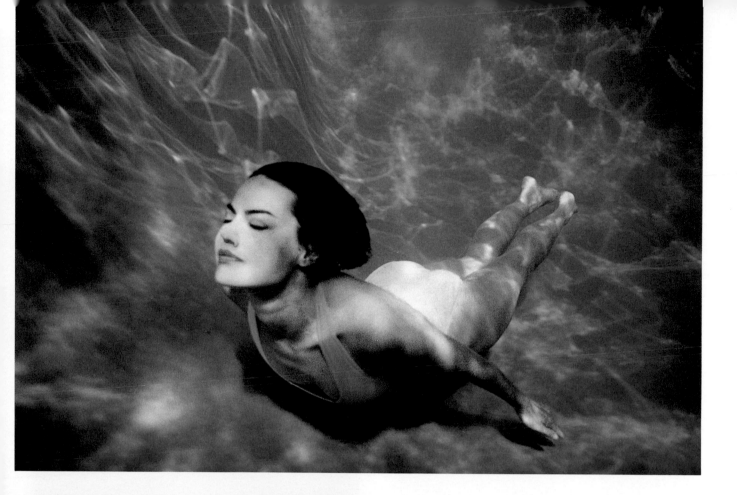

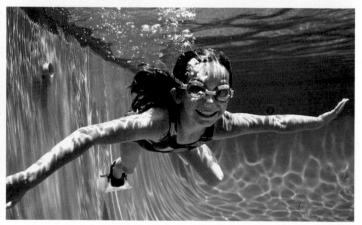

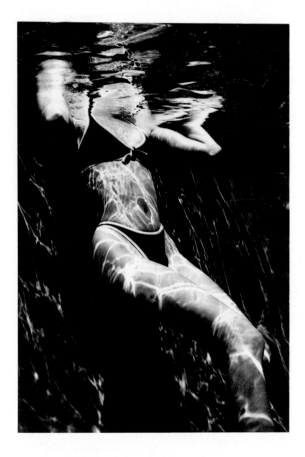

KIRK WEDDLE PHOTOGRAPHY

LOS ANGELES: 818 797 4567
PARIS: 41 18 33 33

MARC SIMON
PHOTOGRAPHY

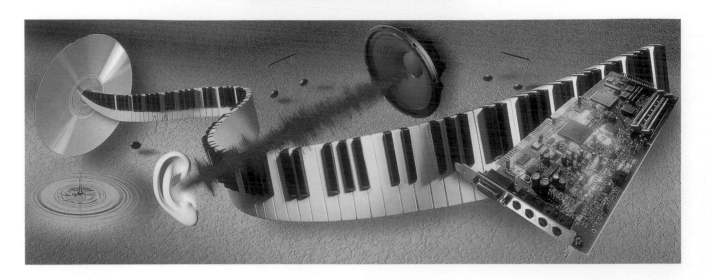

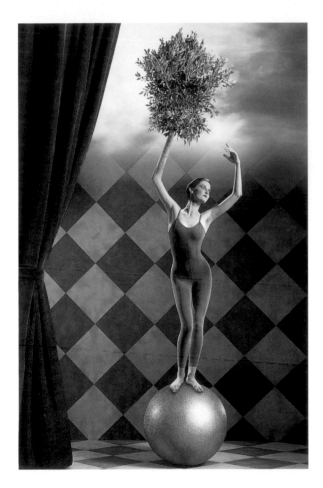

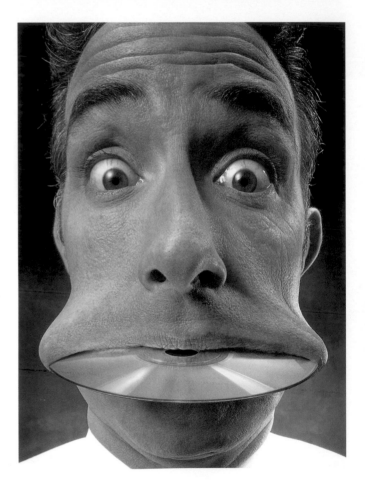

Photography & Digital Imaging

415.864.5606

1062 Folsom Street, San Francisco, CA 94103 Fax 415.864.6094

MARC SIMON
PHOTOGRAPHY

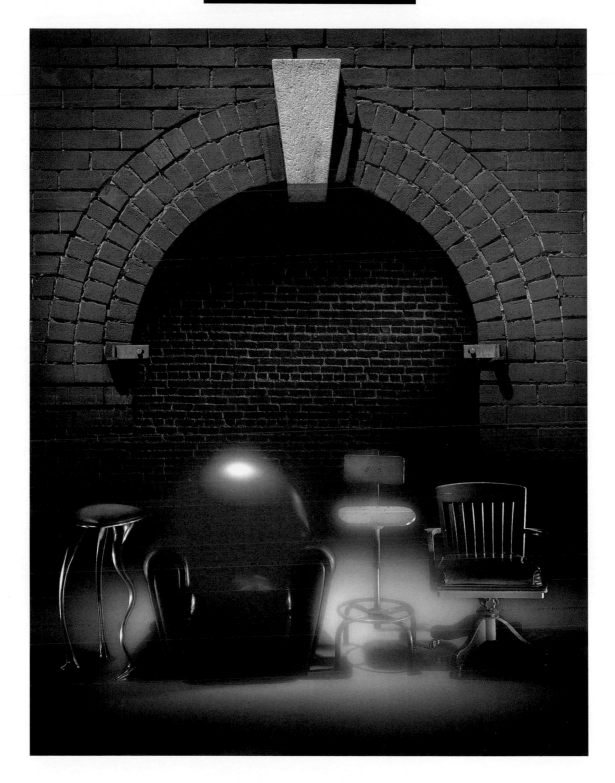

Photography & Digital Imaging

415.864.5606

1062 Folsom Street, San Francisco, CA 94103 Fax 415.864.6094

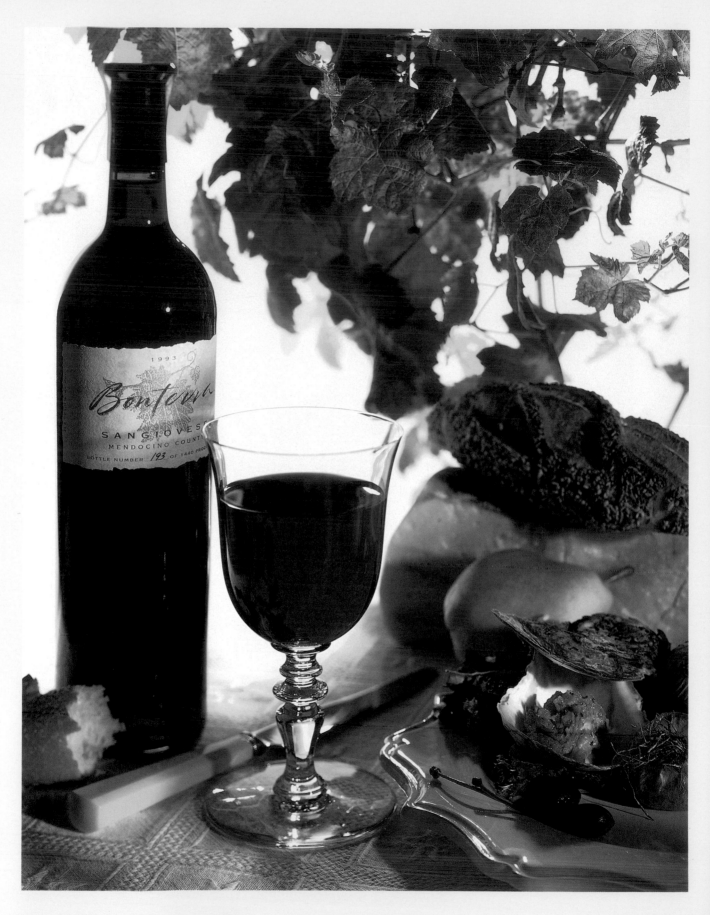

Kathlene Persoff

213 934-8276

749 North La Brea Ave.
Los Angeles Ca 90038

Jodi Pais
Creative Representation

818 795-1340

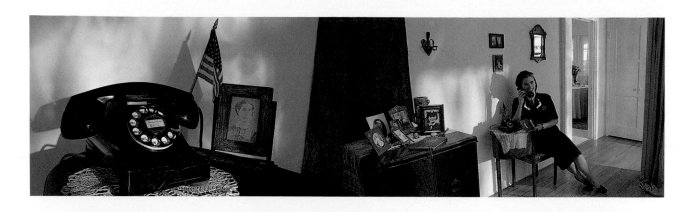

Seth Joel
818 761-4908

Jodi Pais
Creative Representation
818 795-1340

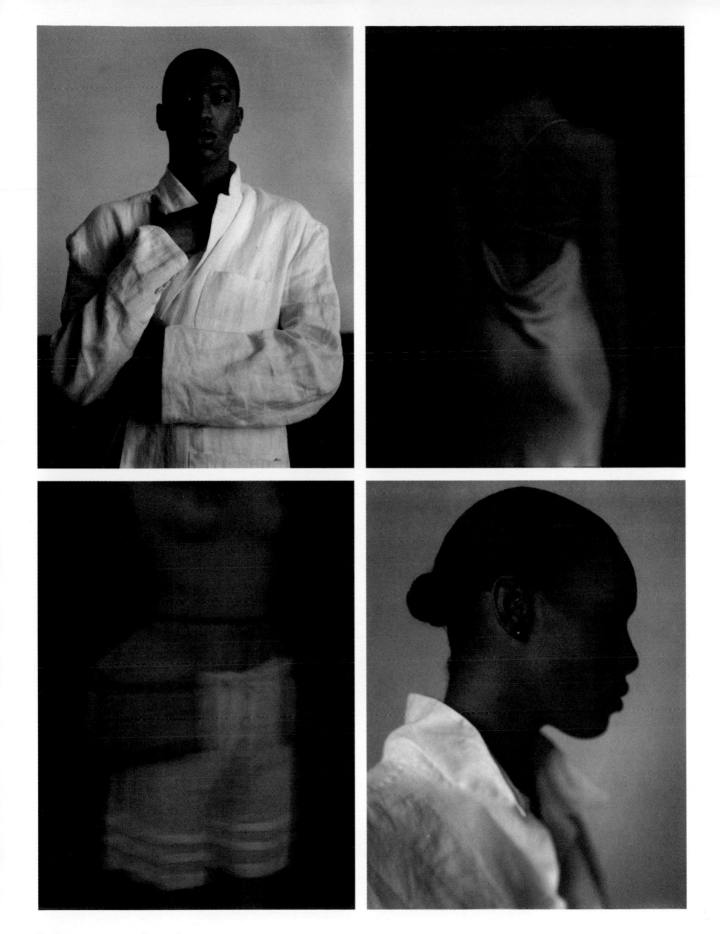

Mario de Lopez

213 225-7044

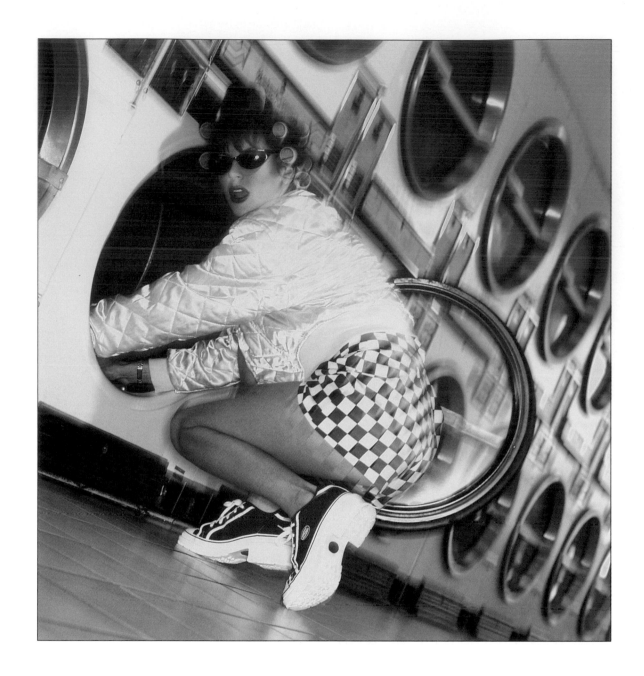

SALOUTOS

PETE SALOUTOS

LOS ANGELES 310 397 5509

SEATTLE 206 842 0832

petefoto@halcyon.com

STOCK 800 999 0800

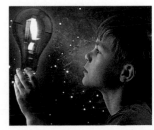

BRUCE JAMES

NEW YORK
ROBERT BACALL
212-254-5725

LOS ANGELES
MARI-ANNE AIZAC
310-458-1906

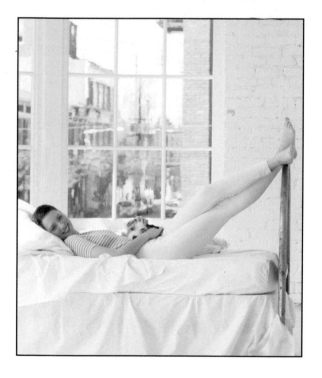

BARBARA PENOYAR

PHONE 206·283·3609
SEATTLE·WASHINGTON

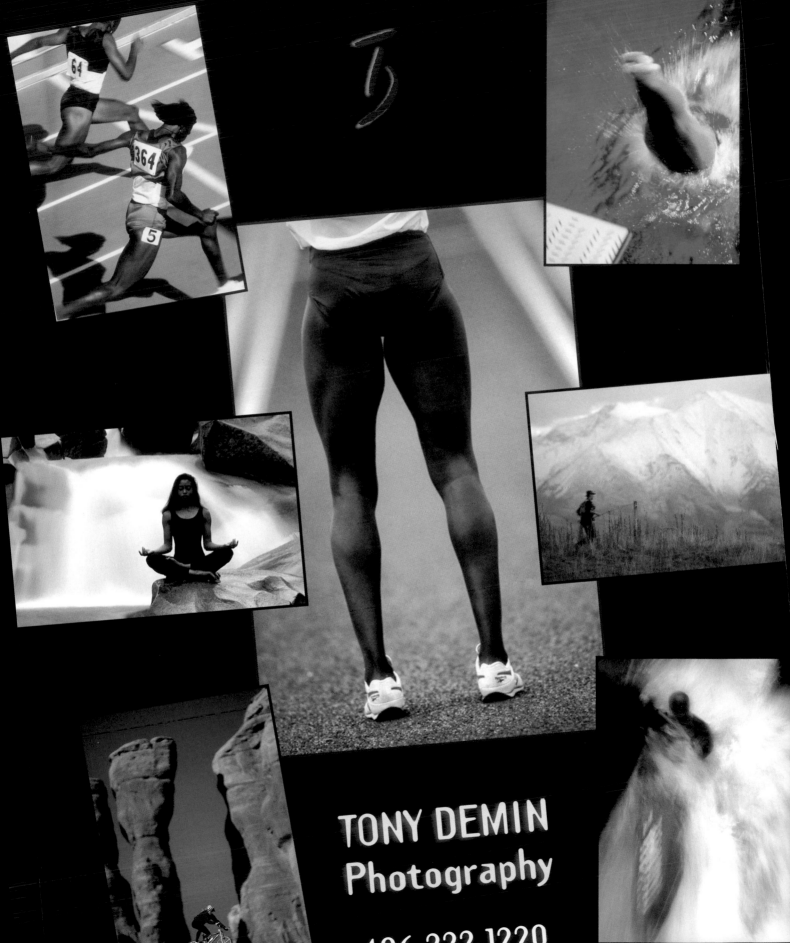

TONY DEMIN
Photography

VENERA

VENERA

MICHAL VENERA PHOTOGRAPHY · 400 TREAT AVE. SUITE G · SAN FRANCISCO CA 94110 · 415.558.9060 · FAX 415.552.991

REPRESENTED IN · SF: FREDA SCOTT 415.398.9121 · LA: MICHELE KARPÉ 818.760.0491

VENERA

ICHAL VENERA PHOTOGRAPHY • 400 TREAT AVE. SUITE G • SAN FRANCISCO CA 94110 • 415.558.9060 • FAX 415.552.9915

REPRESENTED IN • SF: FREDA SCOTT 415.398.9121 • LA: MICHELE KARPÉ 818.760.0491

Stan Musilek Photography 415.621.5336
REPRESENTED BY FREDA SCOTT 415.398.9121

Stan Musilek Photography 4 1 5 . 6 2 1 . 5 3 3 6
REPRESENTED BY FREDA SCOTT 4 1 5 . 3 9 8 . 9 1 2 1

REPRESENTED BY FREDA SCOTT 415.398.9121

Stan Musilek Photography 415.621.5336

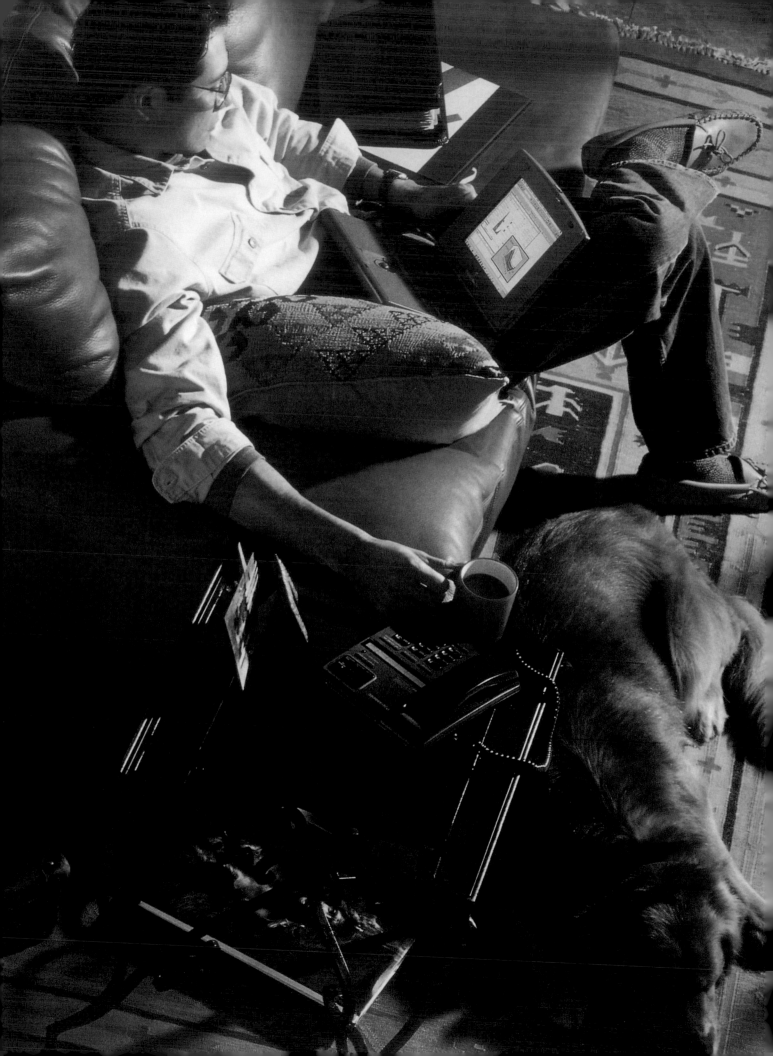

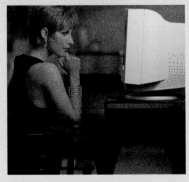

SCHELLING

Word had it the mayor was trying to sneak his new floozy out of town. Short on photographers, the local gossip sheet called Ernie Friedlander to cover the airport. Wouldn't you know it - Ernie caught the mayor and the red head red-handed in the airport lounge. But upon examining the eyewitness photos, the editor was furious!! He should've known - Ernie Friedlander just couldn't help being a really great studio guy.

MARK TUSCHMAN 415 322-4157

ruschman

SENSE OF PRESENCE.

ROSE HODGES 415 673 0622 FAX 415 921 5500

REPRESENTED BY FREDA SCOTT 415 398 9121

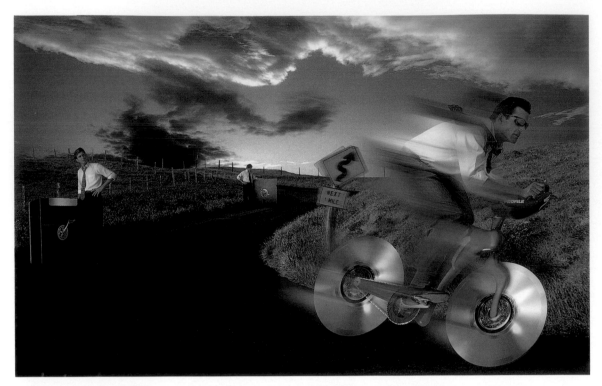

Client: Sony / Winkler McManus

RICHARD WAHLSTROM

DIGITAL IMAGING
TEL 415 550 1400 FAX 415 282 9133

WEST COAST
FREDA SCOTT
TEL 415 398 9121
FAX 415 398 6136

SOUTH/MIDWEST
PHOTOCOM
TEL 214 720 2272
FAX 214 720 2274

EAST COAST
PHOTOCOM EAST
TEL 212 924 4450
FAX 212 645 2059

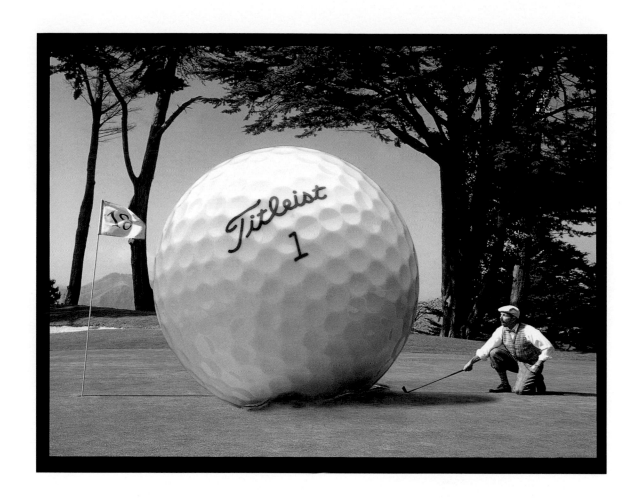

RICHARD WAHLSTROM

DIGITAL IMAGING
TEL 415 550 1400 FAX 415 282 9133

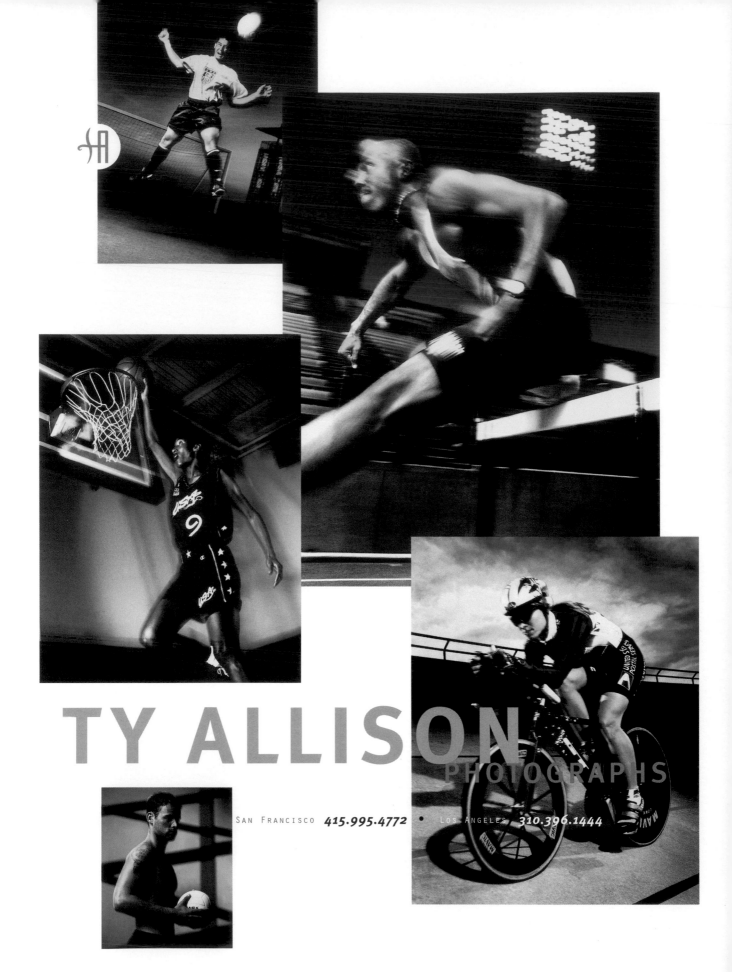

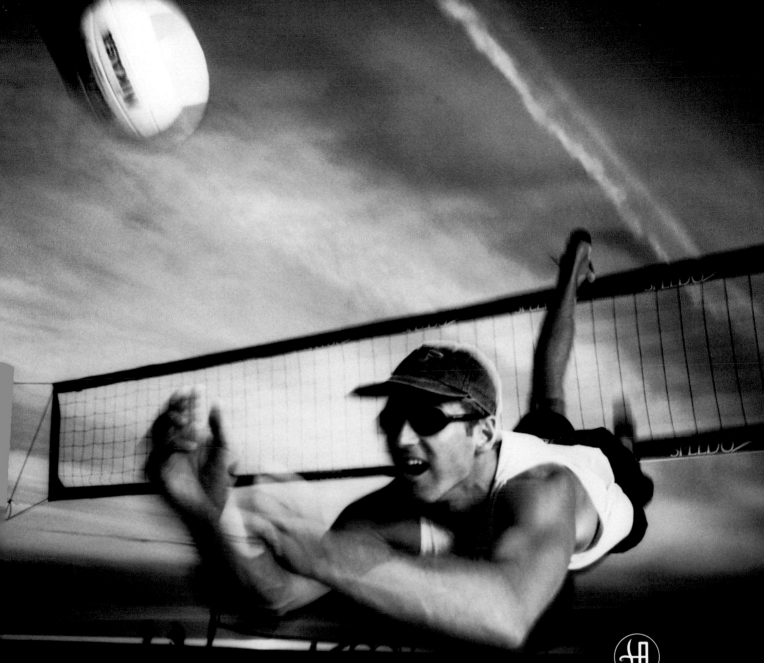

TY ALLISON

PHOTOGRAPHS

SAN FRANCISCO **415.995.4772** • LOS ANGELES **310.396.1444**

415.552.0671

1810 Harrison Street, No.10, San Francisco, CA 94103

Kevin Irby

irby

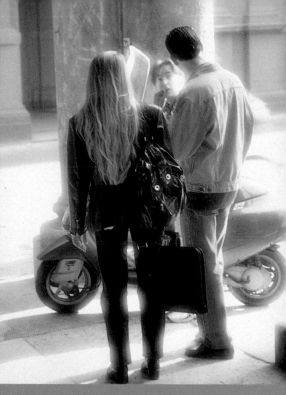

R O N • S T A R R
4 1 5 . 5 4 1 . 7 7 3 2

represented by
F R E D A S C O T T
4 1 5 . 3 9 8 . 9 1 2 1

R J M U N A
P I C T U R E S
still + moving

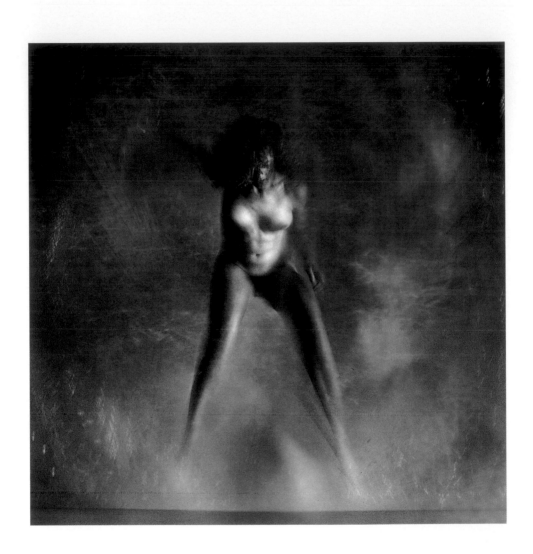

SAN FRANCISCO
STUDIO 415.468.8225

still + moving

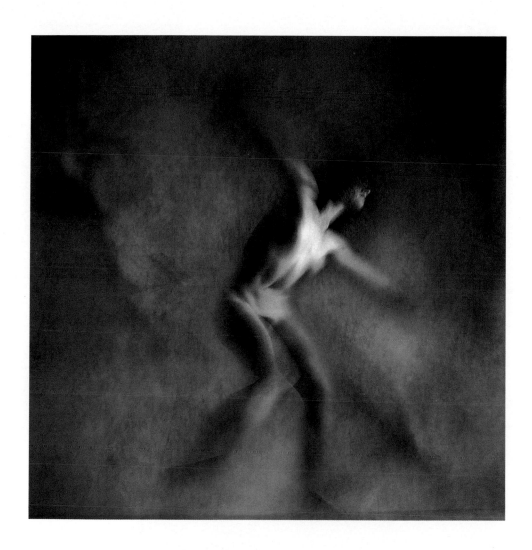

LOS ANGELES
CYNTHIA HELD 213.655.2979

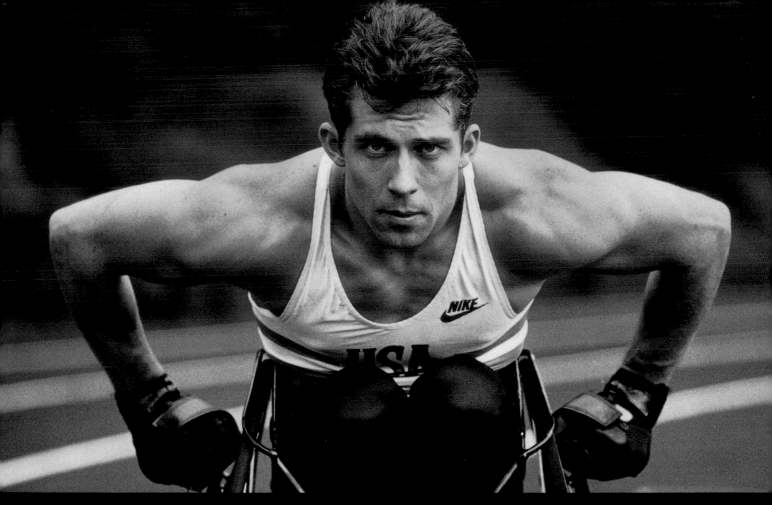

JOHN **BLAUSTEIN** PHOTOGRAPHY

510.525.8133 [REPRESENTATIVE FREDA SCOTT 415.398.9121]

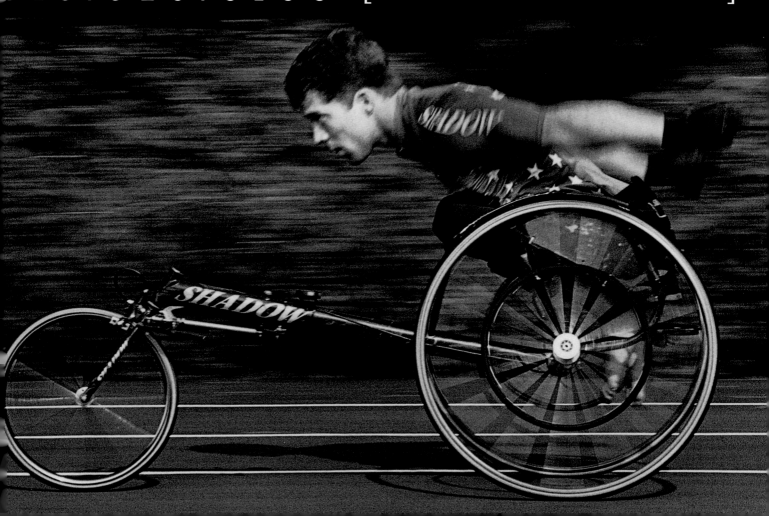

L on Clark.

Lon Clark. 415 9828377 photography— San Francisco Represented by Freda Scott 415 6212992

robert
schlatter

2325 third street nº 207
san francisco CA 94107
ph 415 ¦ 621 / 3316

represented by freda scott
ph 415 ¦ 398 / 9121

O₂

G-2

Virgie's
WEST

MEXICAN FOOD

STEAKS

2720 W.

ROUTE US 66

Gray Studio

Bud Lammers Photography

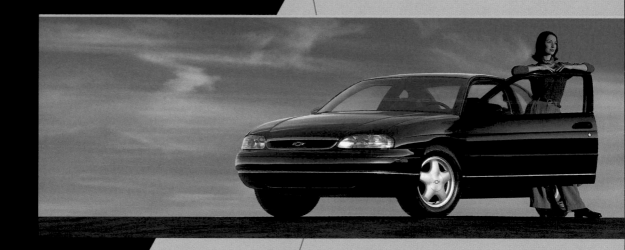

Campbell Ewald

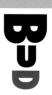

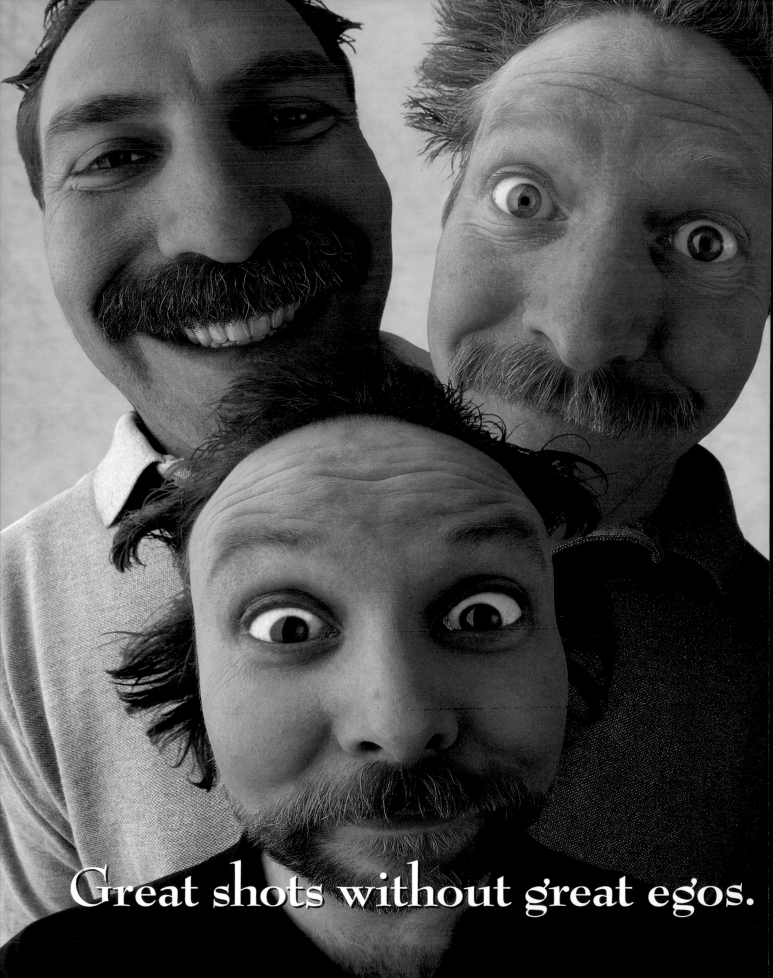

Great shots without great egos.

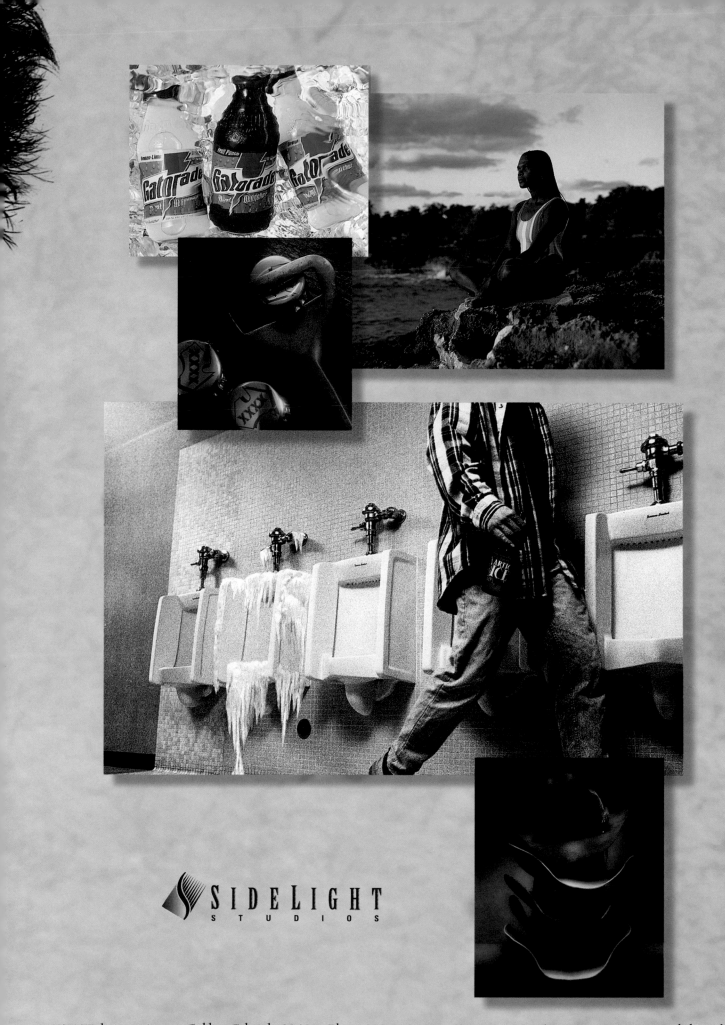

TOM COLLICOTT PHOTOGRAPHY

Studio 206 223 0038 Fax 206 223 2757 Represented by Kolea Baker 206 784 1136 email: BakerKolea@aol.com

TOM COLLICOTT PHOTOGRAPHY

Studio 206 223 0038 Fax 206 223 2757 Represented by Kolea Baker 206 784 1136 email: BakerKolea@aol.com

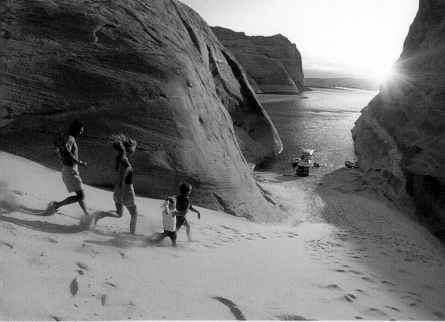

Aaron Strong PHOTOGRAPHER
ASPEN 970 . 963 . 0773
BOSTON 508 . 768 . 3344

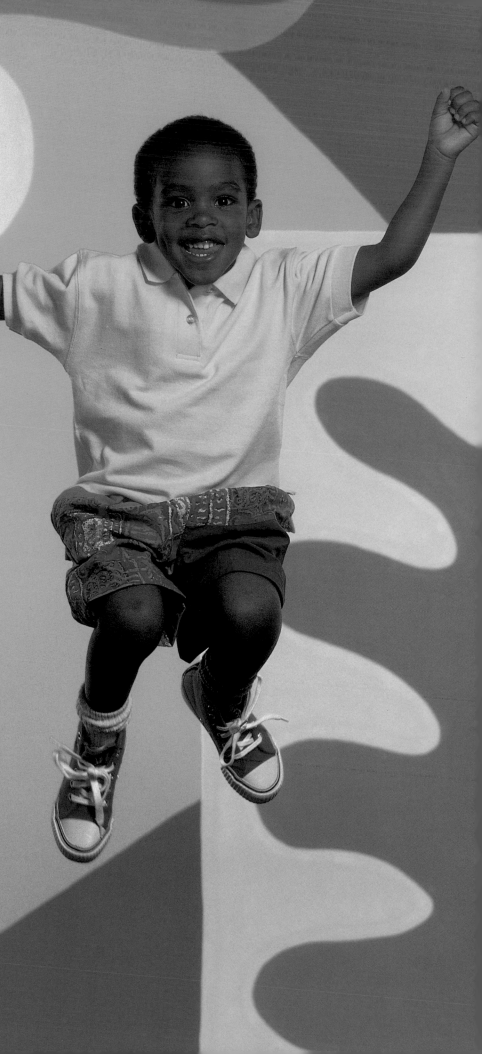

CARNATION

DISNEY

HANNA-BARBERA

THE RIGHT START

NISSAN

KIDS MART

EDUCATIONAL INSIGHTS

KAUFMAN & BROAD

LAKESHORE

MATTEL

FUTUREKIDS

nex

Anthony Nex Photography

Los Angeles 310.836.4357

New York 212.741.7934

e-mail: AnthoNex@aol.com

nex

Anthony Nex Photography

Los Angeles 310.836.4357
New York 212.741.7934

e-mail: AnthoNex@aol.com

CARNATION

DISNEY

HANNA-BARBERA

THE RIGHT START

NISSAN

KIDS MART

EDUCATIONAL INSIGHTS

KAUFMAN & BROAD

LAKESHORE

MATTEL

FUTUREKIDS

Hello Mr. Holloway?

It's Butch from Ace Plumbing ...
That hissing sound underneath your
house wasn't your pipes.

Goodby Silverstein & Partners / Polaroid

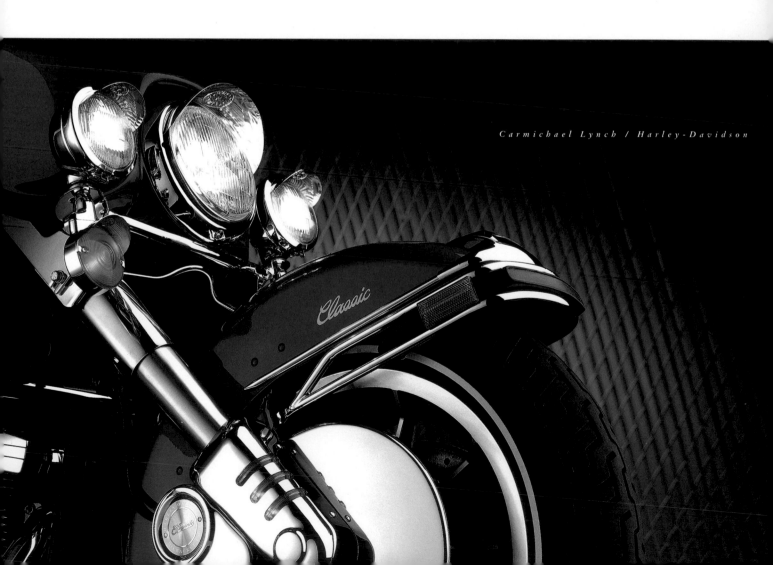

Carmichael Lynch / Harley-Davidson

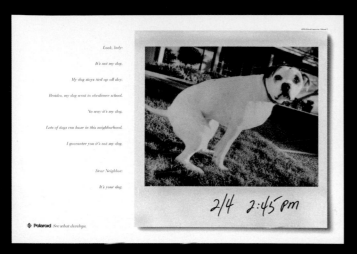

R e p r e s e n t e d *by* H e a t h e r E l d e r

R e e l *and* P o r t f o l i o A v a i l a b l e

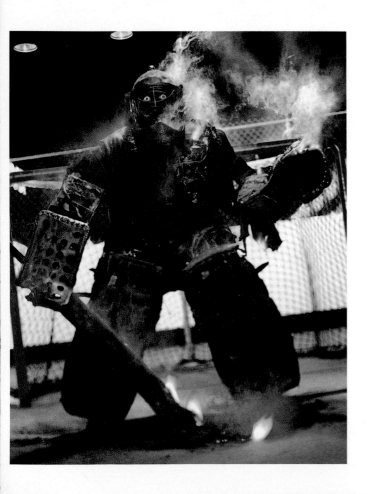

One Fifty Two

Mississippi St

San Francisco

California 94107

Ph? 415 252 1910

Fax 415 252 1917

Carmichael Lynch / Rollerblades

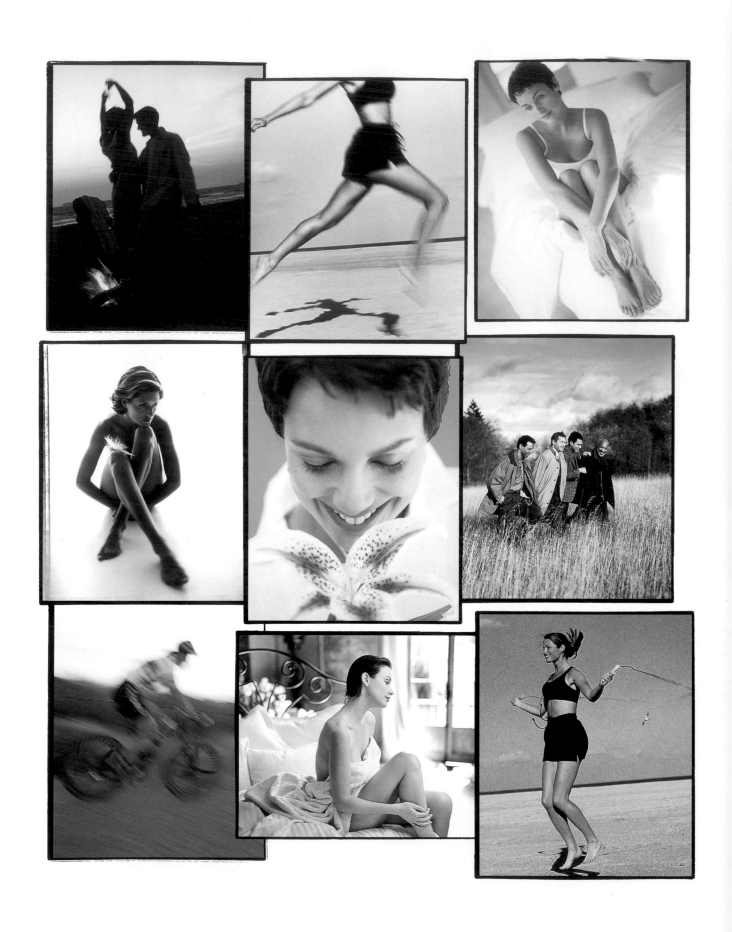

David Martinez Represented By Heather Elder Tele 415.543.7008

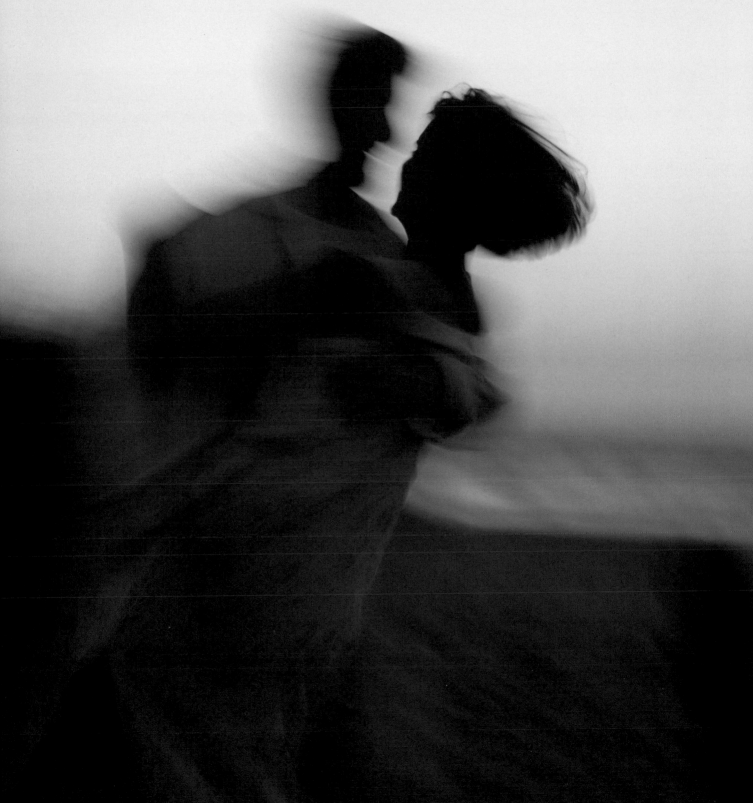

TERRY HUSEBYE

SAN FRANCISCO

Assignment and Stock

Telephone: 415.864.0400

Fax: 415.864.0479

Represented by Heather Elder

TERRY HUSEBYE

Assignment and Stock

Telephone: 415.864.0400

Fax: 415.864.0479

Represented by Heather Elder

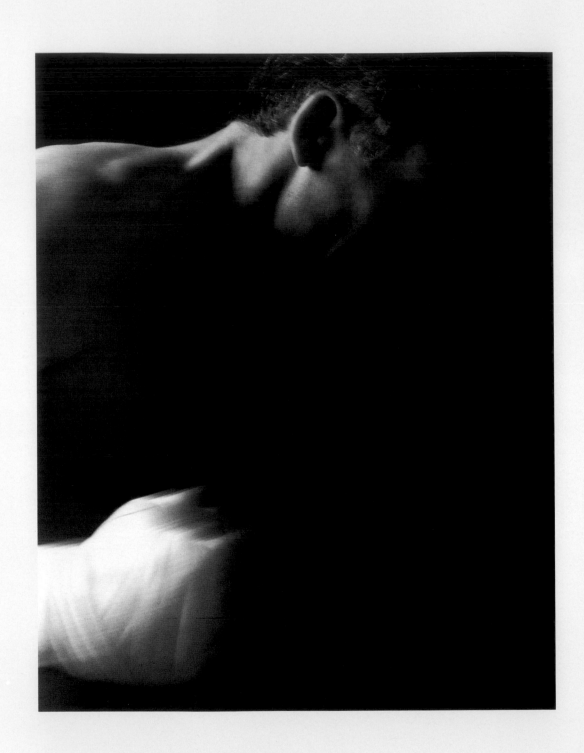

DAVID PETERSON

San Francisco 415·552 6954

JEFF NADLER Studio

2 1 3 . 4 6 7 . 2 1 3 5

REPRESENTED BY:

CAROLYN POTTS

773.935.8840

FAX 773.935.6191

MIDWEST, EAST,

CANADA

J E F F N A D L E R Studio

213.467.2135

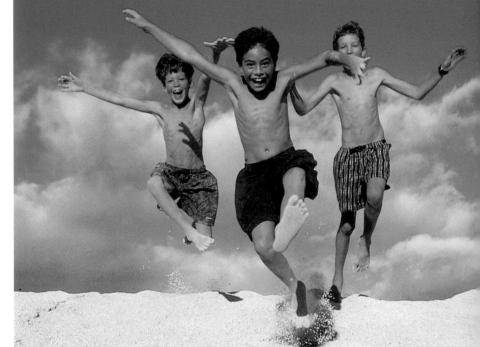

JOHN RUSSELL
PHOTOGRAPHY

ASPEN ∎ HAWAII
970·920·1431

HENRY BLACKHAM

Photography

LOS ANGELES

Telephone

818·799·9891

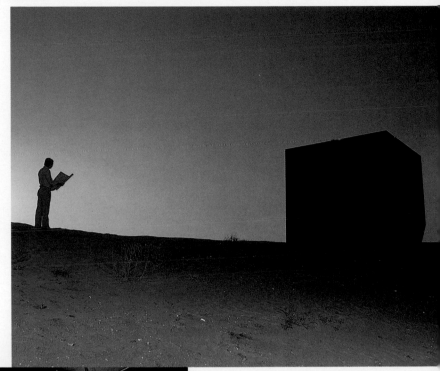

HENRY BLACKHAM PHOTOGRAPHY

HENRY BLACKHAM

Photography

LOS ANGELES

Telephone

818·799·9891

8 1 8 799·9891

Michael Voorhees Photographer

"Oscar De La Hoya"

MiStudio · 714 · 250 · 1585

1032

Michael VoorHees PHotoGrapHer
Studio · 714 · 250 · 1585

Michael Voorhees
Photographer
714 · 250 · 1585

Michael Voorhees Photographer

"YAGA YOUTH"

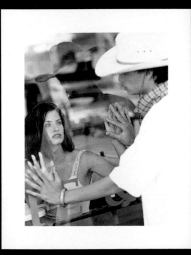

Studio · 714 · 250 · 1585

JOHN KELLY

PHOTOGRAPHY

818 - 508 - 7718

JOHN KELLY

PHOTOGRAPHY

T.E.D. DAYTON
PHOTO

1041 NORTH NAOMI STREET
BURBANK, CALIFORNIA 91505
telephone 818-848-2718 facsimile 818-848-3973

TED DAYTON
P H O T O

1041 NORTH NAOMI STREET
BURBANK, CALIFORNIA 91505
telephone 818-848-2718 facsimile 818-848-3973

scott morgan

For stock call

5 0 5 . 9 8 6 . 0 8 8 3

For assignments call Deborah Ayerst

4 1 5 . 5 6 7 . 3 5 7 0

call for our stock catalog

For stock call the Scott Morgan Studio

505.986.0883

For assignments call Deborah Ayerst

415.567.3570

a a r o n
r a p o p o r t
p h o t o g r a p h y
2 1 3 . 8 8 3 . 0 3 8 8
2 1 3 . 8 8 3 . 0 3 8 5 f a x
r e p r e s e n t e d b y
h a l l & a s s o c i a t e s
3 1 0 . 6 5 2 . 7 3 2 2

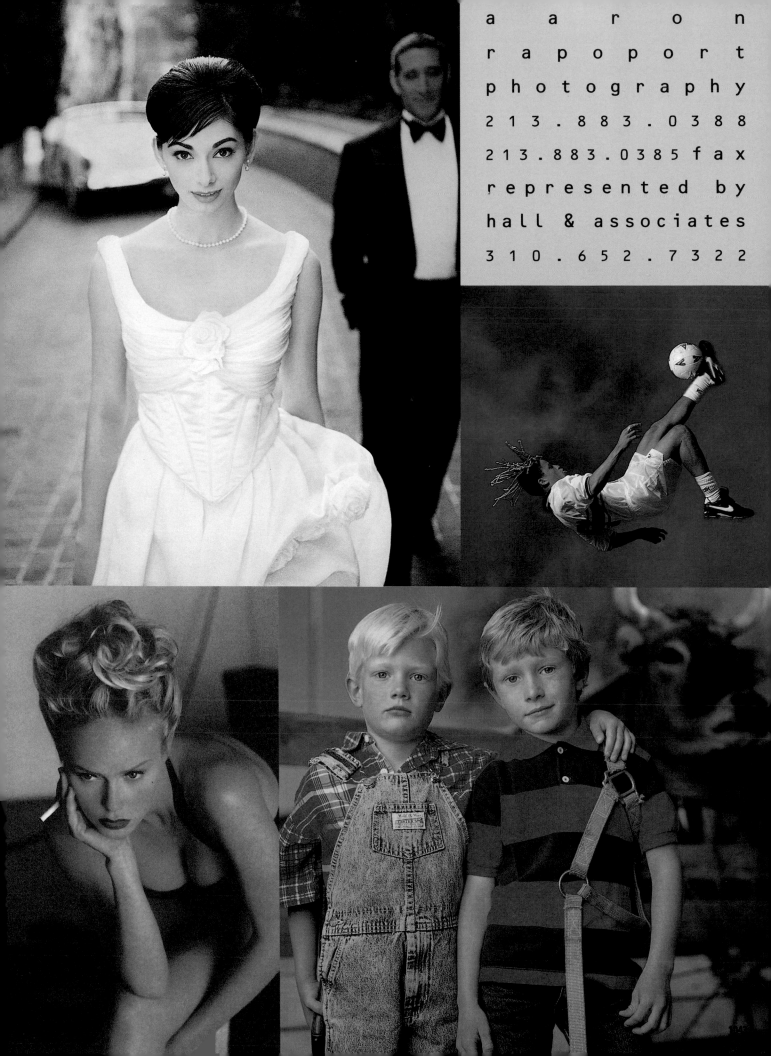

a a r o n
r a p o p o r t
p h o t o g r a p h y
2 1 3 . 8 8 3 . 0 3 8 8
2 1 3 . 8 8 3 . 0 3 8 5 f a x
r e p r e s e n t e d b y
h a l l & a s s o c i a t e s
3 1 0 . 6 5 2 . 7 3 2 2

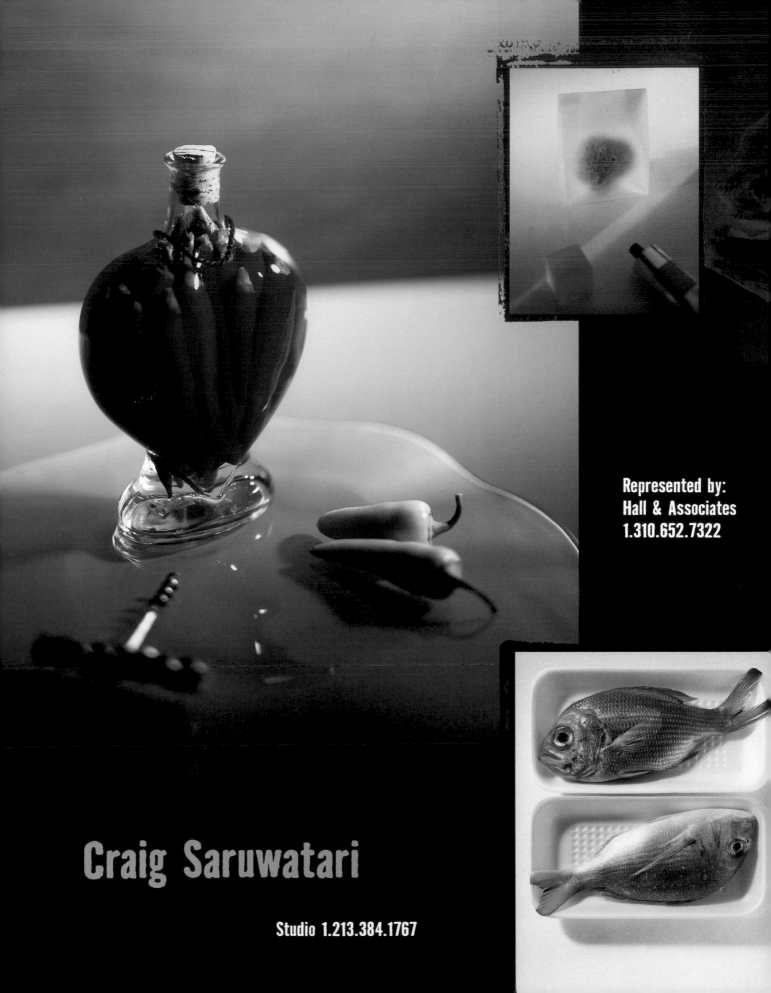

Represented by:
Hall & Associates
1.310.652.7322

Craig Saruwatari

Studio 1.213.384.1767

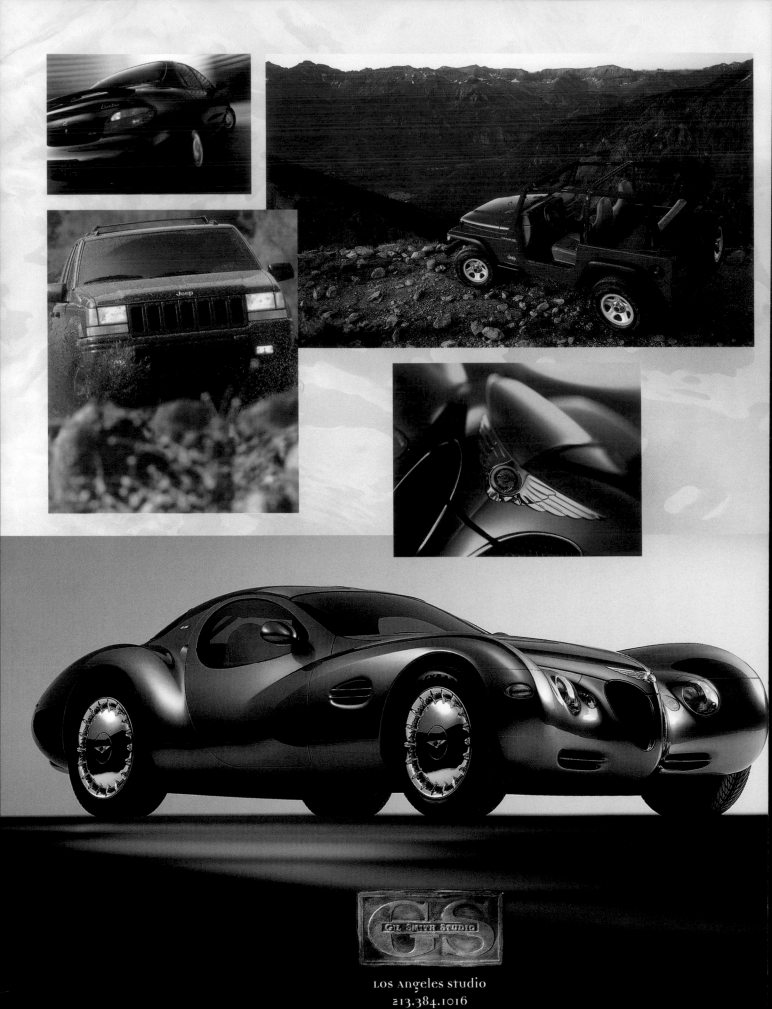

los angeles studio
213.384.1016

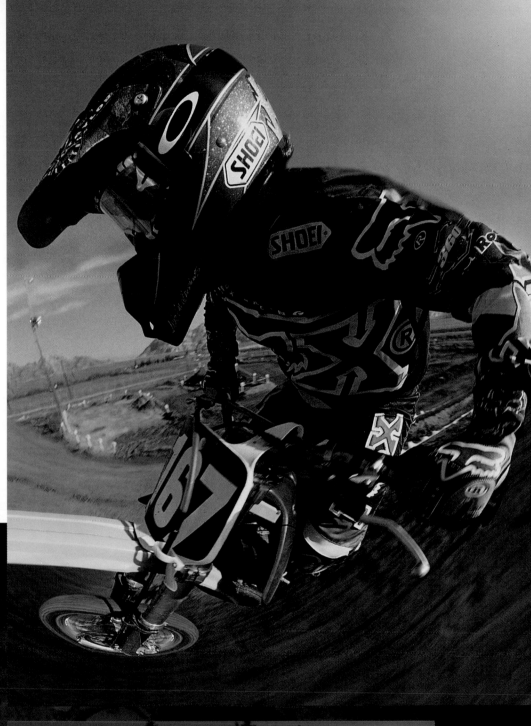

represented by:

united states
hall & associates
310.652.7322

detroit
skb productions
810.619.0066

europe
cosmos
1.41.18.33.33

Myron Beck Photography
213.933.9883 • Fax 213.933.1535

Represented by Hall & Associates
310.652.7322 • Fax 310.652.3835

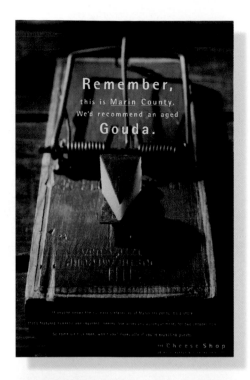

Remember,
this is <u>Marin County</u>.
We'd recommend an aged
Gouda.

BECK

«Quando
scrissi
Andromeda,
l'editore
pronosticò si e
no duemila
copie
di vendita.
Invece, fu un
successo che
sorprese
tutti».

DOUGLAS KIRKLAND

Los Angeles:
Hall & Associates
310 652 7322
310 652 3835 fax

Milan:
Grazia Neri
02 62 52 71

Hamburg:
Margot Klingsport
Focus
40 450 2230

DOUGLAS KIRKLAND

Los Angeles:
Hall & Associates
310 652 7322
310 652 3835 fax

Milan:
Grazia Neri
02 62 52 71

Hamburg:
Margot Klingsport
Focus
40 450 2230

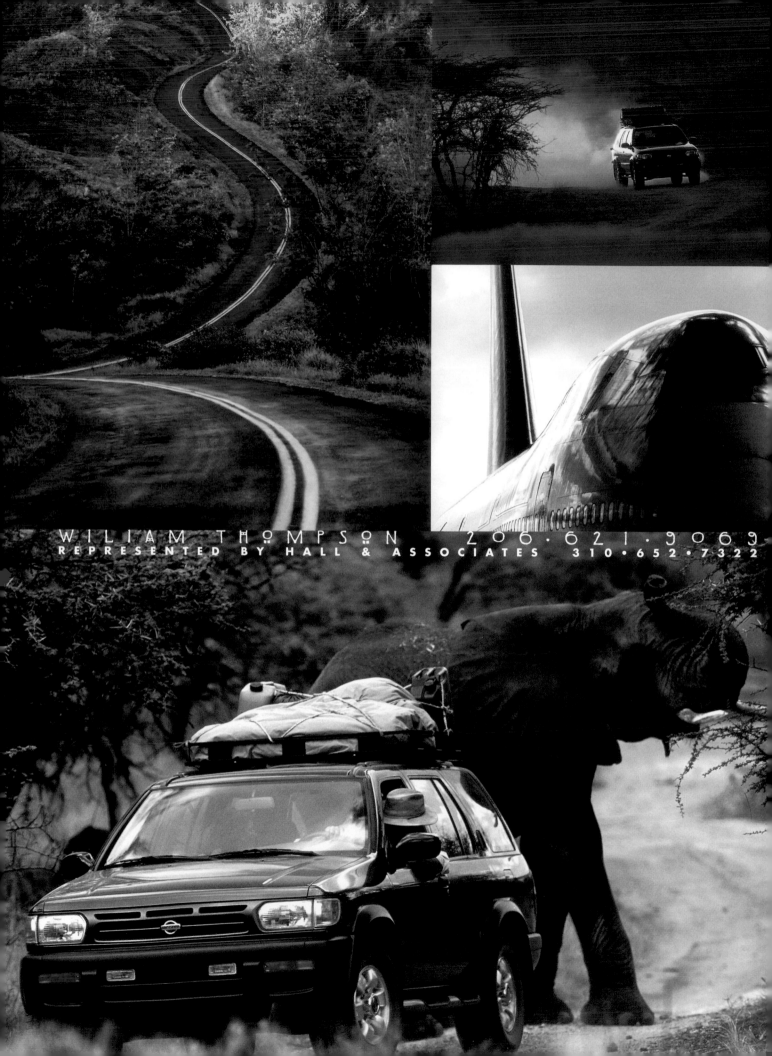

WILIAM THOMPSON 206·621·9069
REPRESENTED BY HALL & ASSOCIATES 310·652·7322

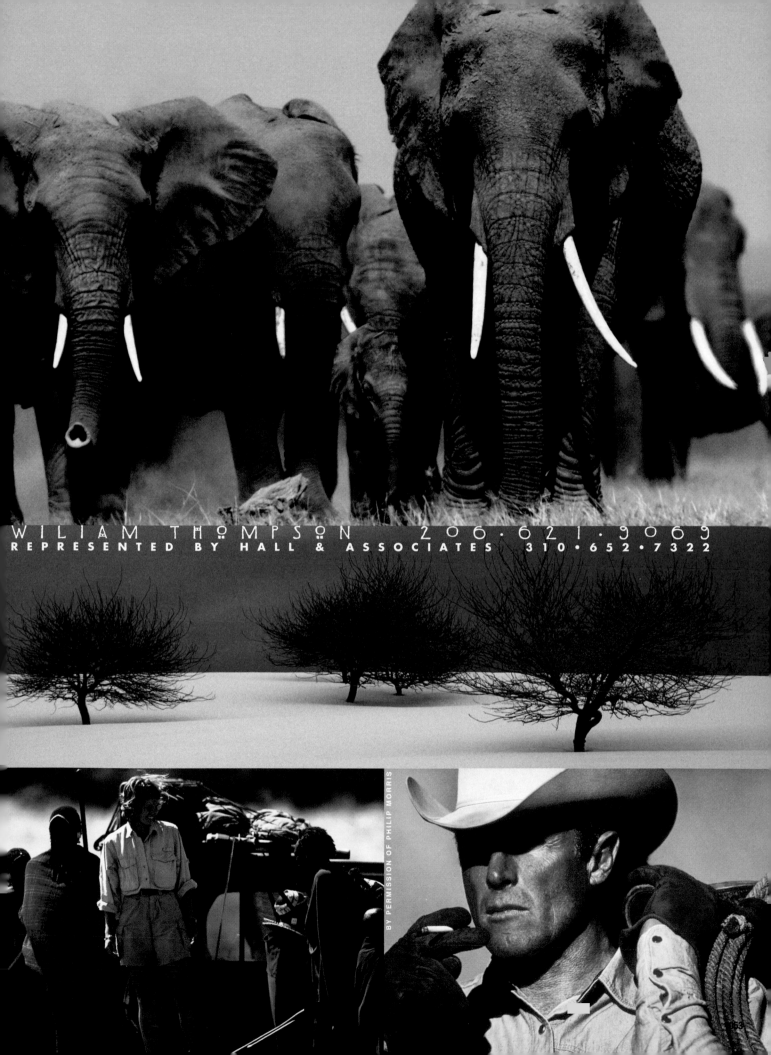

WILIAM THOMPSON 206·621·9069
REPRESENTED BY HALL & ASSOCIATES 310·652·7322

BY PERMISSION OF PHILIP MORRIS

213
└─463.3305 telephone
└─463.6121 facsimile

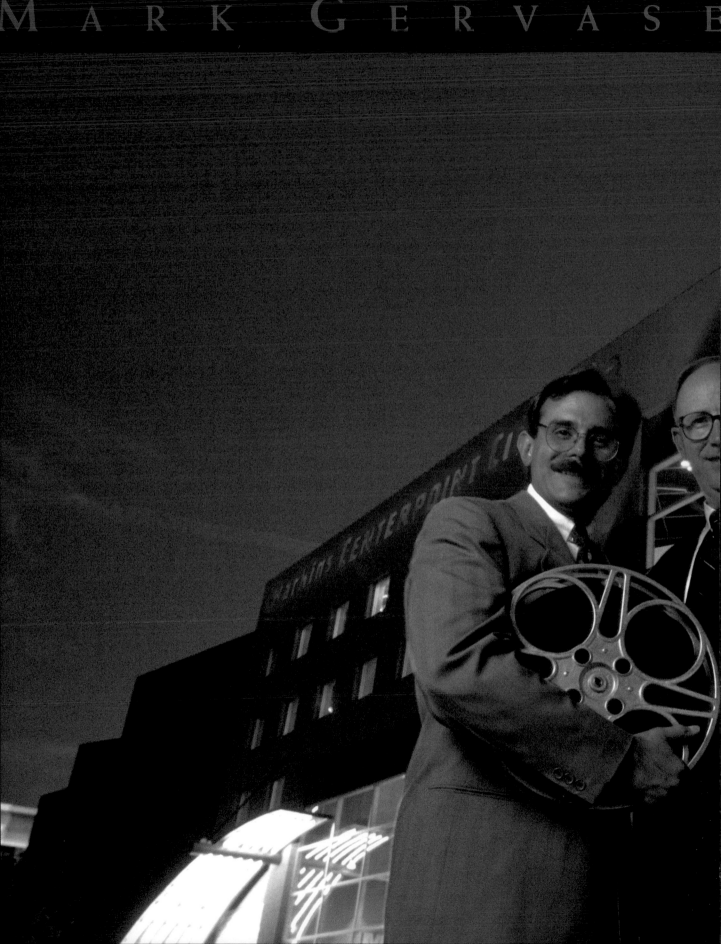

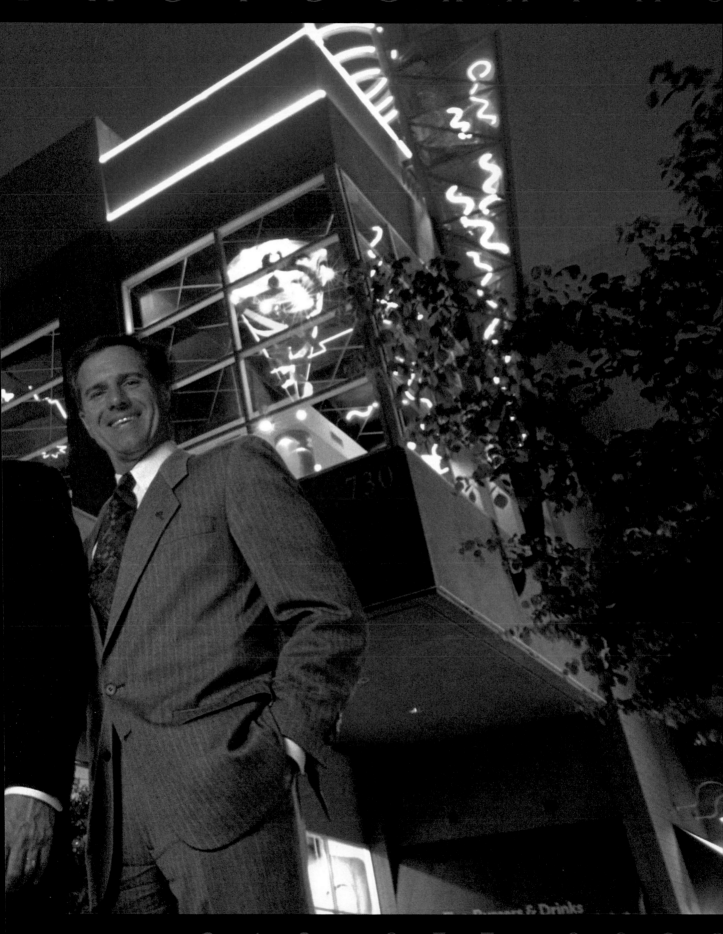

Mercedes-Benz / The Designory

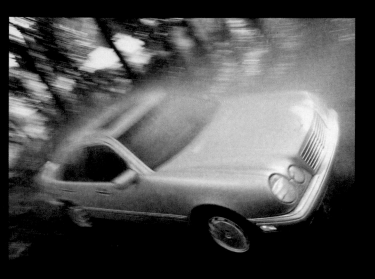

DAMON

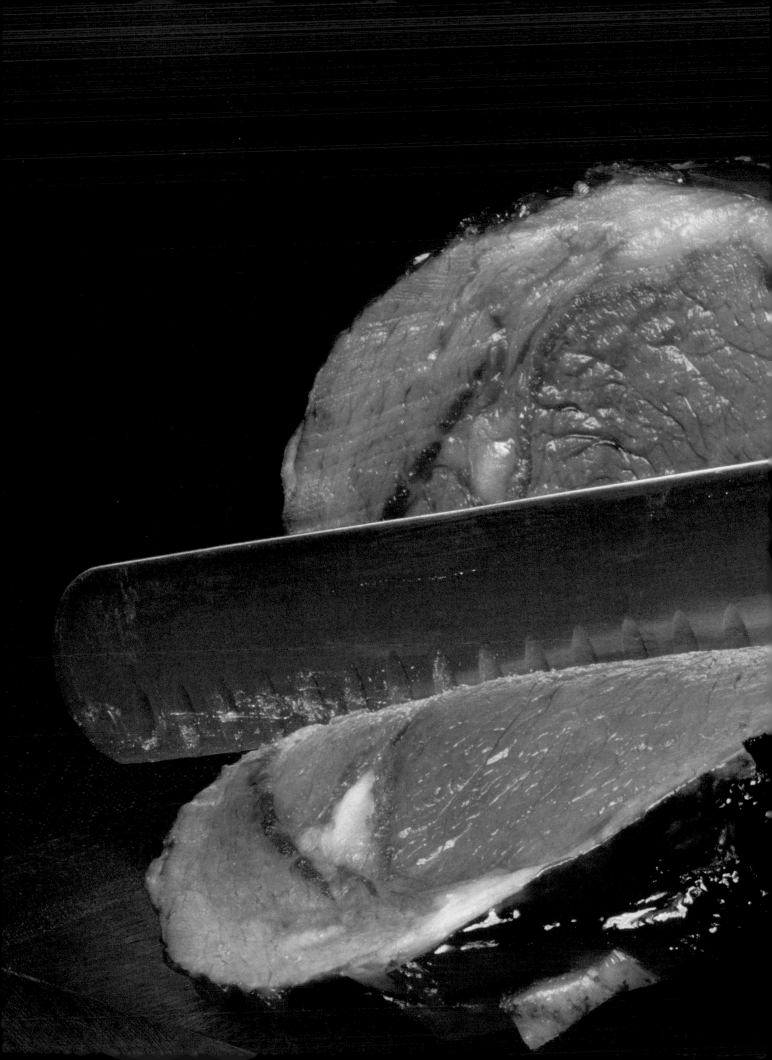

JOE ATLAS

(T) 2 1 3 . 6 6 0 . 0 9 8 8 (F) 2 1 3 . 6 6 6 . 5 3 5

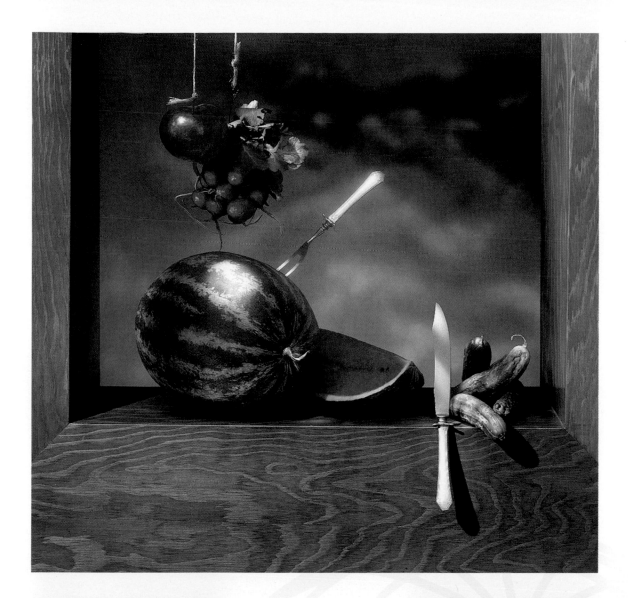

JOE ATLAS

T) 2 1 3 . 6 6 0 . 0 9 8 8 (F) 2 1 3 . 6 6 6 . 5 3 5 3

NICOLE
KATANO

photographer

213/655-1717

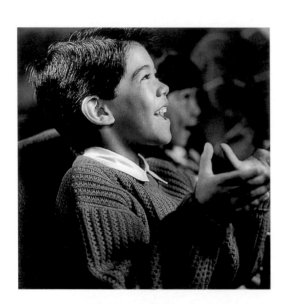

Pizza Hut Sony Warner Bros. Procter & Gamble McDonald's Prudential Cigna Health Care

photographer

213/655-1717

Pleasant Company Mitsubishi Paramount Pictures Walt Disney Co. L.A. Gear Panasonic Applause

LANDECKER

Allegory (Greek, c
to speak of one thi

1. Figurative l
stand for somethi
of a blindfolded v
allegory for Justic
sents more of
and extensive
than the poen
other meaning
kind of intens
the underworl
were merely a

A boat, beneath a sunny s
Lingering onward dreami
In an evening of July—

Children three that nestle
Eager eye and willing ear
Pleased a simple tale to h

Long has paled that sunny
Echoes fade and memorie
Autumn frosts have slain

Still she haunts me, phant

ther literary wo
Queen is per
Book III, for ex
who knocks him

ity) La
meaning
ition
y" of the s

Bubble-Gum Fiction A term
lice of Fiction in America to
much *metafiction, which ha
concentrate on language, als
the reader through creating e
The term does not all have
gum

to keep th
allowing l
dernists w
The hope
ore possib
me modernist
e—have used
t a deepe
goals are
gh the mea
page of Finn

The fall (bab

Landecker Studio, San Francisco California
http://www.sightphoto.com/landecker.html
Email: Landeck@sirius.com
Human: 415.864.8888
Fax: 510.530.207

LANDECKER

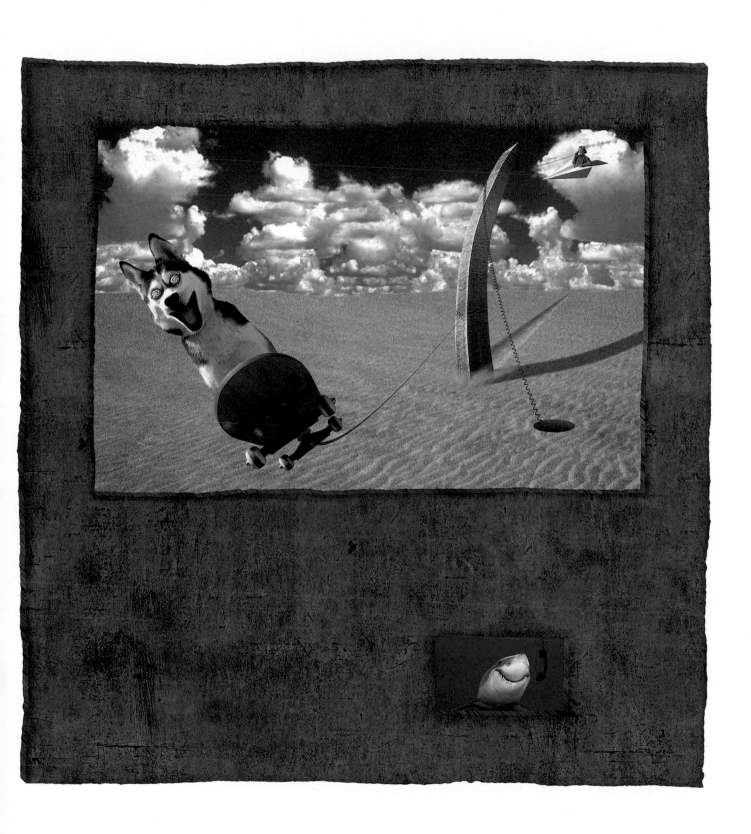

decker Studio, San Francisco California

http://www.sightphoto.com/landecker.html

Email: Landeck@sirius.com

Human: 415.864.8888

Fax: 510.530.2075

Casablanca Fan
JMA

Sherwin-Williams
Poppe Tyson

SAFRON

Fuji Photo Film USA

Knoll
Chermayeff & Geismar

Marshal Safron Studios, Inc.

11821 Mississippi Avenue

Los Angeles, California

90025

310 268 2880 Tel

310 268 2882 Fax

NIKE

ADIDAS

REEBOK

MARLBORO

UNITED AIRLINES

COCA-COLA

LEVI DOCKERS

LIFE MAGAZINE

SPORTS ILLUSTRATED

BUDWEISER

SPEEDO

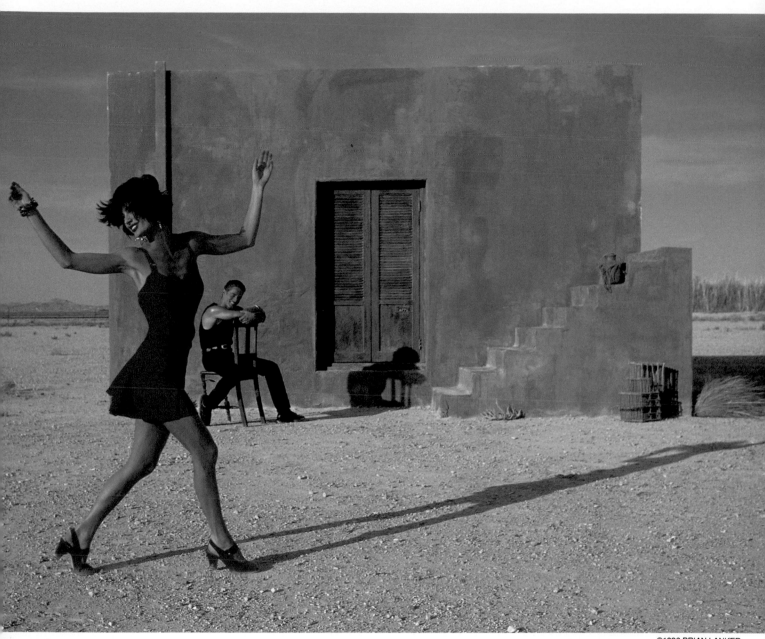

BRIAN LANKER

(5 4 1) 4 8 5 - 0 0 7 0
(8 0 0) 5 5 5 - 3 2 3 7

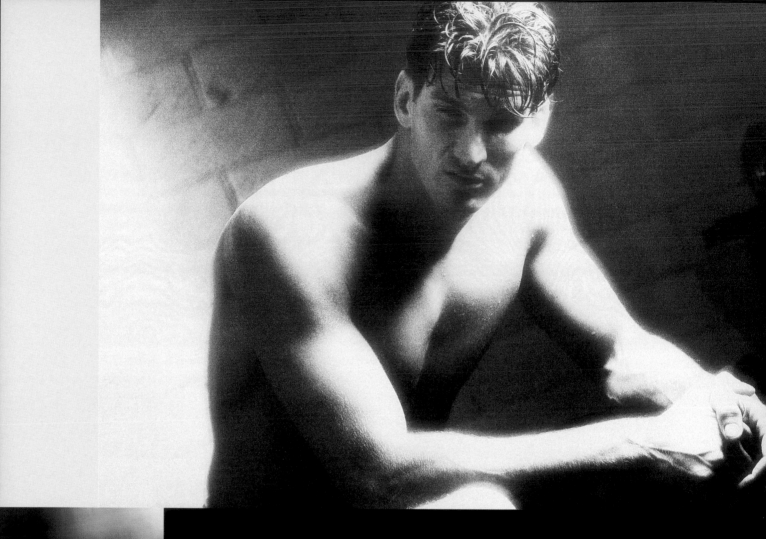

vogel

415. 487. 1400

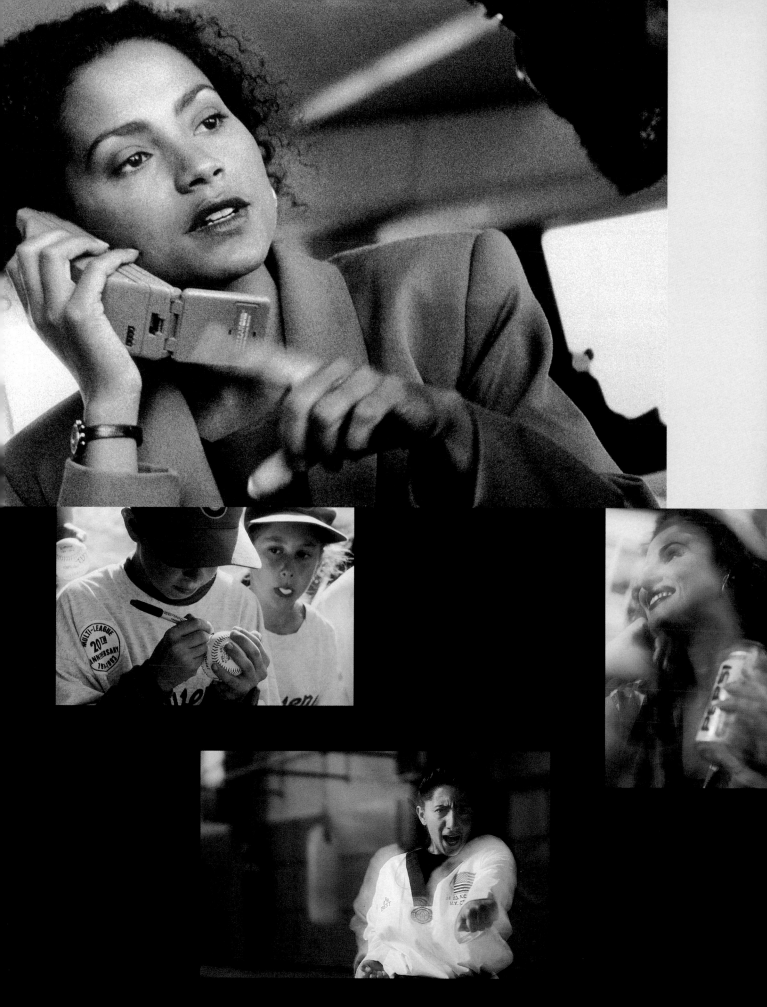

RANDY SCHWARTZ PHOTOGRAPHER
415.668.6507

RON KRISEL

RON KRISEL

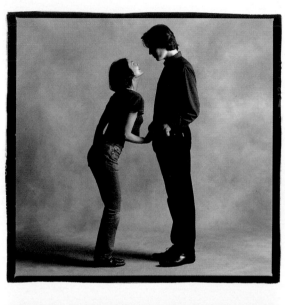 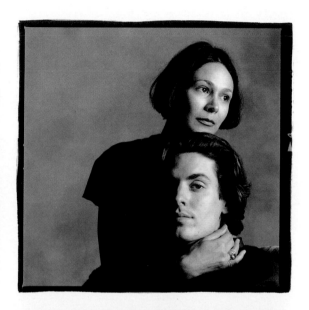

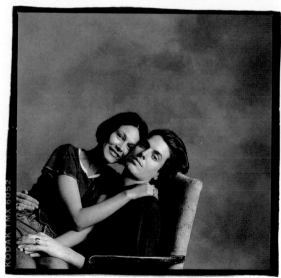

STUDIO / LOCATION / STOCK PHOTOGRAPHY

1925 PONTIUS AVE. • WEST LOS ANGELES

STUDIO 310/477-5519 • FAX 310/477-6421

http://www.leonardo.net/~krisel

STEVEN MECKLER 520 792 2467

JAY P. MORGAN
P I C T U R E S

Copyright 1995 Jay P. Morgan 213-224-8288

Call for our film reel.

Call or write to add your name to our mailing list.

(213)224-8288, FAX (213)224-8386, 618-D Moulton Ave., Los Angeles, CA 90031
Represented by Kelly Keith (213)224-8288

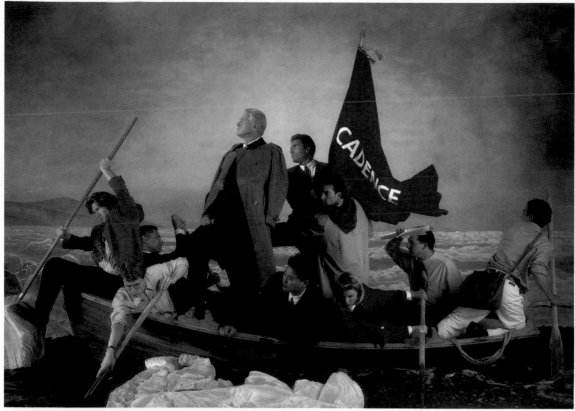

HERMAN AGOPIAN *photography*

Studio: 213.962.1509 Fax: 213.962.1328

Represented by: Jean Gardner & Assc. 213.464.2492

B R Y A N T R E B E L C O C K

RUSING PHOTO
STUDIO. 602.967.1864
LOS ANGELES. JEAN GARDNER 213.464.2492
CHICAGO/DETROIT. SKB PRODUCTIONS 810.619.0066
NEW YORK. CASE & PARTNERS 212.645.6655

RICK RUSING

RUSING PHOTO
STUDIO. 602.967.1864
LOS ANGELES. JEAN GARDNER 213.464.2492
CHICAGO/DETROIT. SKB PRODUCTIONS 810.619.0066
NEW YORK. CASE & PARTNERS 212.645.6655

1188 South La Brea, Los Angeles, CA 90019
Tel 213 937 5964 Fax 213 937 6799

Representation Jean Gardner
213 464 2492

BRIAN

LEATART

Brian Leatart represented by Jean Gardner 213 / 464-2492

STUDIO PHONE *213.931.9319* STUDIO FAX *213. 931.9616* MARK *SCOTT*

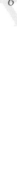

REPRESENTED BY

LOS ANGELES
Jean Gardner *213.464.2492*

PACIFIC NORTHWEST
Christine Prapas *503.246.9511*

STUDIO PHONE *213.931.9319* STUDIO FAX *213.931.9616*

MARK**SCOTT**

Photography

1101

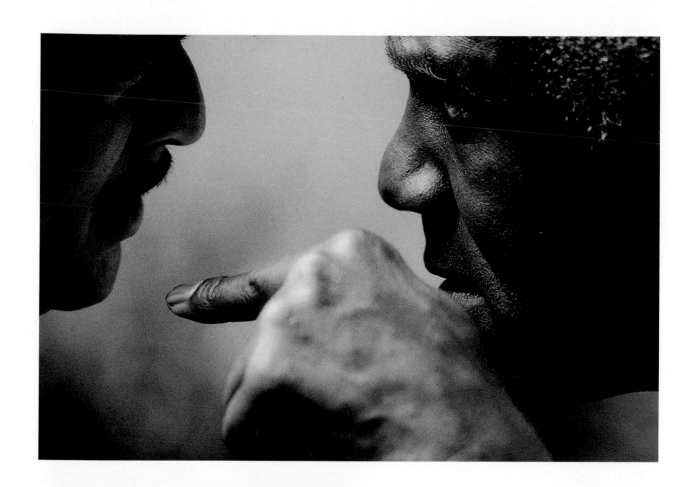

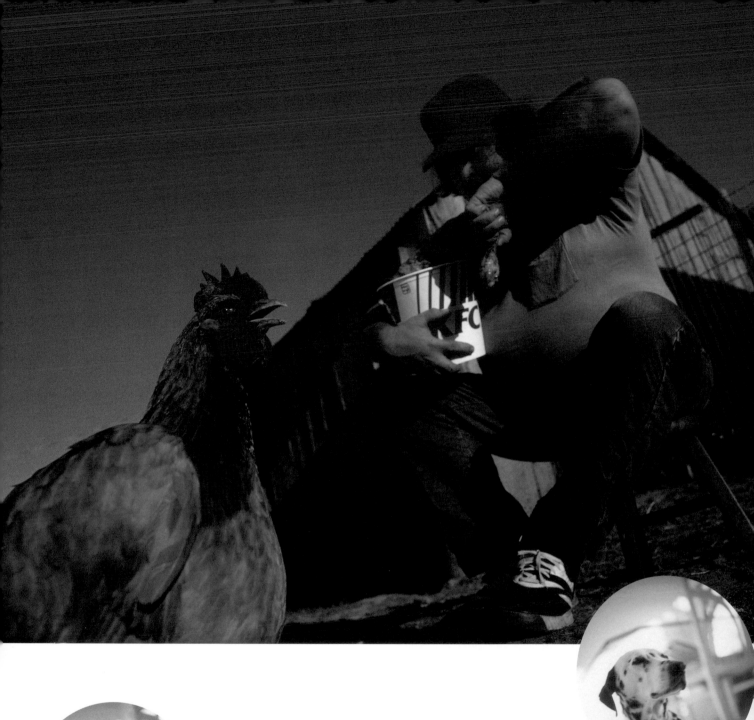

Walt Denson | P R O D U C T I O N S

T 415.331.5555 F 415.332.5552

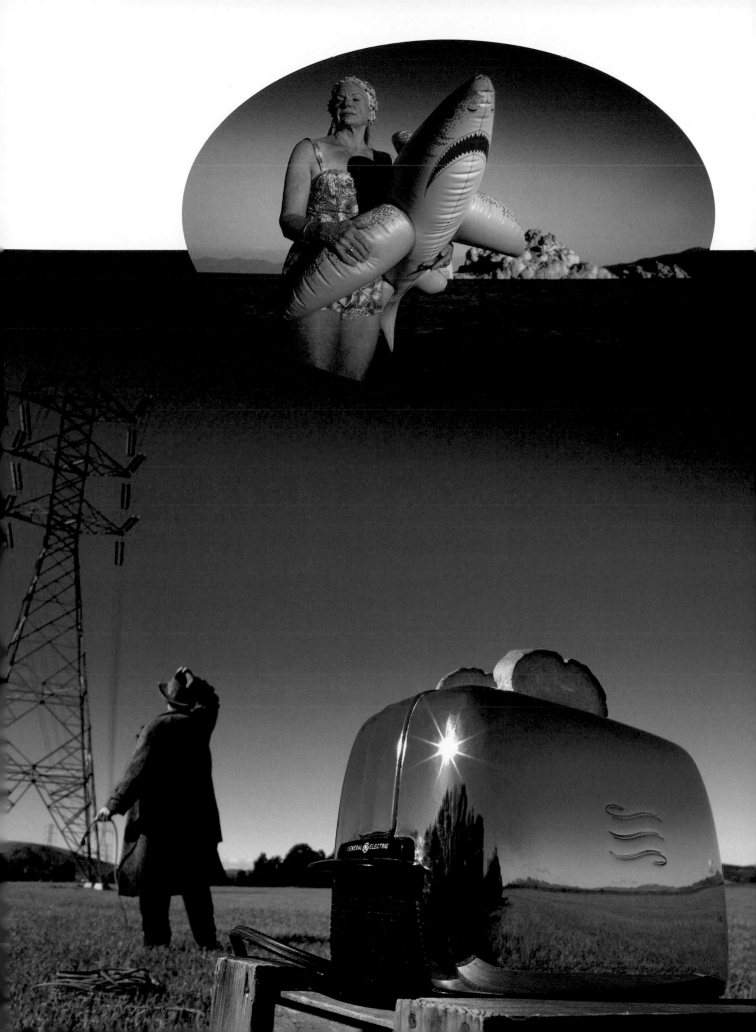

Detroit
Kent Lund
810.548.2100

Detroit
Kent Lund
810.548.2100

RON STRONG PHOTOGRAPHY

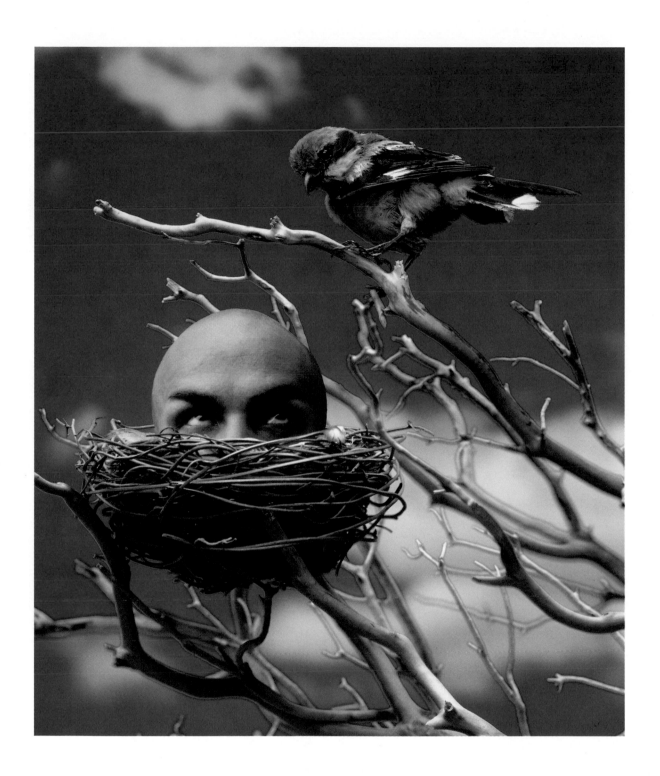

Studio 213.463.8260 • Fax 213.463.1399 • Represented by Elizabeth Poje 310.556.1439

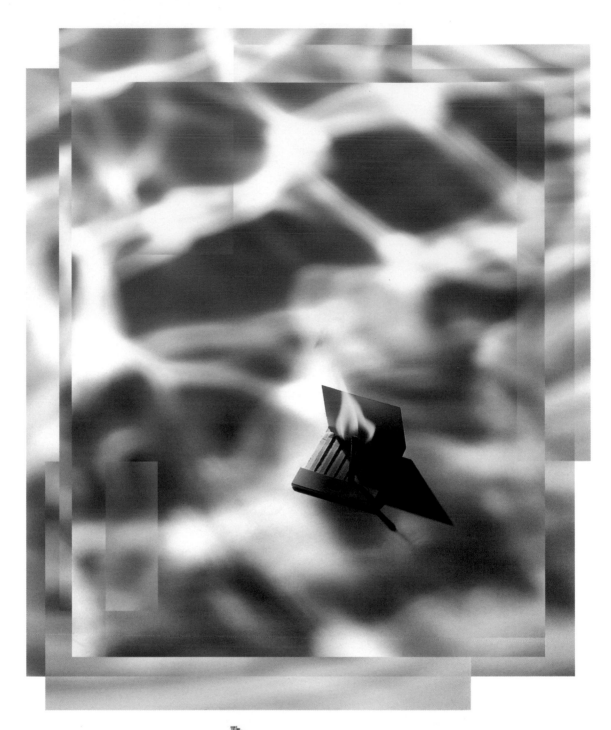

andersen

3 1 0 2 0 4 4 2 4 6

310
556
14 39

2
90
840

Los Angeles
Elisabeth Pule

New York
Susan Mille

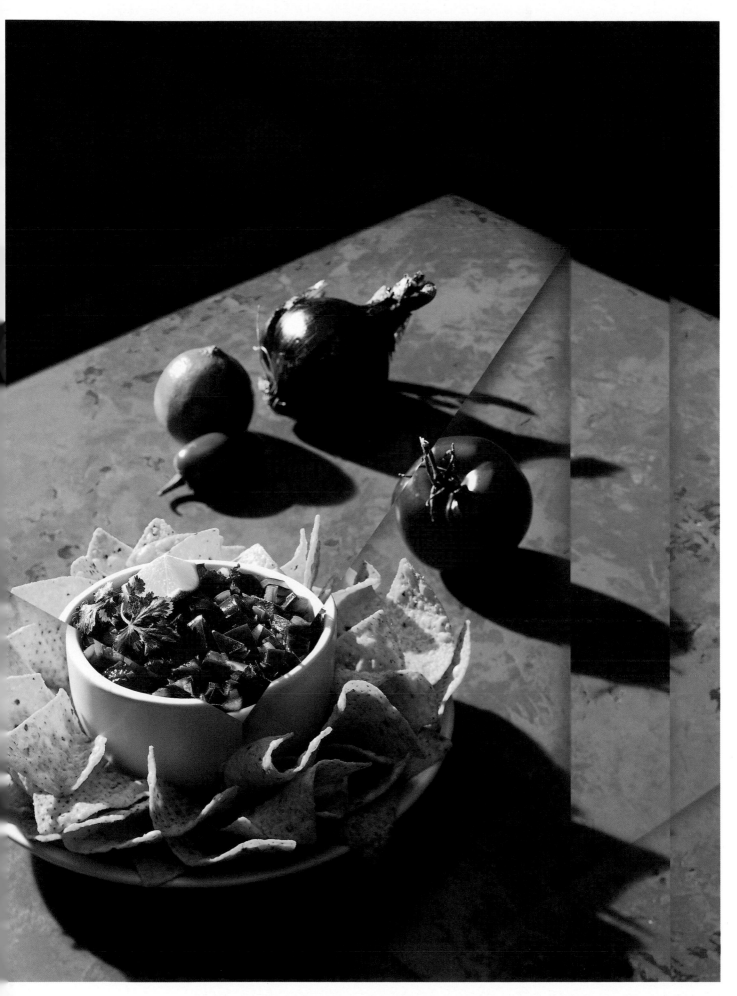

LITTLE MOMENTS

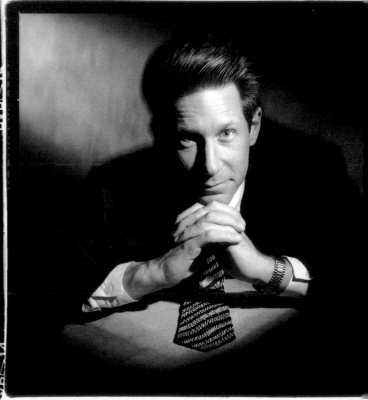

bill robbins

BILL ROBBINS STUDIO 310.314.7771
PRINT and FILM

REPS: **LA** ELIZABETH POJE 310.556.1439 **NY** SUSAN MILLER 212.905.8400 **BOSTON** AMY FRITH 617.268.2506

BOB HEUERMAN
P H O T O G R A P H Y

PHONE 310.842.9555 / FAX 310.842.9553

ROCKI PEDERSEN PHOTOGRAPHY

@ CARL FURUTA STUDIOS

PHONE 213.655.1911 FAX 213.651.1377

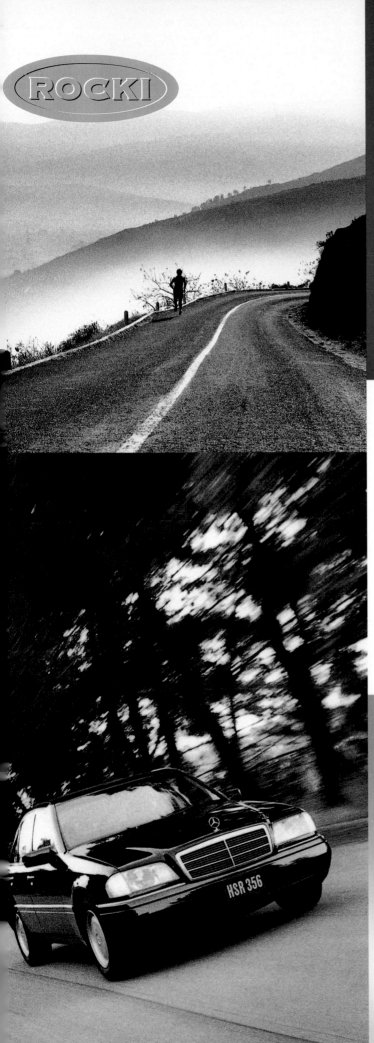

ROCKI

"Making Good Pictures Every Day."

ATLANTIC RECORDS . BMW . CALIFORNIA CHEESE . CANON . CLARION
CHOICE HOTELS . DISNEY . GMC . HOME SAVINGS . ITT SHERATON . LA EYEWORKS
LA GEAR . LA TIMES . MATTEL . MERLE NORMAN . MEXICANA . MICROSOFT . MITSUBISHI
PIONEER . PLANET GOLF . TOYOTA . US WEST . VOLKSWAGON . WALL STREET JOURNAL

PRESCRIPTIVES

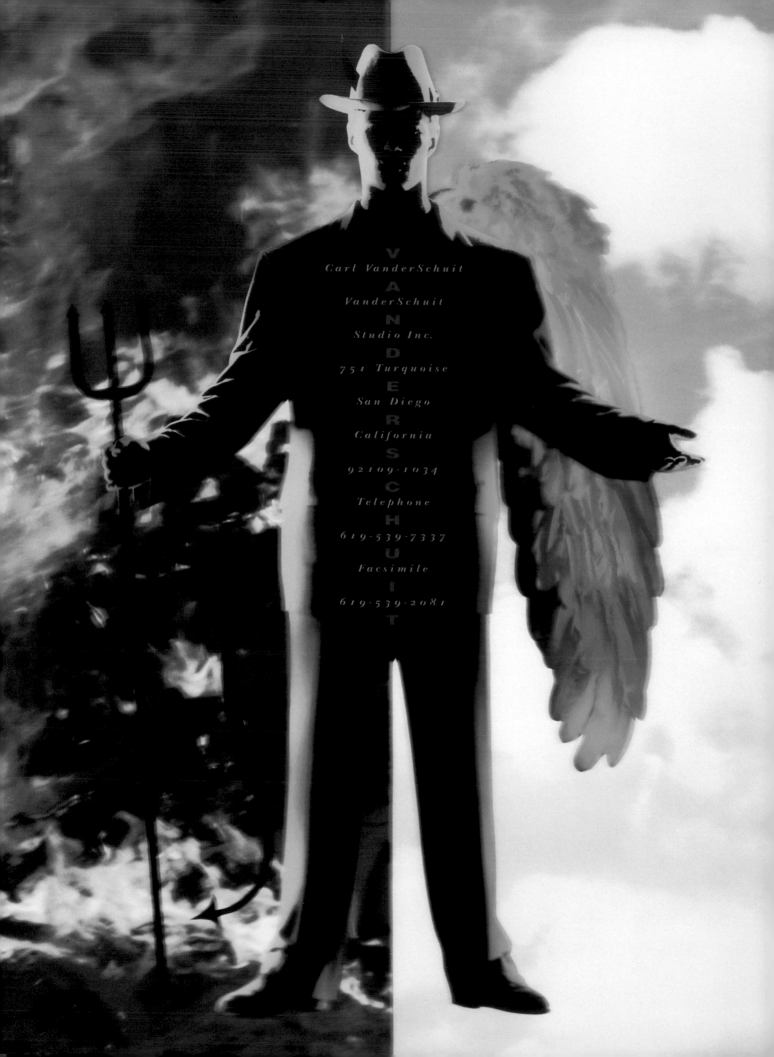

Carl VanderSchuit

VanderSchuit

Studio Inc.

751 Turquoise

San Diego

California

92109-1034

Telephone

619-539-7337

Facsimile

619-539-2081

VANDERSCHUIT

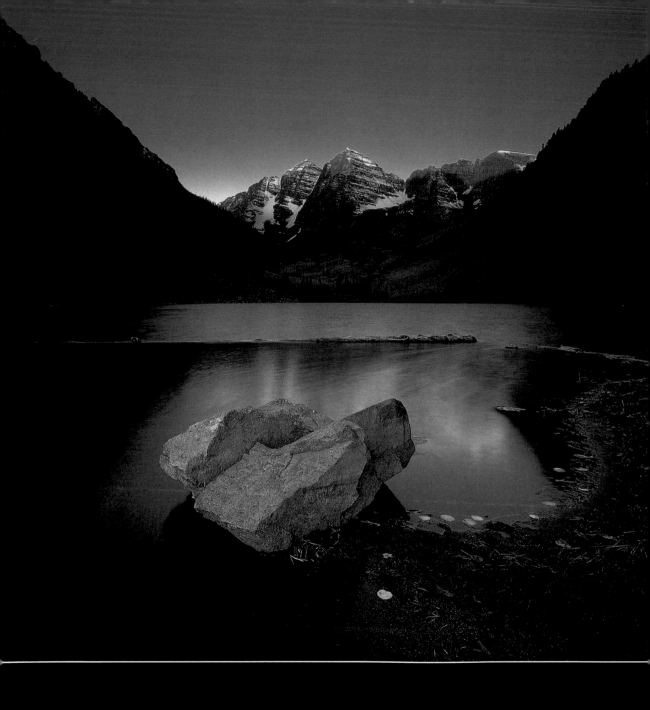

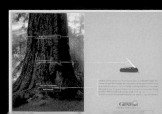
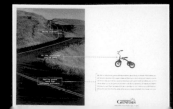

ALLEN BIRNBACH

303.499.0360 Fax: 303.499.2625

Represented in the Midwest by Karen Dolby
312.855.9336 Fax: 312.855.9337

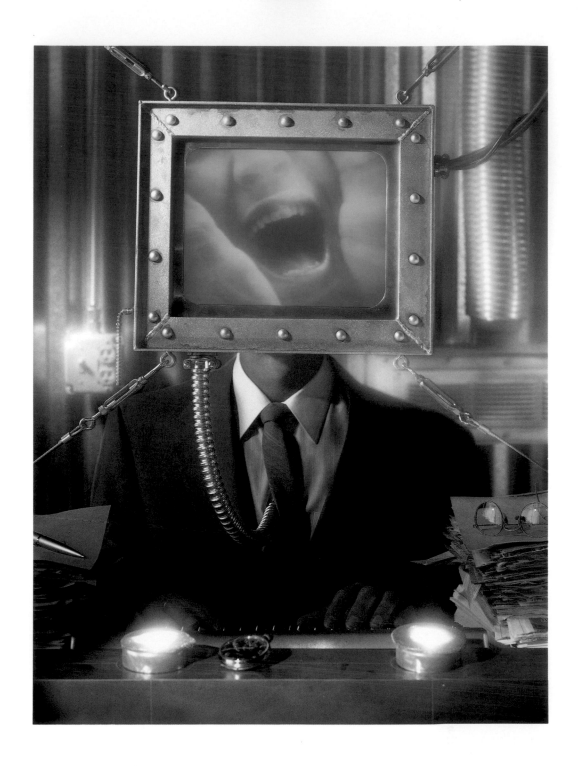

MEL LINDSTROM

415 325 9677

MEL LINDSTROM

415 325 9677

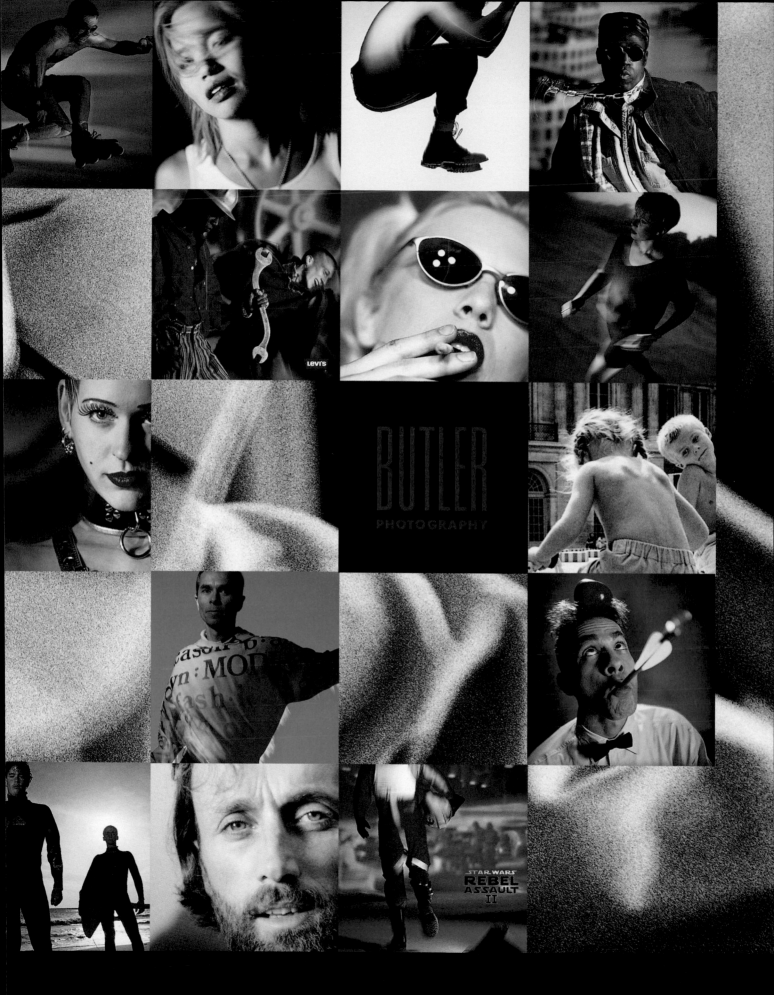

BUTLER
PHOTOGRAPHY

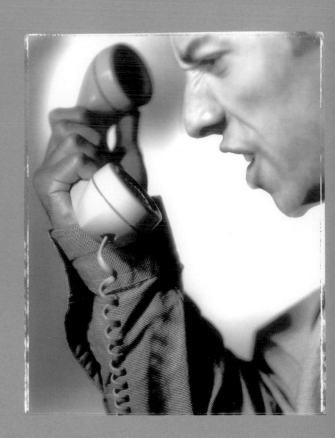

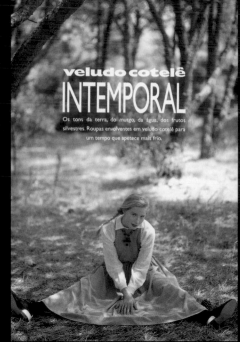

veludo cotelê
INTEMPORAL

Os tons da terra, do musgo, da água, dos frutos
silvestres. Roupas envolventes em veludo cotelê para
um tempo que apetece mais frio.

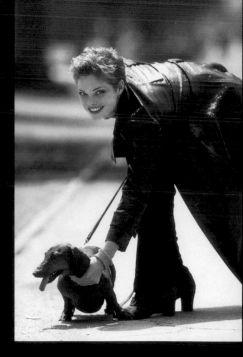

Blazer e calças de tweed – tudo Marella para Pinto's; camisa Stefanel; écharpe Casa Sousa;
boina Azevedo Rua ; sapatos Via Nova para Agostini

 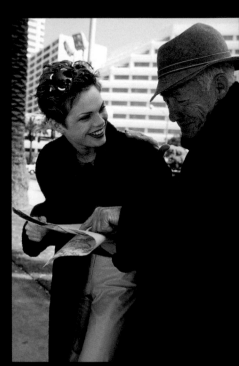

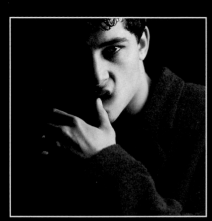

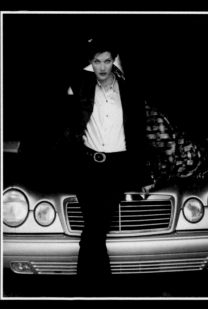
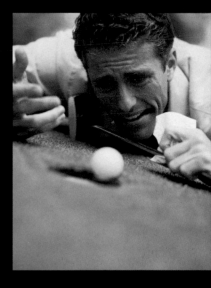

Robert Deutschman

PHOTOGRAPHY

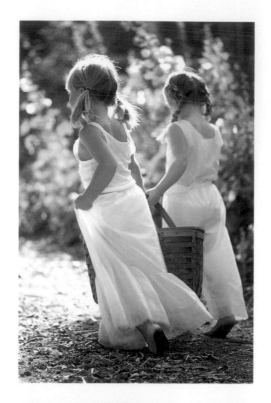

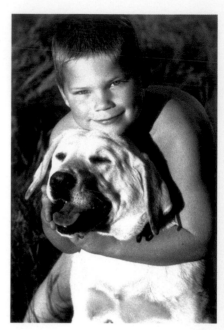

THERESA VARGO

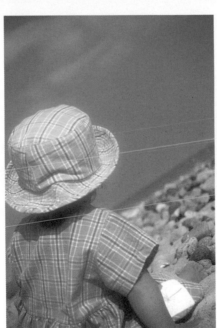

STOCK AVAILABLE

Studio

Location

Motion Rigs

Stock

Digital Imaging

Special Assignments

[714] 432.8400

1996 Mazda Millenia

luxury sedan

1996 Mazda 626

sedan

1996 Mazda Trucks

4x2 · 4x4

7¹4] 432.8400

reg Zajack Photography Studio: 714-432-8400 FAX: 714-432-1809 Detroit – Kent Lund: 810-548-2100

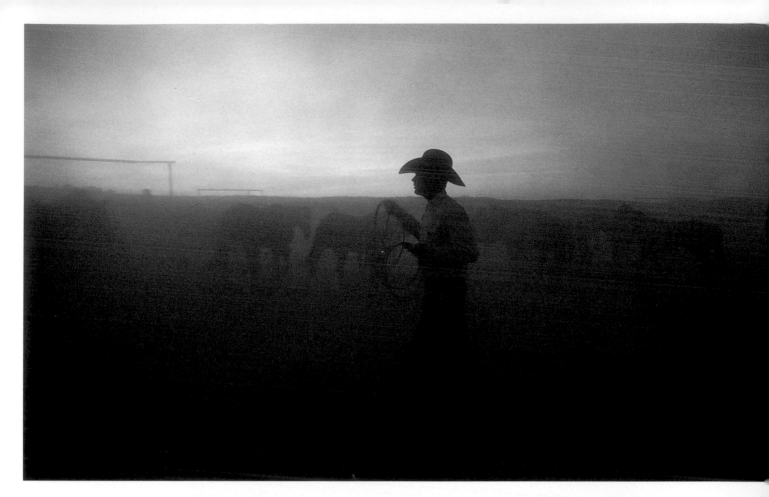

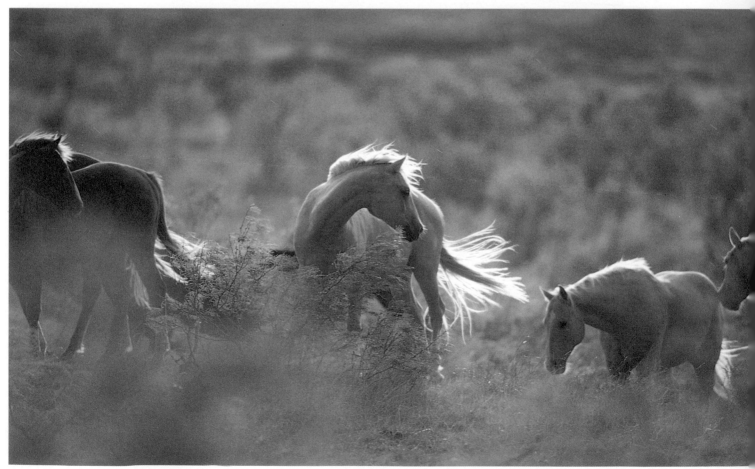

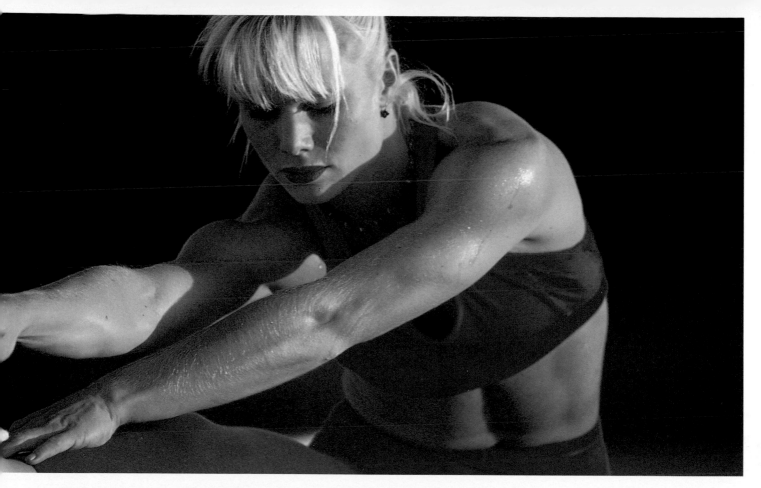

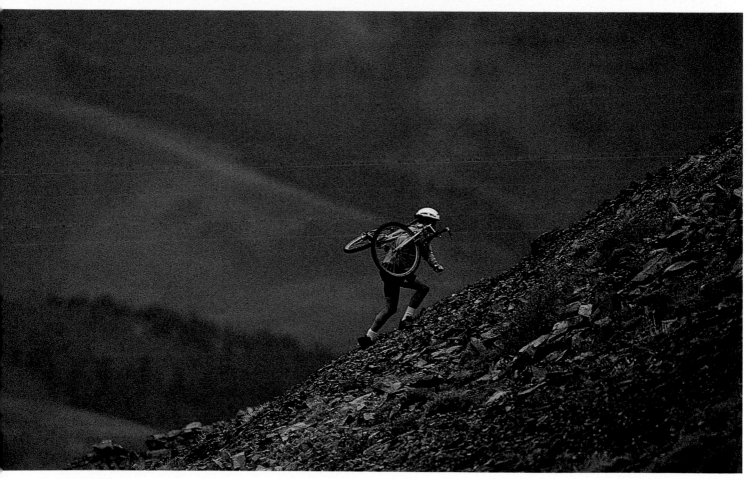

Phone: 208 726-5191 Fax: 208 726-9752
Street Center--A1, PO Box 856 Kethum, ID 83340
Represented by Ed Kaurala Associates
In Michigan call (810) 548-4500

David R. Stoecklein
STOCK AND ASSIGNMENT PHOTOGRAPHY

Partial Client List: Marlboro, Chevrolet, Ford, U.S. Tobacco,
Larry Mahan Boots, Jeep, Amoco, Remington, Wrangler,
Colt Firearms, Timberland, Fila, Scientific Angler,
Snow Country Magazine, *National Geographic*.

o'gara/
bissell

photo/illustr8ion

berkeley 510 540 6780
las vegas 702 565 3040

photo ⟩illus⟨ration

Macintosh
PowerBook 180c

o'gara'
bissell

berkeley 510 540 6780
las vegas 702 565 3040

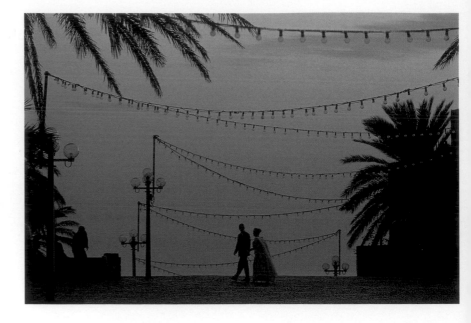

REITZEL

PHOTOGRAPHY

bill reitzel 415.927.0980

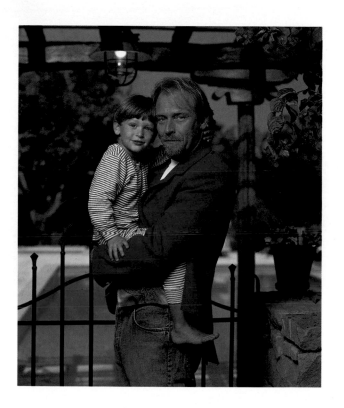

represented by

J o y c e O u d k e r k p o o l

Joyce Oudkerk Pool

tel 415.864.3252

Represented by

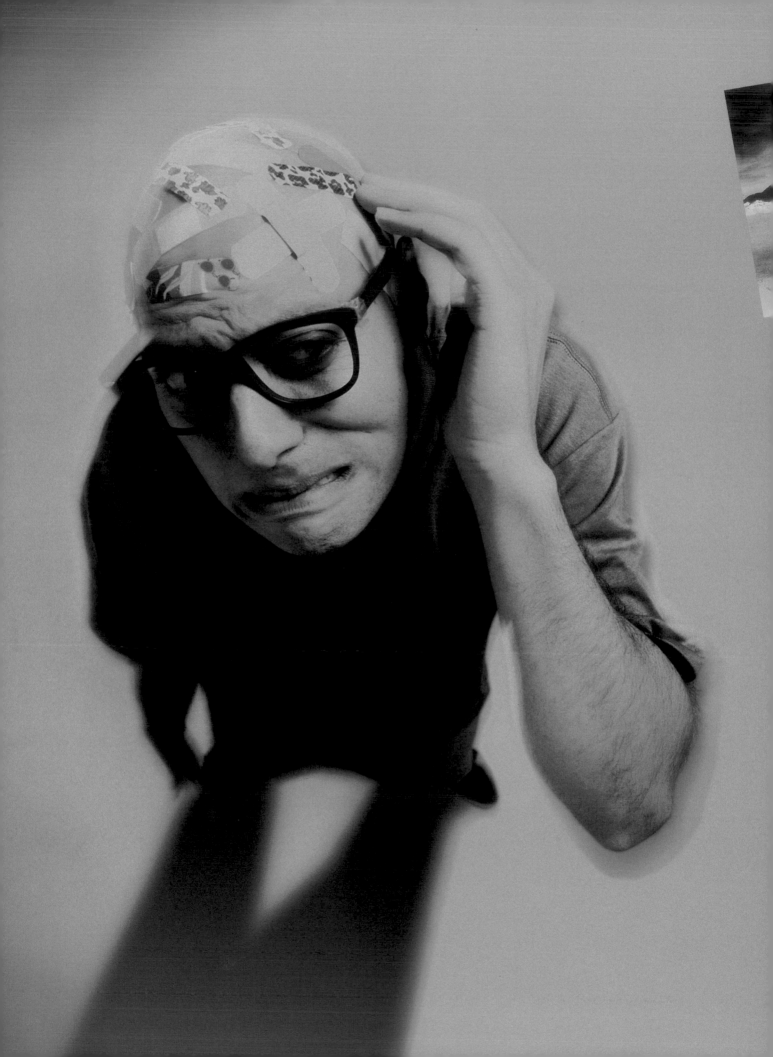

Bill Zemanek
415.861.5557

Isuzu

WIRED

Alaska Airlines

Hewlett-Packard

Goodby, Silverstein & Partners

Fujitsu

1143

 LES WARD PHOTOGRAPHY, INC. PHONE: 810-350-8666 FAX: 810-350-1019 REPRESENTED NATIONALLY BY MICHAEL POWDITCH: 818-707-6274

Peter.**LOPEZ**

213.655.1050 Agent: Michael Powditch 818.707.6274

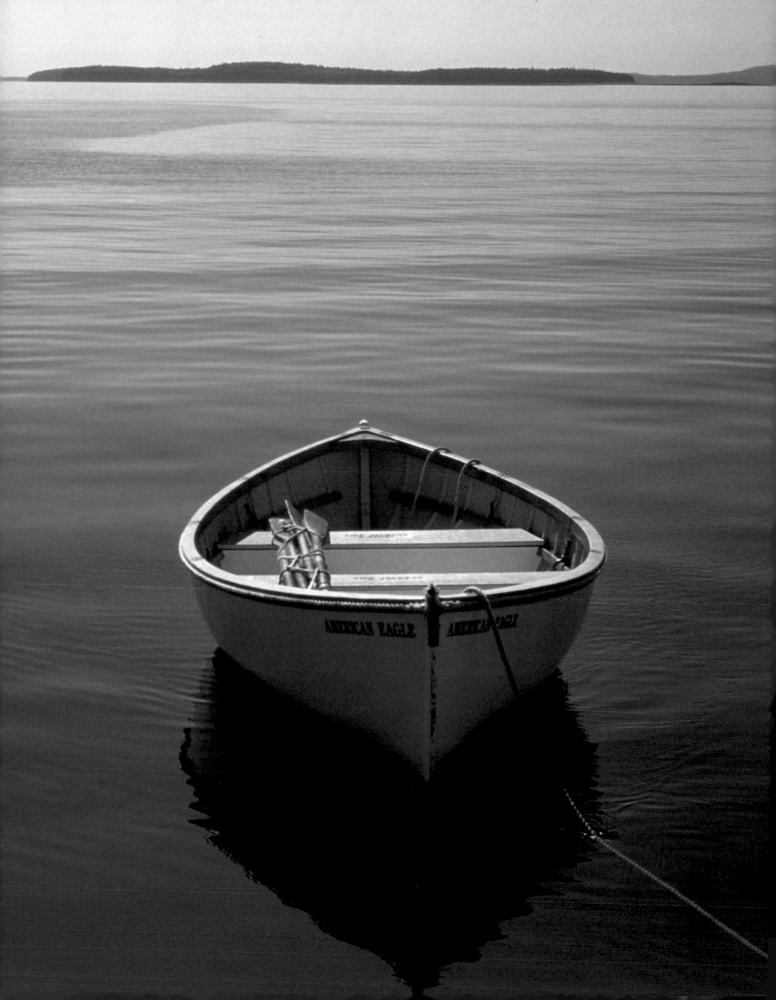

JIM BLAKELEY 415 / 558 - 9300

JIM BLAKELEY 415/558-9300

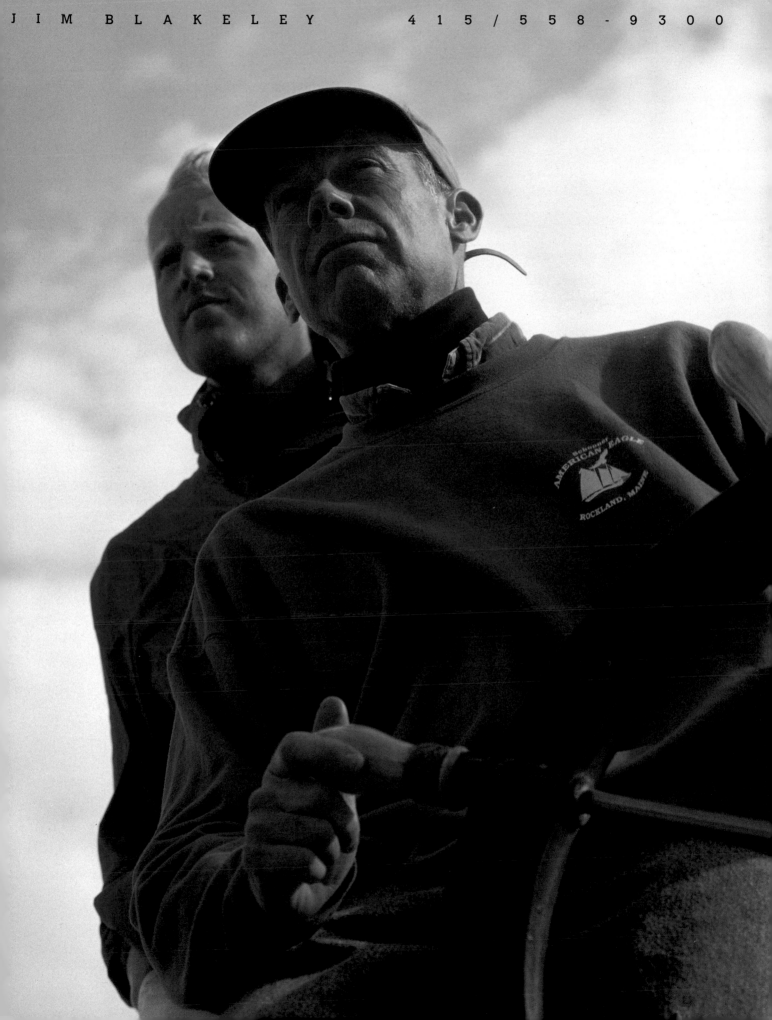

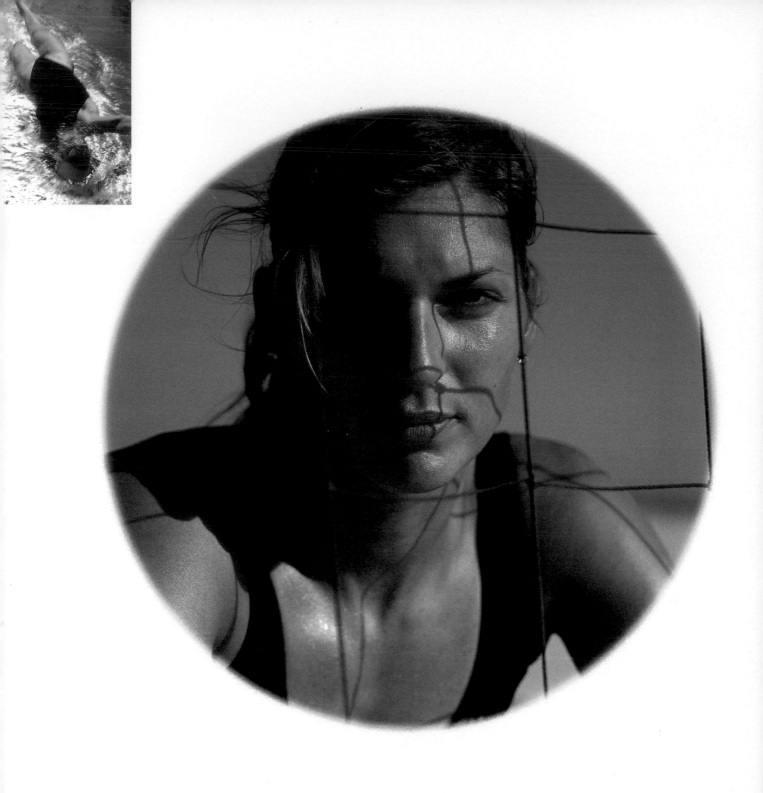

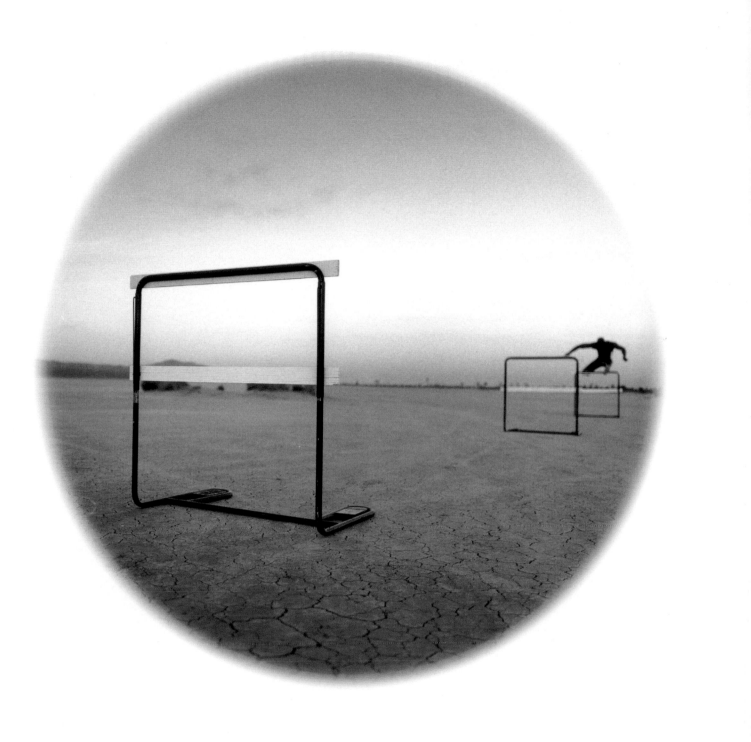

PRINT

GARY – **N**

O

L AGENCIES: ANDERSON LEMBKE, WIEDEN & KENNEDY, FCB/SF,

T J. WALTER THOMPSON, LEO BURNETT, ELGIN/DDB, TBWA

O REPRESENTED BY: (WEST) MARIANNE CAMPBELL 415.433.0353

N (EAST) AMY FRITH 617.423.2212 (STUDIO) 503.228.0844

FILM

MICHAEL LAMOTTE PHOTOGRAPHY SAN FRANCISCO 415 431 1443

№ 102794

LAMOTTE

1153

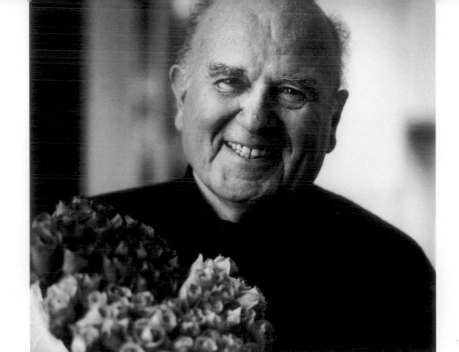

MOSSGROVE

Wm. Mosgrove
Represented by
Marianne Campbell
415 433 0353
Studio
415 331 1526

Member APA

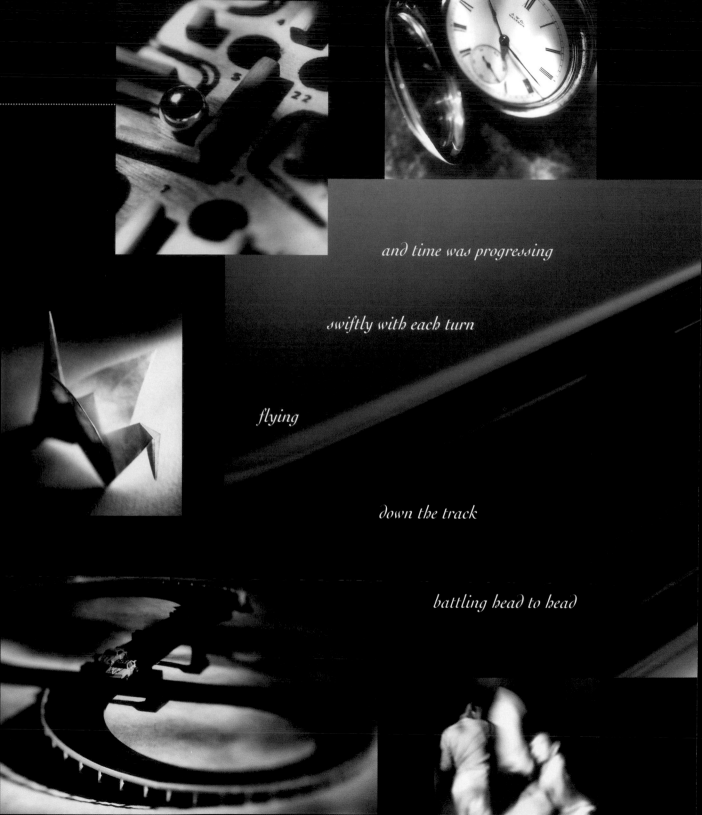

and time was progressing

swiftly with each turn

flying

down the track

battling head to head

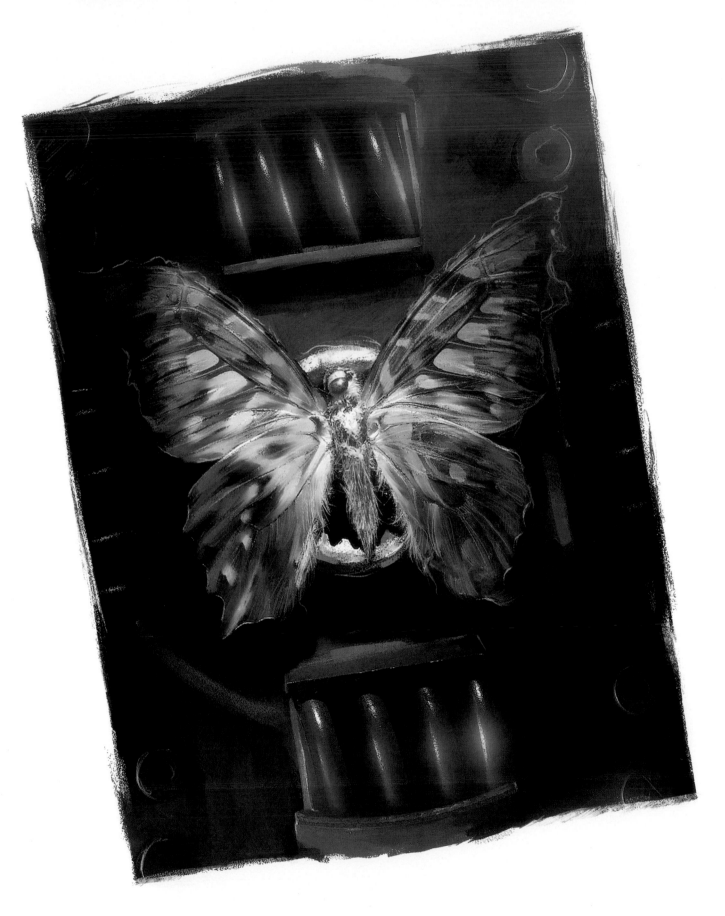

REPRESENTED BY JIM LILIE · 415·441·4384 · FAX 415·395·9809

Barnhurst / Spatafore

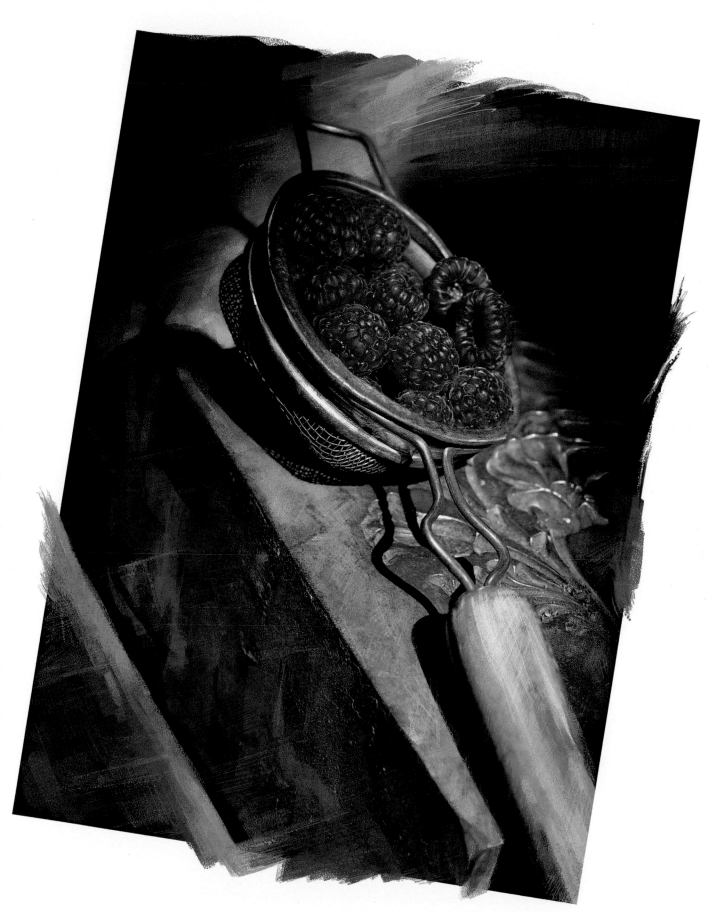

REPRESENTED BY JIM LILIE · 415·441·4384 · FAX 415·395·9809

DIRK DOUGLASS
P H O T O G R A P H Y

S T U D I O
8 0 1 4 8 5 5 6 9 1

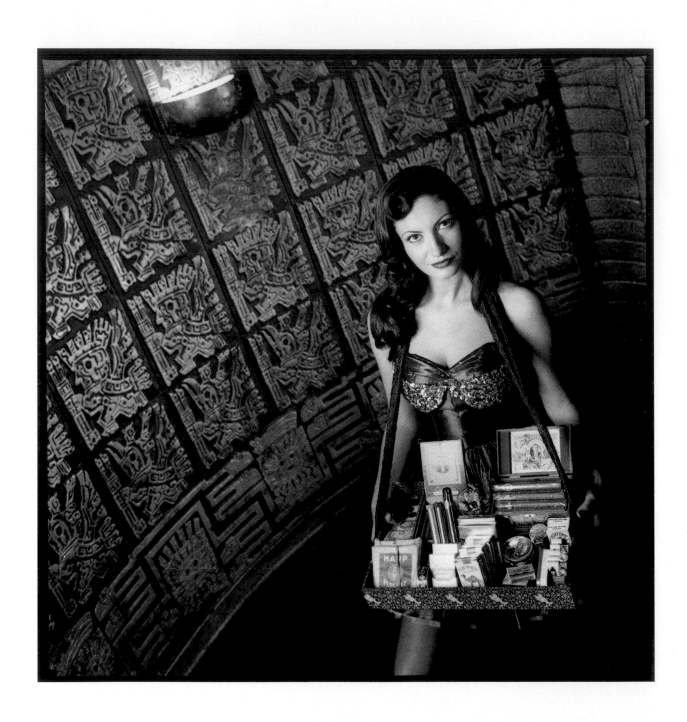

BRUCE HERSHEY
PHOTOGRAPHY

7 1 4 . 5 4 4 . 8 9 1 7 F A X 7 1 4 . 5 4 4 . 5 5 8 6

Pete
Stone

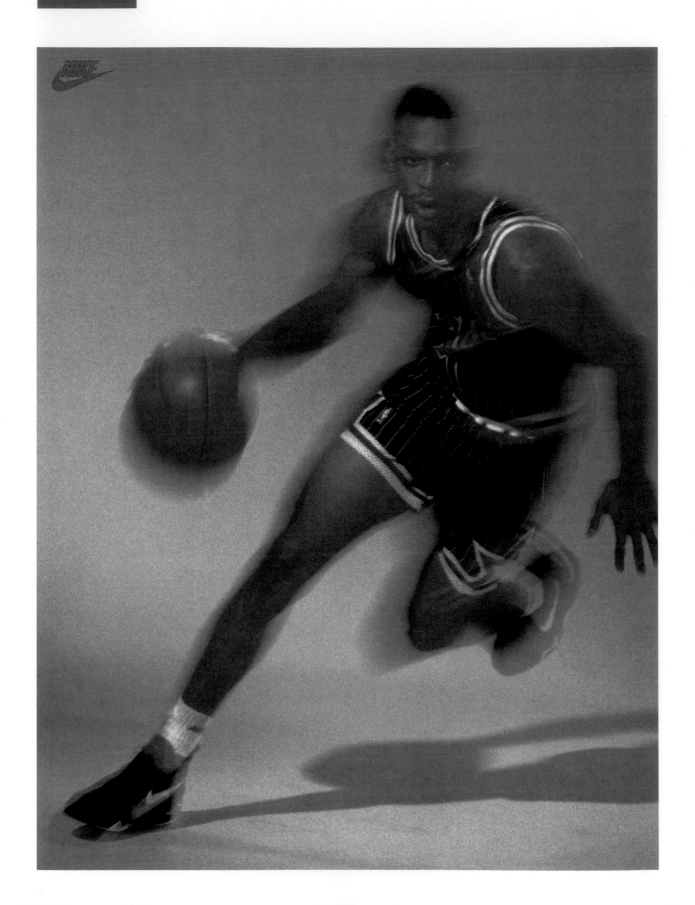

WEST COAST Arlene Johnson (415) 543-1131 FAX (415) 543-1197 EAST COAST D L M (212) 297-0041 FAX (212) 297-0043 STUDIO (800) 383-1167 FAX (503) 224-6235

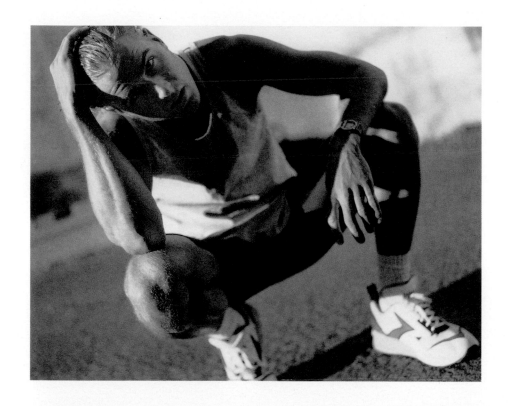

WEST COAST Arlene Johnson (415) 543-1131 FAX (415) 543-1197 EAST COAST ⒟ ⒧ ⓜ (212) 297-0041 FAX (212) 297-0043 STUDIO (800) 383-1167 FAX (503) 224-6235

Dan Escobar, Photographer, San Francisco (415) 626-4119 Represented by Arlene Johnson (415) 543-1131

Dan Escobar, Photographer, San Francisco (415) 626-4119 Represented by Arlene Johnson (415) 543-1131

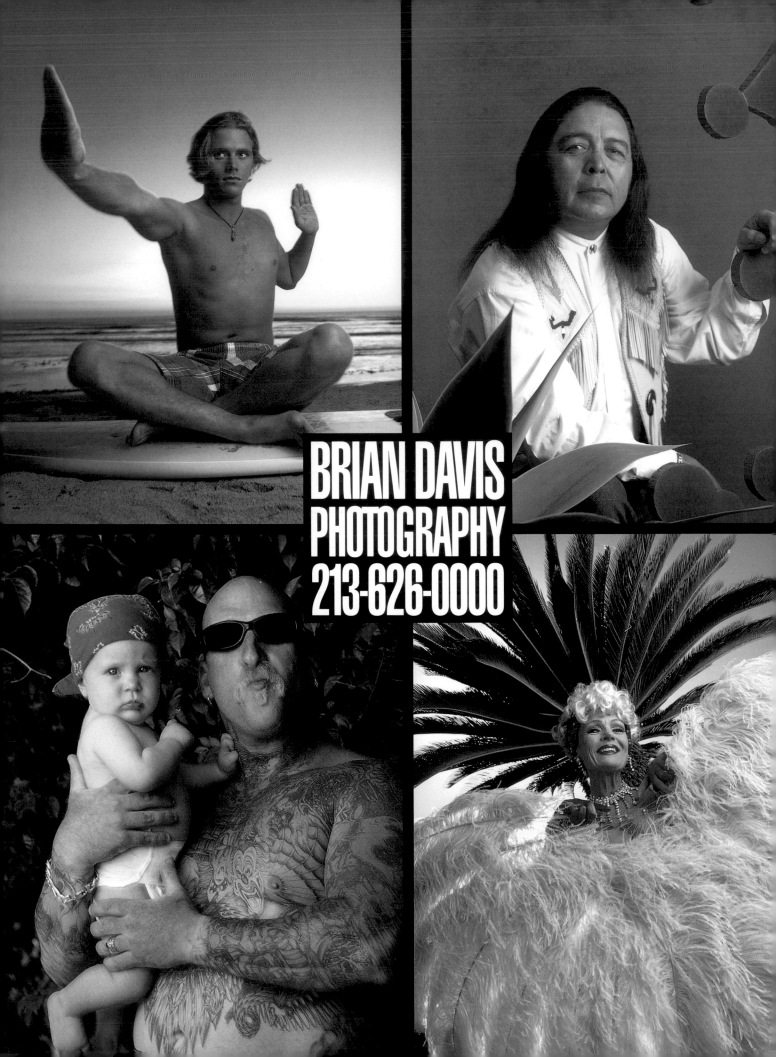

BRIAN DAVIS
PHOTOGRAPHY
213-626-0000

BMW 5 SERIES

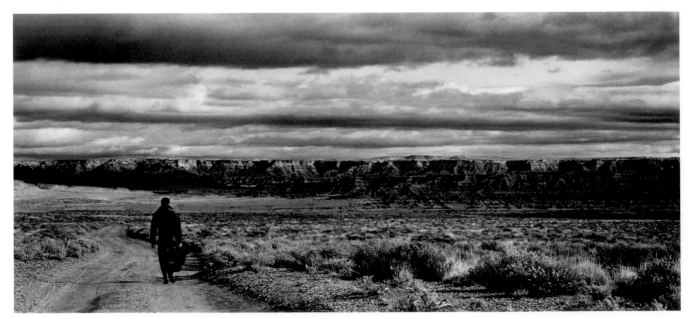

TAYLOR GUITARS

CHRIS WIMPEY

CHRIS WIMPEY STUDIO 619.275.0595
WEST COAST AND MIDWEST: TRICIA BURLINGHAM 310.275.3495
NEW YORK: JOHN KENNEY 914.962.0002, 212.517.4714

CANON

FORD EXPLORER

CHRIS WIMPEY

CHRIS WIMPEY STUDIO 619.275.0595
WEST COAST AND MIDWEST: TRICIA BURLINGHAM 310.275.3495
NEW YORK: JOHN KENNEY 914.962.0002, 212.517.4714

PHILIP JON

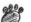 red BeAr studiOs

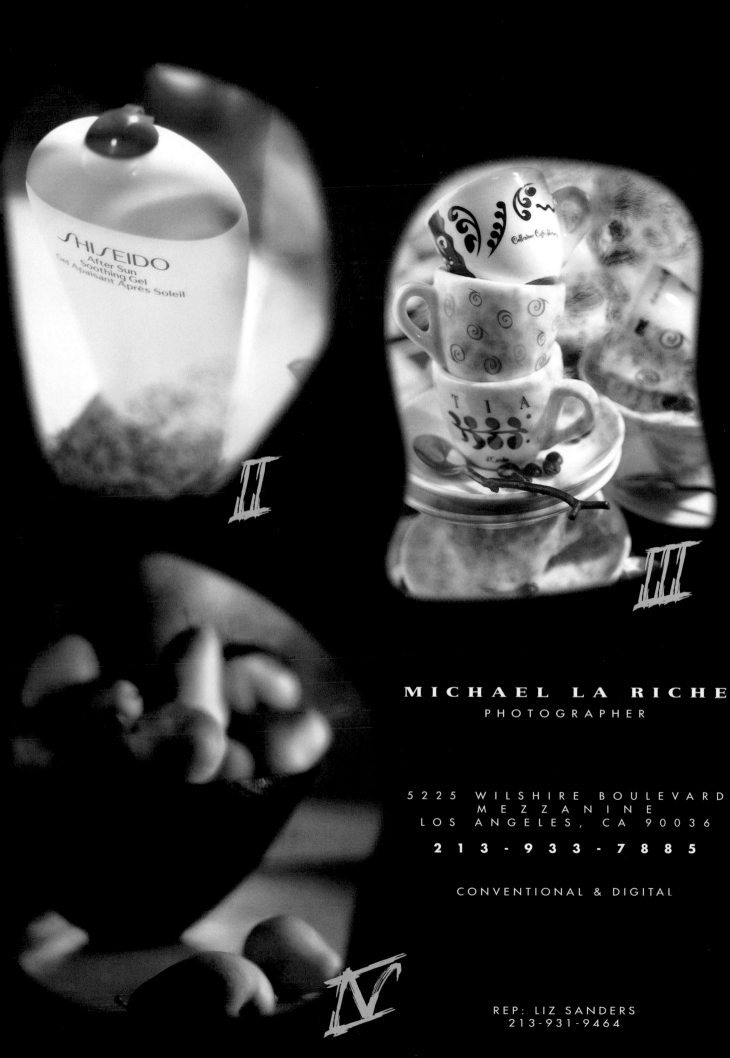

MICHAEL LA RICHE

PHOTOGRAPHER

5225 WILSHIRE BOULEVARD
MEZZANINE
LOS ANGELES, CA 90036

2 1 3 - 9 3 3 - 7 8 8 5

CONVENTIONAL & DIGITAL

REP: LIZ SANDERS
213-931-9464

RICHARD HUME

PHOTOGRAPHY

310. 827-0450

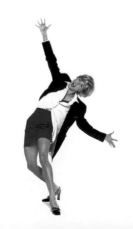

RICHARD HUME

PHOTOGRAPHY

310. 827-0450

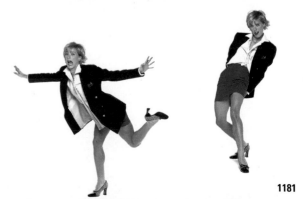

PAVLINA ECCLESS

Photography

415•282•4251
Fax 415•282•7691

REPRESENTED BY RON SWEET (415) 433-1222

HAMEISTER

CALL ·············▶ ERIC HAMEISTER

LE BON STUDIOS 310·637·7200

FAX 310·637·0402

RICH HALL REPS 310·637·1112

www.mktg101.com

LeBon

LeBon

David LeBon Studios

voice: 310.637.7200

fax: 310.637.0402

USA/International

Rich Hall Reps

voice: 310.637.1112

www.lebon.com

EARLY

Toyota

Subaru

Nissan

Mercedes-Benz

Mitsubishi

Mazda

Isuzu

GMC

Audi

AAA

RICH HALL REPS
310.637.1112

ONLINE PORTFOLIO:
HTTP://WWW.PRIMENET.COM/~EARLYPH/

JOHN EARLY PHOTOGRAPHY

DAVID LEBON STUDIOS

310.637.7200

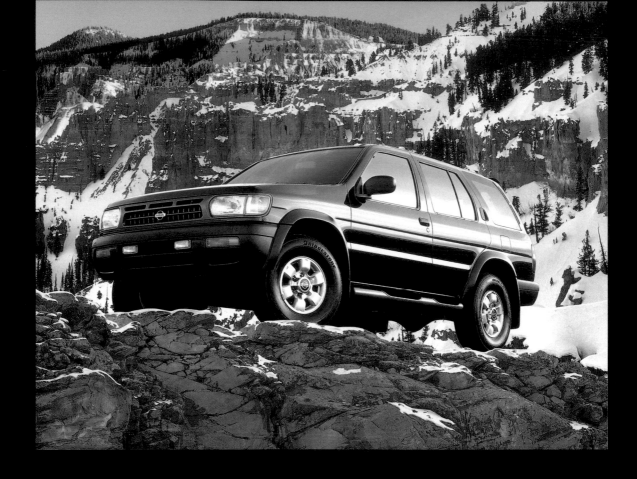

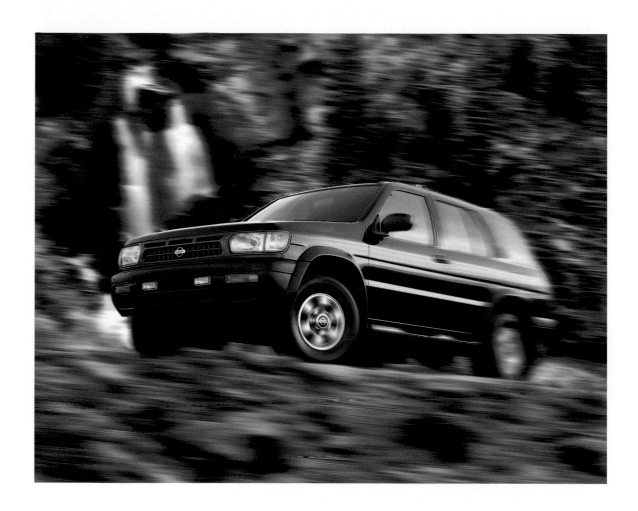

Michael Brown

Michael Brown Photographic Productions Inc.
phone 310.379.7254 ▪ fax 310.379.3306 ▪ e-mail mbprod@earthlink.net
Interactive CD-ROM portfolio available upon request

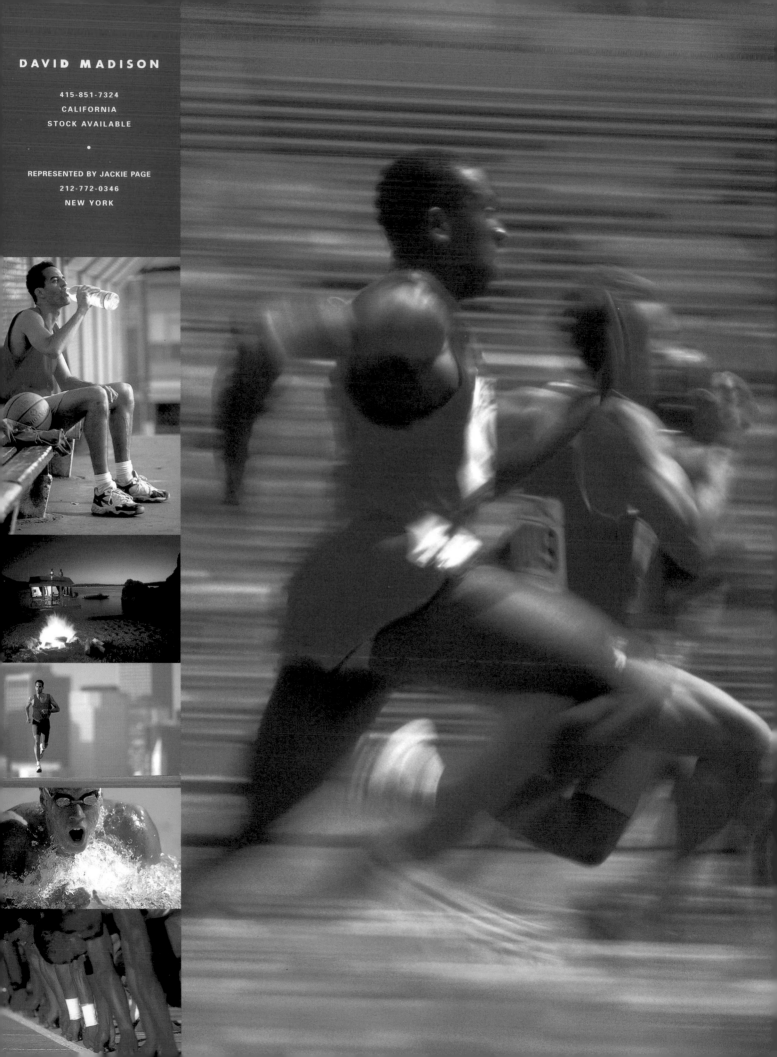

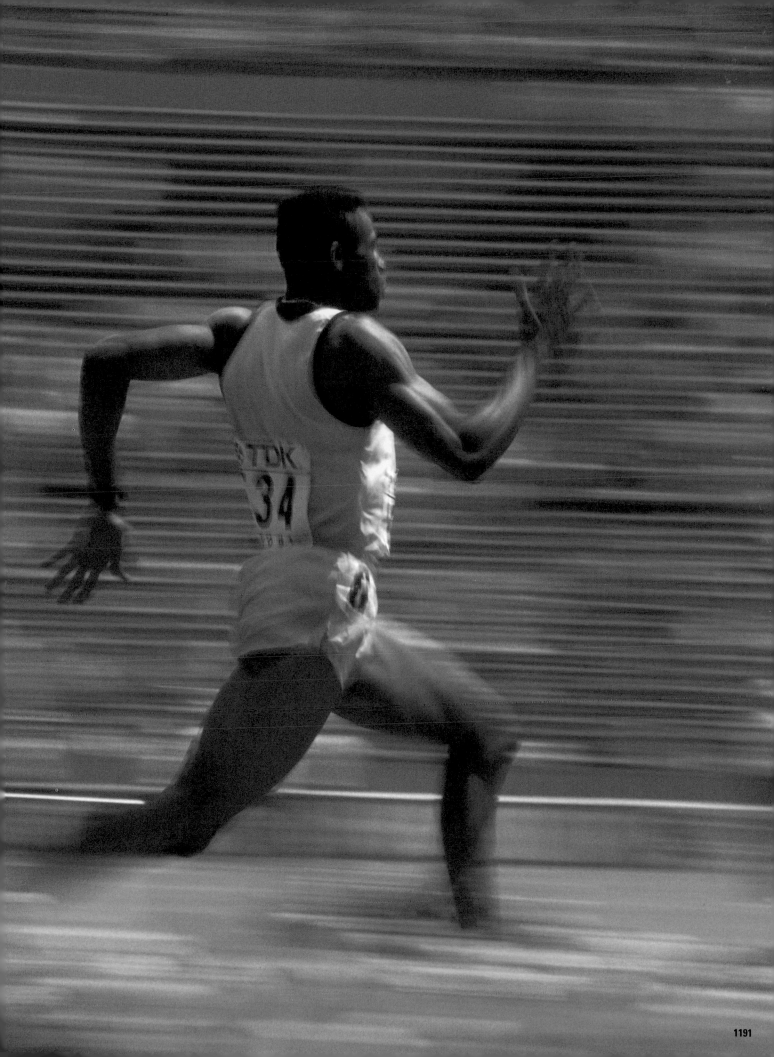

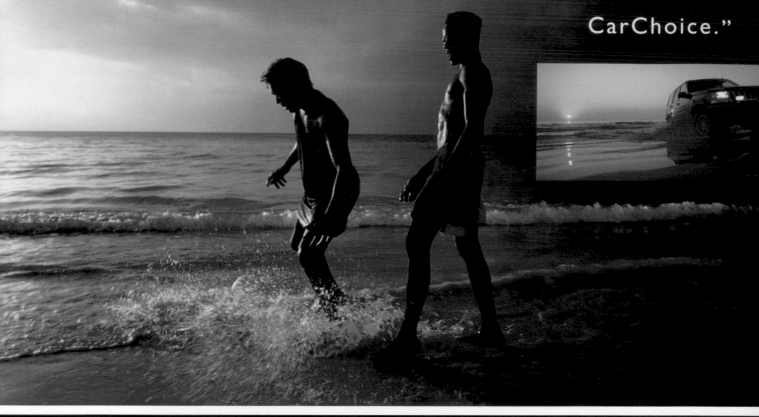

STEVE HIX PHOTOGRAPHY 415.388.3554

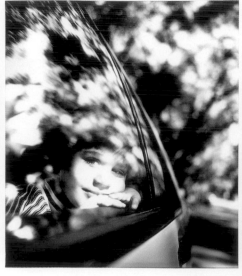

Thomas Heinser

415.495.0365

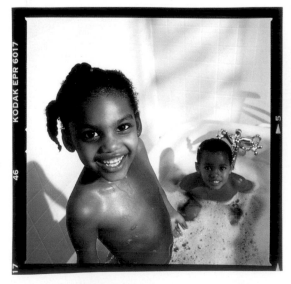

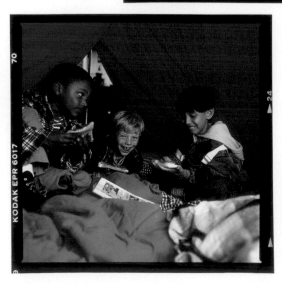

How will it take care of me?

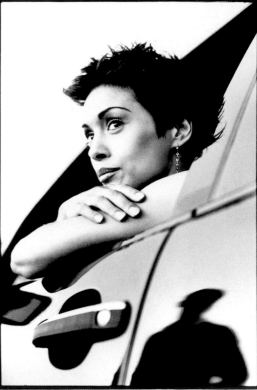

©1996 Thomas Heinser

Thomas Heinser

415.495.0365

Where will your desires drive you?

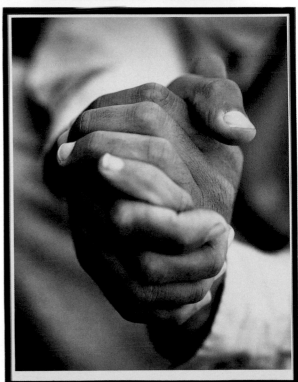

still life

FOTO*graphia*

STYLIST:POUKÉ WELDON OWEN PUBLISHING

STYLIST:MELINDA MANISCALCO

pEmInA

[415] 541~9946

represented by

MISSY PEPPER

[415] 543~6881

TABLETOP

STYLIST:POUKÉ WELDON OWEN PUBLISHING

food

STYLIST:POUKÉ WELDON OWEN PUBLISHING

STYLIST:THERESA DOUGLAS-MITCHELL

pEmInA

[415] 541~9946

represented by

MISSY PEPPER

[415] 543~6881

STYLIST:COURTNEY

ALLIED TELESYN INTN'L

BABY GAP

LOGITECH

JOE BOXER

HERB CAEN

LOUISIANA

3COM

SATURN

3COM

McDonald

Represented by: Southern California, Torrey Spencer [818] 505-1124 Northern California, Missy Pepper [415] 543-6881
USA, Howard Bernstein [212] 682-1490

MICROSOFT

ALLIED TELESYN INTN'L

NᵀH DEGREE SOFTWARE

ICROSOFT

JOE BOXER

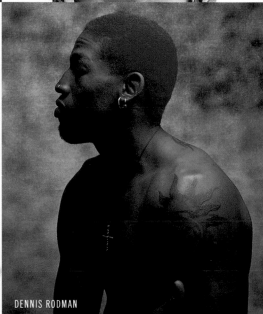

DENNIS RODMAN

E BOXER

SATURN

BABY GAP

McDonald

Jock McDonald Photography: 46 Gilbert, San Francisco California 94103

[415] 621-0492 fax [415] 621-0601

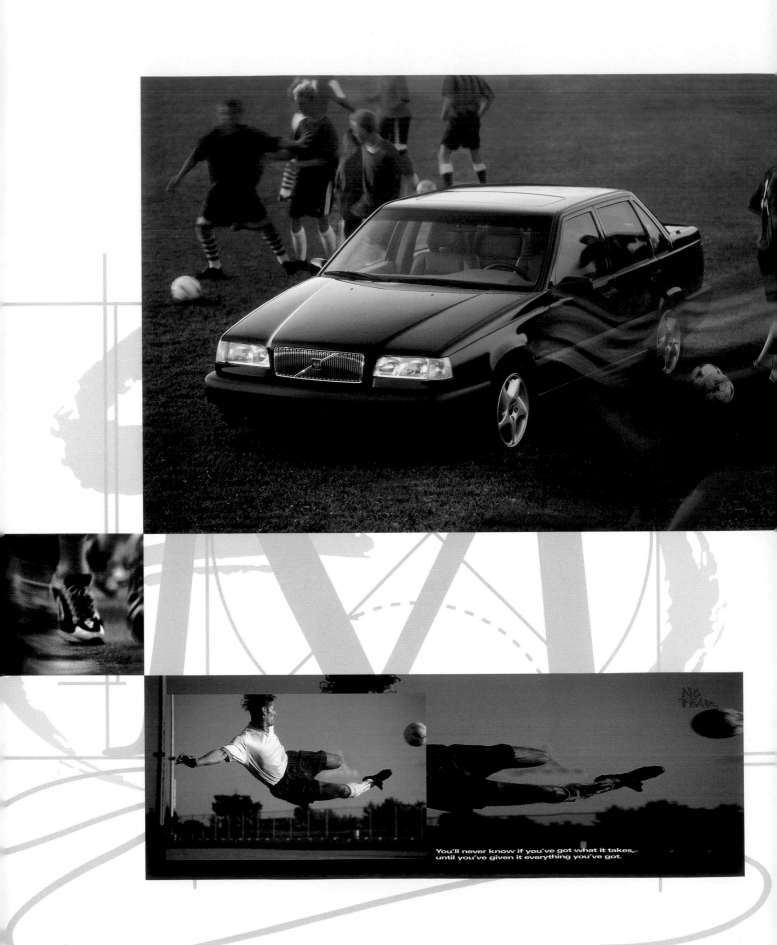

You'll never know if you've got what it takes,
until you've given it everything you've got.

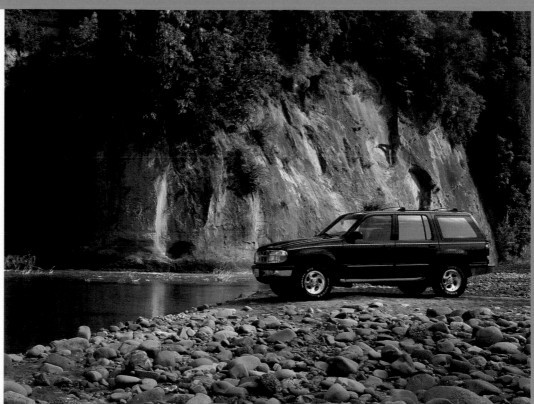

SCOTT MONTGOMERY
P H O T O G R A P H Y

Scott Montgomery
Photography

800.621.1676

Drkslyd@primenet.com

<u>West</u>
Torrey Spencer
818–505–1124

<u>East</u>
Joan Carelas
919–833–6659

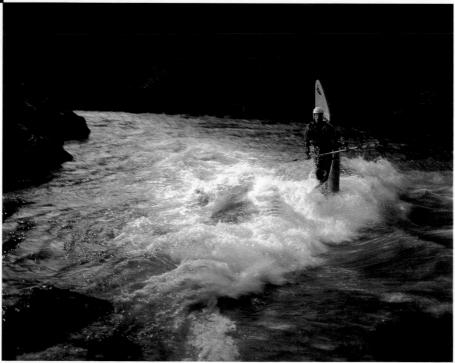

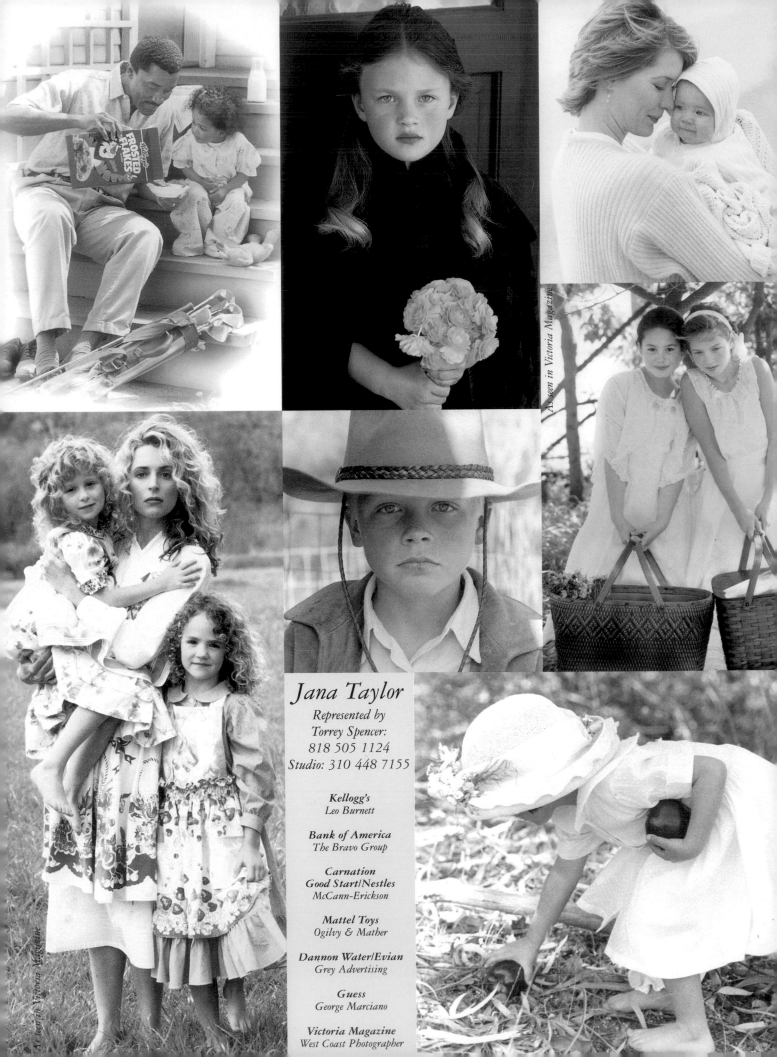

Jana Taylor

Represented by
Torrey Spencer:
818 505 1124
Studio: 310 448 7155

As seen in Victoria Magazine

TAYLOR
Paul

Paul Taylor
P:213•467•0404
F:213•856•4328
Represented by
Torrey Spencer
P:818•505•1124
F:818•753•5921

Holly Stewart Photography
415.777.1233

CLIENT: MEN'S JOURNAL, NOTEBOOK: "THE SMART CIGAR"

HOLLY STEWART PHOTOGRAPHY, 370 FOURTH STREET, SAN FRANCISCO, CA 94107 PHONE: 415.777.1233 FAX: 415.777.2997
REPRESENTED BY BETSY HILLMAN, SAN FRANCISCO 415.391.1181 REPRESENTED BY TORREY SPENCER, LOS ANGELES 818.505.1124

Holly Stewart Photography
415.777.1233

CLIENT: FORE SYSTEMS, ANNUAL REPORT, ATM NETWORKING

HOLLY STEWART PHOTOGRAPHY, 370 FOURTH STREET, SAN FRANCISCO, CA 94107 PHONE: 415.777.1233 FAX:
REPRESENTED BY BETSY HILLMAN, SAN FRANCISCO 415.391.1181 REPRESENTED BY TORREY SPENCER, LOS ANGELES

15.777.2997

818.505.1124

1207

RAPHY

7091 F· 415.861.2188